7" SHEAVE

WEIGHT
175 to 195 lbs.

3/8" WIRE
CABLE 45'
LONG

4 1/4" SHEAVE

ARRANGEMENT OF CLOCKWORK,
CORD, SHEAVES, DRIVING WEIGHT,
AND FALL
SCALE: 1/2" = 1'-0"
0 1 2 3 4 5 FEET
0 1 2 METERS

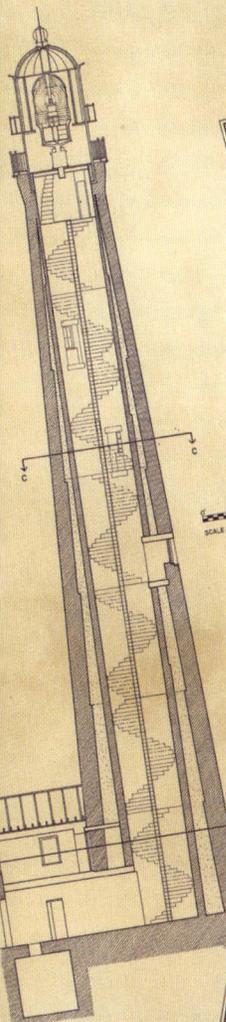

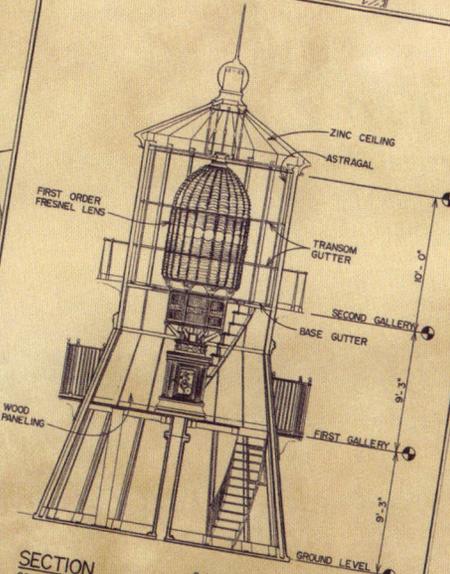

SECTION
SCALE: 1/4" = 1'-0"

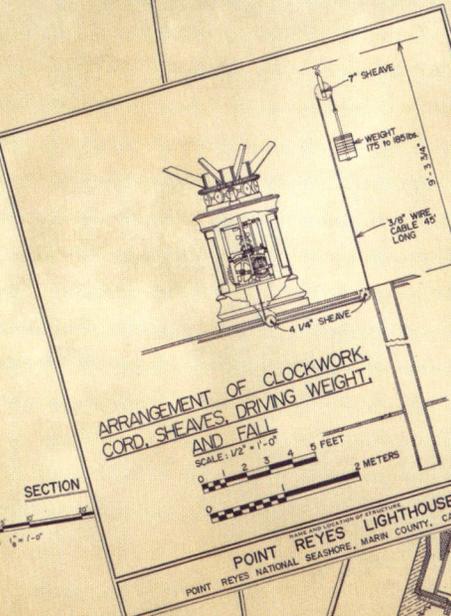

POINT REYES LIGHTHOUSE
POINT REYES NATIONAL SEASHORE, MARIN COUNTY, CALIFORNIA

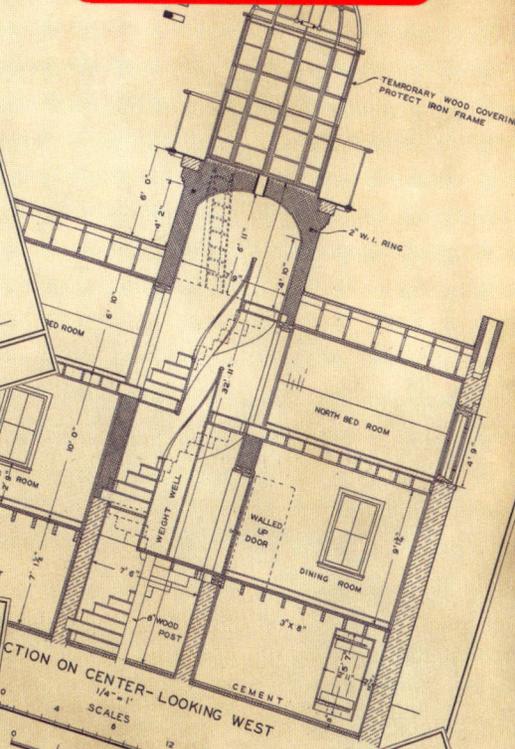

TEMPORARY WOOD COVERING
PROTECT IRON FRAME

2" W. I. RING

NORTH BED ROOM

RED ROOM

LIVING ROOM

DINING ROOM

WEIGHT WELL

WALLED
UP DOOR

BASEMENT

6" WOOD
POST

3" X 8"

CEMENT

SECTION ON CENTER- LOOKING WEST
1/4" = 1'
SCALES
0 4 8 12 16 FT.
0 1 2 3 4 M

CABRILLO NA
POINT LOMA

ZINC CEILING

ASTRAGAL

FIRST ORDER
FRESNEL LENS

TRANSOM
GUTTER

SECOND GALLERY

BASE GUTTER

FIRST GALLERY

WOOD
PANELING

GROUND LEVEL

SECTION
SCALE : 1/4"=1'-0"
0 1 2 3 4 5 FEET
0 1 2 3 4 METERS

POINT REYES LIGHTHOUSE
POINT REYES NATIONAL SEASHORE, MARIN COUNTY, CALIFO

RESILIENT TILE FLOORING
OVER THE CAST IRON DECK

WOOD PANELING TYP AT
FIRST GALLERY

CLOCKWORKS

HATCH TO GROUND
LEVEL - SHOWN IN
CLOSED POSITION

IRON STAIRS
TO SECOND
GALLERY LEVEL

SHELF

UP

WOOD CATWALK

HOLE FOR
CLOCKWEIGHT

CABINETS

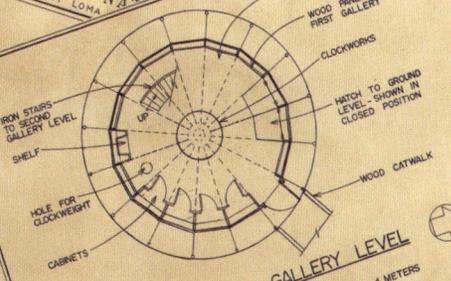

PLAN OF FIRST GALLERY LEVEL
SCALE: 1/4"=1'-0"
0 1 2 3 4 METERS
0 1 2 3 4 5 FEET

POINT REYES LIGHTHOUSE
POINT REYES NATIONAL SEASHORE, MARIN COUNTY, CALIFORNIA

PENSACO
NAVAL AIR STATION

RESERVATION

LIGHTHOUSES
of AMERICA

LIGHTHOUSES
of AMERICA

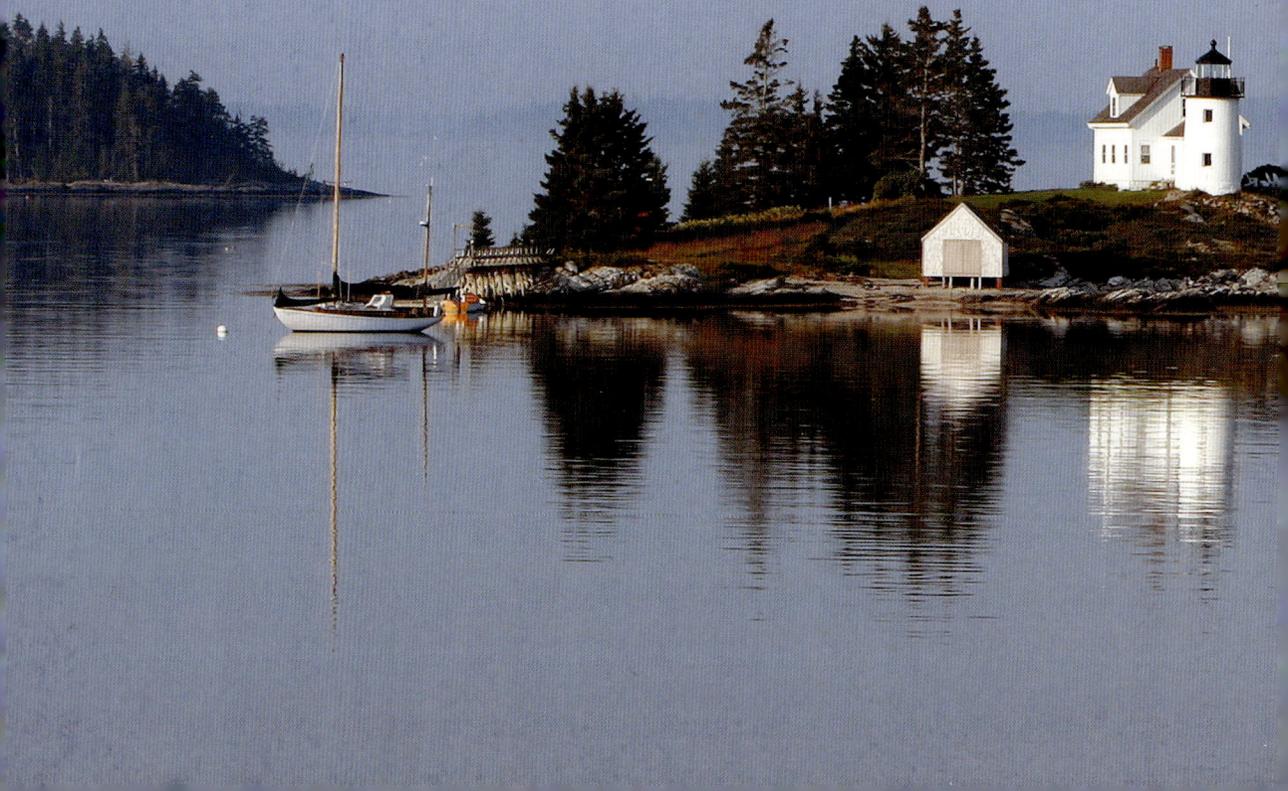

Tom Beard, *EDITOR IN CHIEF*

Tom Thompson, *GRAPHICS EDITOR*

welcome
BOOKS
A Division of
Rizzoli New York

(Pages 2–3)

PUMPKIN ISLAND LIGHTHOUSE, MAINE
The fifth-order Fresnel lens used in this lighthouse in 1855 was among the first Fresnel lenses used in Maine. This new light was visible at nine nautical miles.

▶ DIAMOND HEAD LIGHTHOUSE, HAWAII
The remodeled keeper's residence of this lighthouse has been home to admirals commanding the Coast Guard's 14th District for the past 50 years.

Welcome Books ®
A Division of Rizzoli International Publications, Inc.
300 Park Avenue South
New York, NY 10010
www.rizzoliusa.com

© 2017 Welcome Books

The United States Lighthouse Society is a nonprofit historical and educational organization incorporated to educate, inform, and entertain those who are interested in lighthouses, past and present. For more information, visit uslhs.org.

Project Editor: Candice Fehrman
Book Design: Lori S. Malkin

2022 2023 2024 2025 / 10 9 8 7 6 5 4

Printed in Hong Kong

ISBN-13: 978-1-59962-140-1

Library of Congress Catalog Control Number: 2017931910

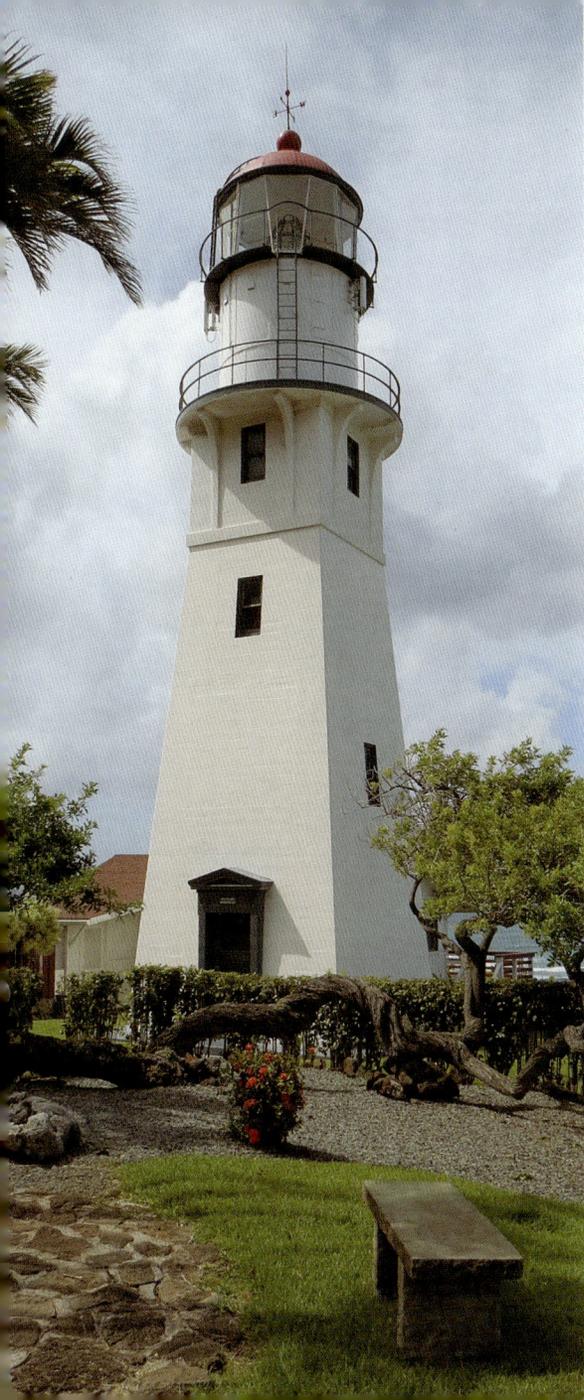

Contents

Preface

by Wayne Wheeler

FOUNDER AND PRESIDENT OF THE BOARD OF DIRECTORS,
UNITED STATES LIGHTHOUSE SOCIETY

LIGHTHOUSES OF AMERICA is a glimpse into the magical attraction these unique structures offer today. Images here evoke the hidden splendor of earlier American architecture and science.

Modern technology has doomed the classic lighthouse. The US Coast Guard, in its role as custodian, has automated all light stations in this country and, in the process, eliminated the need for operating personnel. Sterile, rotating beacons on monopoles have replaced the many proud coastal ladies of former years, with their sweeping towers of brick and Victorian gingerbread.

Concerned individuals acted locally by attempting preservation measures or applying meager restorative steps. Problems were nationwide and far beyond the scope of a few. Through this concern, a national organization emerged.

The United States Lighthouse Society (uslhs.org), established in 1984 as a 501(c)(3) nonprofit organization, became a national voice fostering public awareness of America's lighthouses. The society soon was recognized as an important source for lighthouse heritage support by providing funding and technical assistance to lighthouse organizations nationwide.

Today, many historic light stations are in good condition, with their stewardships spread across federal, state, and local authorities and nonprofit groups. However, there are still lighthouses that need help. Although the 300-year-old era of manned light stations has come to a close, the remaining symbols of our maritime heritage can, and should, be preserved for future generations.

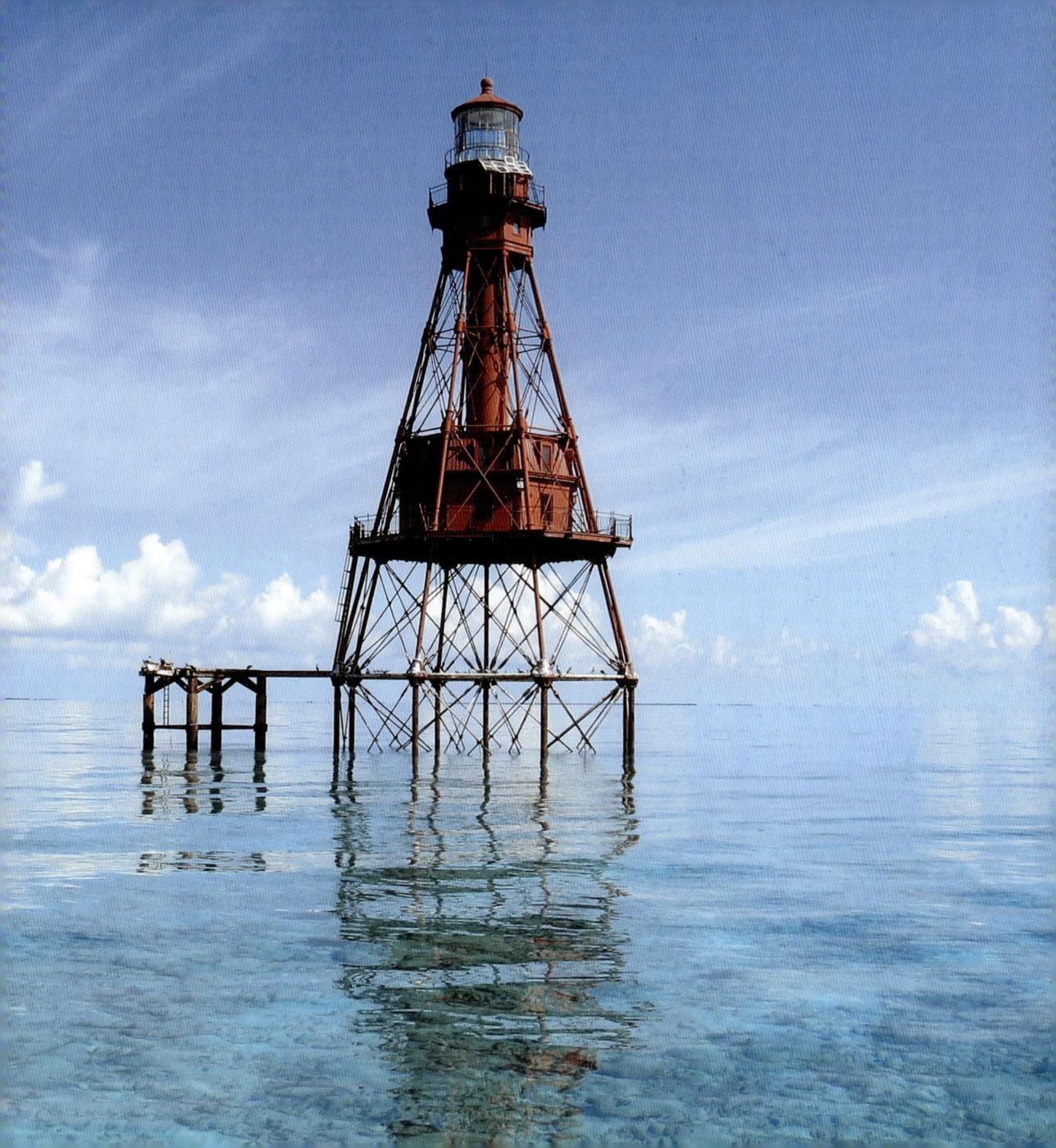

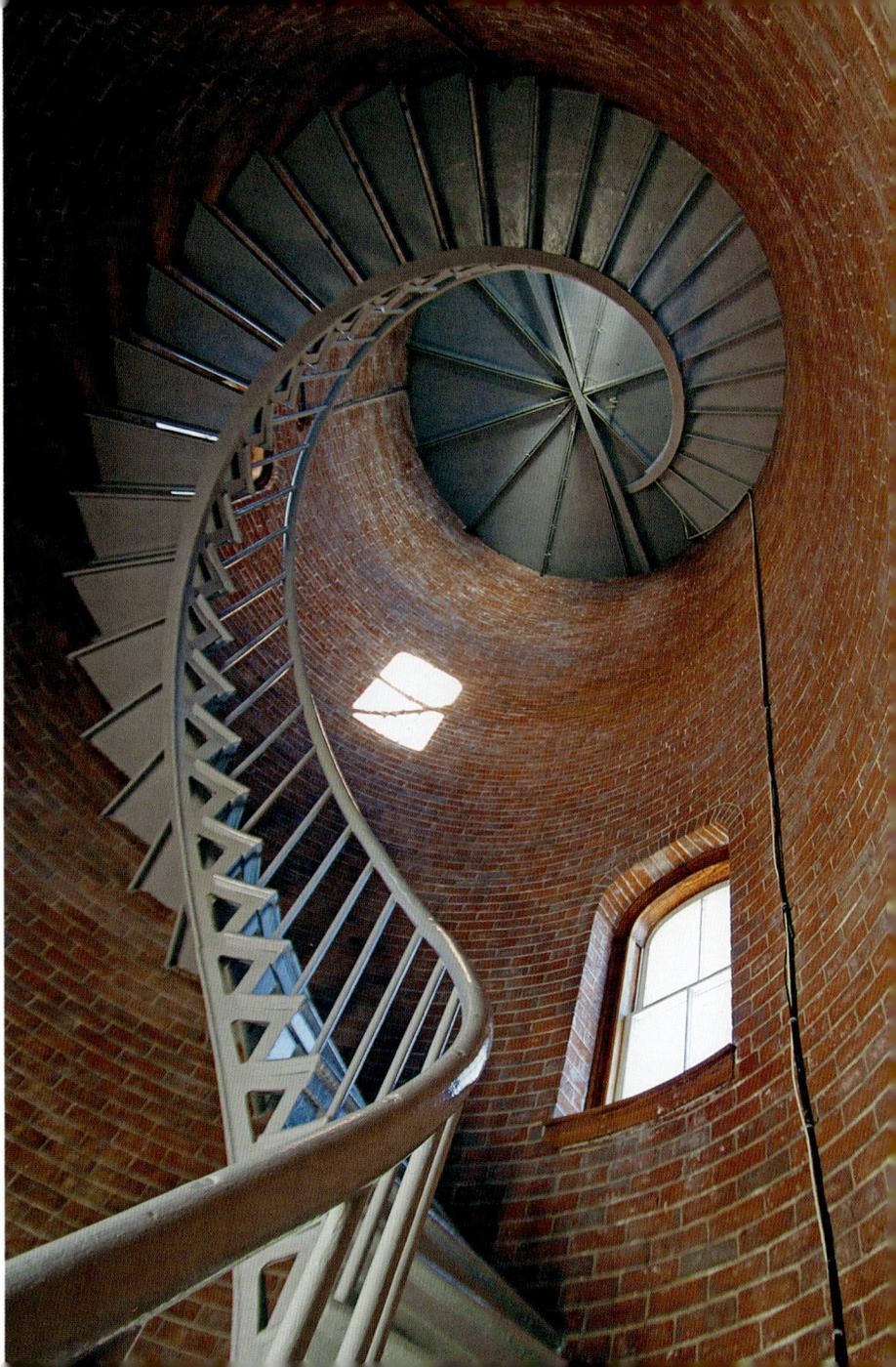

(Pages 6–7)

**AMERICAN SHOAL
LIGHTHOUSE, FLORIDA**
*This lighthouse, mounted on
a screw-pile foundation, was
constructed in skeletal form to
resist hurricane-force winds.*

▶ **PORTSMOUTH
HARBOR LIGHTHOUSE,
NEW HAMPSHIRE**
*Some lighthouse tower stairs
were built around a central
newel post, while others were
attached to the interior wall
as shown here.*

Foreword

by Captain Robert (Bob) Desh, US Coast Guard (Retired)

FORMER EXECUTIVE DIRECTOR, DOOR COUNTY MARITIME MUSEUM AND
MEMBER, BOARD OF REGENTS, FOUNDATION FOR COAST GUARD HISTORY

COASTAL TOWERS PLAYED ESSENTIAL ROLES in this nation's maritime history. Signal towers, watchtowers, and light towers in all forms dotted America's coastlines. Some maritime artifacts continue to serve and fascinate. Those surviving today are treasured relics and popular visitor attractions.

The best-known maritime towers are the ubiquitous lighthouses, often called "America's castles." These aged columns are still found at entrances to major harbors, perched precariously atop remote dunes, or looming over rocky outcroppings. They exist simply as navigational aids. However, they are architecturally and culturally much more.

A lighthouse's function is practical, yet there is something elusive about these structures that fascinates both the mariner and landsman alike. The allure for some is the towers' link to the past, and for others the heroic purposes these structures served. Their only task, however, is

simply to show a light, guiding sailors past shoals and directing them safely into harbors of refuge and commerce.

Because their existence spans the history of this country, these magnificent structures embrace many secrets: tales of lives saved, storms survived (or not), and strange accounts of souls residing within their walls.

Open sea in darkness is an eerie, sometimes frightening experience for navigators, but a distant, flashing light to sailors conveys a symbol of

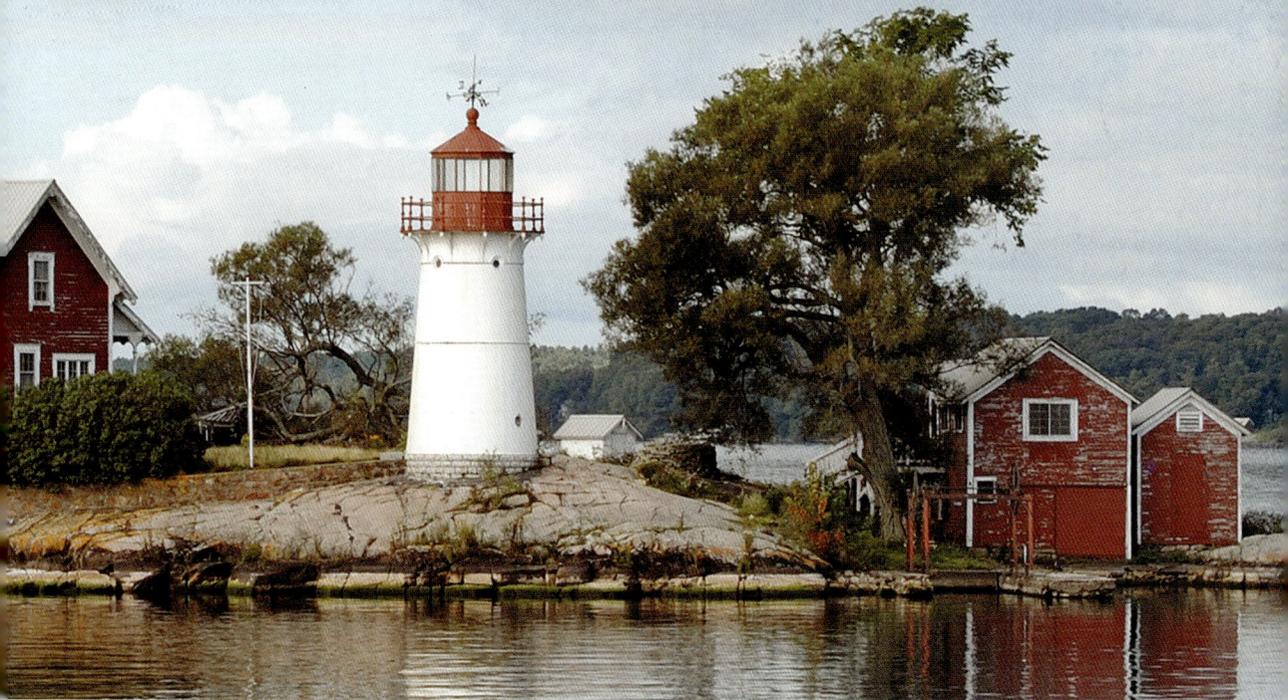

hope, tranquility, and comfort. Inside the tower, stalwart lighthouse keepers, tending lights in all manner of weather and personal privation, add to the mystique. Remote locations, where land meets sea, compound the magic.

There is just something extraordinarily special about lighthouses. They become landmarks that are forever and essentially identified with a community or location. The view from their gallery decks or lantern rooms offers a perspective on the world below like no other.

Introduction

Tom Beard, US Coast Guard (Retired)

BONFIRES ON THE BEACH offered ancient navigators both guidance and hazards. By steering ships toward harbors, fires were a community's economic muscle and—without government—a pirate's plunder.

Individuals initiating local economic opportunities built the first lighted beacons, offering safe passage into colonial harbors. As the New World communities joined in maritime trade, oil lanterns flickered for those first beacons set on headlands, reefs, and islands, defining safe routes into ports.

America's War of Independence ended with an emerging nation without income or funds to pay its tolls. The new United States had massive economic potential if products could sail safely through its ports and move reliably along bordering waters. Villages could reap major economic boosts and become seaports with the safe sea-lanes provided by lighthouses.

EASTERN POINT LIGHTHOUSE, MASSACHUSETTS
This keeper's dwelling is a wooden, Gothic Revival style built in 1879.
Winslow Homer spent time here painting his landscapes and seascapes.

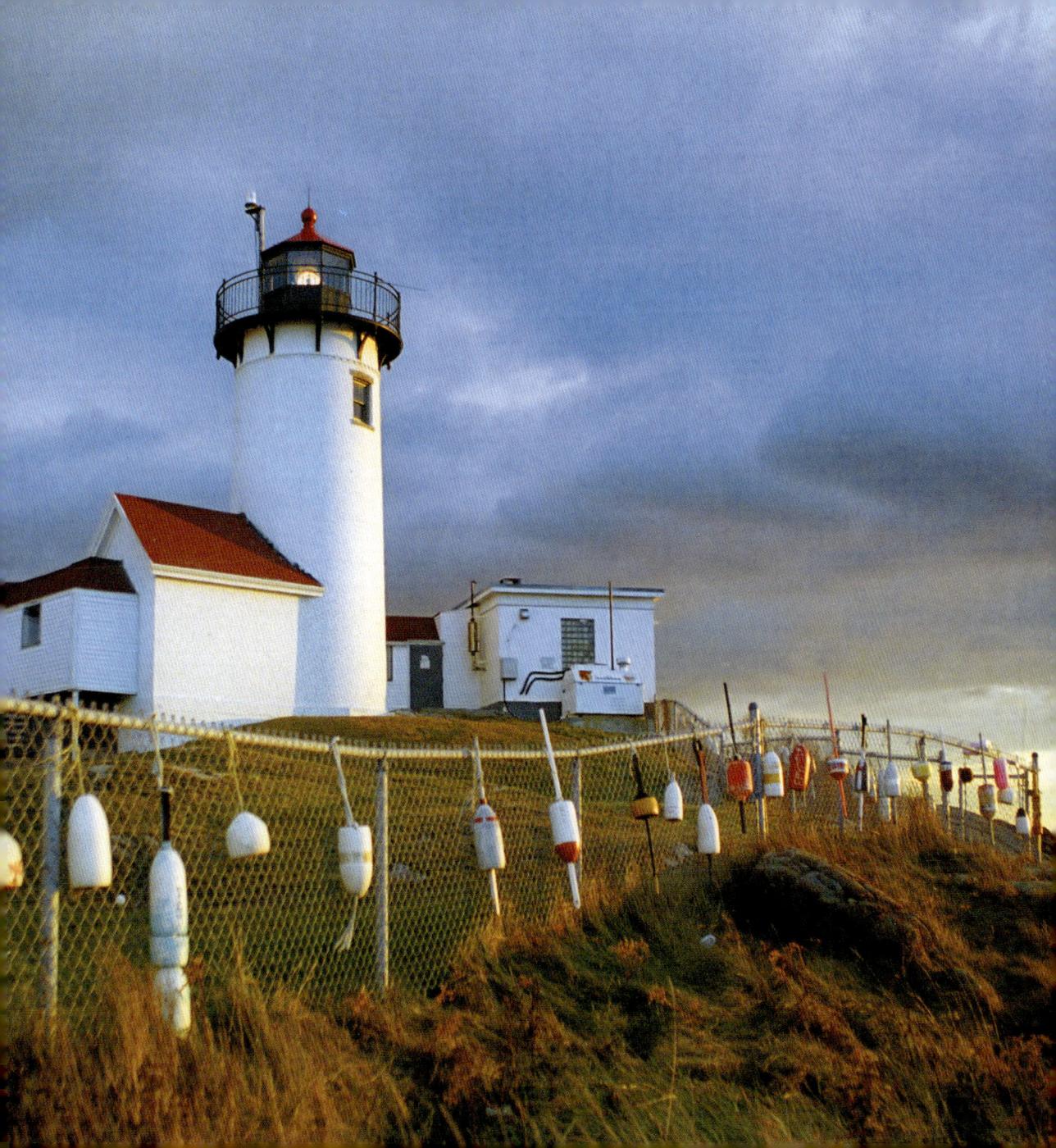

A solution for the postbellum nation's income was to tax cargos moved by ships. The ninth act of the First Congress in 1789 established the United States Lighthouse Service to enhance safe shipping. Existing colonial community light structures were assembled into a planned national system. An aggressive program started with building new beacons, advancing major ports. Lesser lights were also created in webs of lighthouses connecting the new nation's many emerging coastal, river, and Great Lakes ports.

A co-element in 1790, with Treasury Secretary Alexander Hamilton's plan bringing economic independence, was the creation of the Revenue-Marine (later Revenue Cutter Service and, in 1915, US Coast Guard) to enforce the collection of tariffs. The US Coast Guard absorbed the US Lighthouse Service in 1939, becoming responsible for all aids to navigation and acquiring all US Lighthouse Service properties. For nearly 200 years, keepers lived with and kept the light. Then the US Coast Guard, beginning in the late 1960s, began automating all light stations, leaving them unattended, which opened new problems and opportunities.

Architecture and engineering stretched the limits of knowledge in building lighthouses. Towers to mount lights were

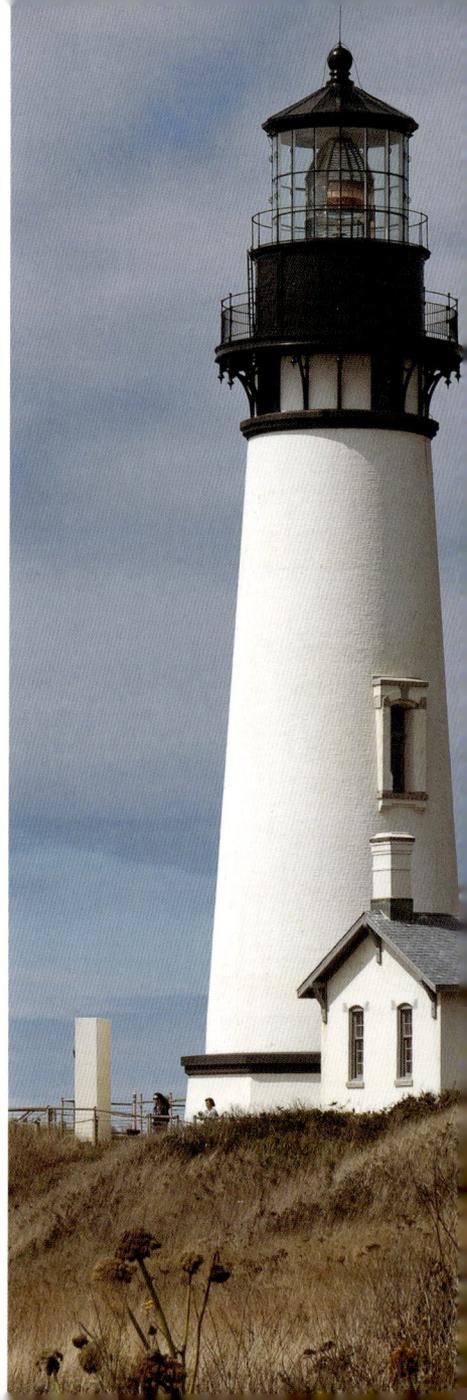

anchored on isolated rock headlands, submerged reefs, great sandbars, and seabeds. Many structures withstood the harshness of encroaching seas to stand firm for a century or more—some, catastrophically, less.

Lanterns needed to be lit, extinguished, and fueled. Their wicks needed to be trimmed, and their reflectors and lenses polished. A person tending to these details earned the moniker "wickie." "Keeper" was the formal title bestowed on these tenders with the creation of the US Lighthouse Service. The early keeper's role was so important to the nation's welfare that the president and Congress engaged in personnel and management decisions. Partisan politics even influenced lighthouse assignments.

Rain, snow, and fog reduced visibility and added to light keepers' tasks during daytime. They struck noisemakers, rang bells, operated horns and sirens—even barking dogs saved ships. All these apparatuses added to their daily chores. Lighthouses expanded into light stations as home to more than one keeper, many with families. Socially complex communities developed

YAQUINA HEAD LIGHTHOUSE, OREGON
At 93 feet, this lighthouse is the tallest tower on the Oregon coast. The light's focal plane is 162 feet above sea level and can be spotted at 19 miles.

within these isolated—and environmentally harsh—light stations. Keepers and their families survived in this remoteness, often through unimaginable hardships. From these existences, deaths and unsolved mysteries perpetuated curious and bizarre legends, even the belief in ghosts that still roam the towers.

A major improvement for light magnification came with the invention of the Fresnel lens, introduced in the 1840s. Gas and kerosene replaced animal lard for the lanterns' flames in the late 1800s after the discovery of petroleum. Electric light bulbs snuffed the oil flames in the early 1900s, and this now not-so-modern light still beams through some ancient lenses that once bent light beams from burning whale oil or pig lard. Technology has now eliminated the need for bright, high-powered, electric lamps and Fresnel lenses; light-emitting diodes encased in plastic lenses require nothing more than solar panels to charge batteries and generate electricity for their use.

Today's "bonfires on the beach" show us 300 years of isolated communities that have contributed significantly to American lore, science, and culture.

MINOT'S LEDGE LIGHTHOUSE, MASSACHUSETTS
Petitioning for a light on Minot's Ledge began in 1839, based on the fact that more than 40 vessels struck the submerged rocks within the previous decade.

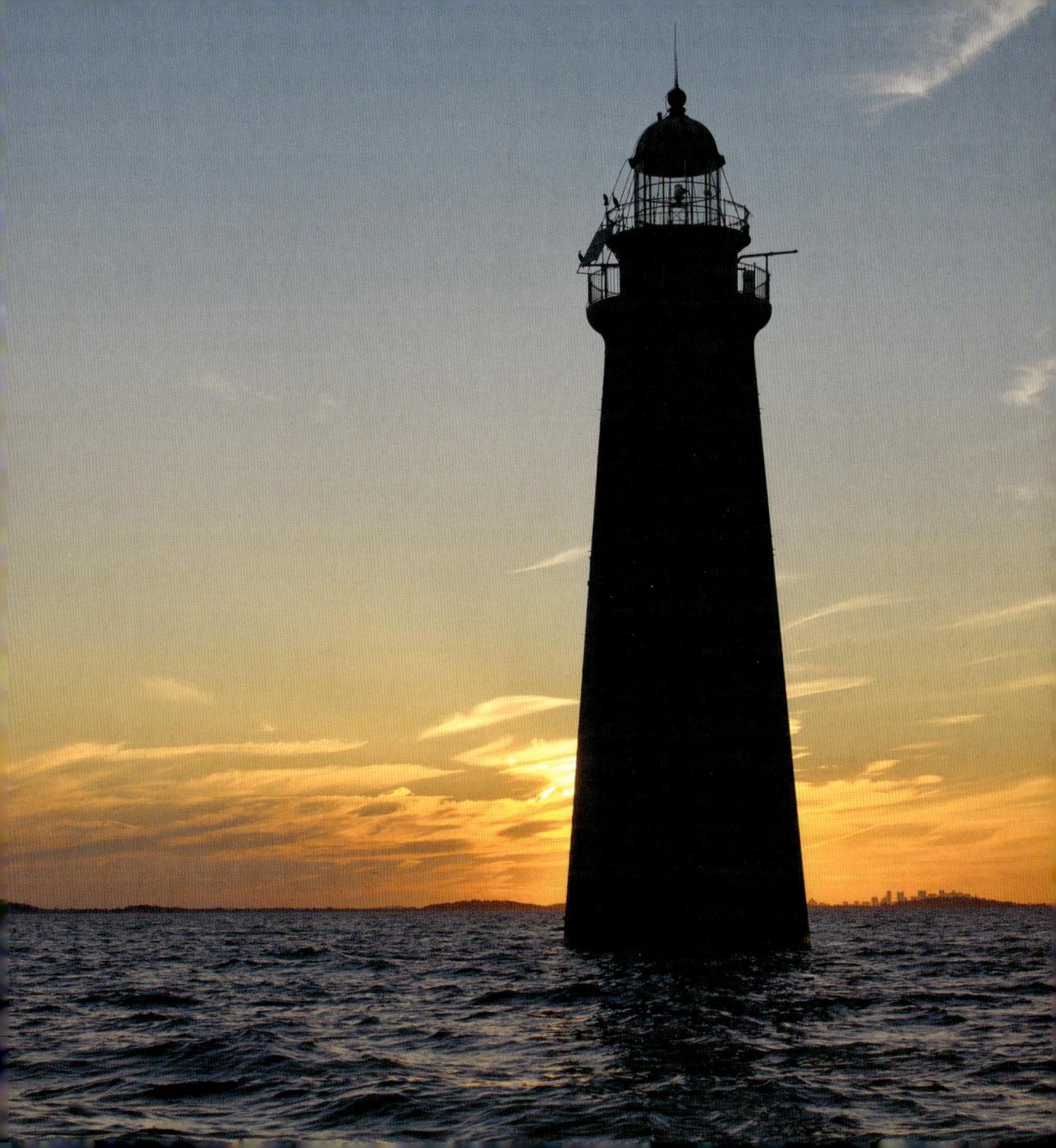

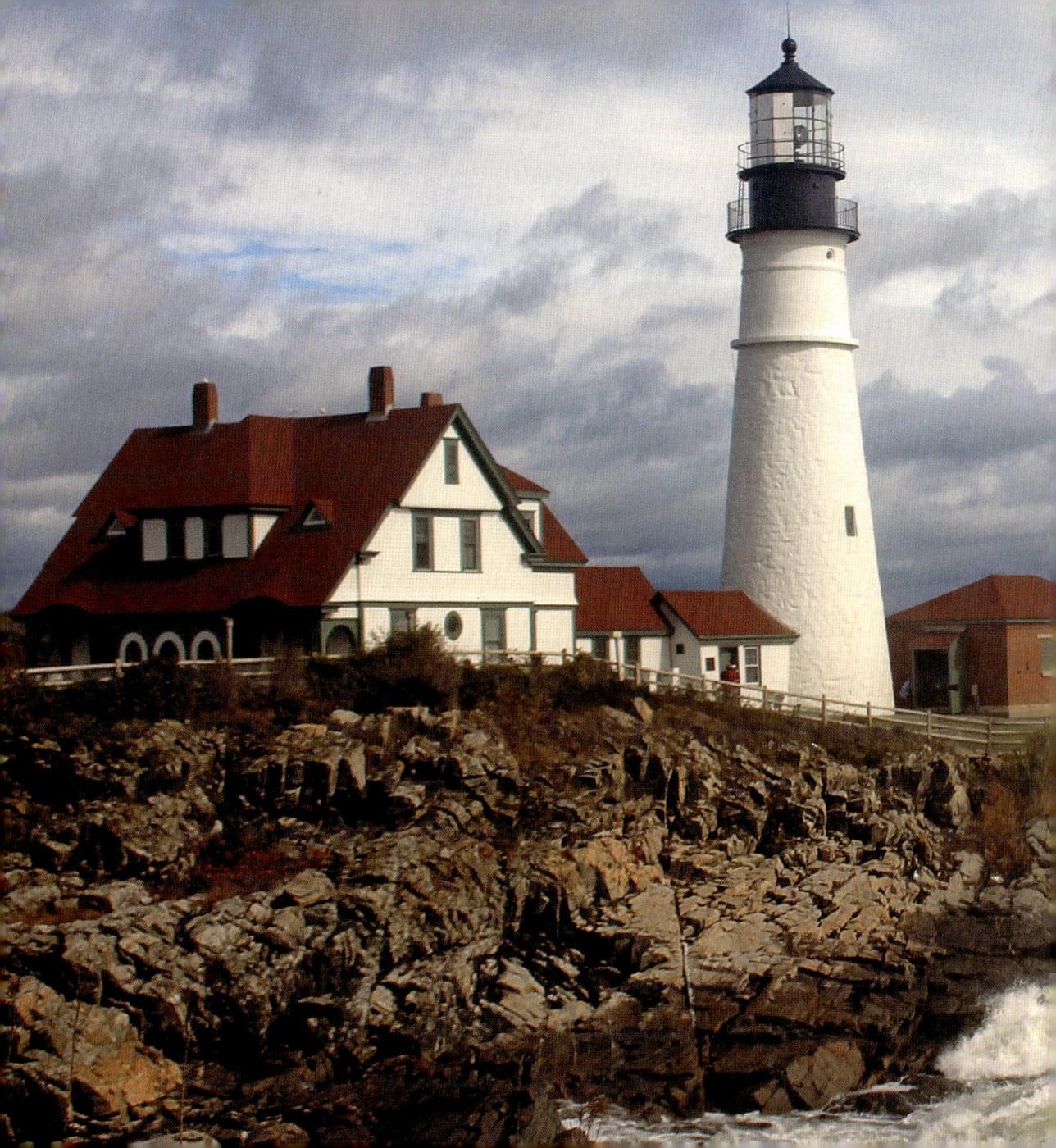

NEW ENGLAND

(Pages 18–19)
PORTLAND HEAD LIGHTHOUSE, MAINE

Portland Head Lighthouse, started by the Massachusetts Colony, was the first federal lighthouse completed in 1790 under the ninth act of the First Congress.

▶ CASTLE HILL LIGHTHOUSE, RHODE ISLAND

This lighthouse is built of stone on a rocky headland, appearing almost as a natural feature. Newport's Castle Hill Inn overwhelms the scene.

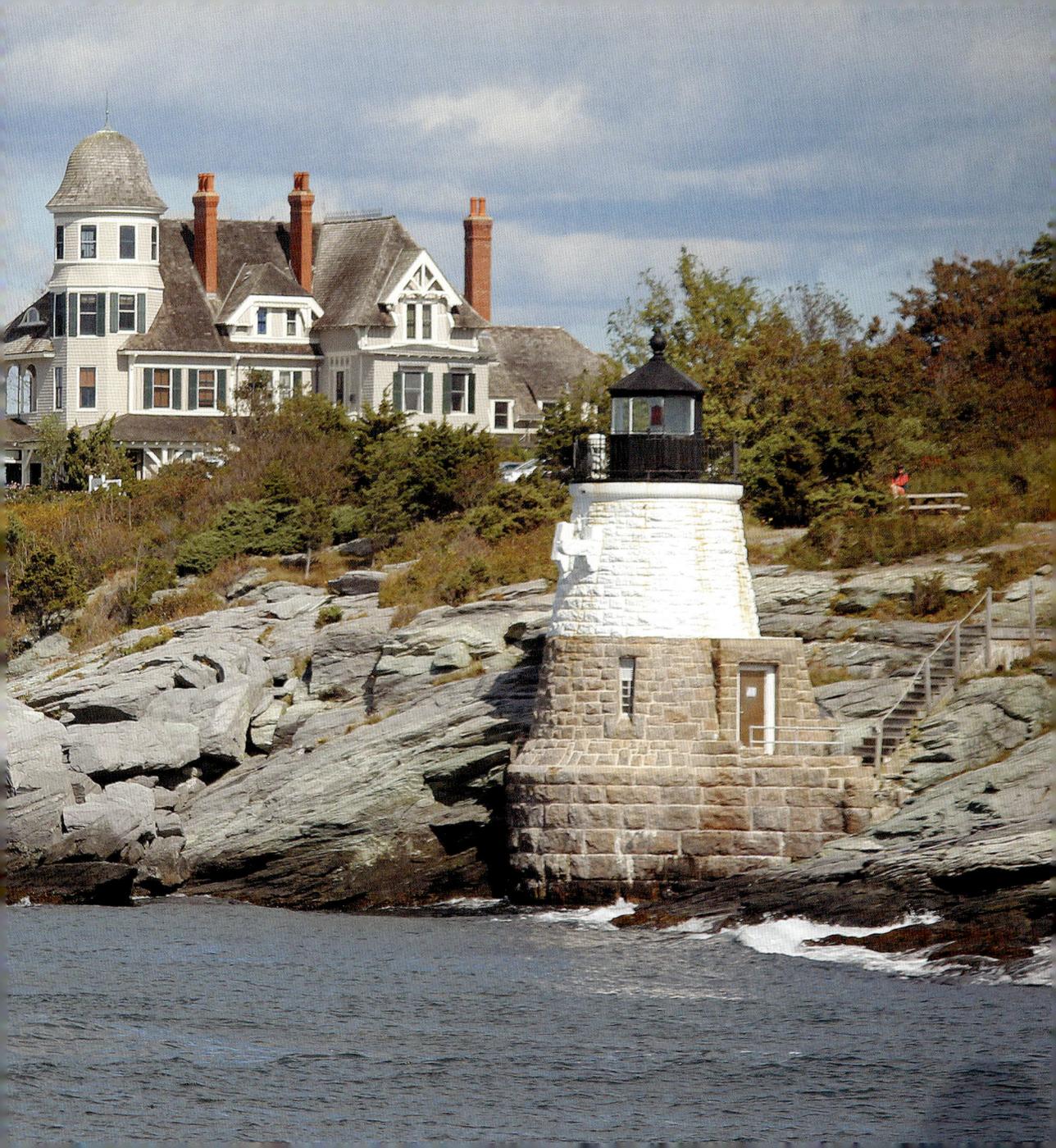

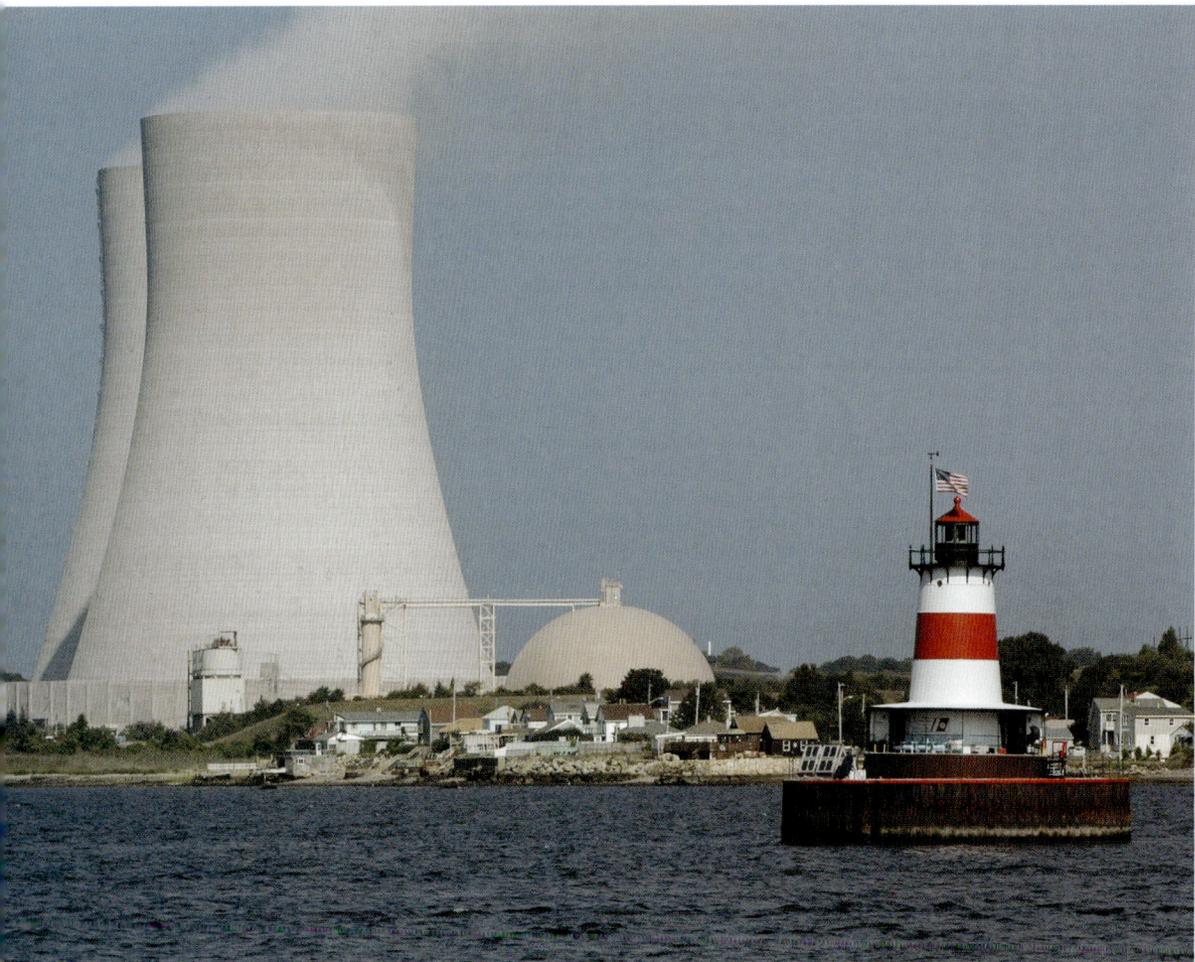

BORDEN FLATS LIGHTHOUSE, MASSACHUSETTS
This tower tilted slightly after being struck during the 1938 Great
New England Hurricane. It retains that list today.

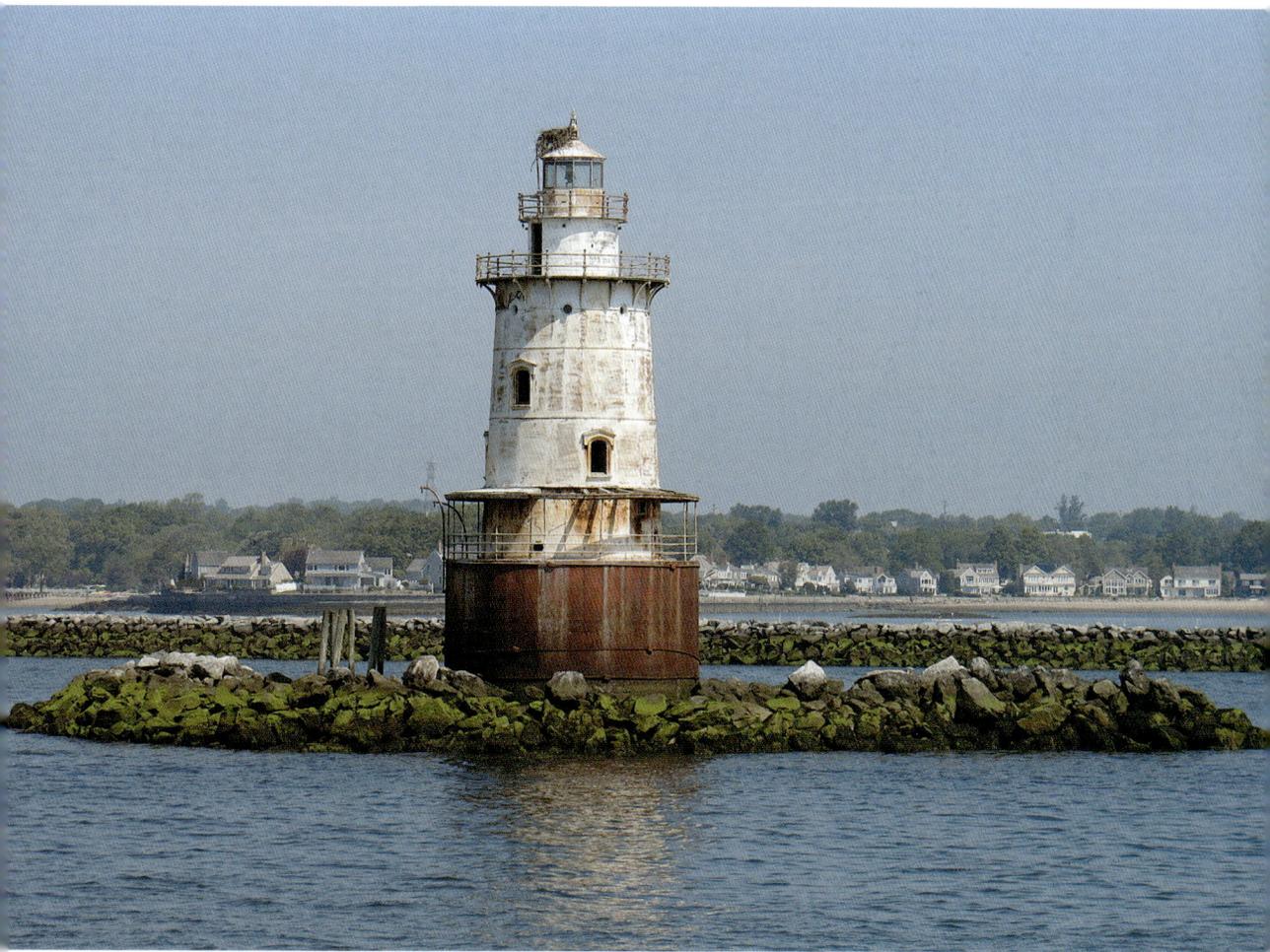

STAMFORD HARBOR LIGHTHOUSE, CONNECTICUT
*It wasn't until 1881 that Congress appropriated $30,000 for construction of this lighthouse
in Stamford Harbor, reportedly the most dangerous harbor on the Connecticut coast.*

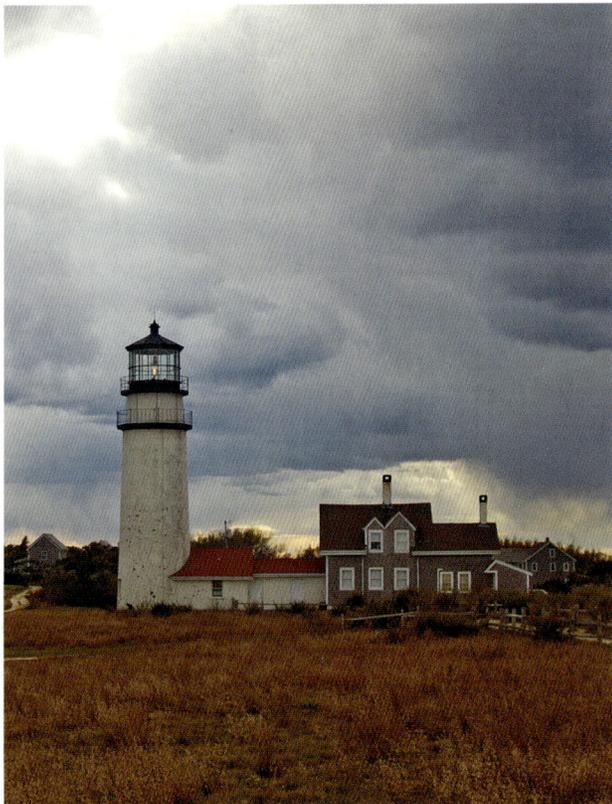

▲ CAPE COD LIGHTHOUSE, MASSACHUSETTS

In 1796, George Washington approved construction of the seventh federal lighthouse, which is known locally as "Highland Light."

▶ FIVE MILE POINT LIGHTHOUSE, CONNECTICUT

This lighthouse in New Haven represents typical American lighthouse construction from the mid-19th century.

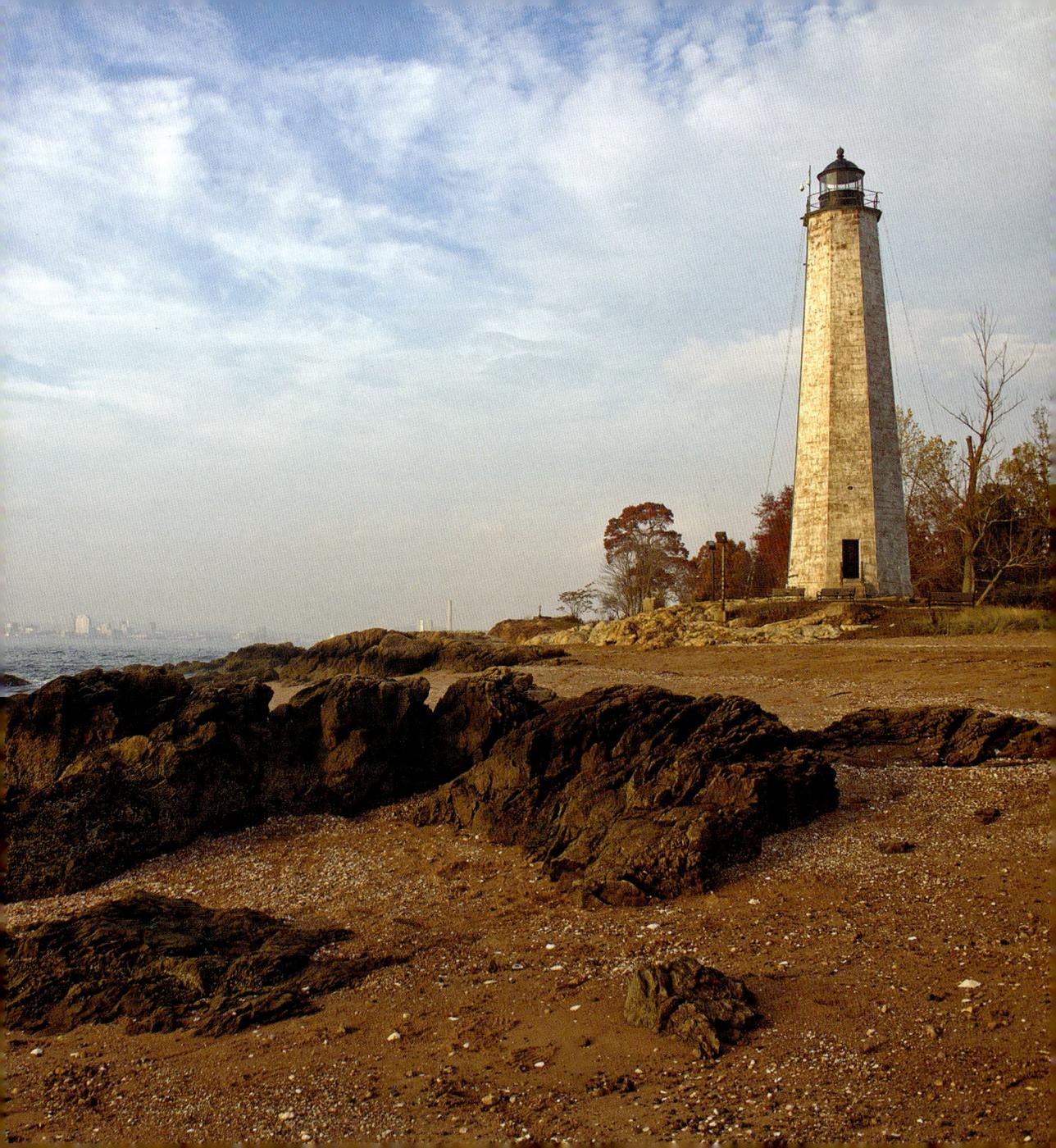

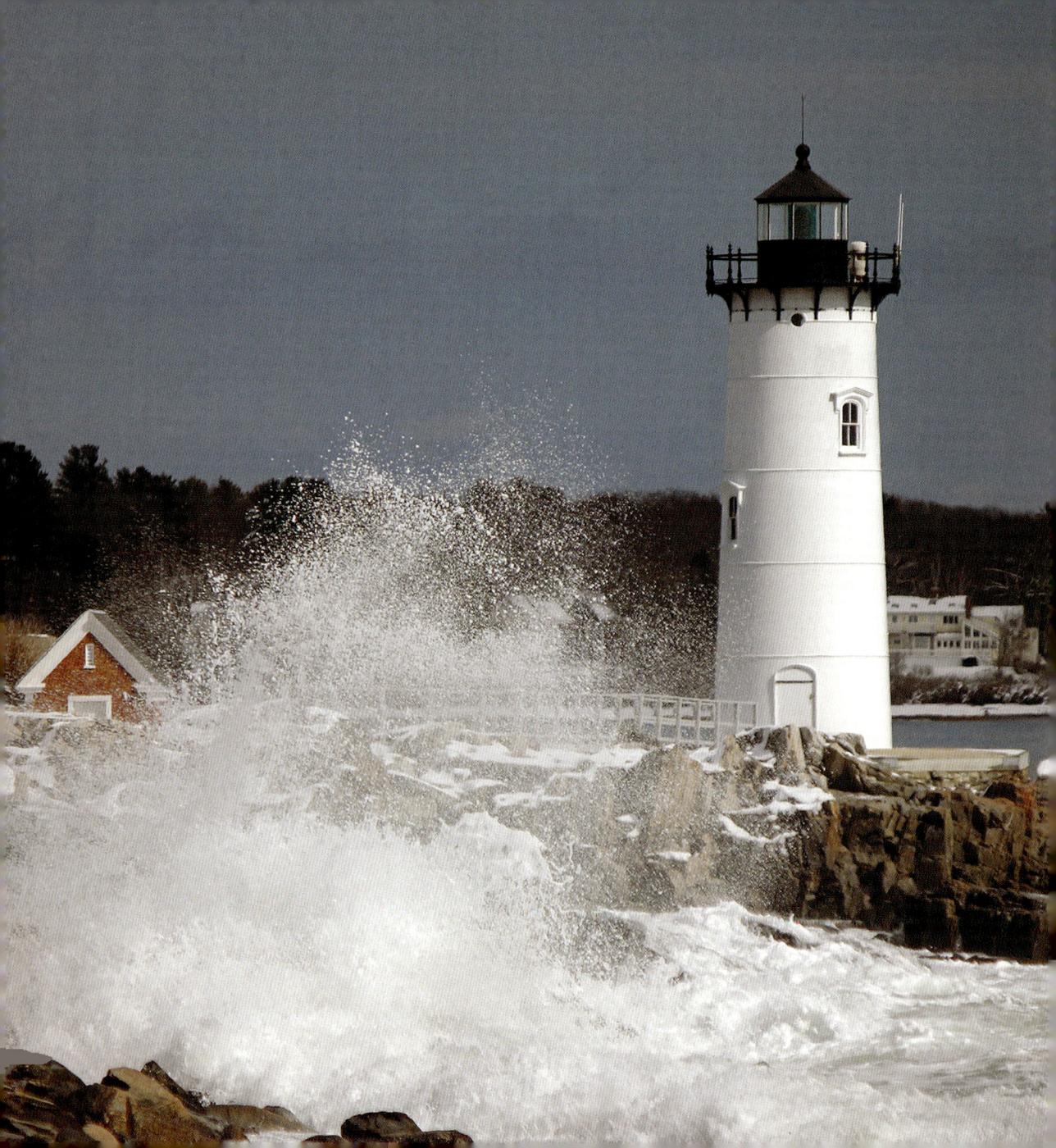

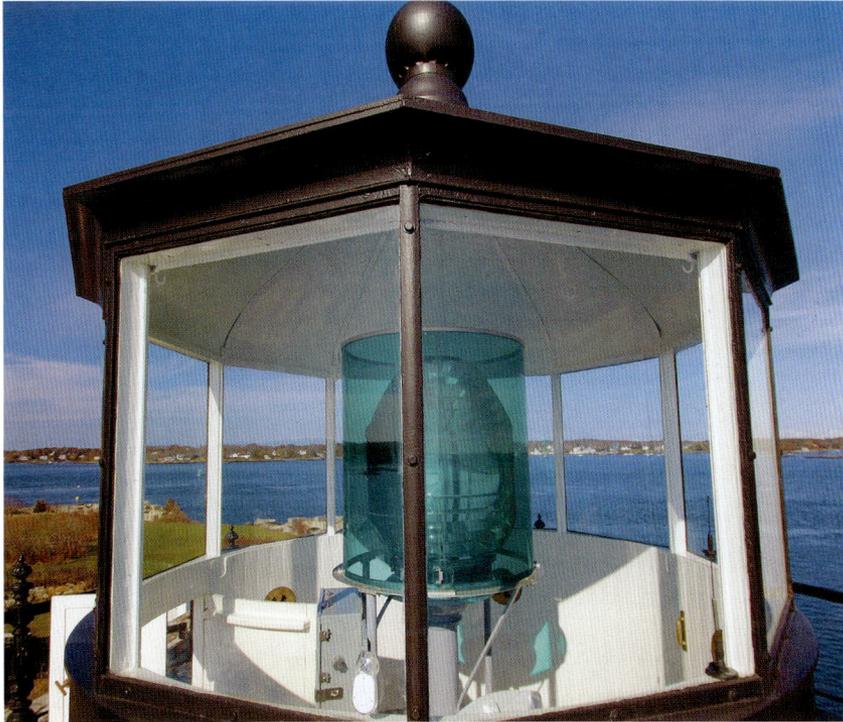

◄ ▲ PORTSMOUTH HARBOR LIGHTHOUSE, NEW HAMPSHIRE

The Coast Guard owns this lighthouse and leases it to Friends of Portsmouth Harbor Lighthouses, a chapter of the American Lighthouse Foundation. In 1854, a fourth-order Fresnel lens replaced the array of 13 lamps in this lighthouse, saving more than 260 gallons of lamp fuel in six months.

▲ HALFWAY ROCK LIGHTHOUSE, MAINE
Following several ships crashing and lives lost, mariners demanded a light on Halfway Rock, yet getting it took 36 years.

▶ GRAVES LIGHTHOUSE, MASSACHUSETTS
Waves from violent storms sometimes crashed over the lantern room of this lighthouse. One storm shoved a three-ton boulder from the seabed onto the tower's base.

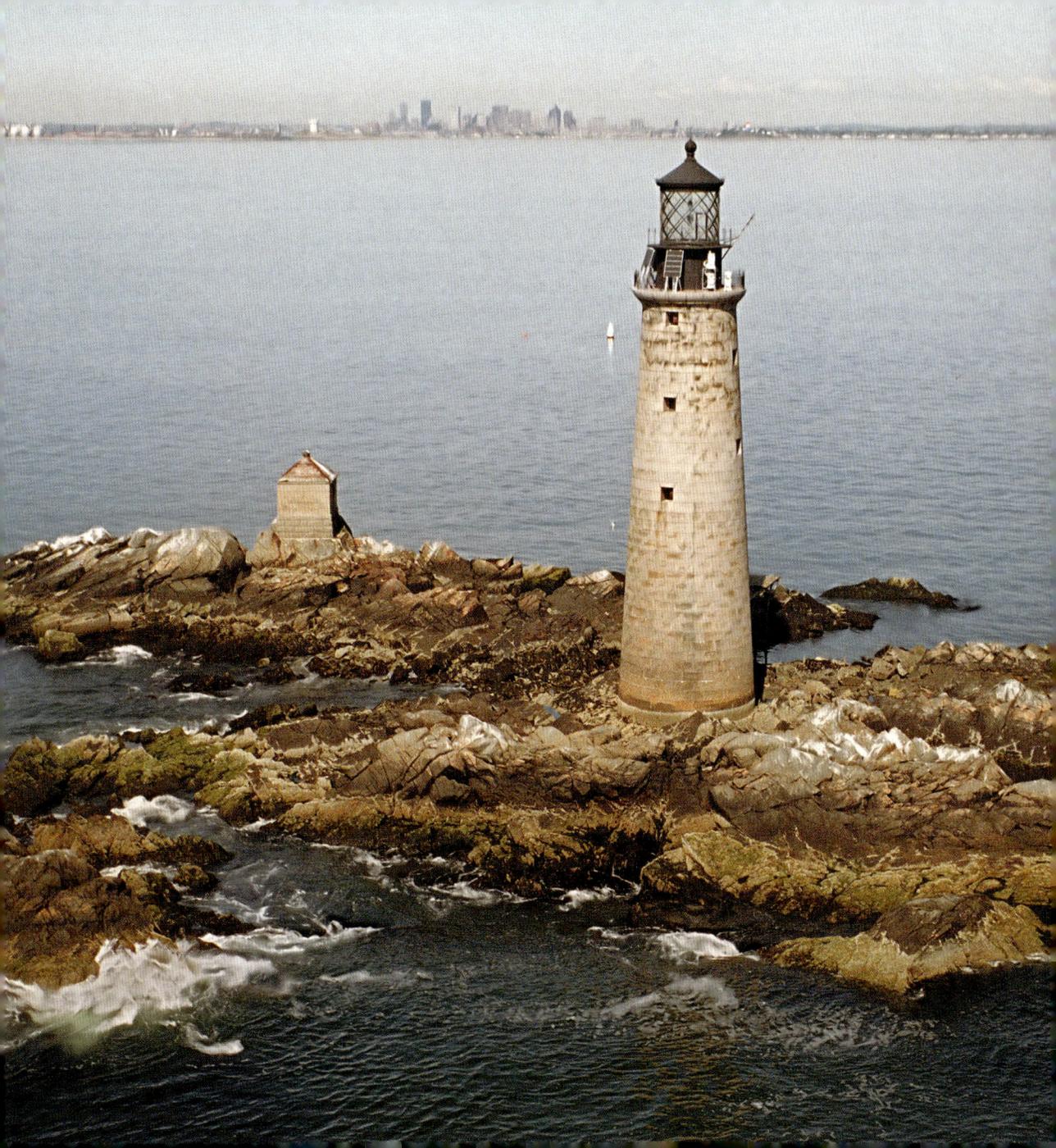

MARSHALL POINT LIGHTHOUSE, MAINE

A telephone line was installed at this lighthouse in 1898 to receive storm warnings from the Weather Bureau.

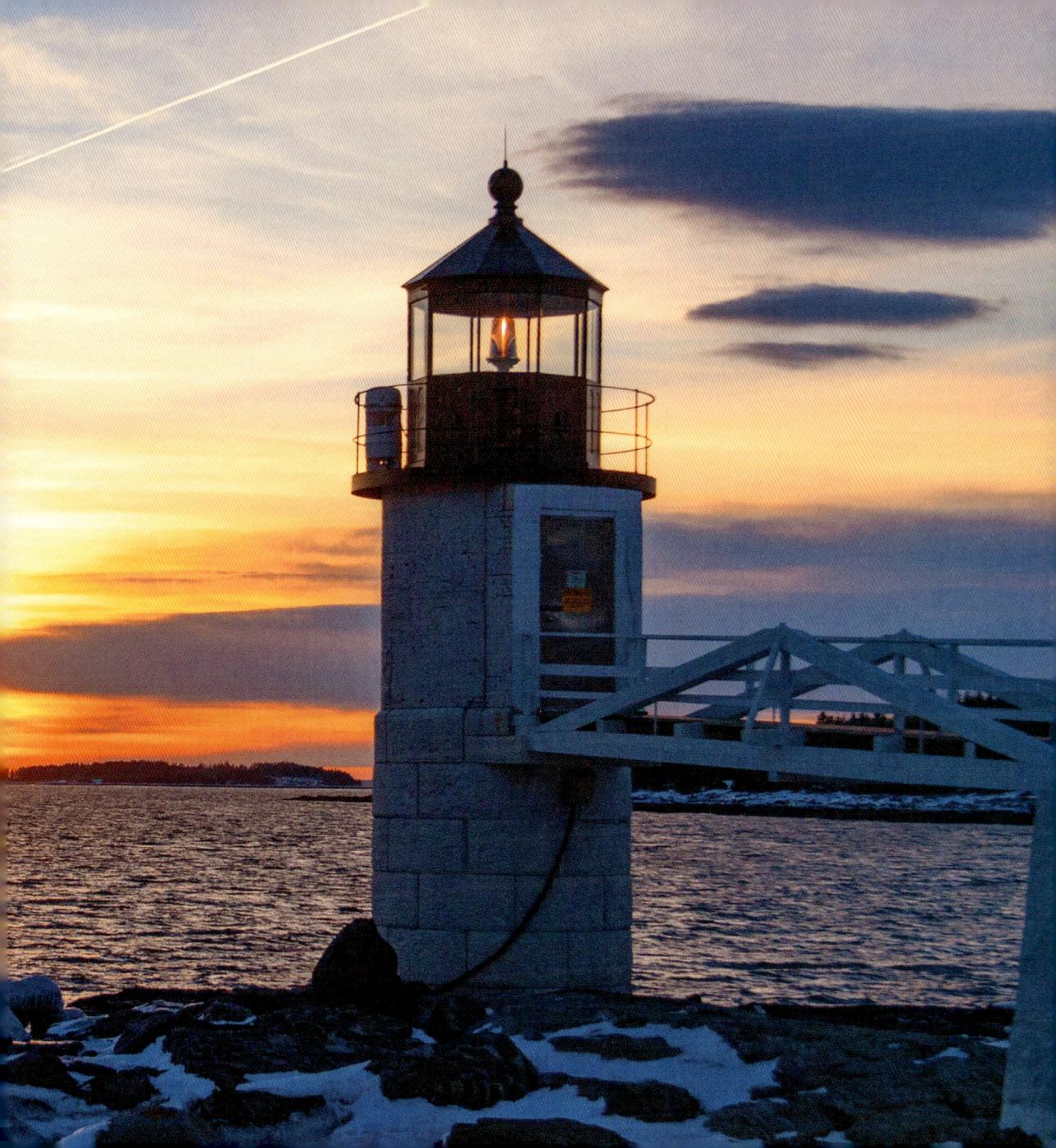

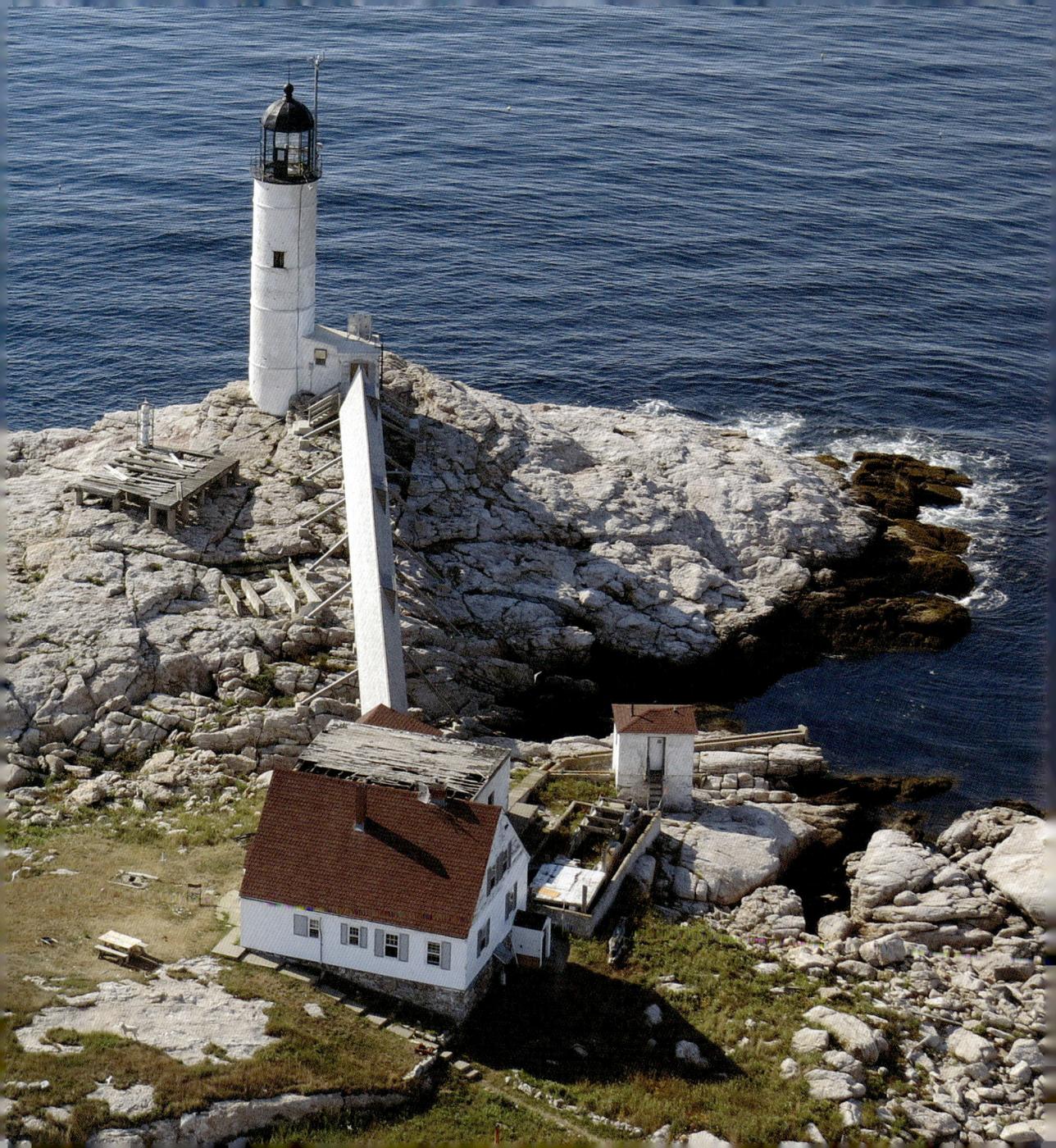

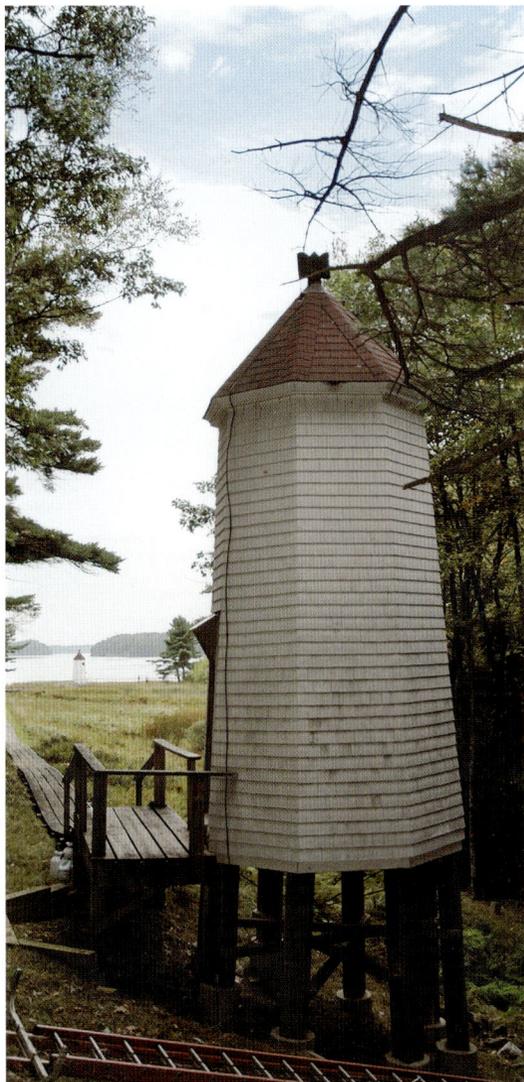

◀◀ ISLE OF SHOALS LIGHTHOUSE, NEW HAMPSHIRE
Lard oil, cheaper than whale oil, burned in the lamps at this lighthouse until replaced with cleaner-burning mineral oil in 1883.

◀ DOUBLING POINT RANGE LIGHTS, MAINE
Mariners navigating the Kennebec River lined up these lights, viewing one over the other to ensure they were in the river's channel.

▼ NAUSET LIGHTHOUSE, MASSACHUSETTS
Erosion imperiled this lighthouse on Cape Cod. The 90-ton lighthouse and associated oil house was moved and relocated 112 yards from the bluff's edge in 1996.

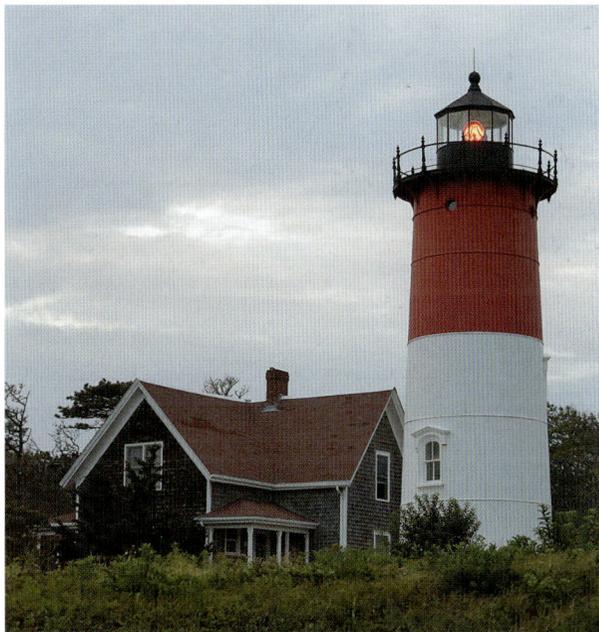

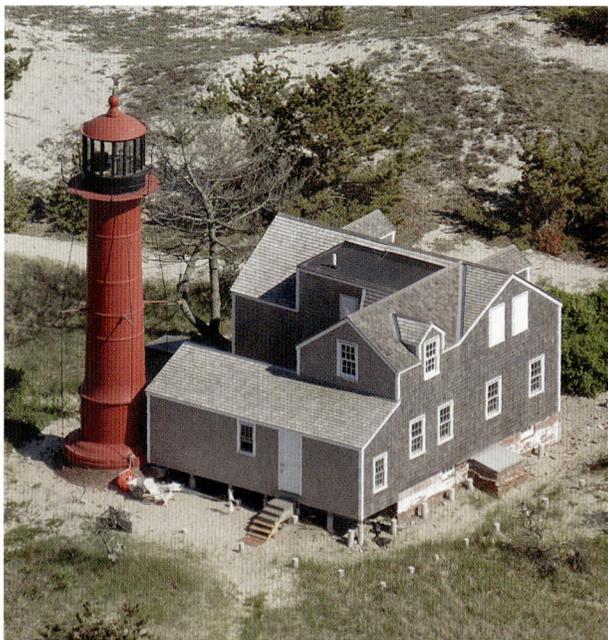

▲ MONOMOY ISLAND LIGHTHOUSE, MASSACHUSETTS
*In 1823, the beacon from Monomoy Island Lighthouse was cast from
13-inch reflectors created by eight oil lamps.*

▶ HERON NECK LIGHTHOUSE, MAINE
*This lighthouse, with its fog bell and foghorn, also had a fog dog, Nemo,
who was trained to bark at ships' whistles.*

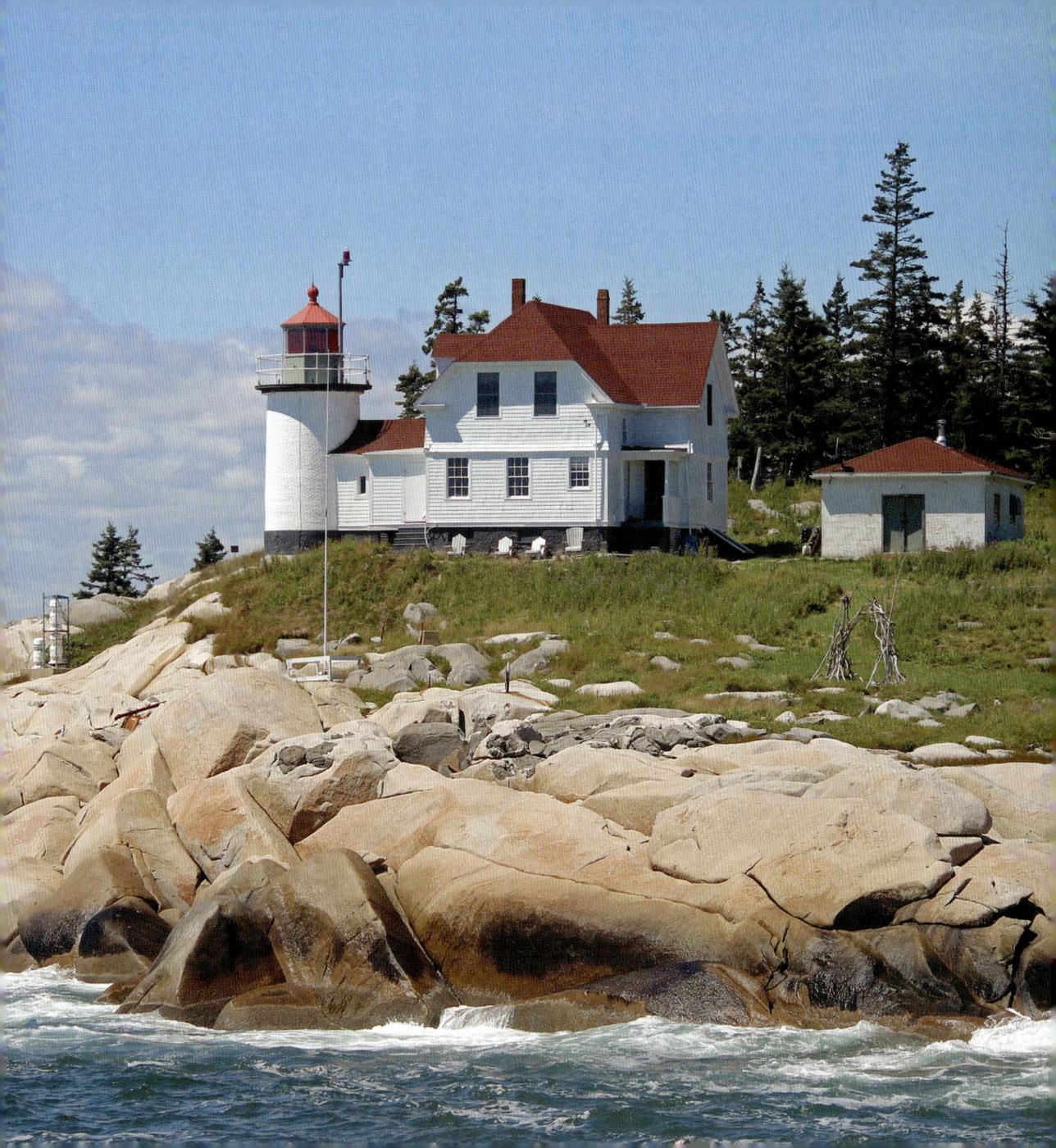

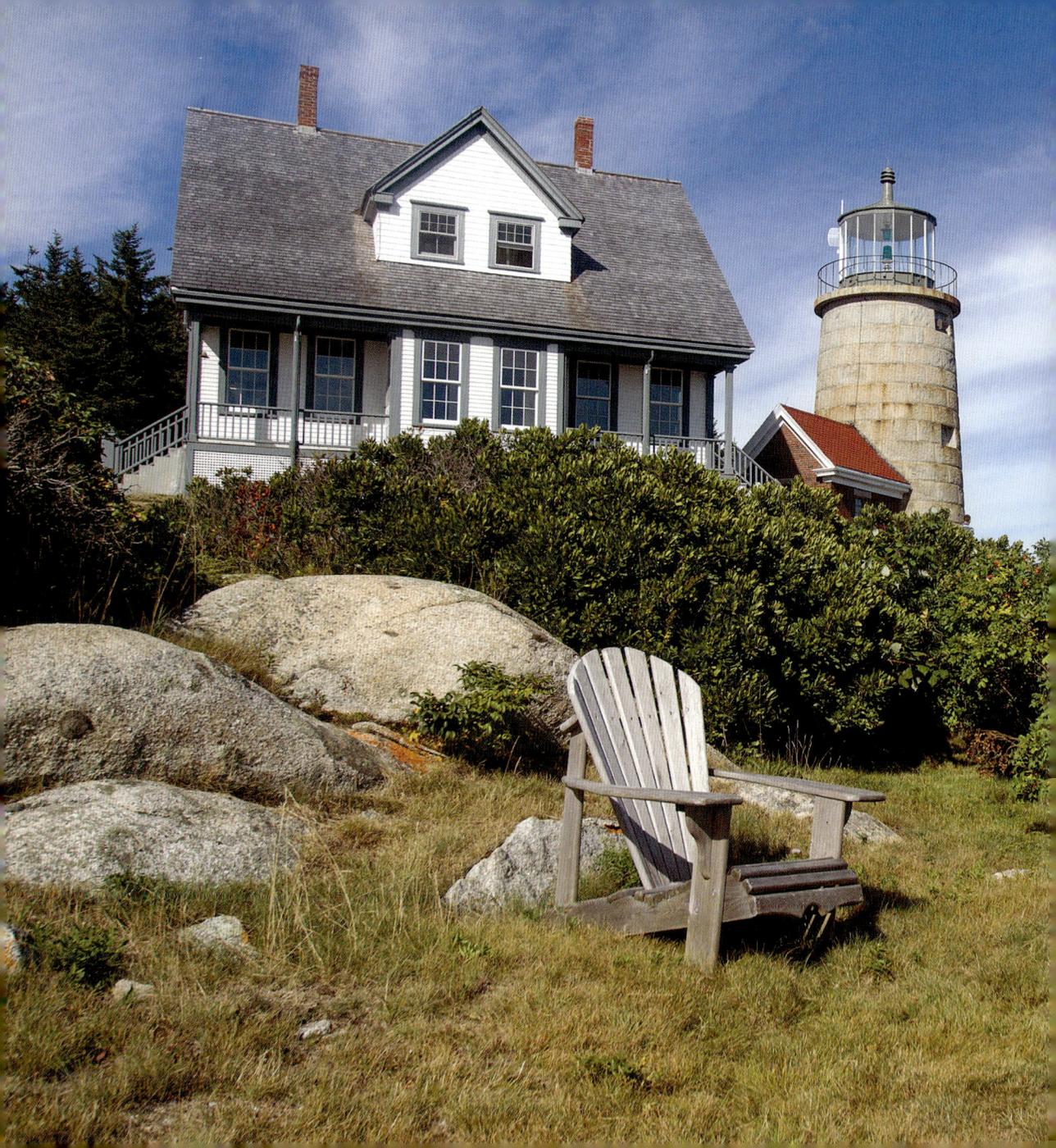

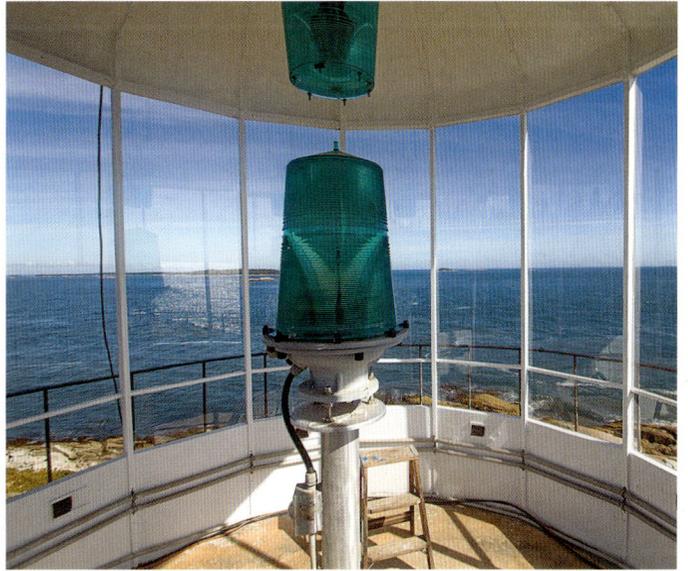

◀▲ WHITEHEAD LIGHTHOUSE, MAINE

This lighthouse's first keeper was dismissed in 1807 for illegally selling 200 gallons of oil to supplement his $200 per year salary. Acrylic optics with electric light bulbs gradually replaced original 19th-century glass Fresnel lenses and aero beacons.

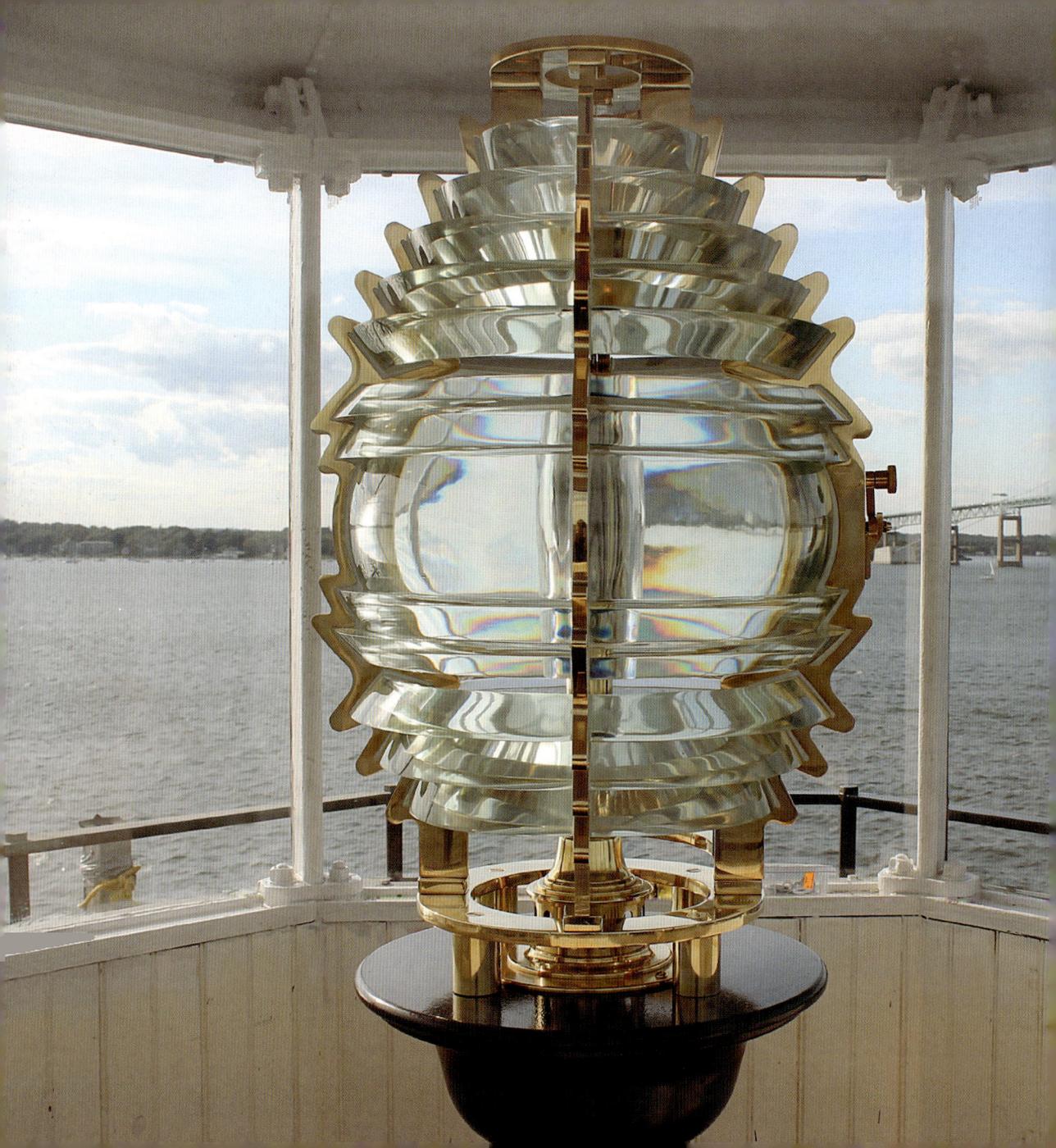

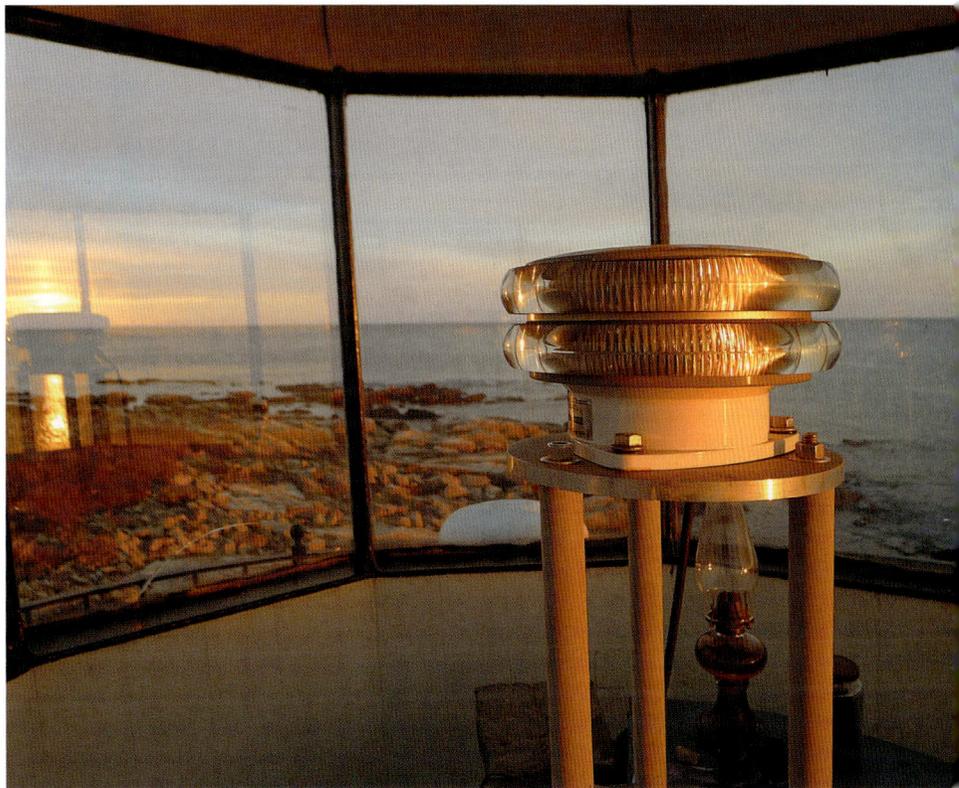

▲ GOAT ISLAND LIGHTHOUSE, MAINE
A VLB-44 beacon in this lighthouse is an LED light source. Each tier uses 10 watts and electronically creates appropriate flashing characters.

◀ ROSE ISLAND LIGHTHOUSE, RHODE ISLAND
When this lighthouse was deactivated in 1971, the original Fresnel lens disappeared. Artworks Florida Classic Fresnel Lenses created a reproduction in 1992.

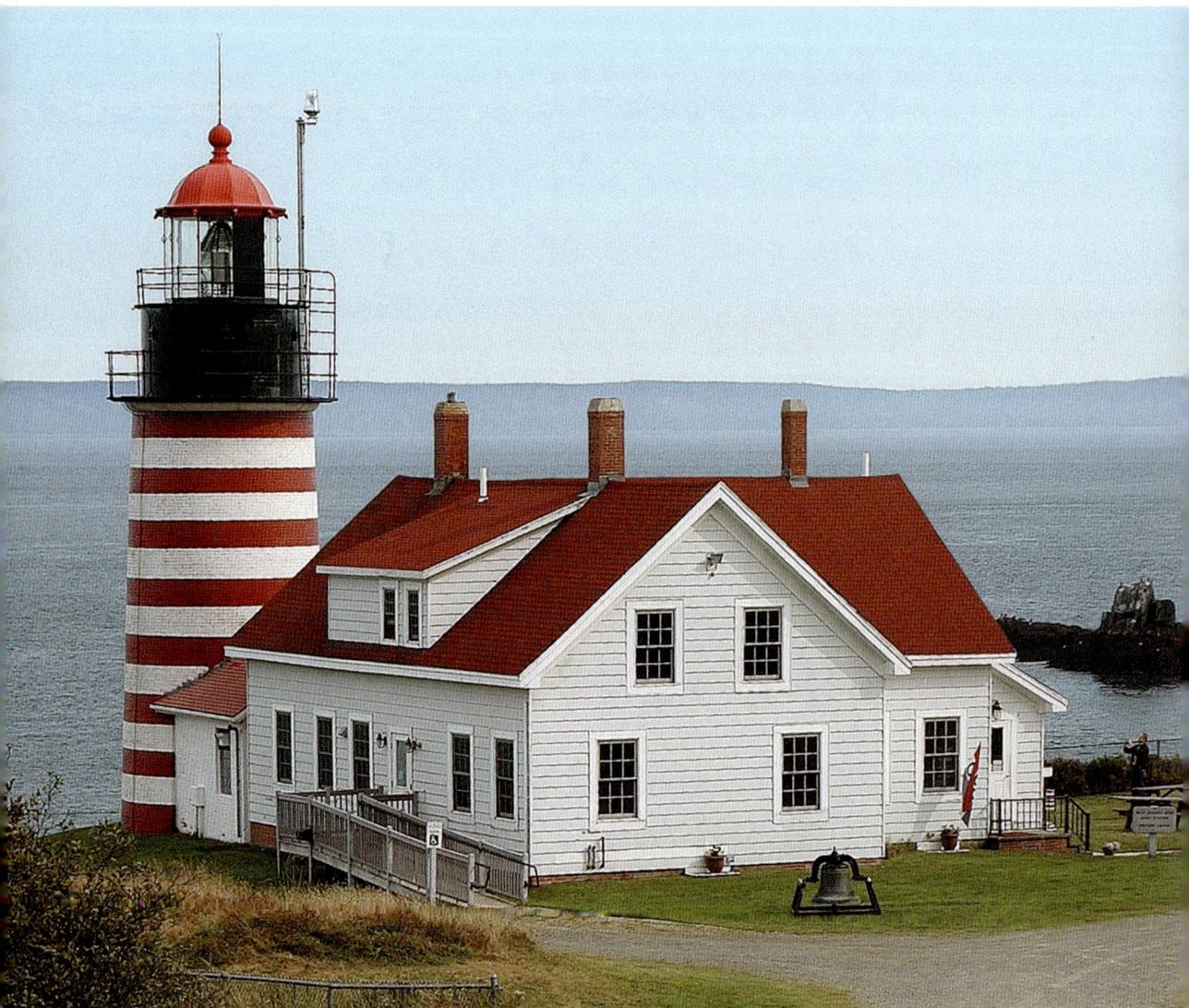

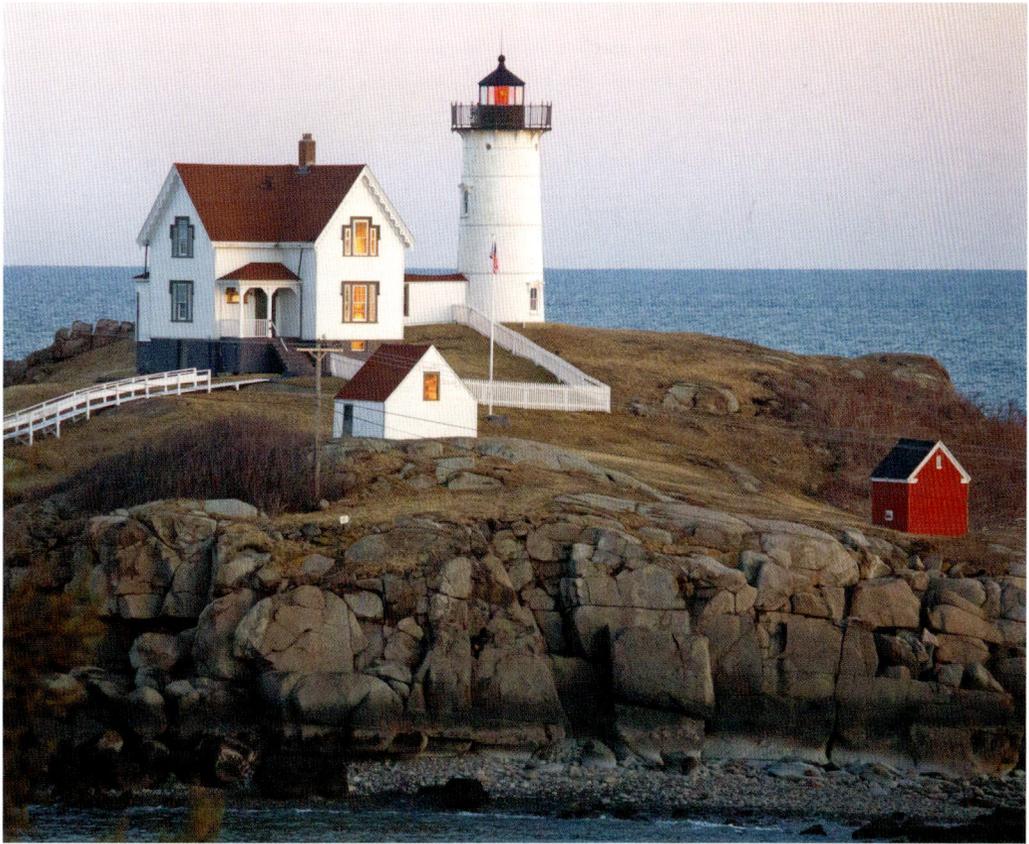

▲ CAPE NEDDICK "NUBBLE" LIGHTHOUSE, MAINE
One keeper at this lighthouse offered visitors fishing tackle and bait. His wife conducted five-cent lighthouse tours.

◀ WEST QUODDY HEAD LIGHTHOUSE, MAINE
After years of complaints from mariners about inadequate American lighthouses, in 1856 this lighthouse received a superior French-made third-order Fresnel lens.

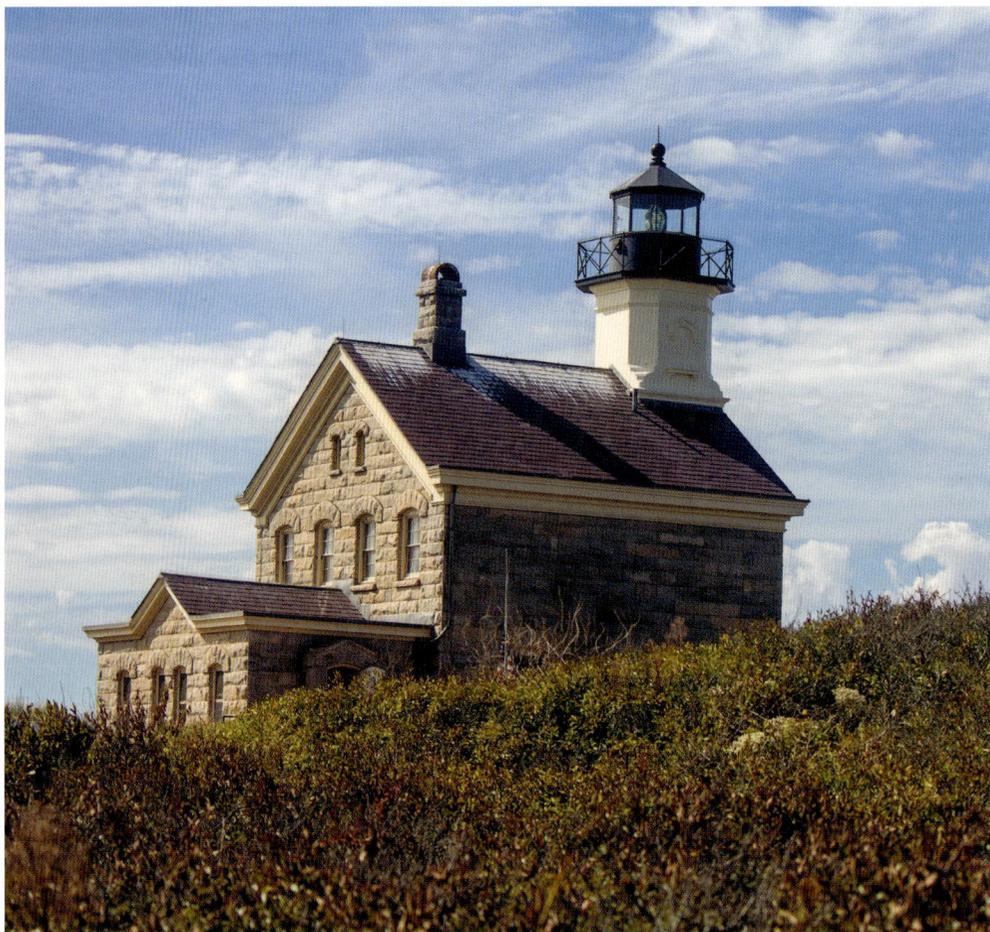

BLOCK ISLAND NORTH LIGHTHOUSE, RHODE ISLAND
Hiram D. Ball, appointed by President Abraham Lincoln, became the keeper of this lighthouse in 1861 and then served here for 30 years.

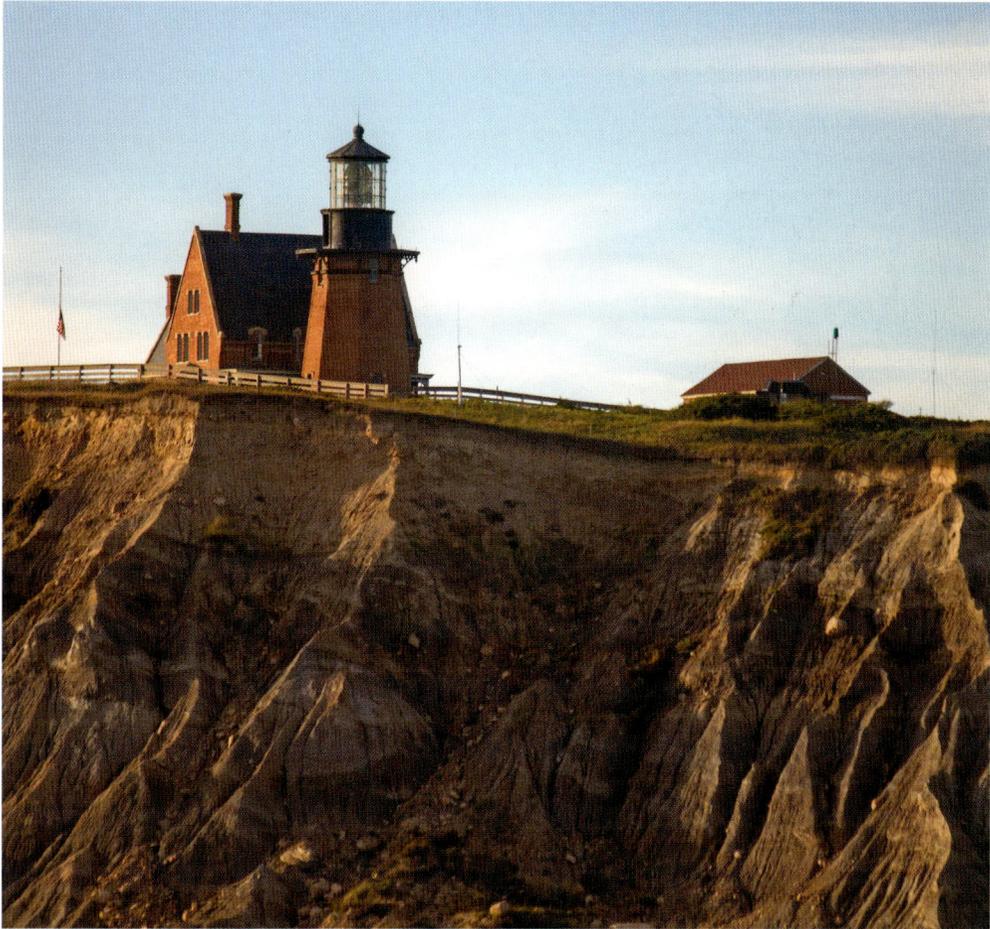

BLOCK ISLAND SOUTHEAST LIGHTHOUSE, RHODE ISLAND

The Block Island Southeast Lighthouse Foundation raised funds in 1993 to move this Victorian and Gothic Revival lighthouse 230 feet back from an eroding bluff.

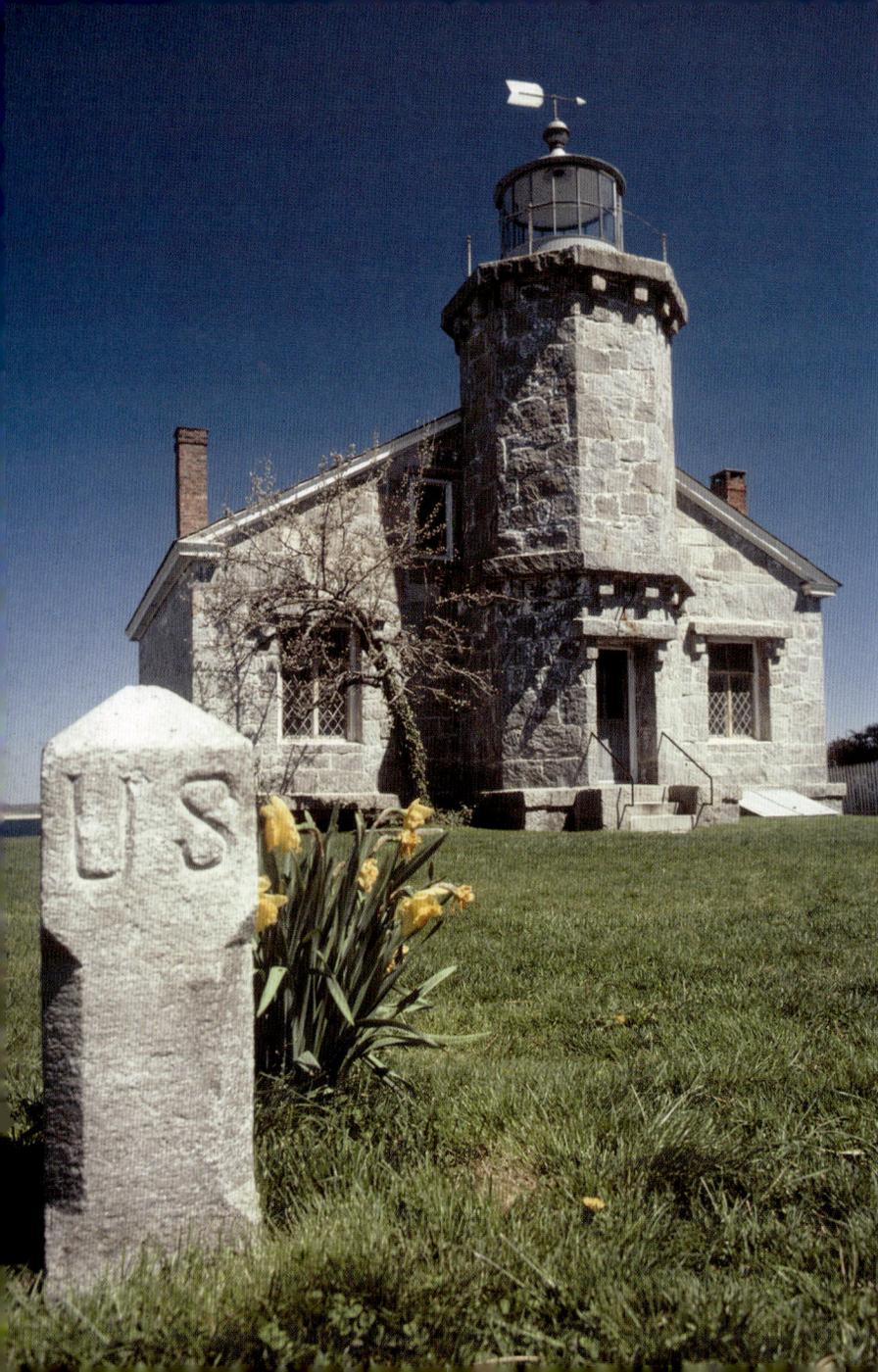

◀ STONINGTON
HARBOR LIGHTHOUSE,
CONNECTICUT
*The original 1823 Stonington
Harbor Lighthouse used 10
whale oil lamps set in 13-inch
reflectors, arranged in an arc,
to cast a beam seaward.*

▶ BOON ISLAND
LIGHTHOUSE, MAINE
*The island on which this light-
house later stood was the scene
of many shipwrecks. Canni-
balism was reported among
survivors from one shipwreck.*

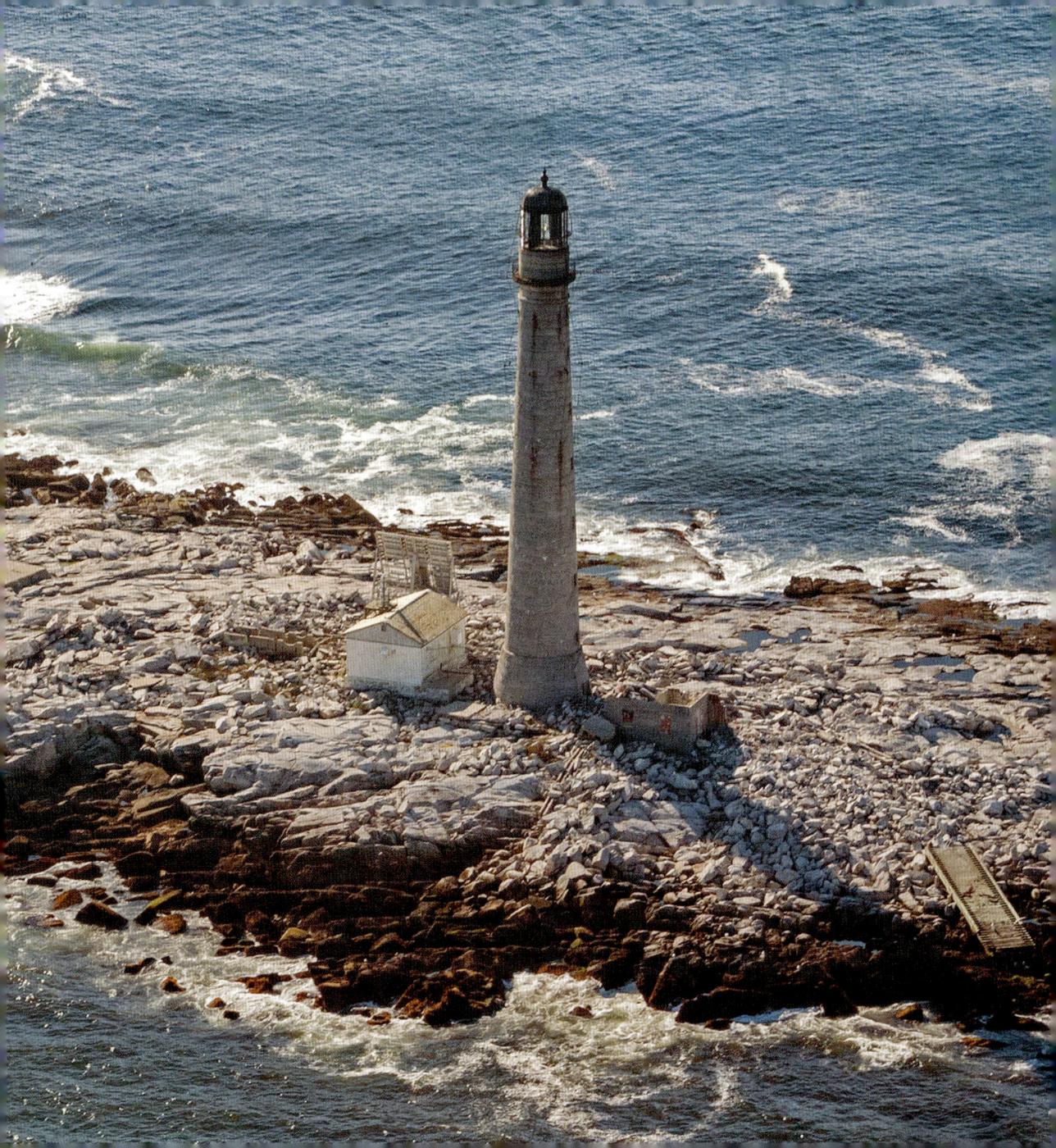

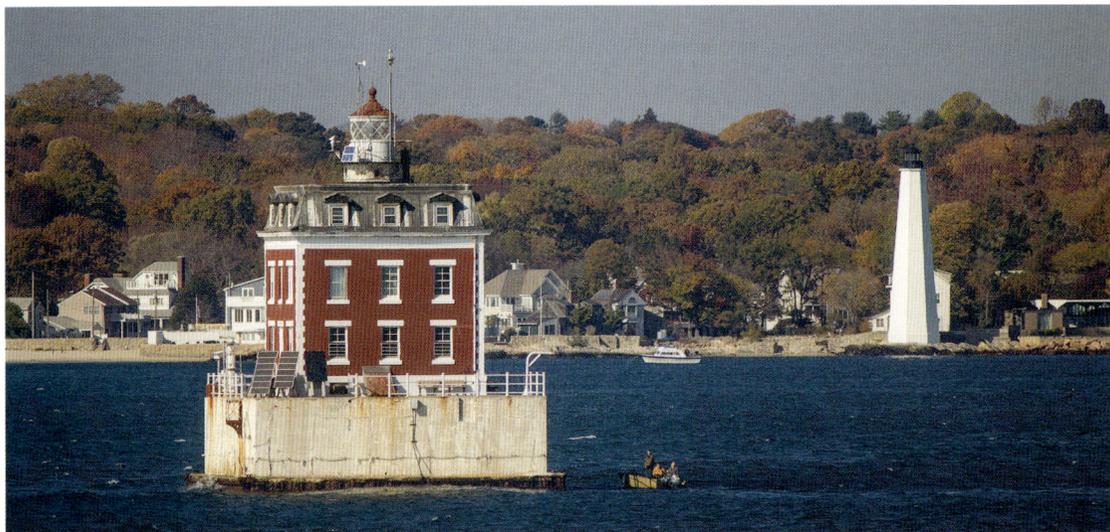

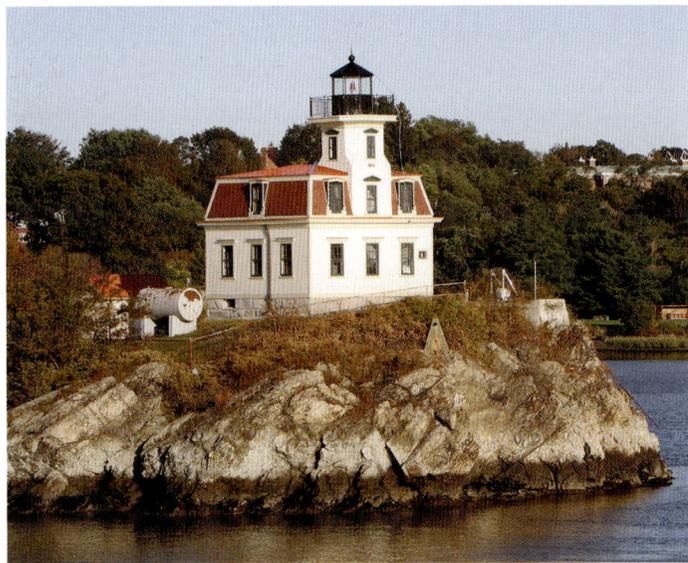

▲ NEW LONDON LEDGE AND HARBOR LIGHTHOUSES, CONNECTICUT

Lottery tickets sold in 1761, raising £500, funded the original New London Harbor Lighthouse on the shoreline, the fourth lighthouse constructed in colonial America. The later New London Ledge Lighthouse (foreground) was designed to reflect local architectural standards.

◀ POMHAM ROCKS LIGHTHOUSE, RHODE ISLAND

This lighthouse on an islet less than a mile from shore had no electricity or running water until both were brought in by the Coast Guard in 1956.

▶ BASS HARBOR HEAD LIGHTHOUSE, MAINE

President Barack Obama was reportedly the first sitting president to visit this lighthouse.

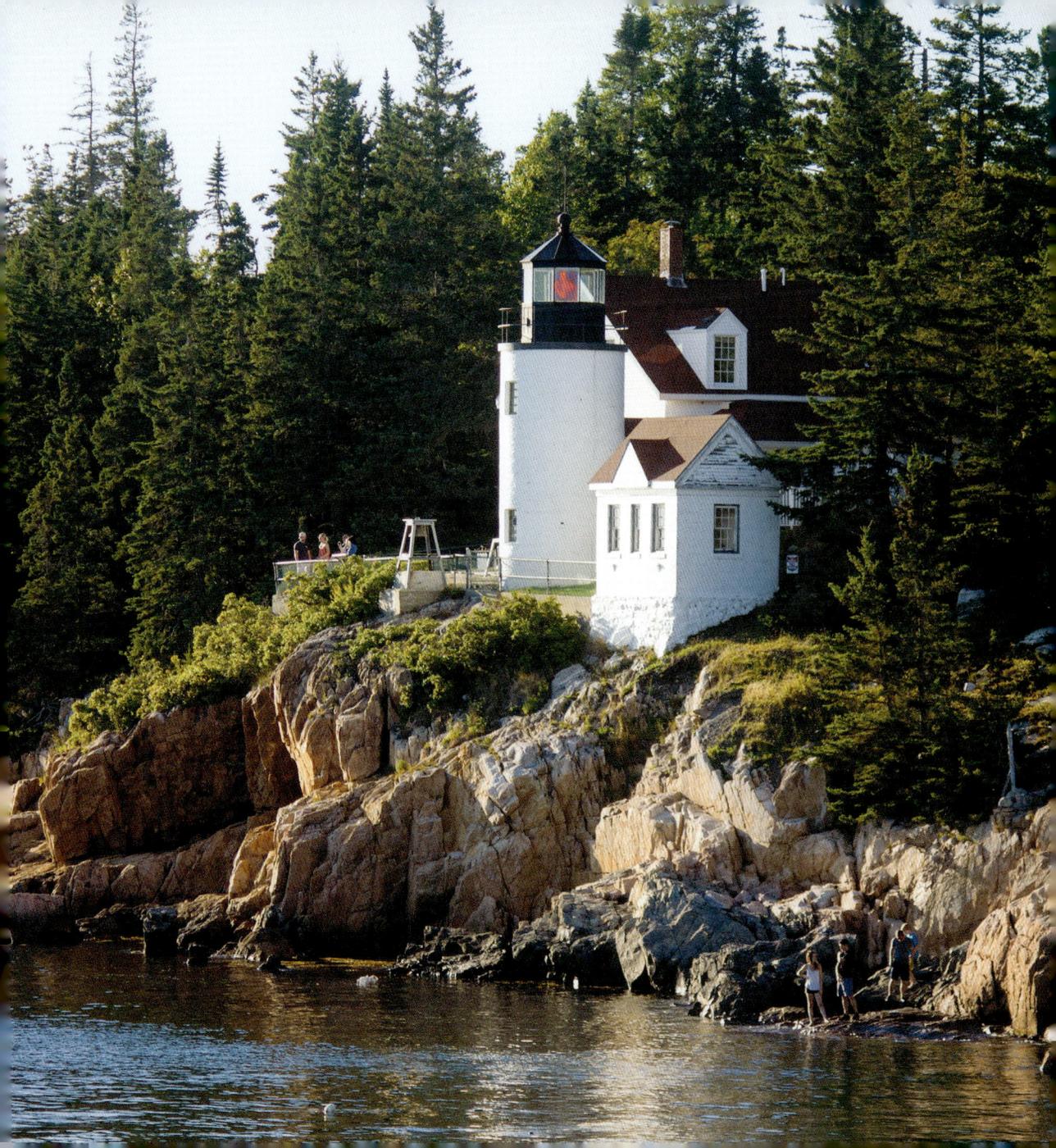

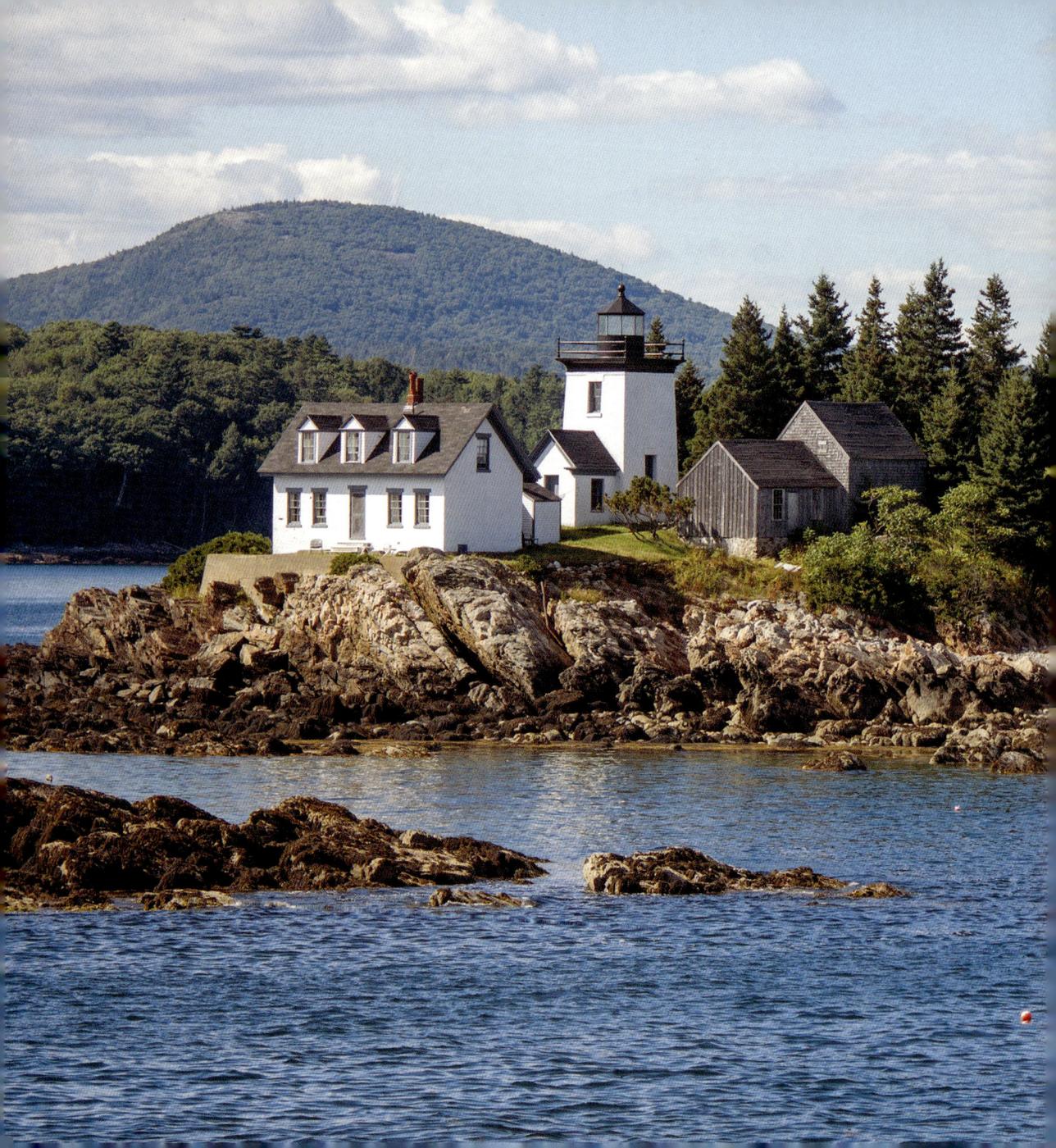

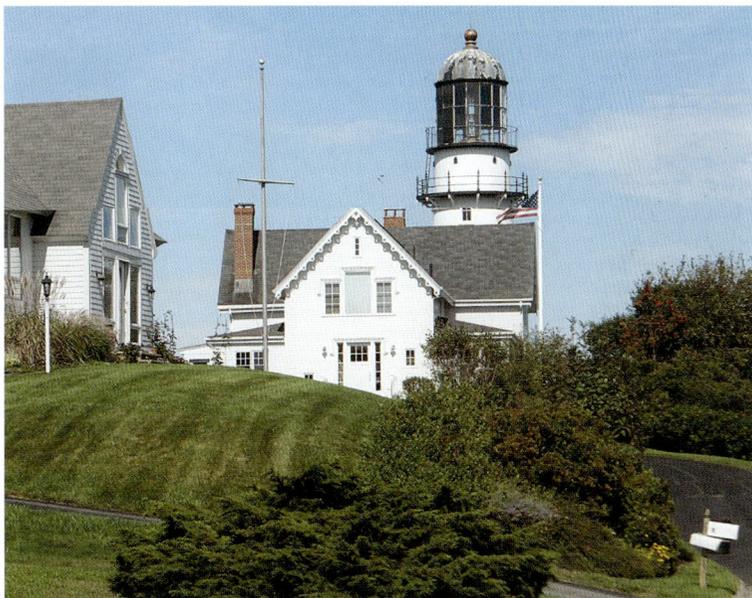

▲ CAPE ELIZABETH LIGHTHOUSE, MAINE
The steam fog whistle at this lighthouse sounded 1,117 hours, using 71,500 pounds of coal, in 1888.

◀ INDIAN ISLAND LIGHTHOUSE, MAINE
Access to this lighthouse was by boat. All supplies, including coal, were unloaded on the beach and then hauled up to the house in a wheelbarrow.

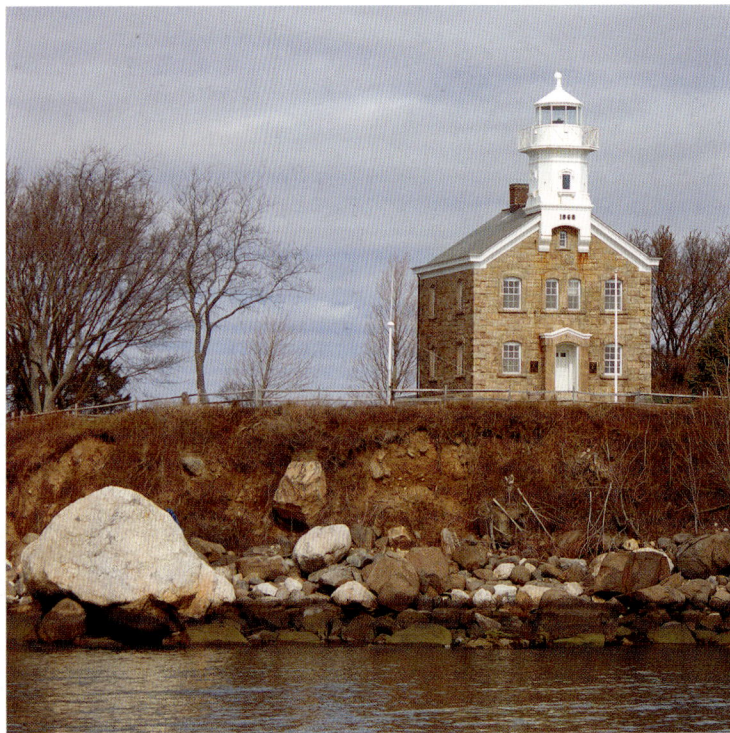

▲ GREAT CAPTAIN ISLAND LIGHTHOUSE, CONNECTICUT

During Prohibition, lighthouse keepers on islands were suspected of aiding bootleggers. In 1925, the Coast Guard discovered 75 empty whiskey cases at this lighthouse.

▶ SAYBROOK BREAKWATER LIGHTHOUSE, CONNECTICUT

Connecticut issued a special "Preserve the Sound" license plate featuring this lighthouse. It was the state's most popular specialty plate in 2010.

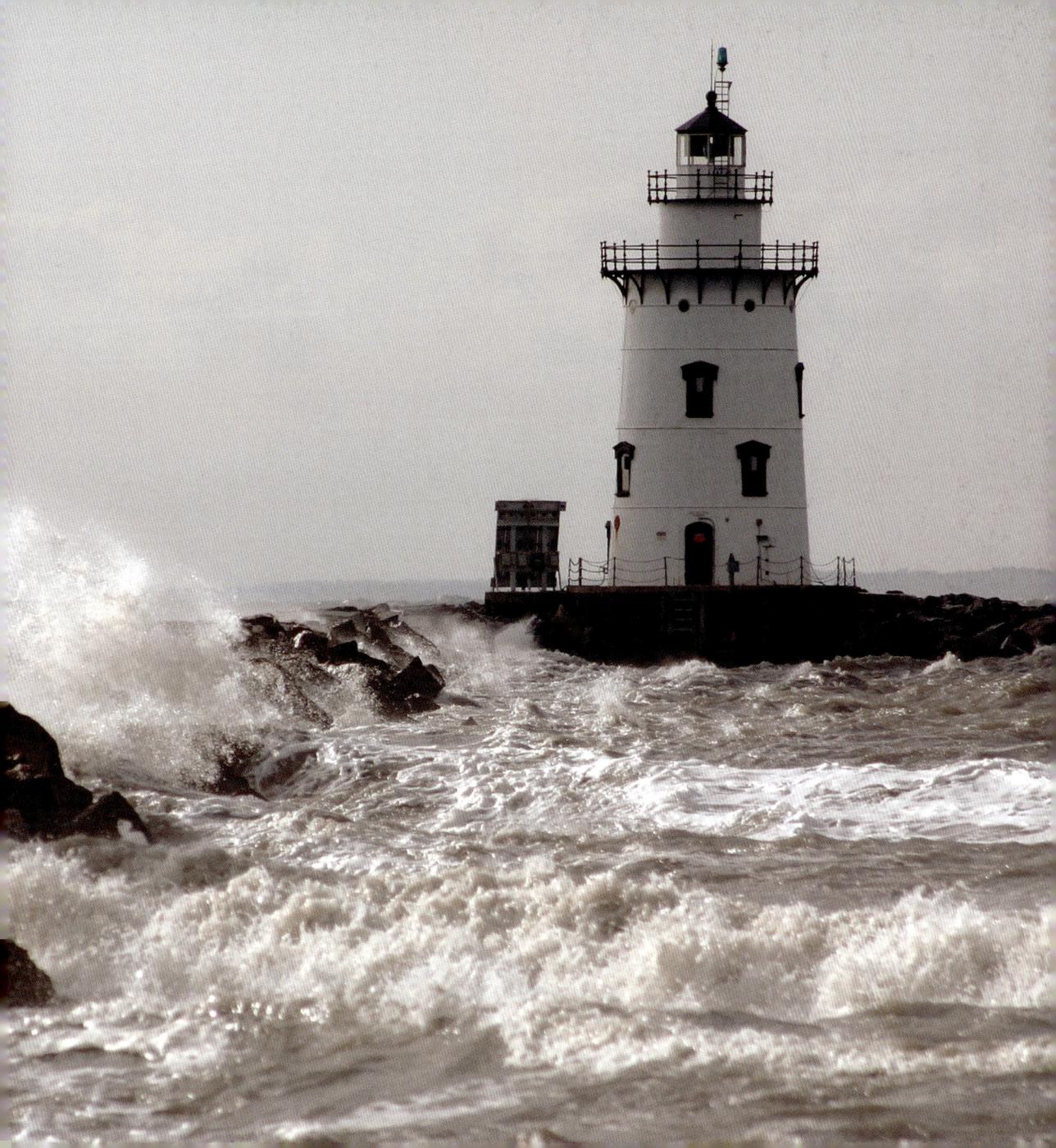

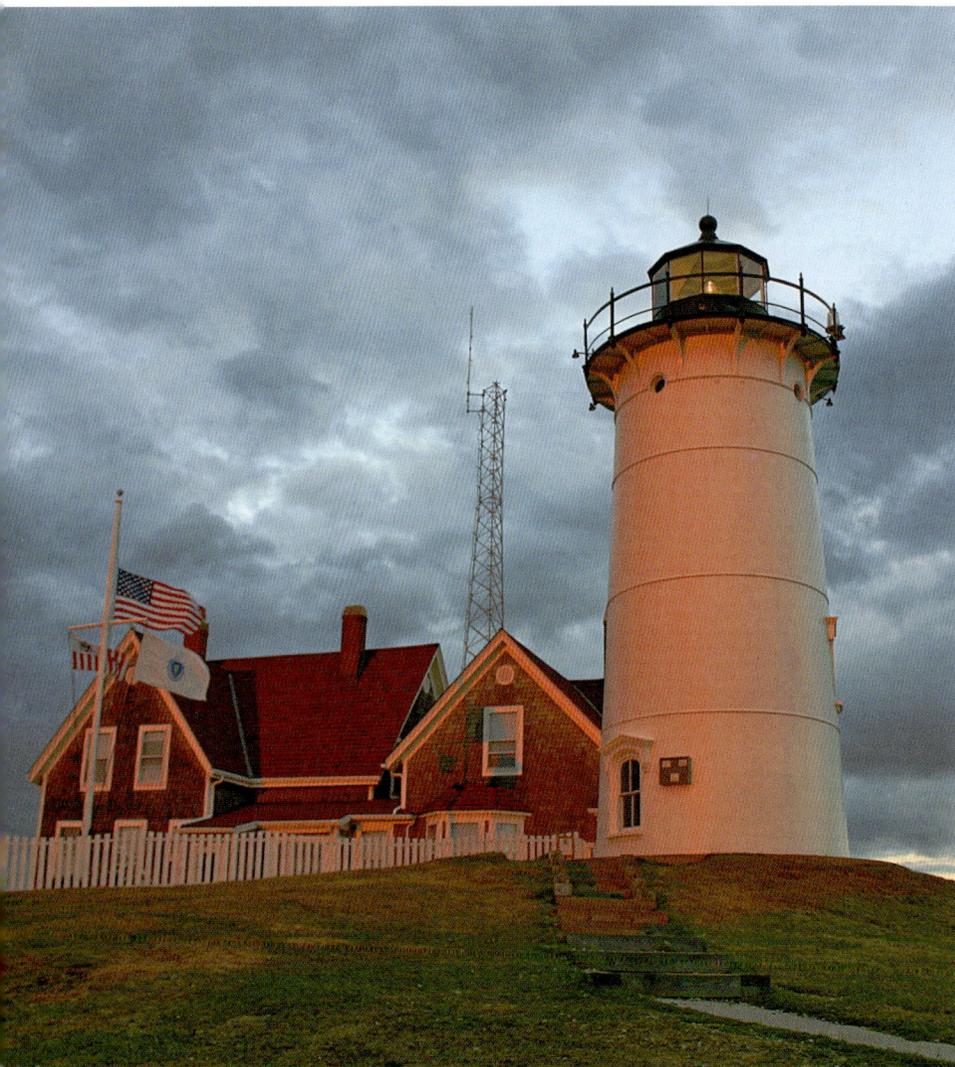

◀ NOBSKA LIGHTHOUSE, MASSACHUSETTS

In 1849, keeper Daggett was removed from this lighthouse for being a Democrat. Early lighthouse-keeping posts were often political appointments.

▶ PETIT MANAN LIGHTHOUSE, MAINE

The Coast Guard ceded this lighthouse and island to the US Fish & Wildlife Service in 1974. It is now a part of Maine Coastal Islands National Wildlife Refuge.

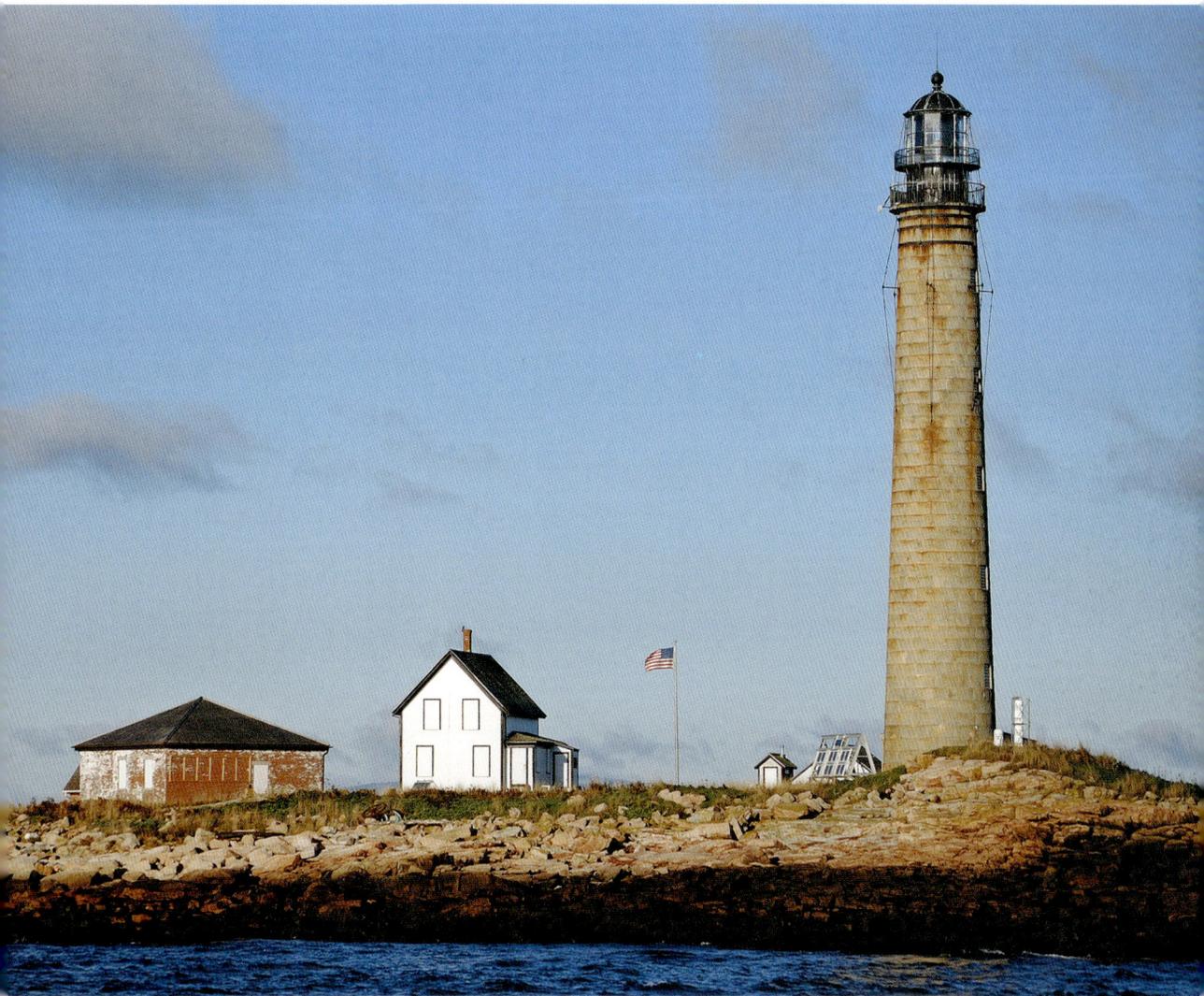

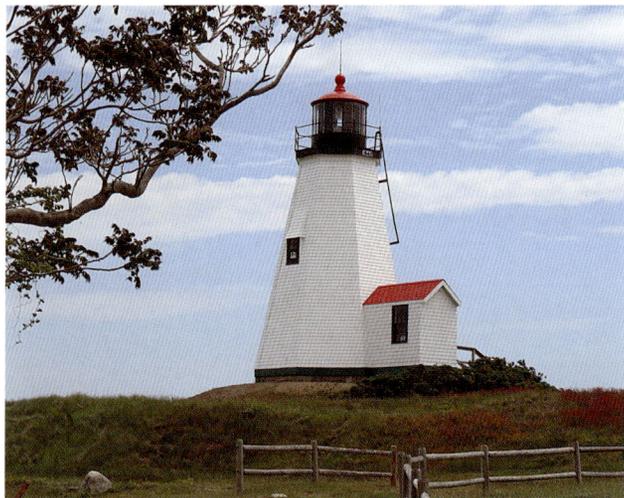

PLYMOUTH "GURNET" LIGHTHOUSE, MASSACHUSETTS

In 1790, after the federal government acquired colonial lighthouses such as this one, the keeper's annual pay was reduced from $266.67 to $200.00.

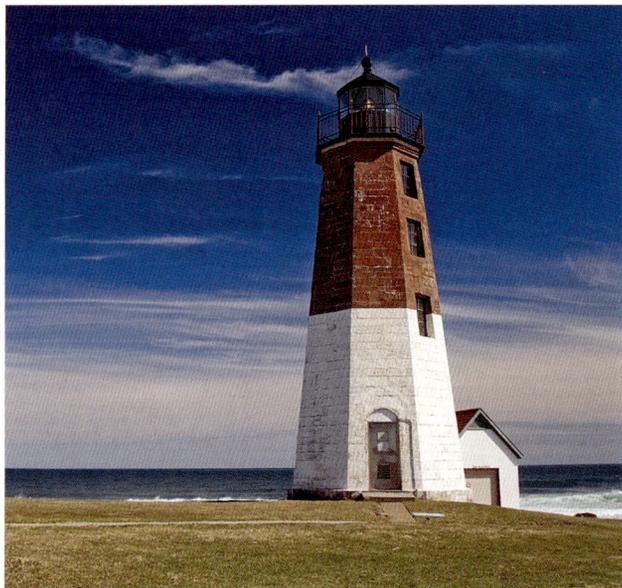

POINT JUDITH LIGHTHOUSE, RHODE ISLAND

This lighthouse was one of five appearing in a set of postage stamps issued by the US Postal Service in 2013, called "New England Coastal Lighthouses."

PLUM ISLAND LIGHTHOUSE, MASSACHUSETTS

The Coast Guard provided for the reshingling of this lighthouse tower in 1997.

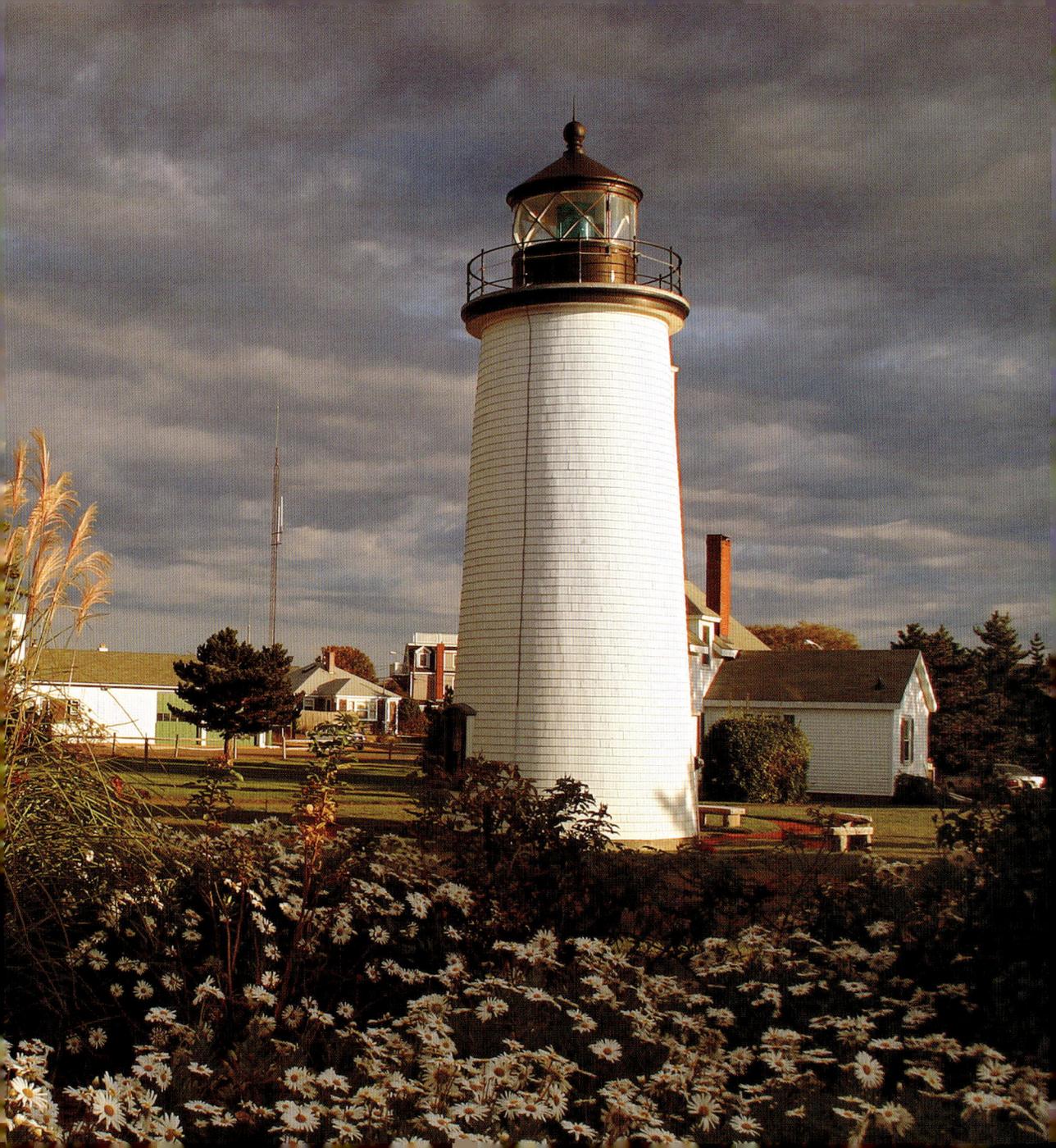

BOSTON LIGHTHOUSE, MASSACHUSETTS

This 300-year-old lighthouse, with its second-order Fresnel lens installed in 1859, was designated a National Historic Landmark in 1964. Little Brewster Island, on which it stands, became a National Recreation Area in 1996.

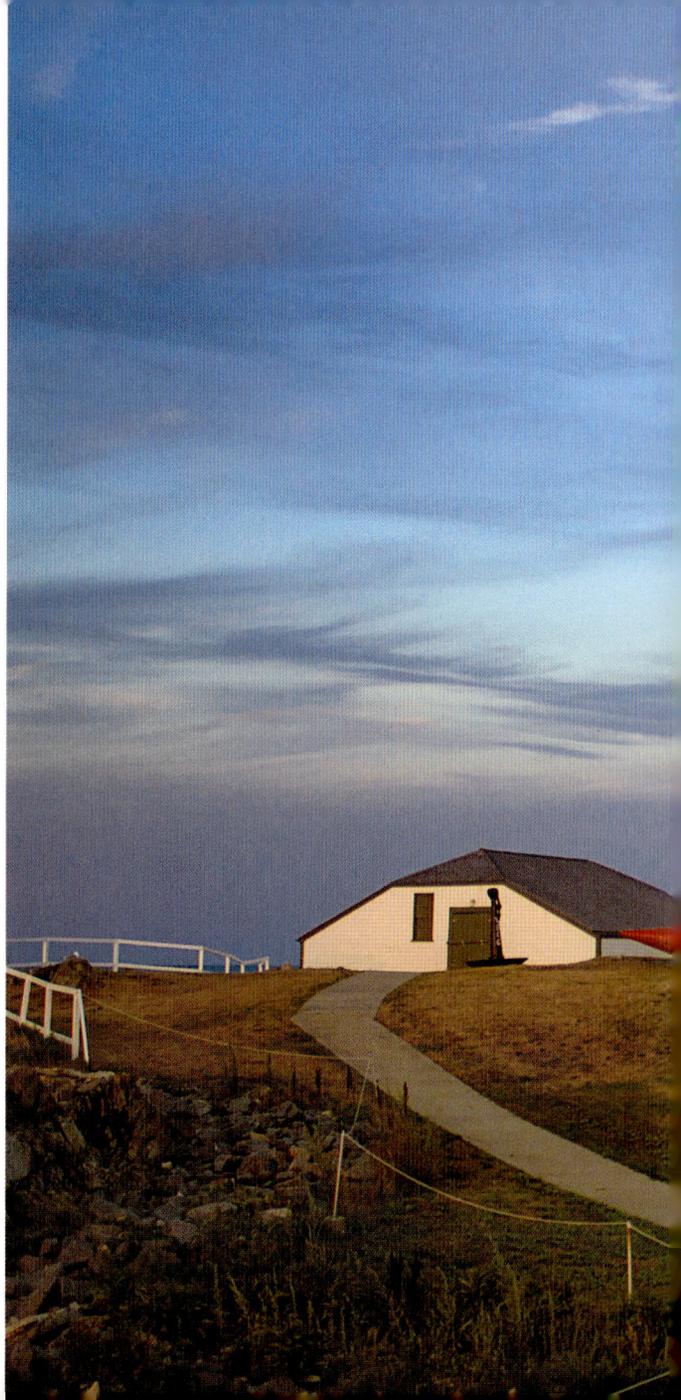

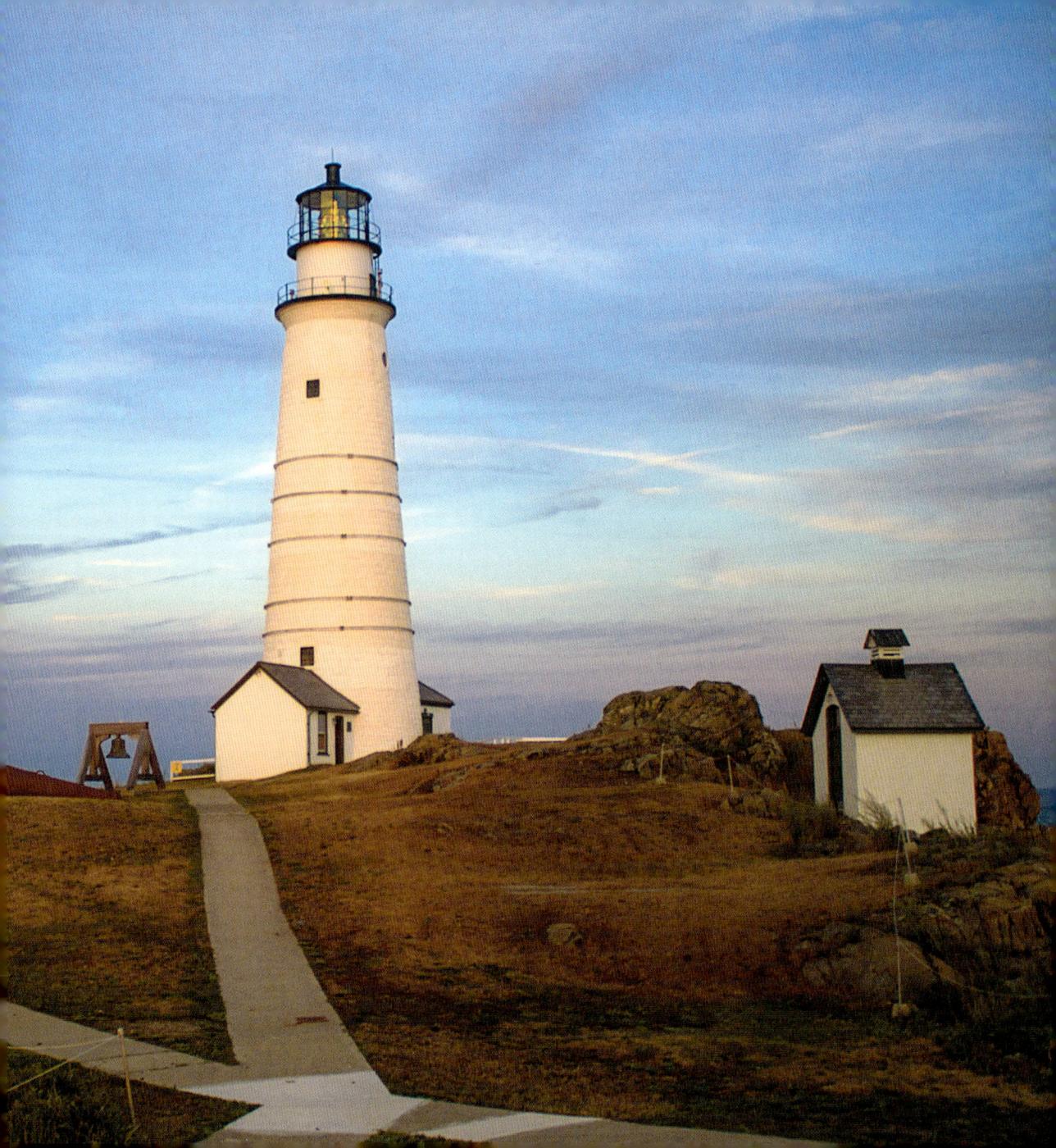

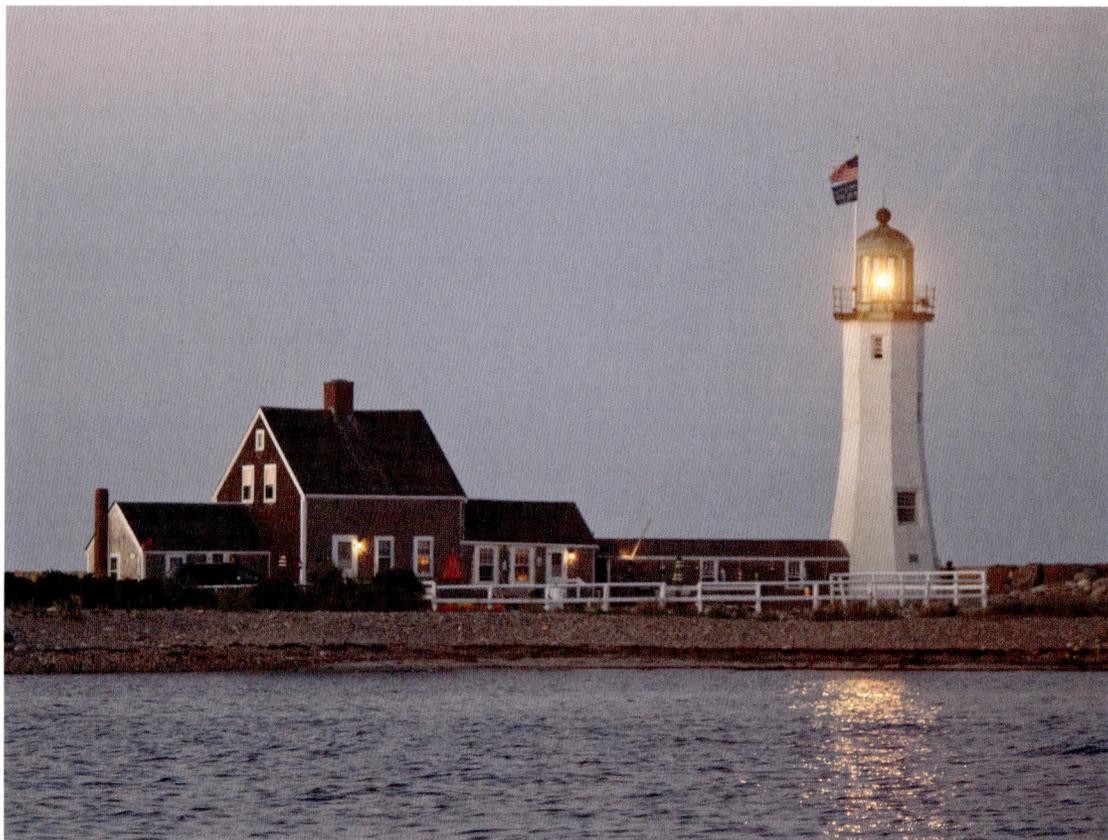

▲ SCITUATE LIGHTHOUSE, MASSACHUSETTS
Residents purchased this lighthouse in 1916, declaring that "a community is judged by the condition of its public buildings; therefore, the lighthouse should be well kept and in pleasing-looking condition."

▶ SPRING POINT LEDGE LIGHTHOUSE, MAINE
The Maine Lights Program Trust opened this lighthouse for public tours, showing a restored interior of period furniture.

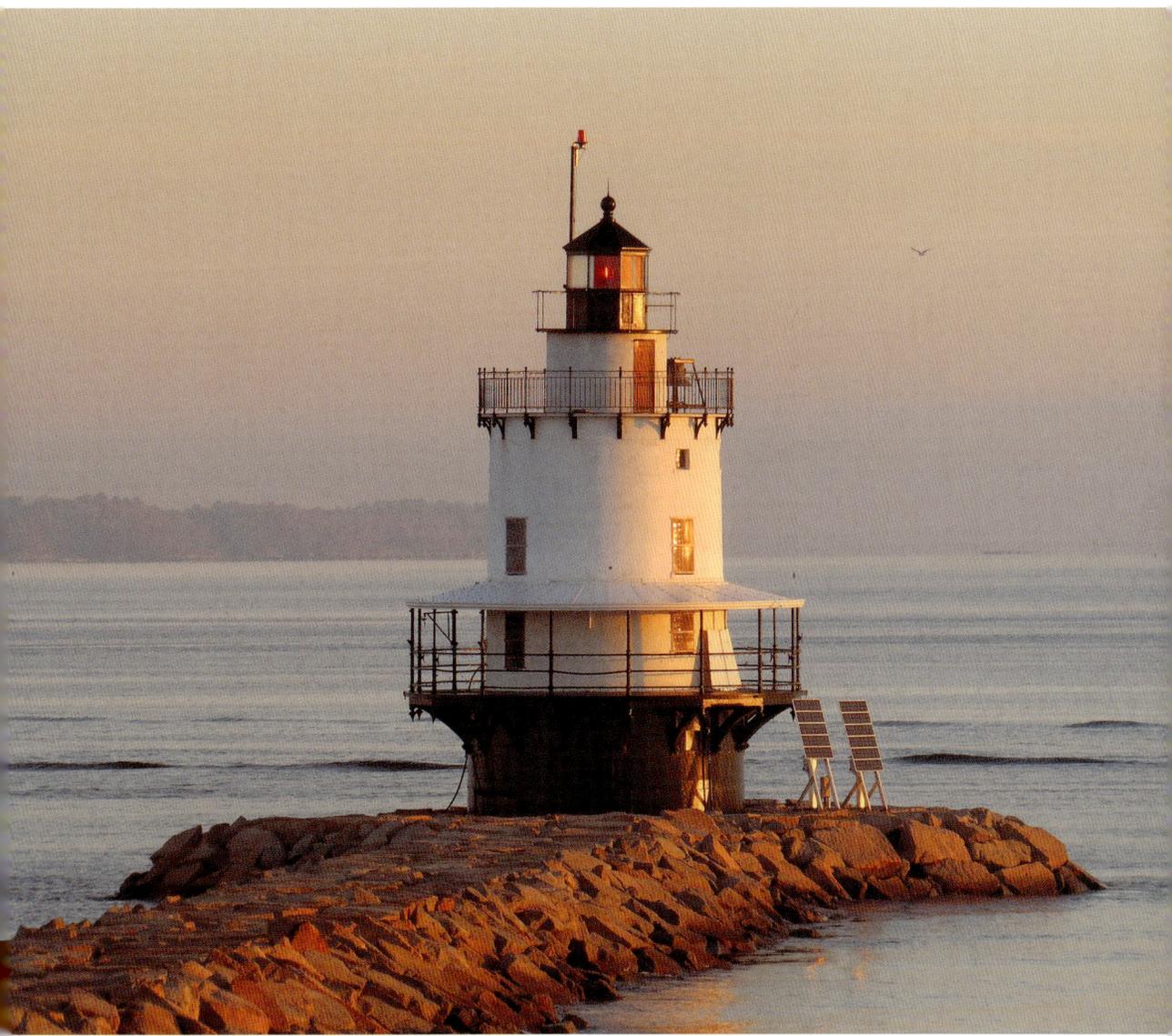

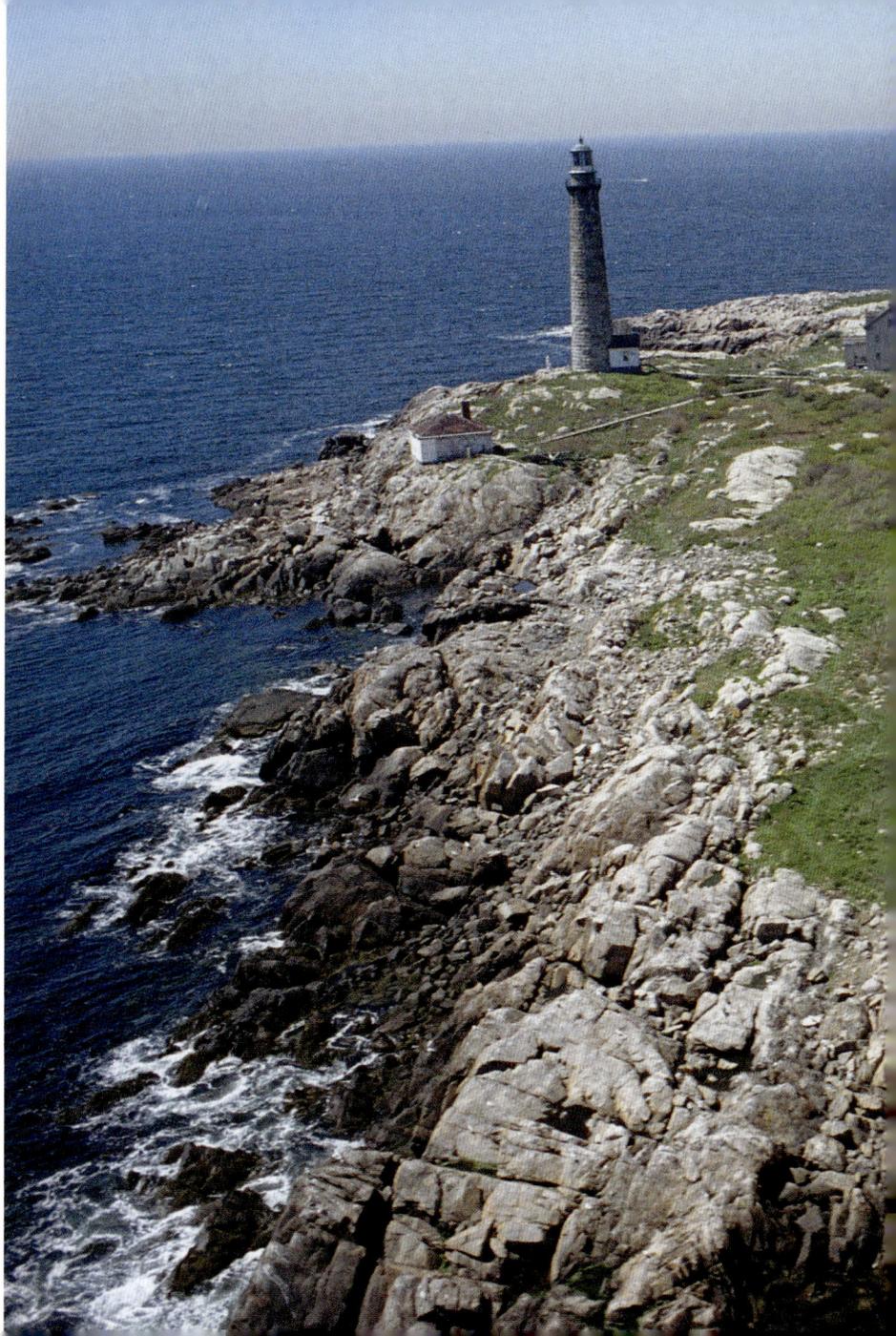

THACHER ISLAND LIGHTHOUSES, MASSACHUSETTS

The unique twin lighthouse towers and structures on the 28-acre Thacher Island have been restored to their original 19th-century appearance.

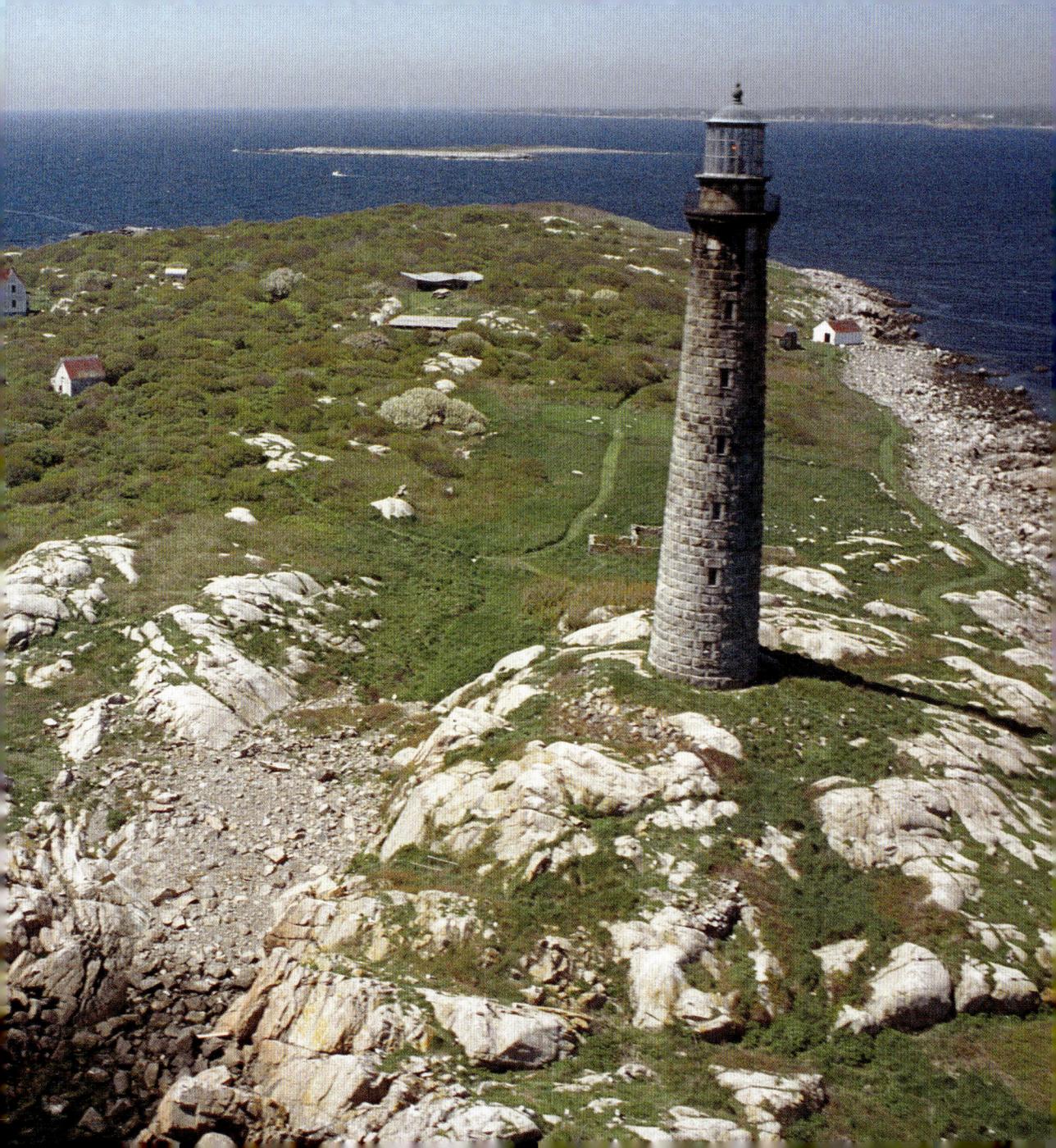

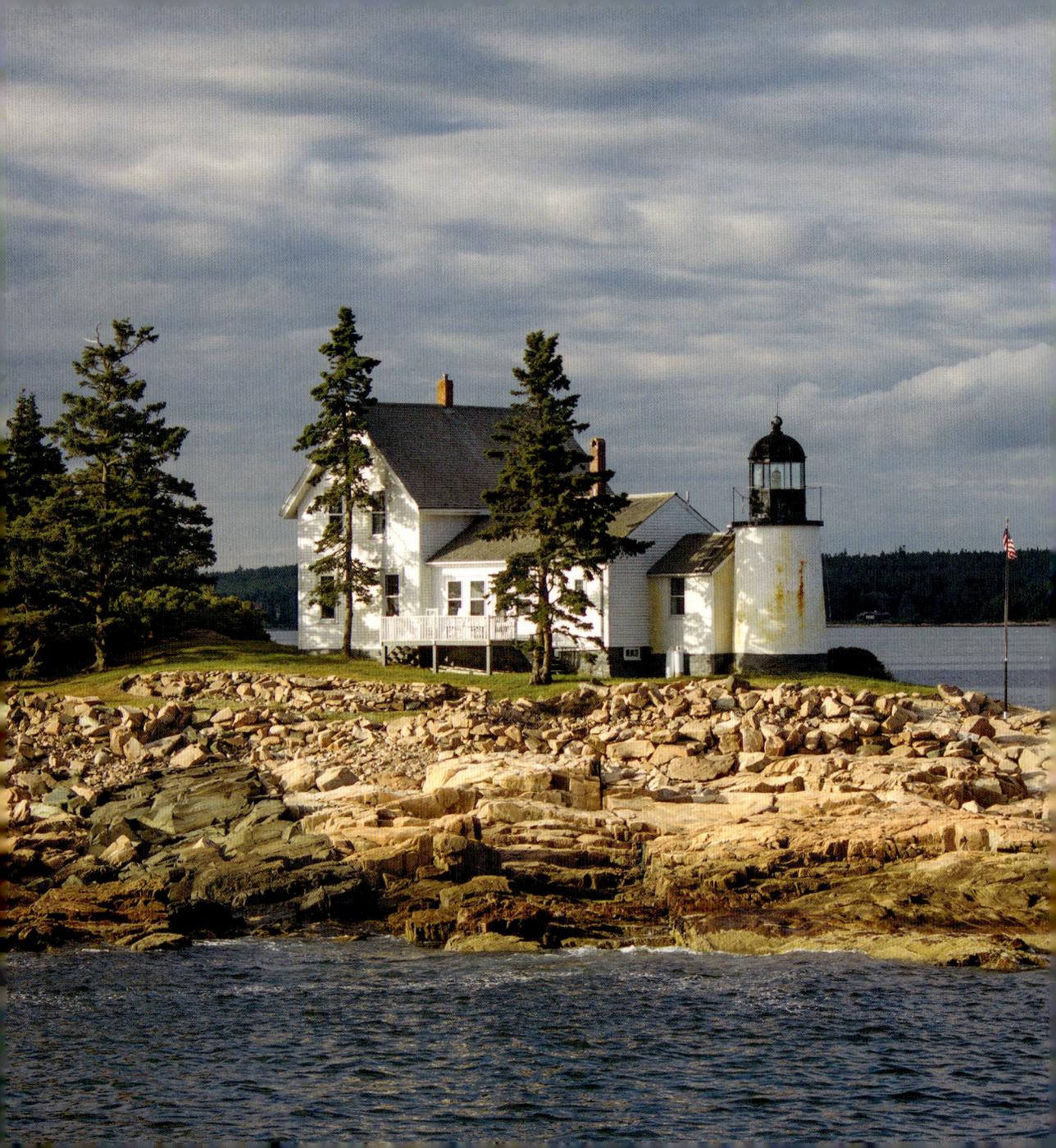

◀ WINTER HARBOR LIGHTHOUSE, MAINE

Author Bernice Richmond wrote two books about the years she lived in this lighthouse on Mark Island: Winter Harbor *and* Our Island Lighthouse.

▶ WHALEBACK LIGHTHOUSE, MAINE

An 1842 report from the original lighthouse in this location noted that large swells shook the lighthouse "in the most alarming manner . . . the vibration was so great as to move the chairs and tables about the floor."

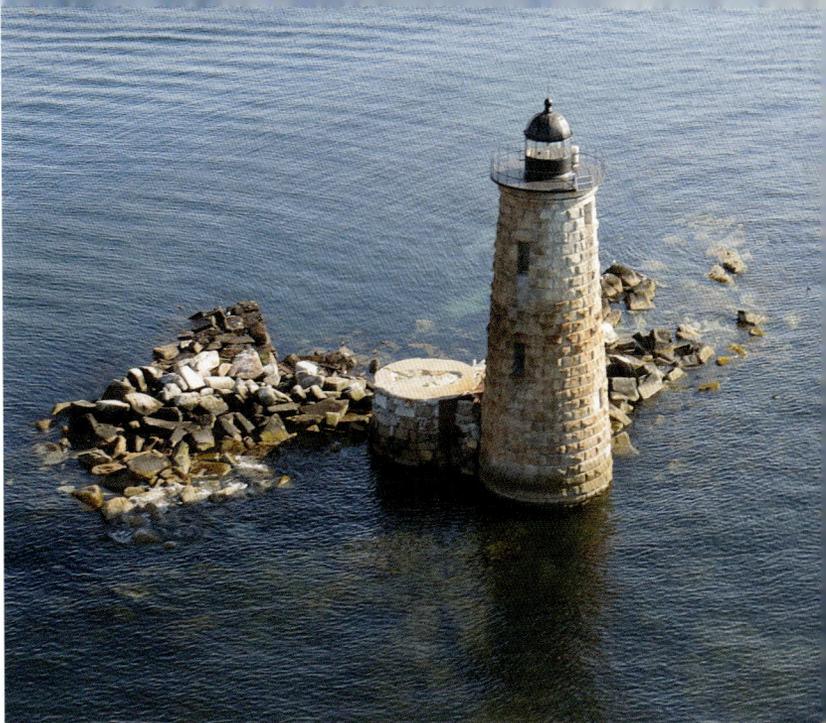

▶ EGG ROCK LIGHTHOUSE, MAINE

This lighthouse was one of seven Coast Guard properties that was transferred to the US Fish & Wildlife Service in 1998 for protection of nesting birds.

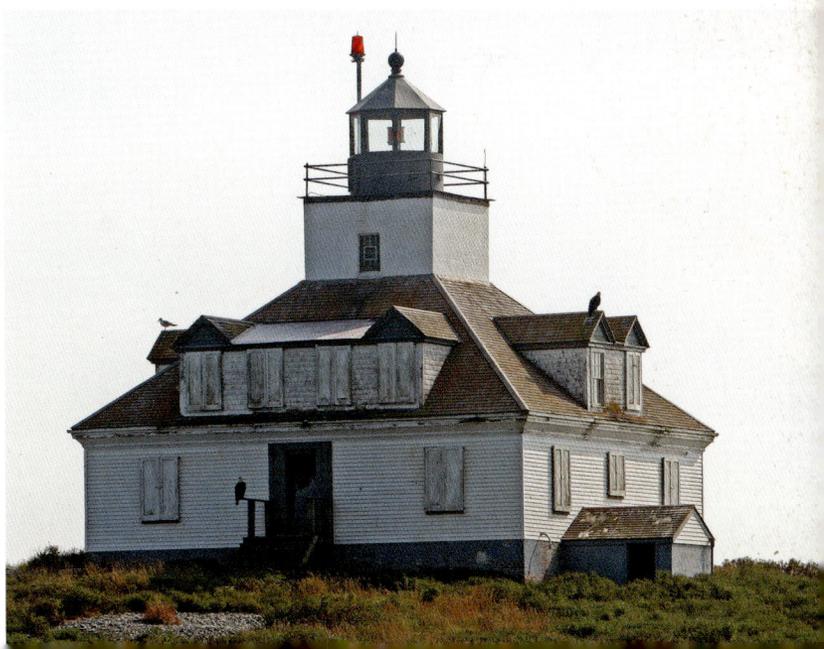

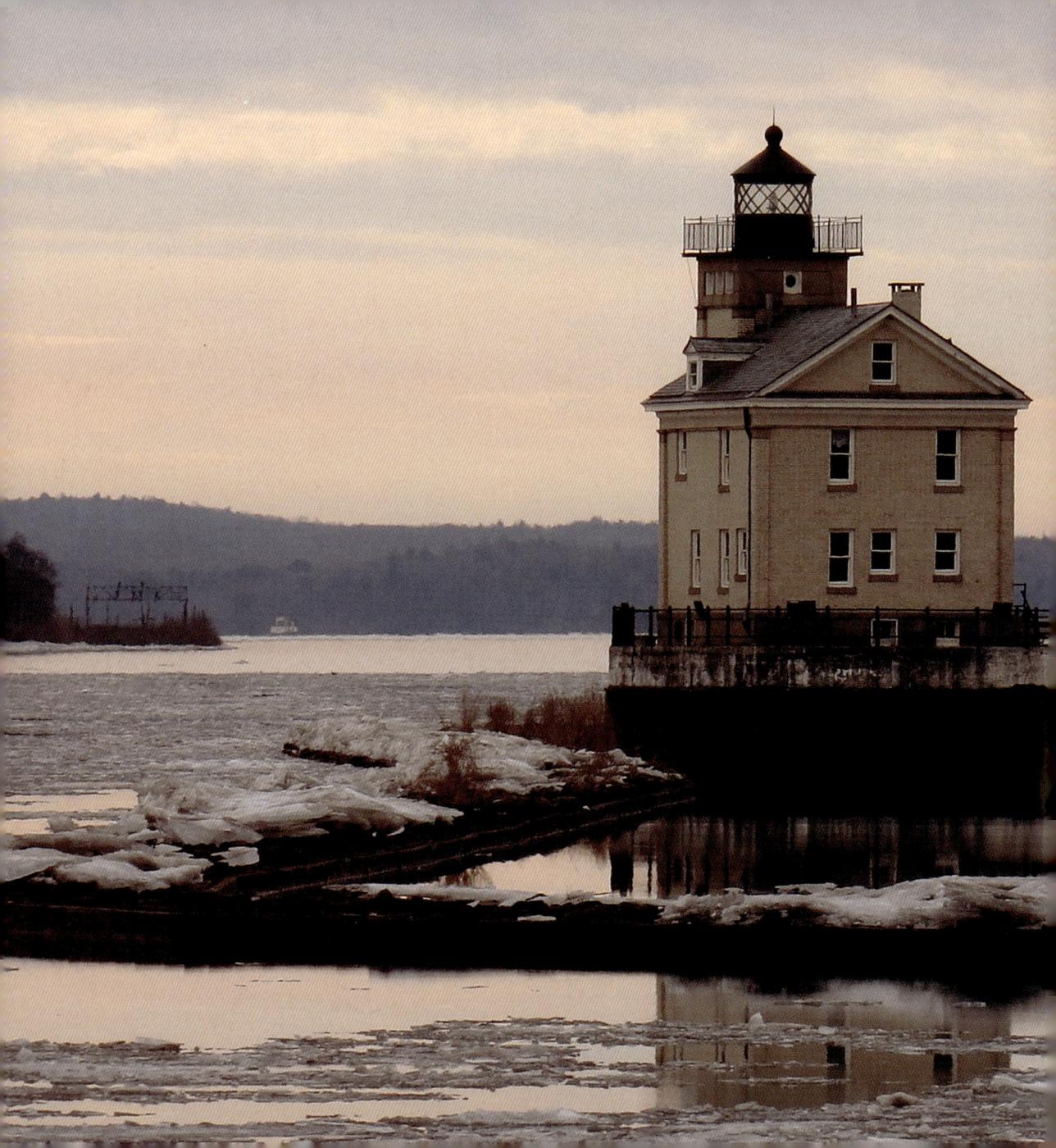

MID-ATLANTIC

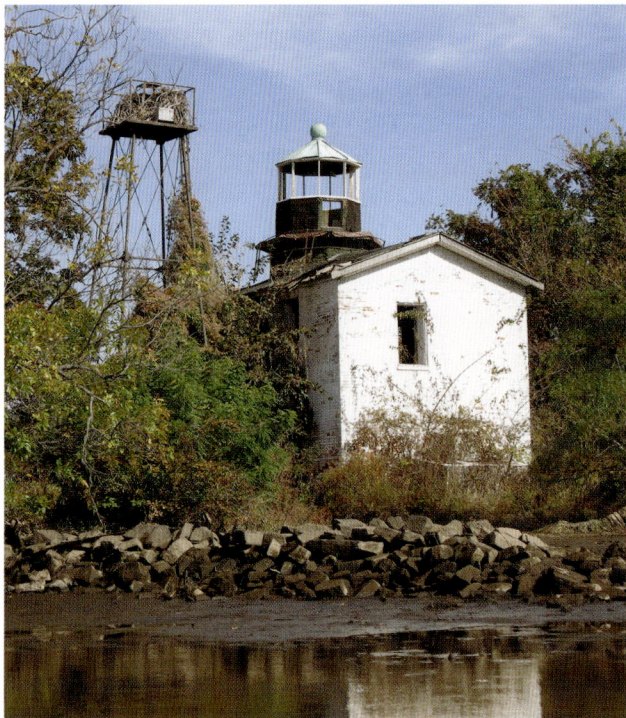

(Pages 64–65)

RONDOUT CREEK LIGHTHOUSE, NEW YORK

Catherine Murdock took over keeper's duties at this lighthouse following her husband's drowning. She continued as keeper for 50 years, retiring in 1907.

▲ FISHING BATTERY LIGHTHOUSE, MARYLAND

Vandalism and official neglect renders this lighthouse, on an artificial island, a questionable restoration project.

▶ NEW DORP LIGHTHOUSE, NEW YORK

Added brightness from an incandescent oil vapor lamp installed in 1908 cast phantom shadows, which were reported as the "New Dorp ghost."

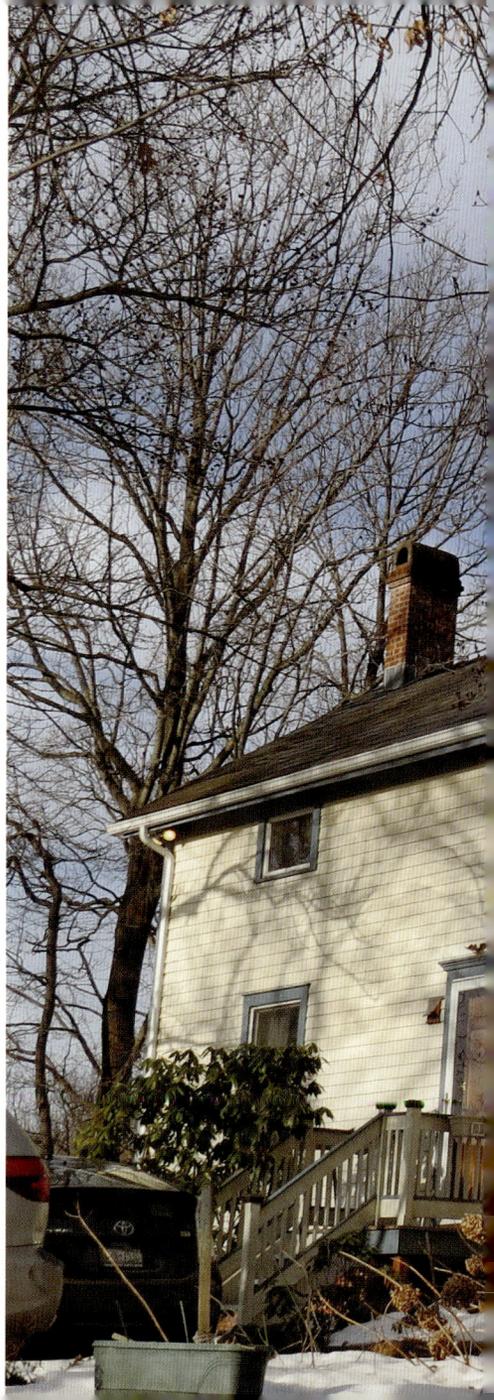

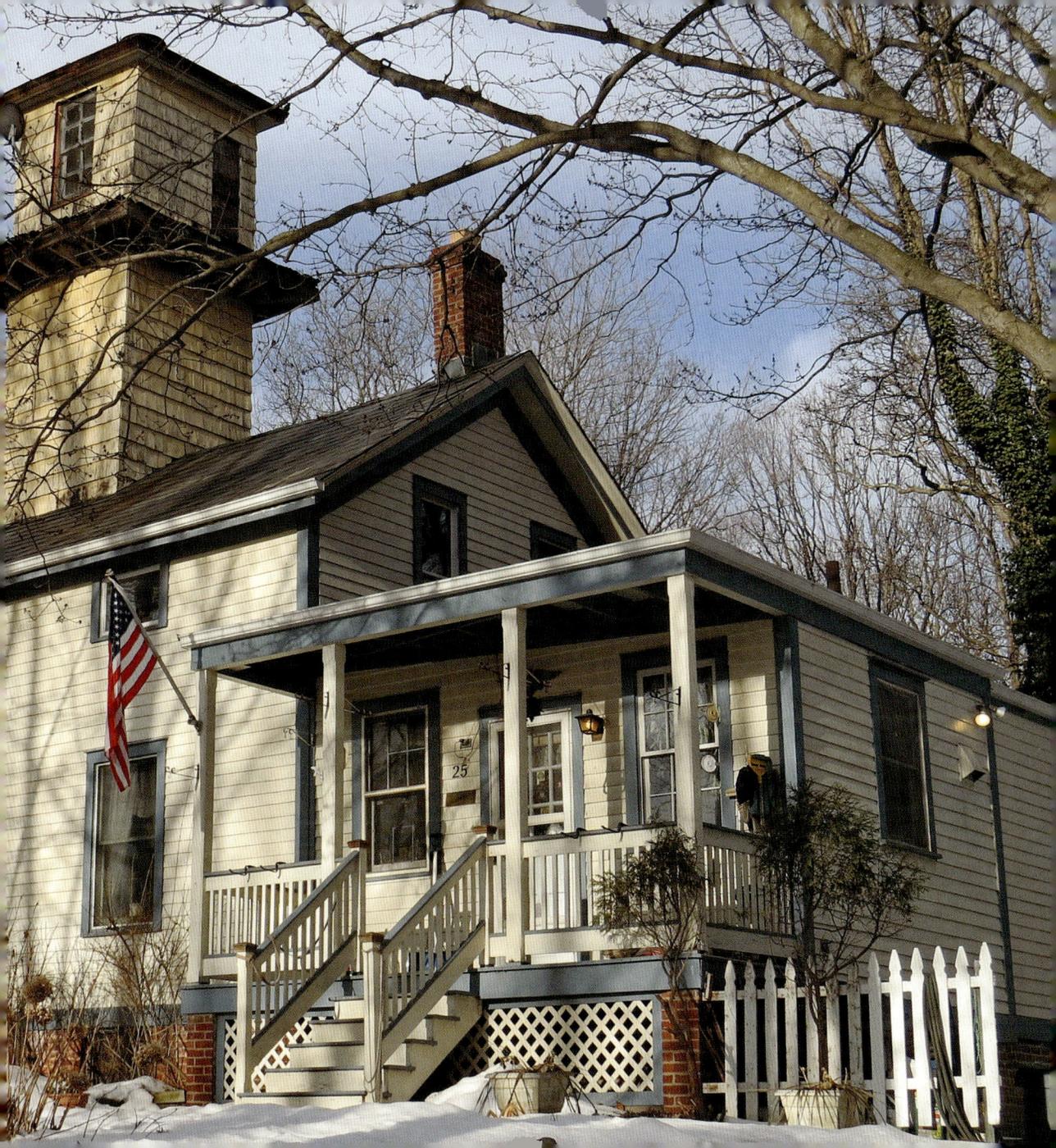

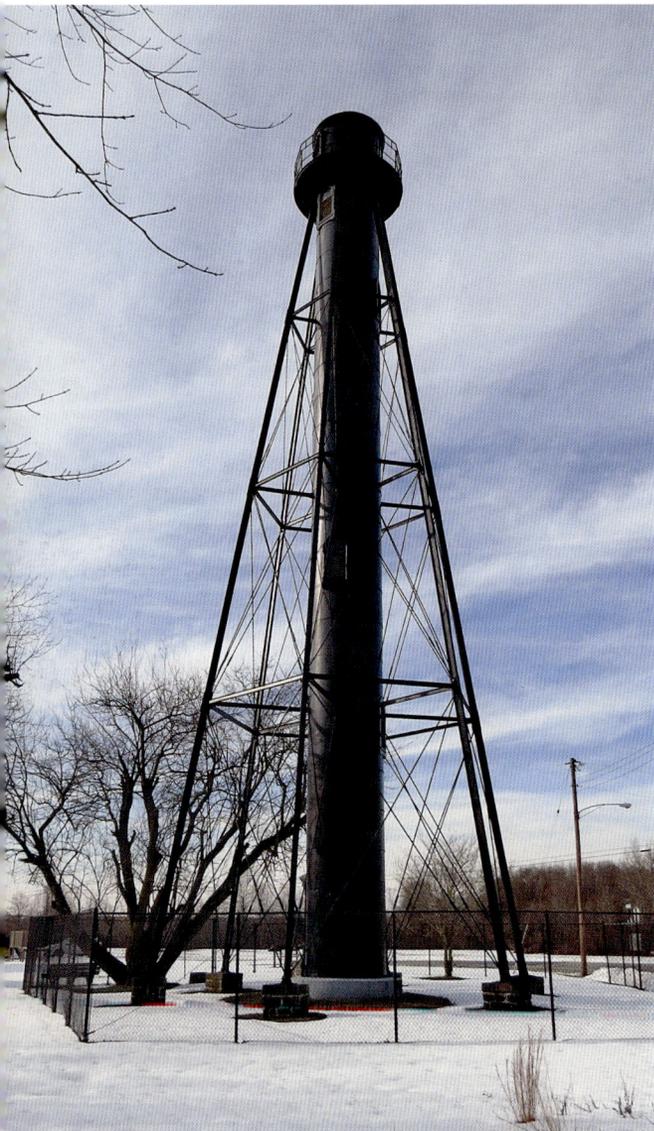

◀ FINN POINT RANGE LIGHTHOUSE, NEW JERSEY

Mule teams pulled wagons loaded with wrought-iron sections for this lighthouse from the Salem, New Jersey, railhead to the construction site in 1876.

▶ LATIMER REEF LIGHTHOUSE, NEW YORK

The interiors of prefabricated cast-iron towers like this one were very cold in winter and very hot in summer. This style was originally called a "coffee pot" lighthouse.

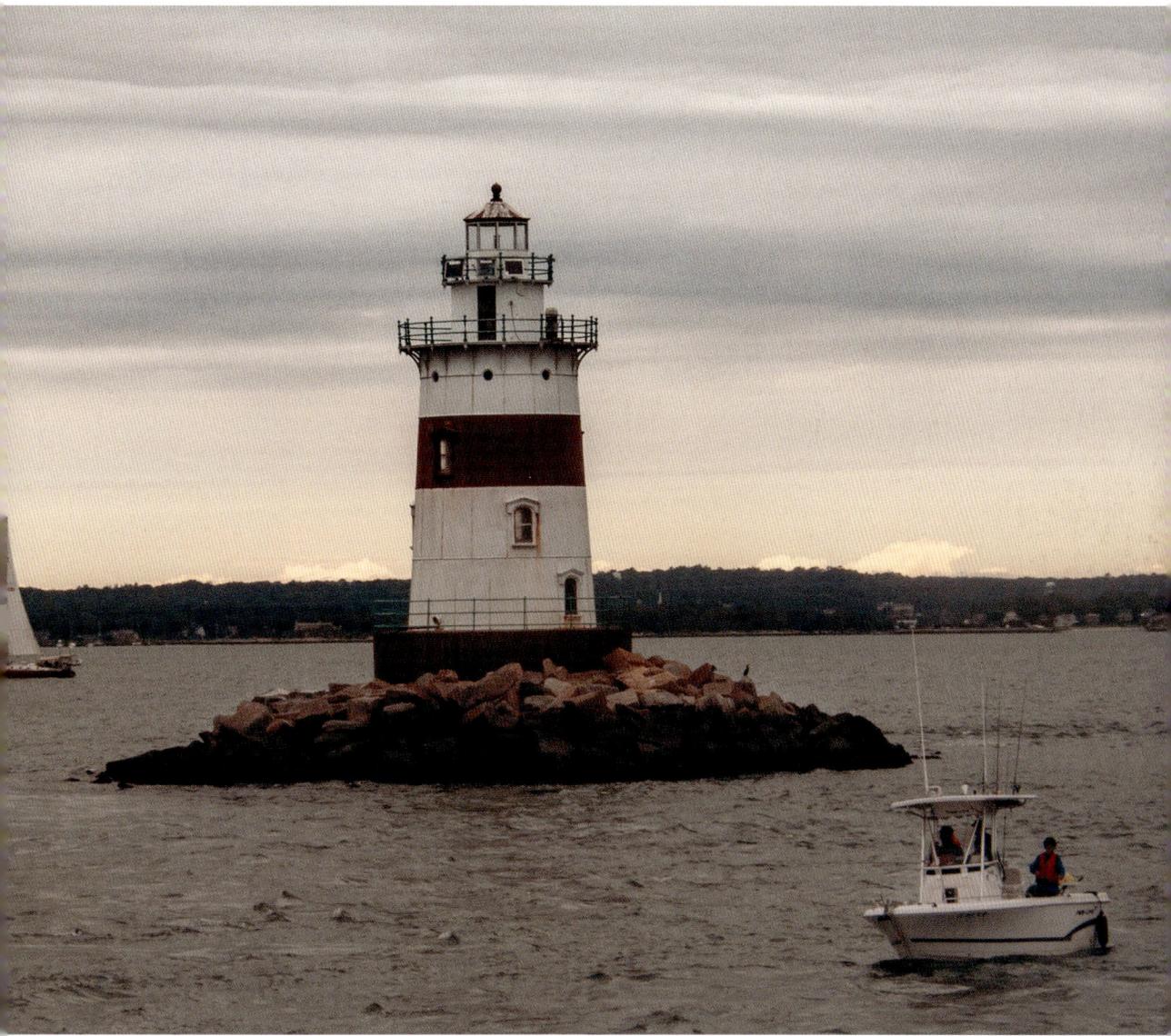

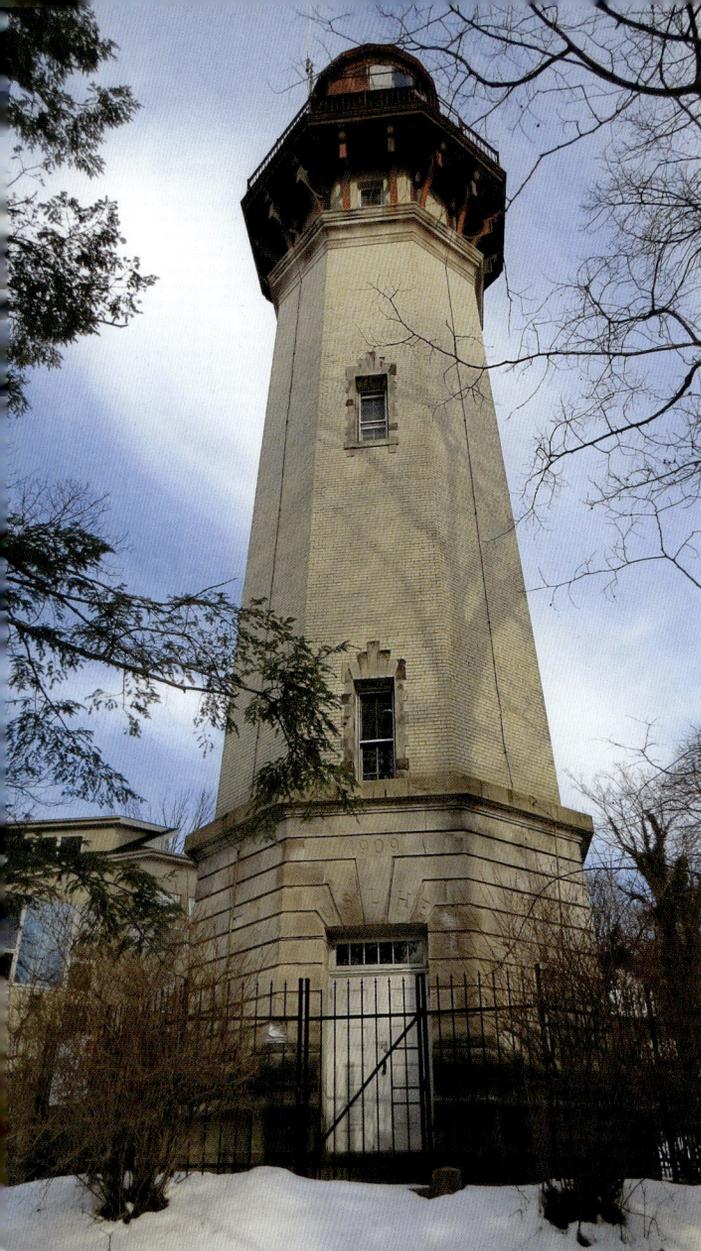

◀ STATEN ISLAND
LIGHTHOUSE,
NEW YORK

*From New York Harbor,
only the top of this light-
house remains visible
above the surrounding
houses and foliage.*

▶ FORT
WADSWORTH
LIGHTHOUSE,
NEW YORK

*Forts defending
19th-century America's
harbors were also
choice locations for
lighthouses such as this
one on Staten Island.*

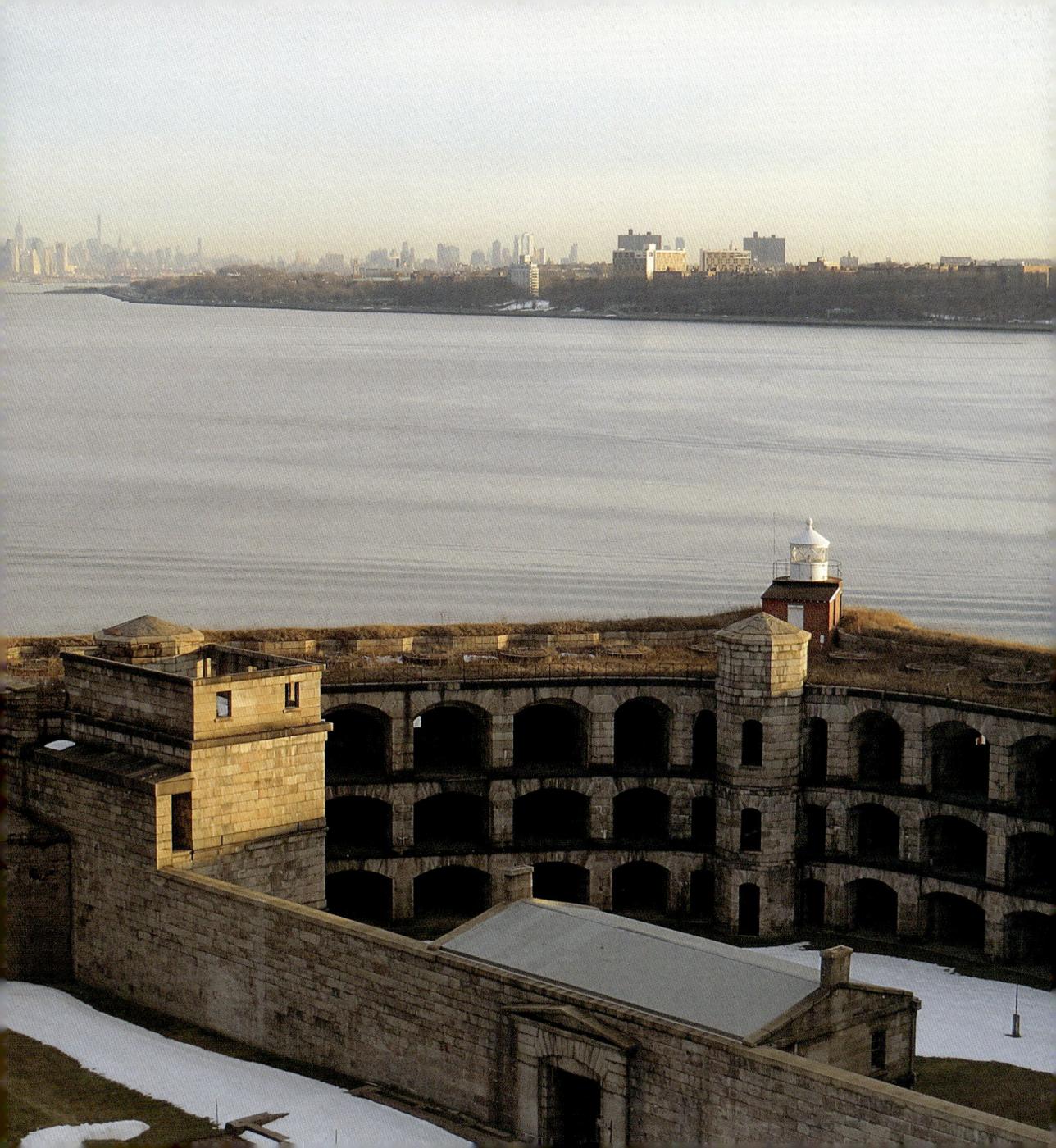

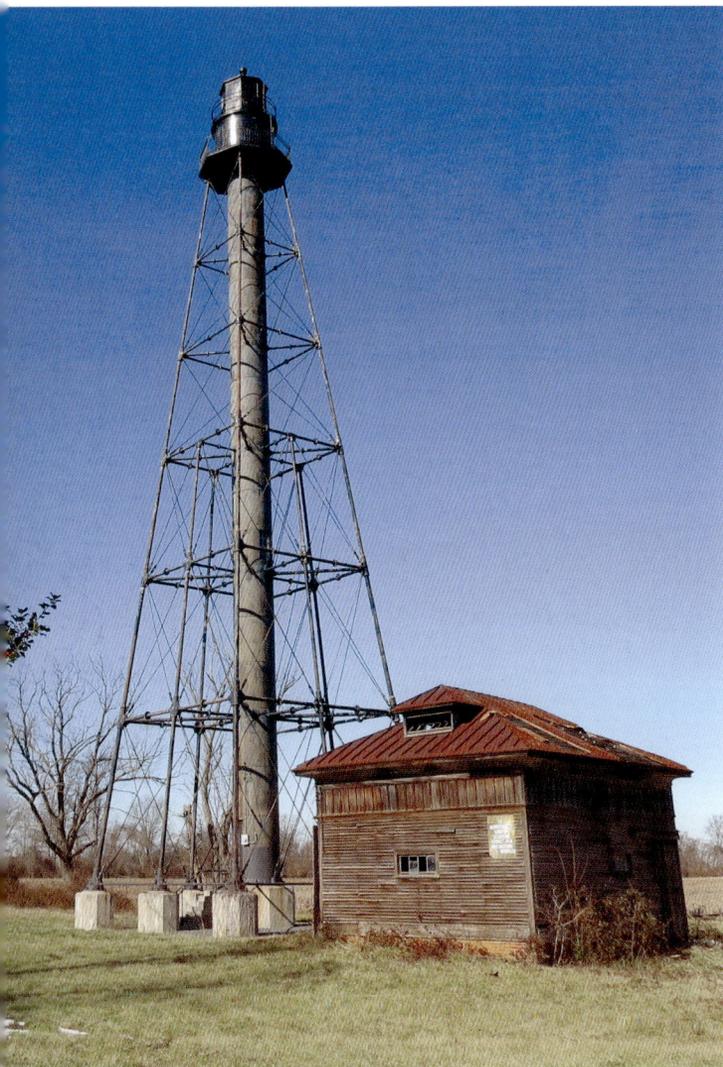

▲ REEDY ISLAND REAR RANGE LIGHT, DELAWARE
This lighthouse began in 1904 as a locomotive headlight on a tall pole.

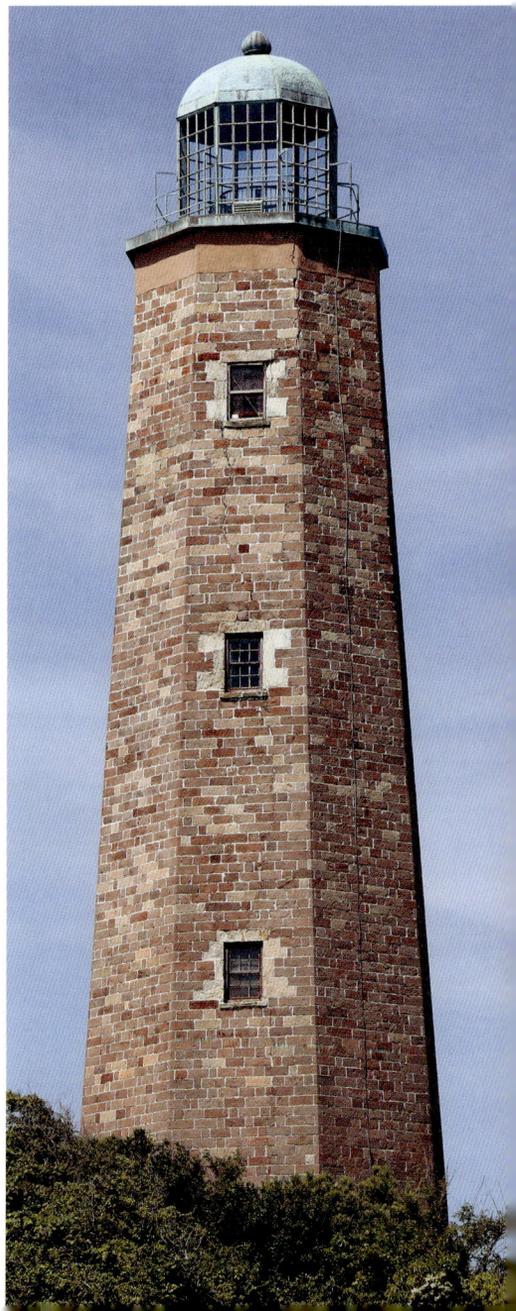

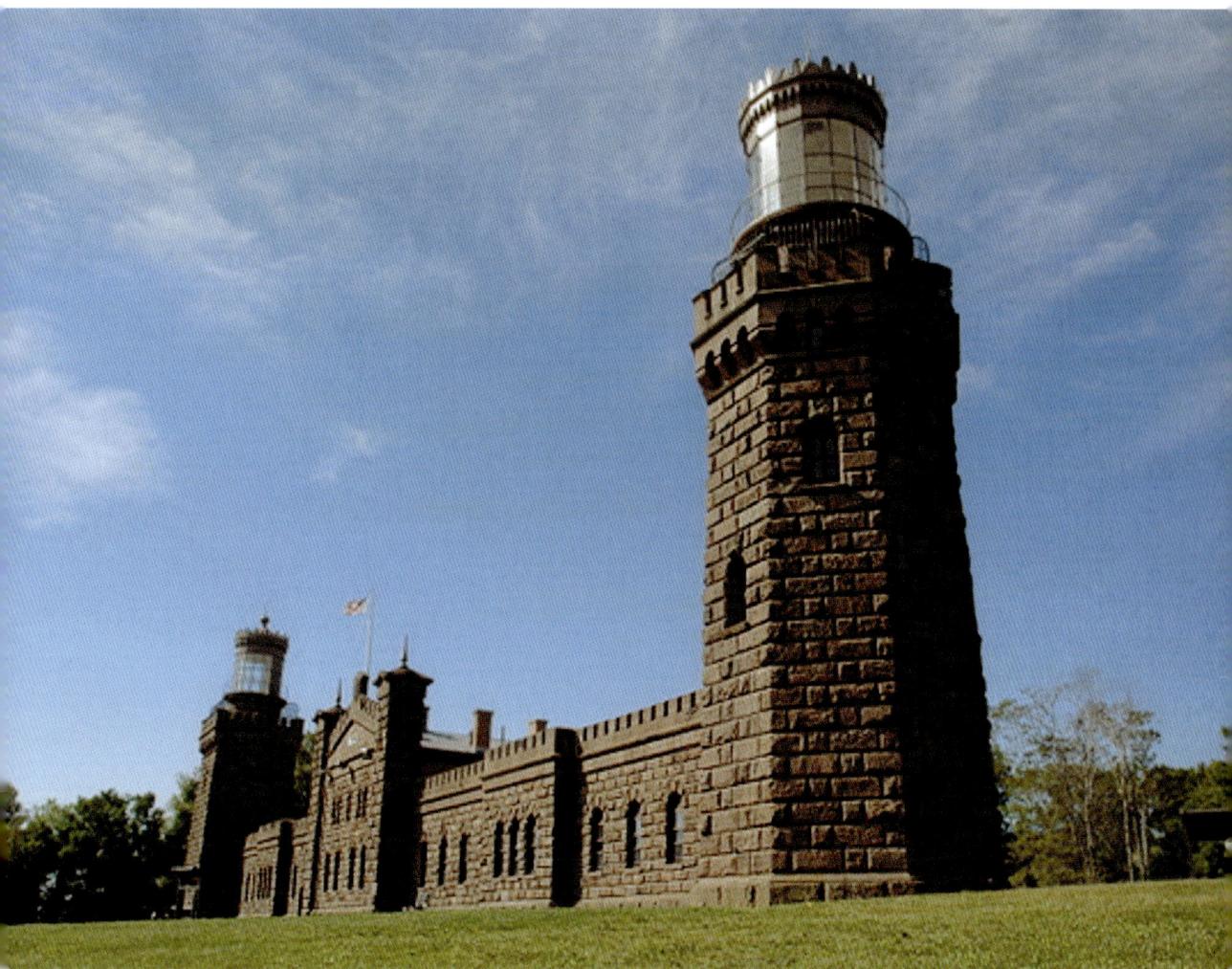

◀ OLD CAPE HENRY LIGHTHOUSE, VIRGINIA
This lighthouse was the first ordered and financed by the first session of the First Congress in 1789.

▲ NAVESINK LIGHTHOUSE, NEW JERSEY
A Fresnel lens designed for an electric arc lamp, producing 25 million candlepower, was installed at this lighthouse in 1898, the first coastal light using electricity.

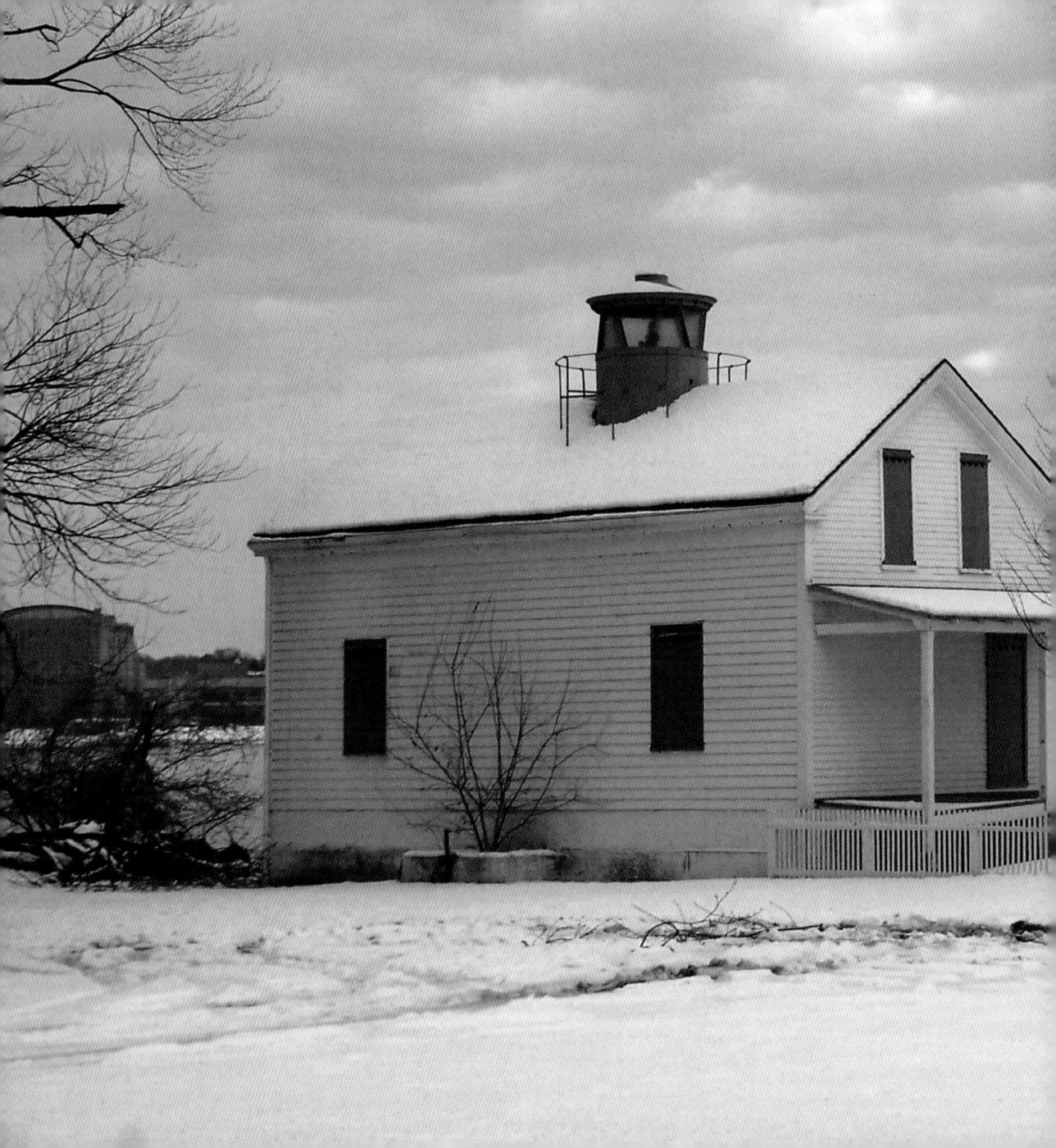

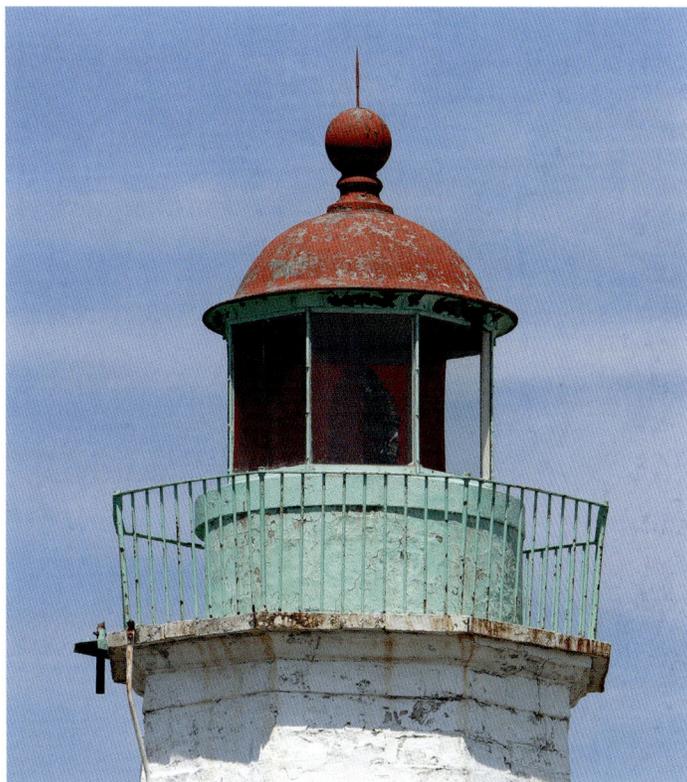

▲ OLD POINT COMFORT LIGHTHOUSE, VIRGINIA
Old Point Comfort Lighthouse became an aviation navigational aid for the country's early airways system.

◄ JONES POINT LIGHTHOUSE, VIRGINIA
The land for this lighthouse, purchased for $501 in 1855, included an original District of Columbia boundary stone placed by George Washington.

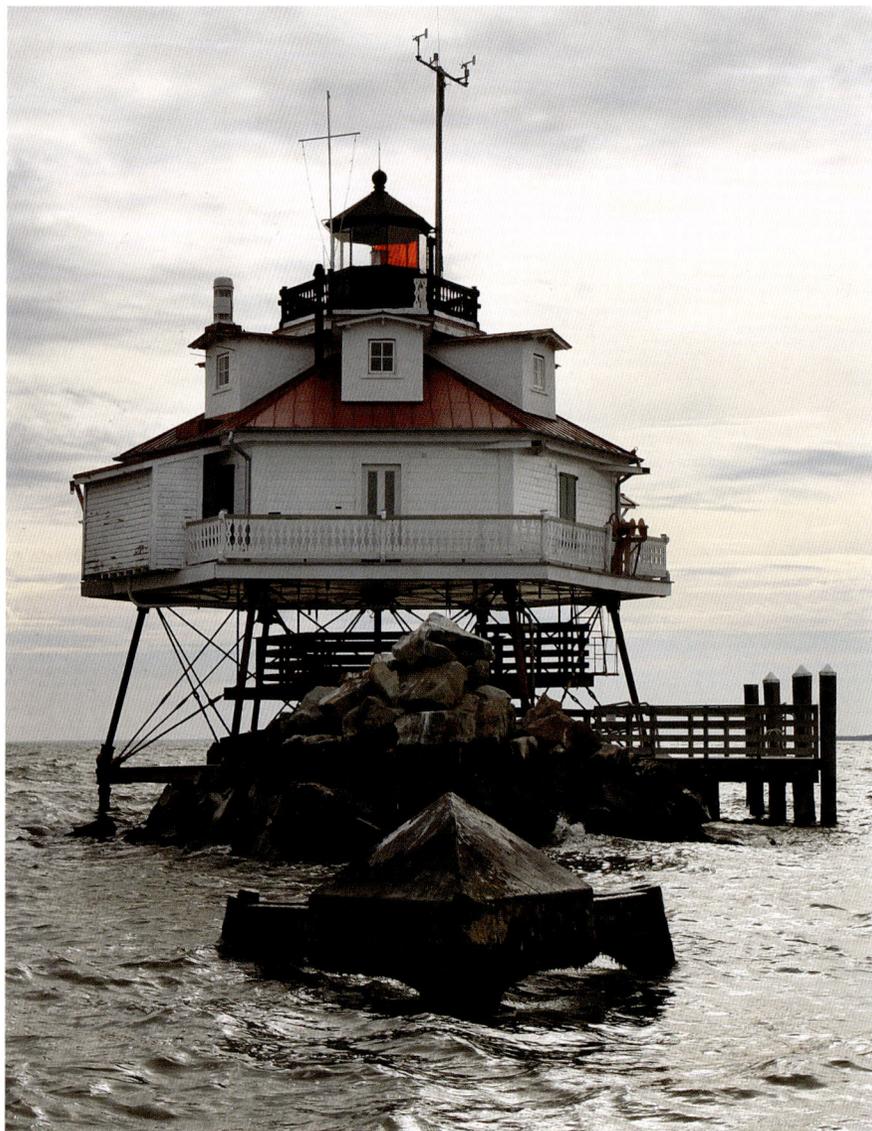

◄ THOMAS
POINT SHOAL
LIGHTHOUSE,
MARYLAND
*Thomas Point Shoal
Lighthouse is the only
unaltered screw-pile
lighthouse in the United
States still mounted on
its original foundation.*

▶ LONG
BEACH BAR
LIGHTHOUSE,
NEW YORK
*Known as the "Bug
Light," Long Beach
Bar Lighthouse was
originally mounted on
a screw-pile platform,
which resembled a bug
walking on water.*

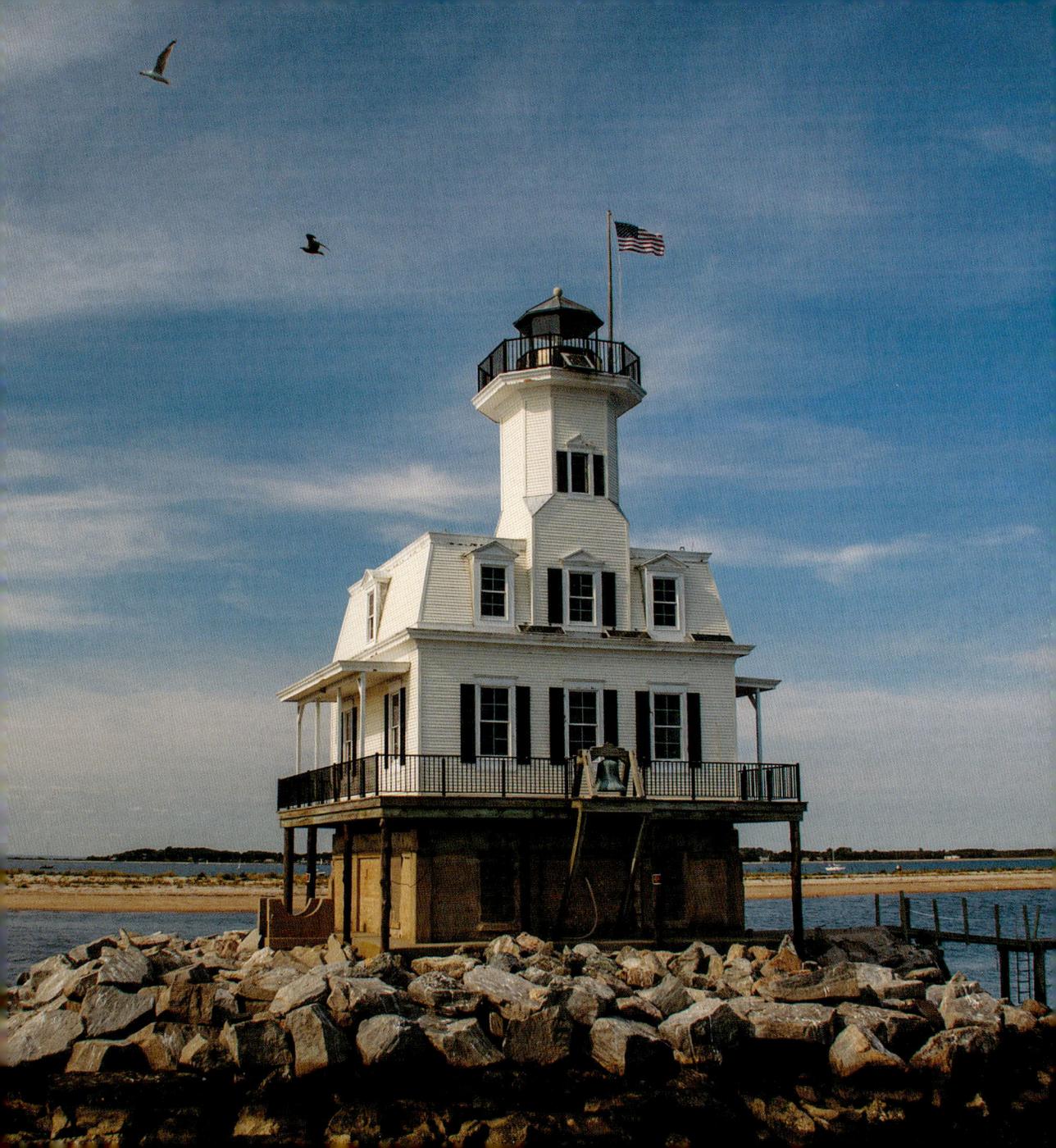

LITTLE RED LIGHTHOUSE, NEW YORK

An annual youth festival at Jeffrey's Hook includes celebrity readings of the children's book, The Little Red Lighthouse and the Great Gray Bridge.

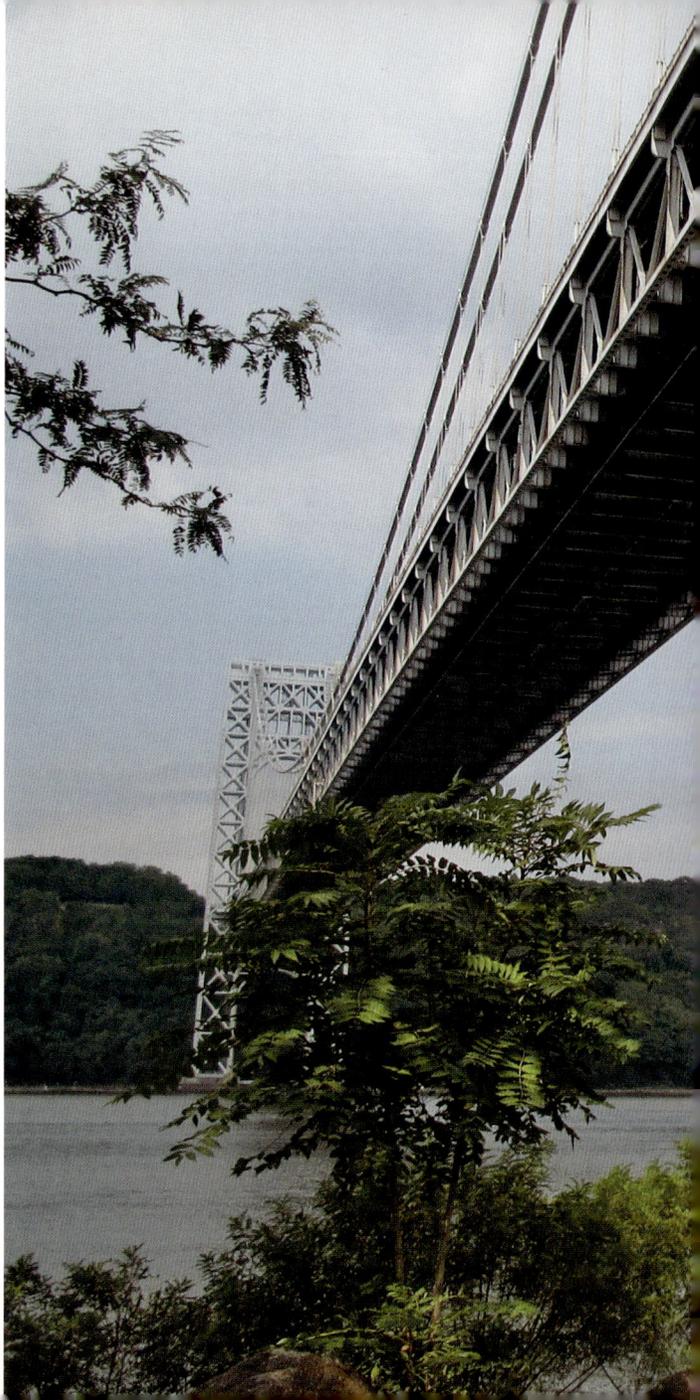

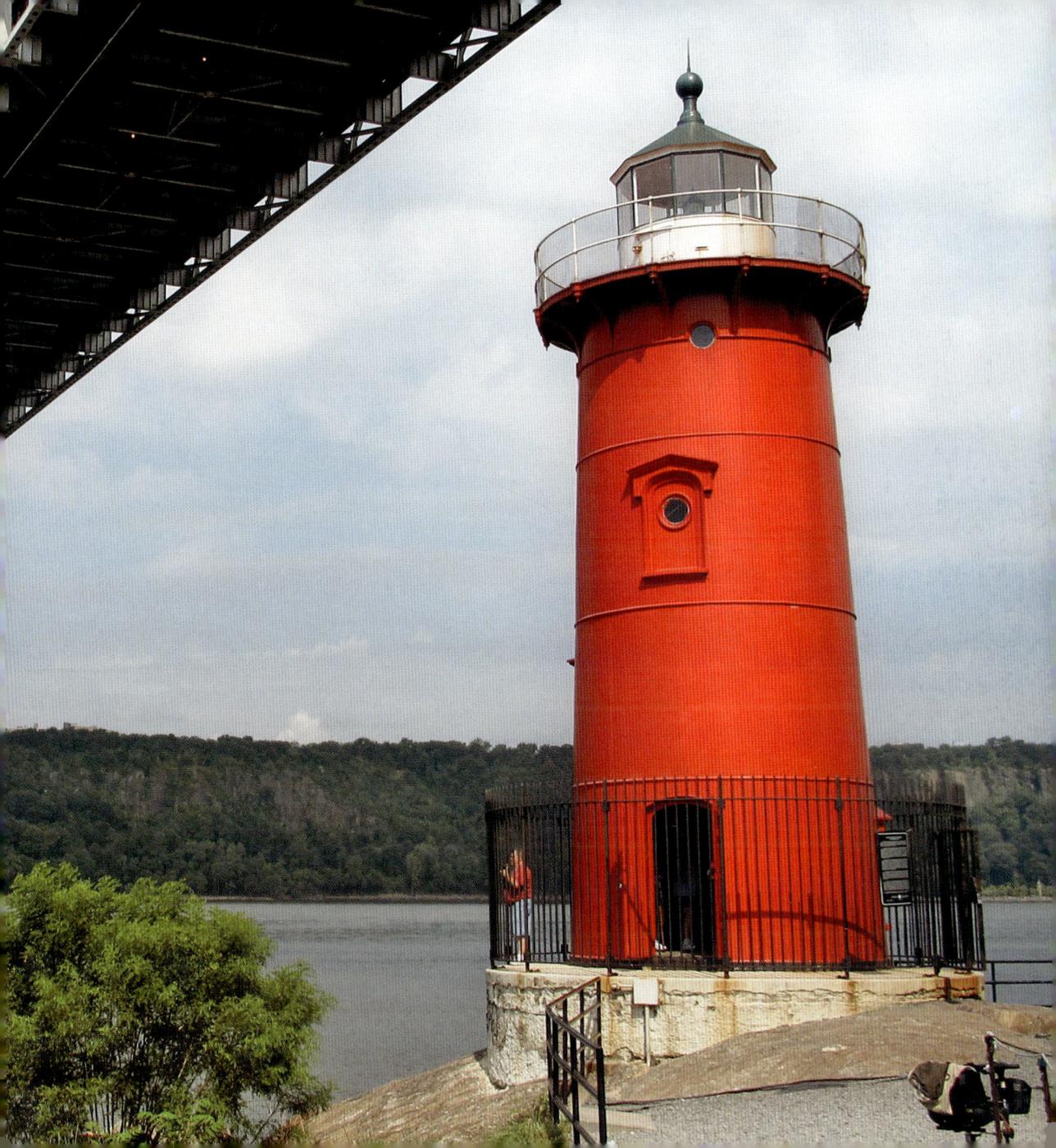

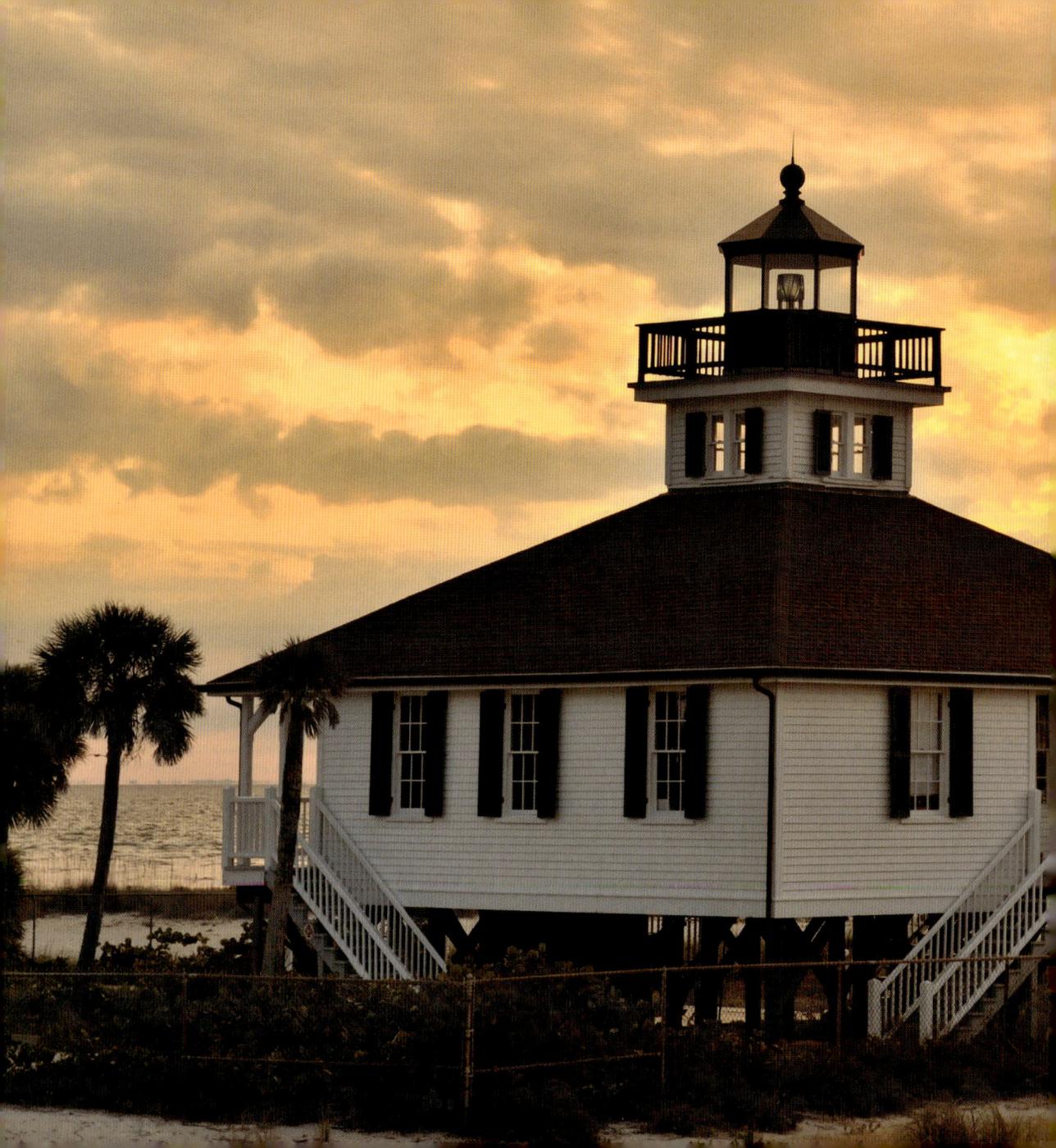

SOUTH ATLANTIC and GULF COAST

(Pages 80–81)

BOCA GRANDE LIGHTHOUSE, FLORIDA

This lighthouse is supposedly haunted by Josefa, a Spanish princess who was decapitated by Jose Gaspar, a pirate after whom Gasparilla Island was reportedly named.

TCHEFUNCTE RIVER LIGHTHOUSE, LOUISIANA

A vertical black stripe painted on this tower aids navigators in lining up with the river's channel coming off Lake Pontchartrain.

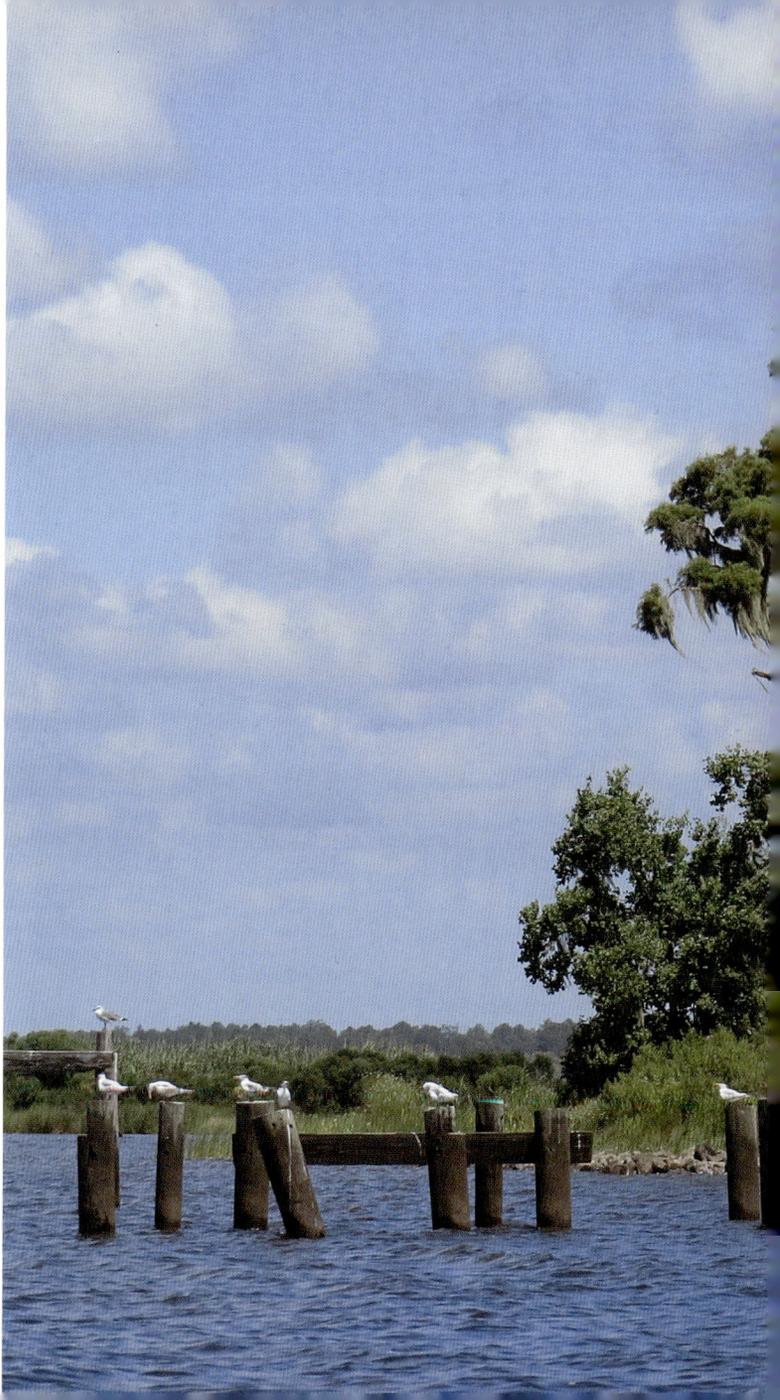

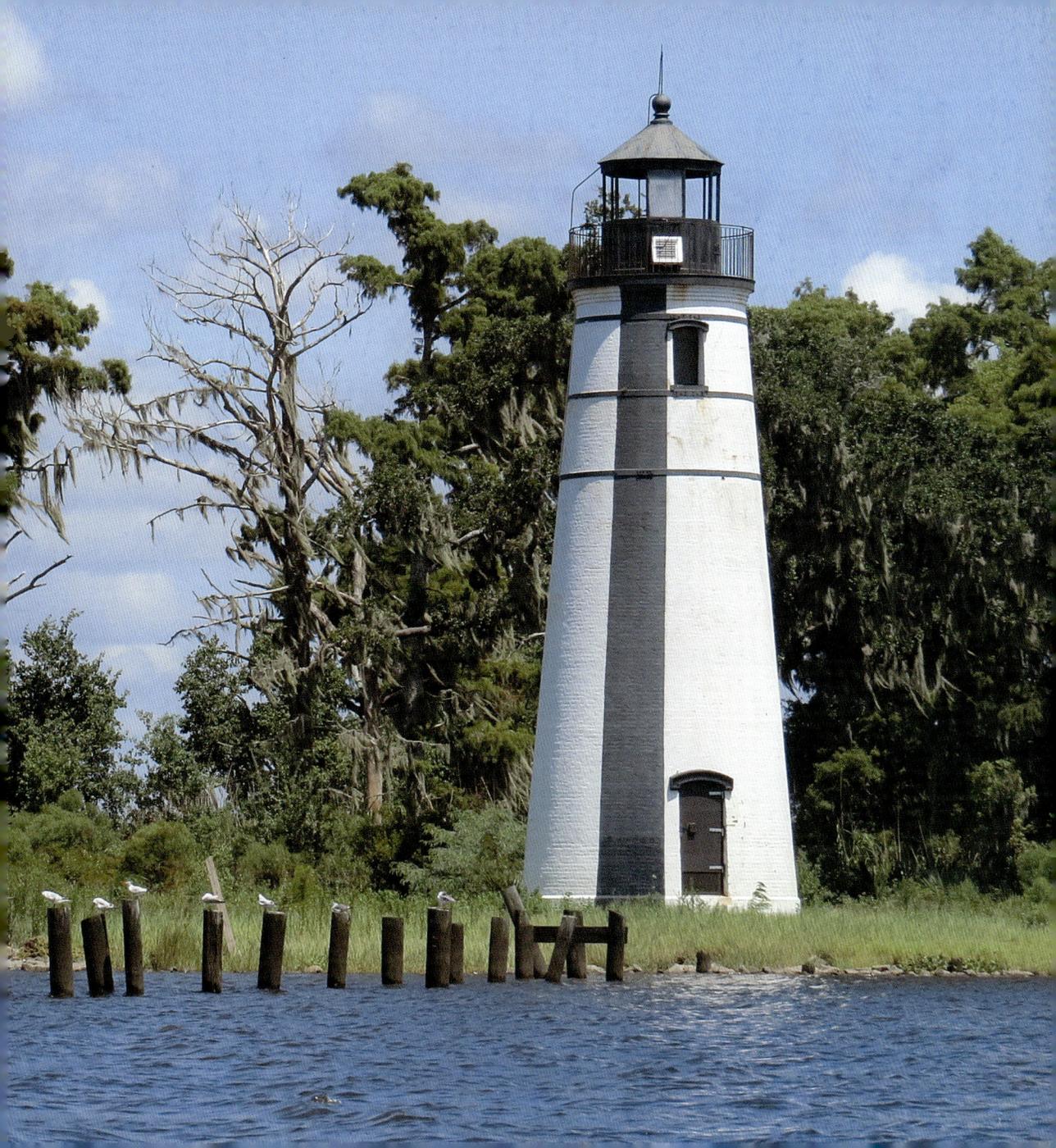

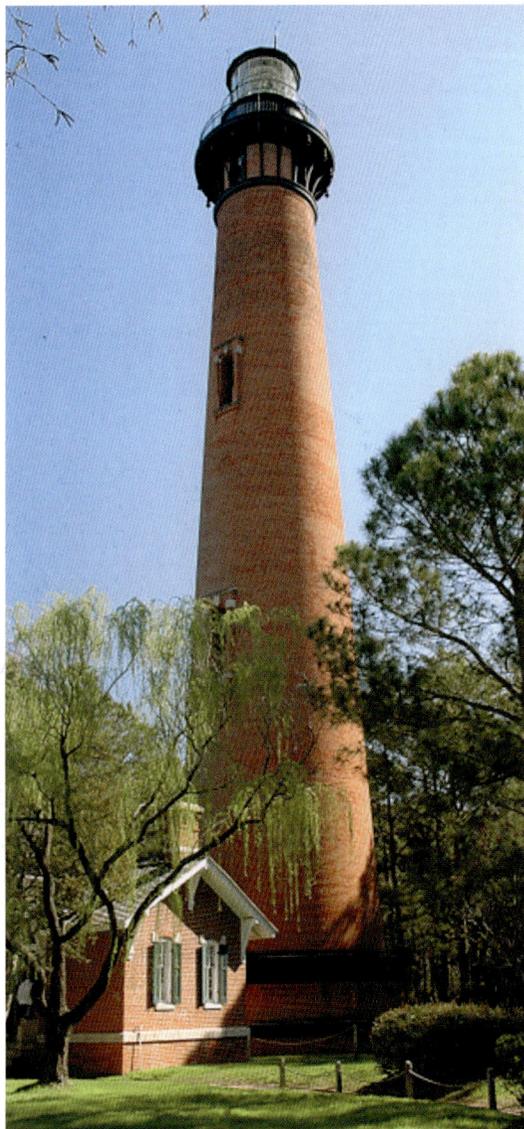

◀ CURRITUCK BEACH LIGHTHOUSE, NORTH CAROLINA

This lighthouse's keeper, William Tate, hosted brothers Wilbur and Orville Wright in his home in 1900. He assisted the brothers in assembling their gliders. His wife, Addie Tate, further aided by sewing wing fabric with her sewing machine.

▶ HUNTING ISLAND LIGHTHOUSE, SOUTH CAROLINA

The original Hunting Island Lighthouse reportedly was blown up by retreating Confederate soldiers to encumber the Union fleet's approach.

▶▶ CAPE HATTERAS LIGHTHOUSE, NORTH CAROLINA

This tower overlooks the "Graveyard of the Atlantic," where reportedly more than 2,000 ships have foundered.

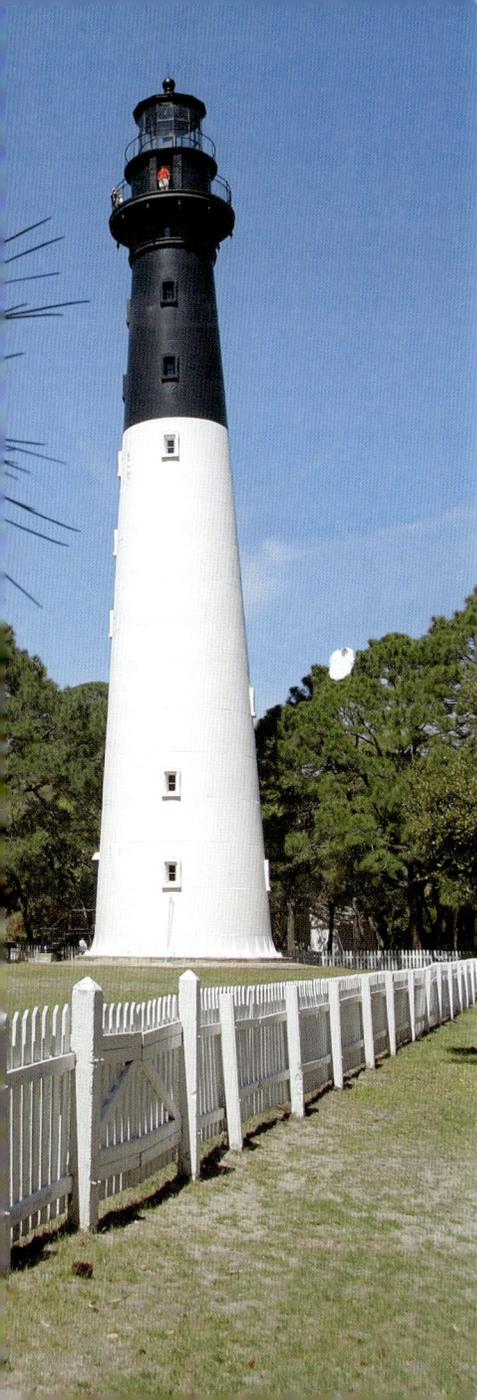

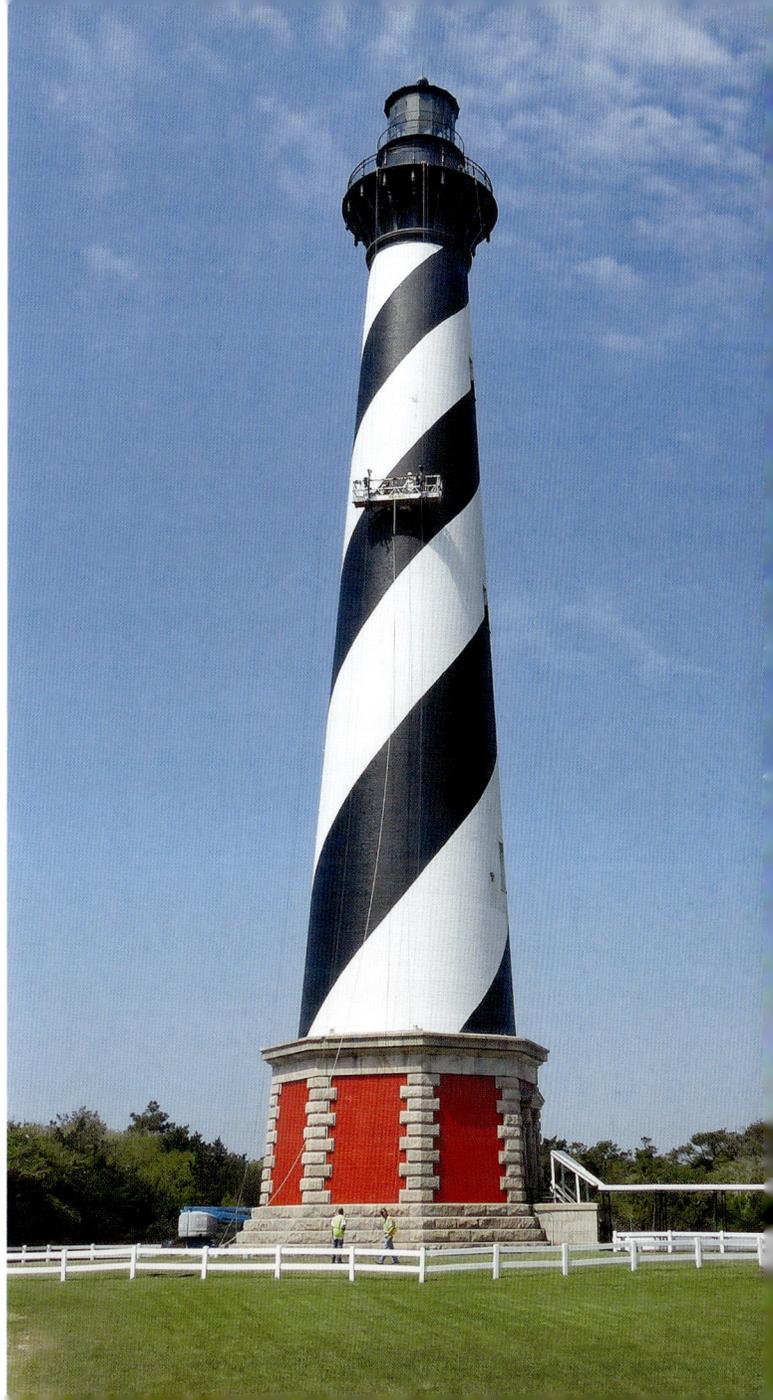

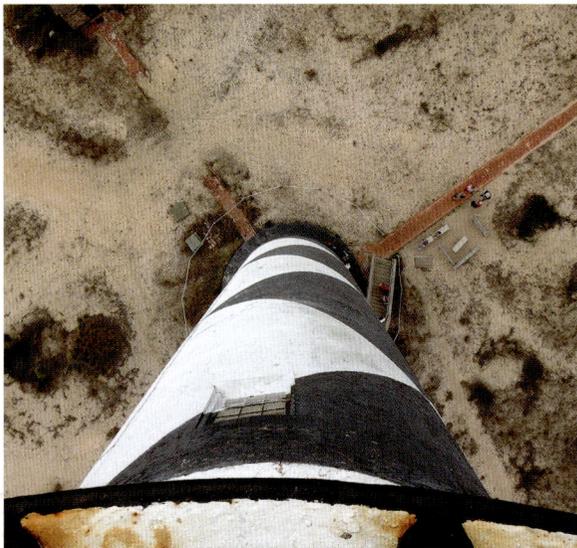

▲ CAPE LOOKOUT LIGHTHOUSE, NORTH CAROLINA
This 163-foot lighthouse built in 1859 remains standing today despite two reported attempts to blow it up during the Civil War.

▶ ROANOKE RIVER LIGHTHOUSE, NORTH CAROLINA
This 1887 screw-pile lighthouse was decommissioned in 1941. Purchased in 2007 by Edenton Historical Society, it was barged to the town waterfront, restored, and opened to the public in 2014.

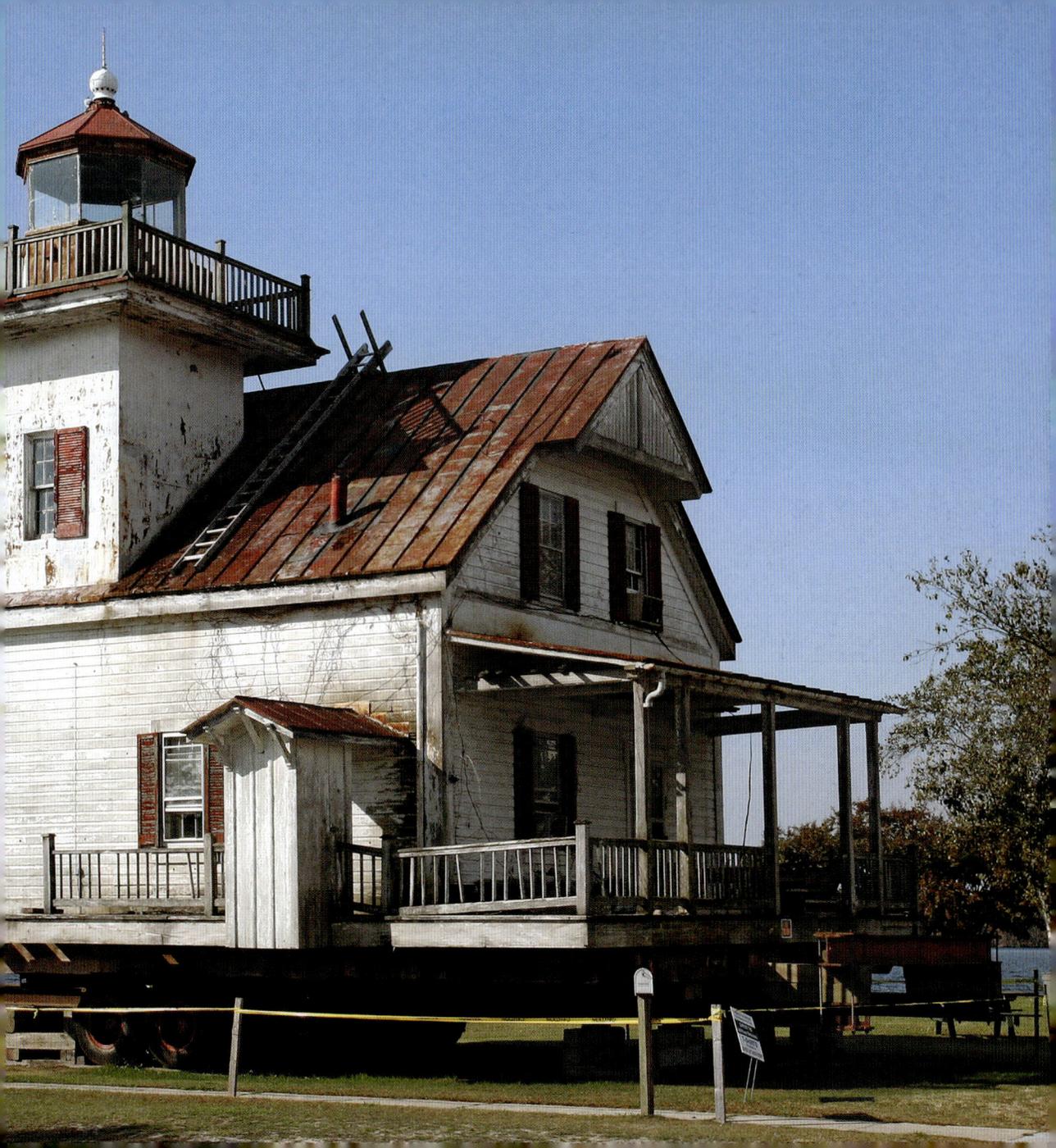

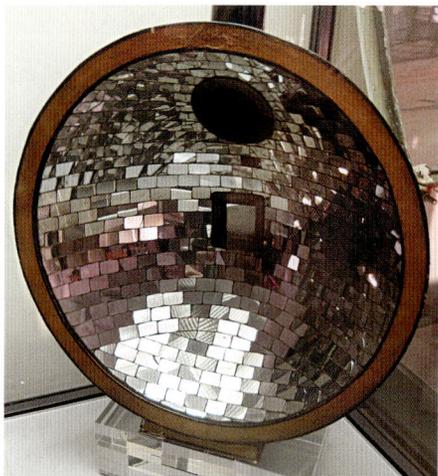

◄ THOMAS SMITH REFLECTOR LAMP

A Thomas Smith reflector lamp from 1787 had a surface lined with small mirrors. Similar silvered, copper-reflector, focusing lamplights were used before Fresnel lenses.

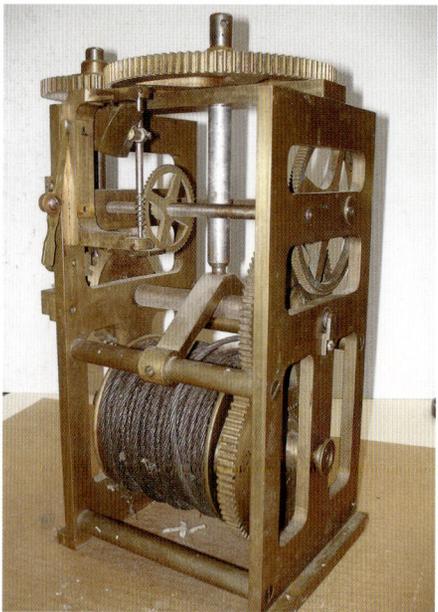

◄ PONCE DE LEON INLET LIGHTHOUSE AND MUSEUM

This clockwork used to rotate a fourth-order lens was powered by a weight attached to a cable, like a grandfather clock's mechanism.

▶ ST. AUGUSTINE LIGHTHOUSE, FLORIDA

This lighthouse is now a private aid to navigation, with its first-order Fresnel lens tended by the maritime museum's staff.

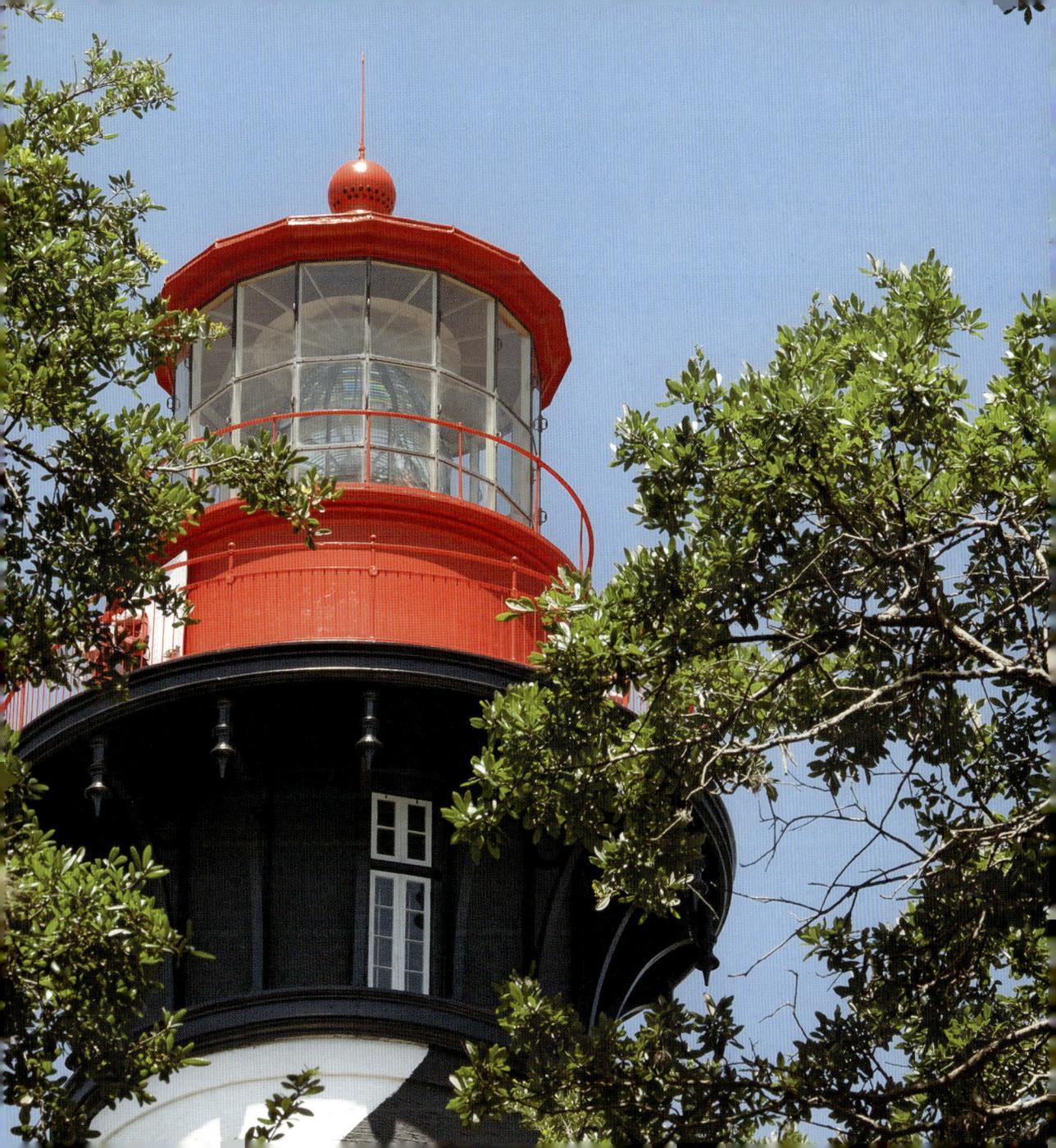

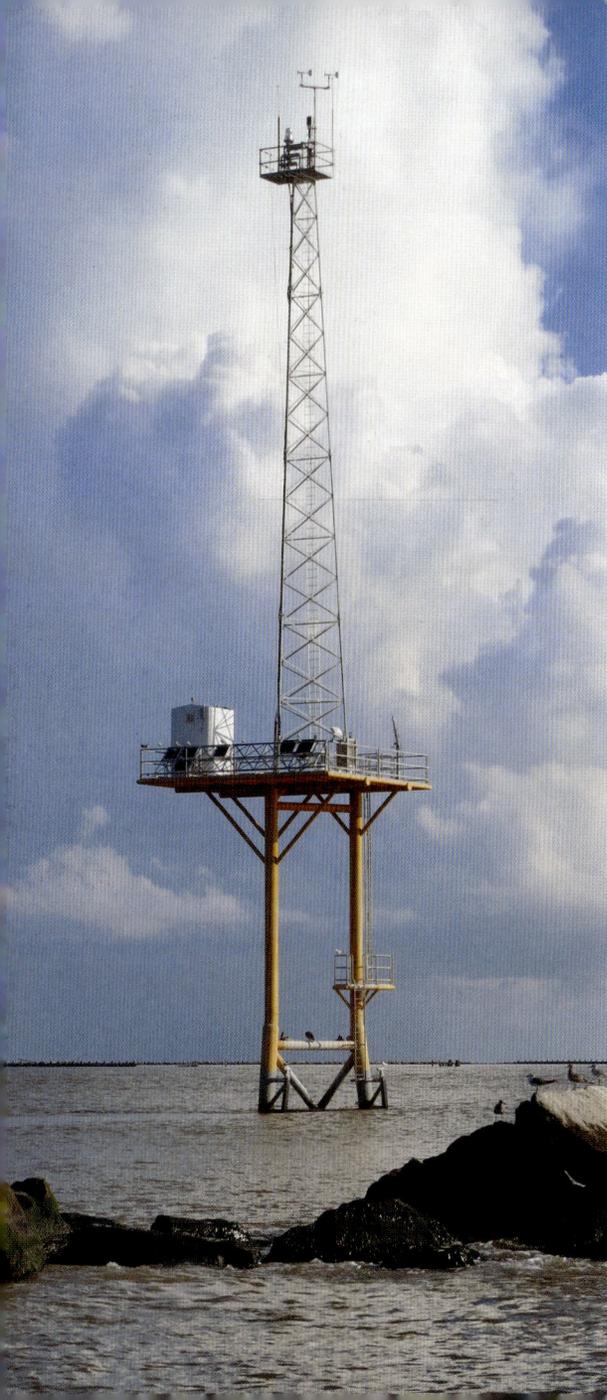

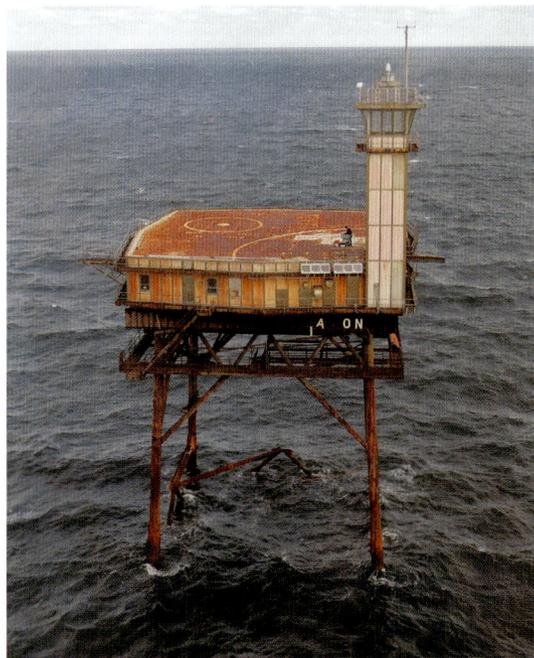

▲ DIAMOND SHOALS LIGHT TOWER, NORTH CAROLINA

This light tower replaced lightship WLV-189 in 1966. Hurricane Fran critically damaged the structure in 1996, and in 2001, it was abandoned and the light was extinguished.

◄ SOUTHWEST PASS ENTRANCE LIGHTHOUSE, LOUISIANA

After Hurricane Katrina struck Louisiana, the Coast Guard built an unmanned, skeletal lighthouse tower mounted on steel piles at Southwest Pass Entrance.

► FRYING PAN SHOALS LIGHT TOWER, NORTH CAROLINA

This light tower, which resembles an oil-drilling platform, was built in 1964. Its steel legs extend 300 feet below the surface.

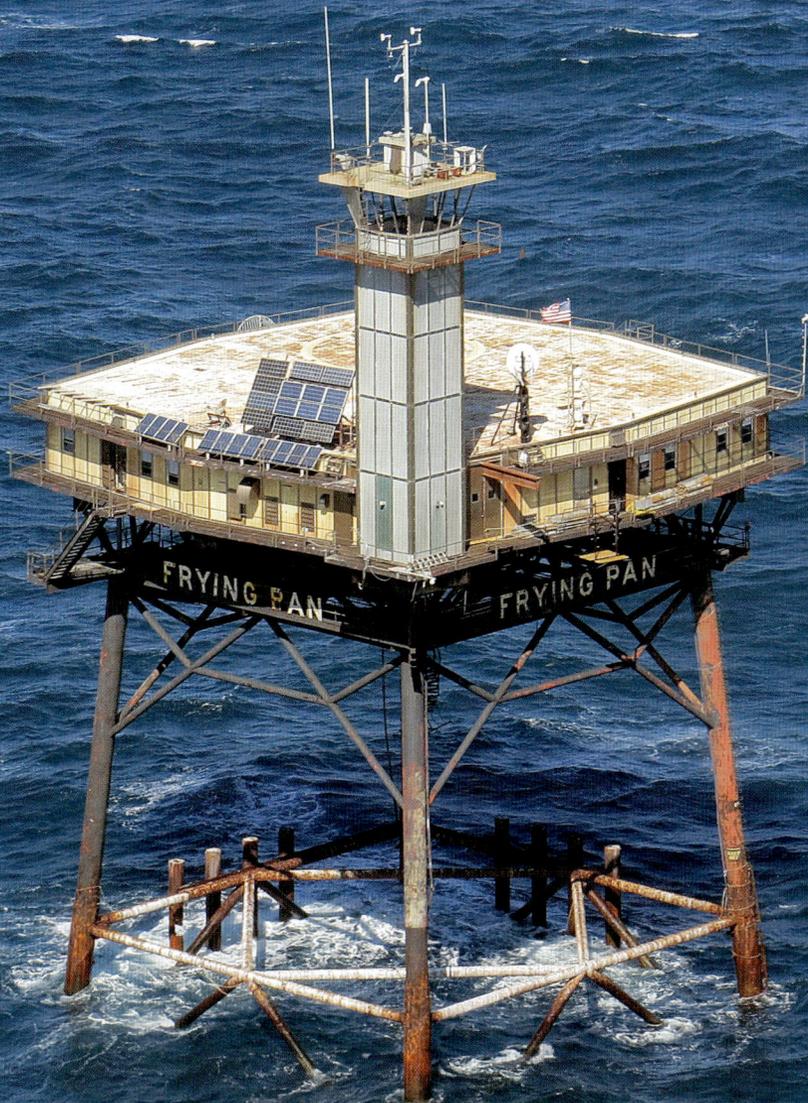

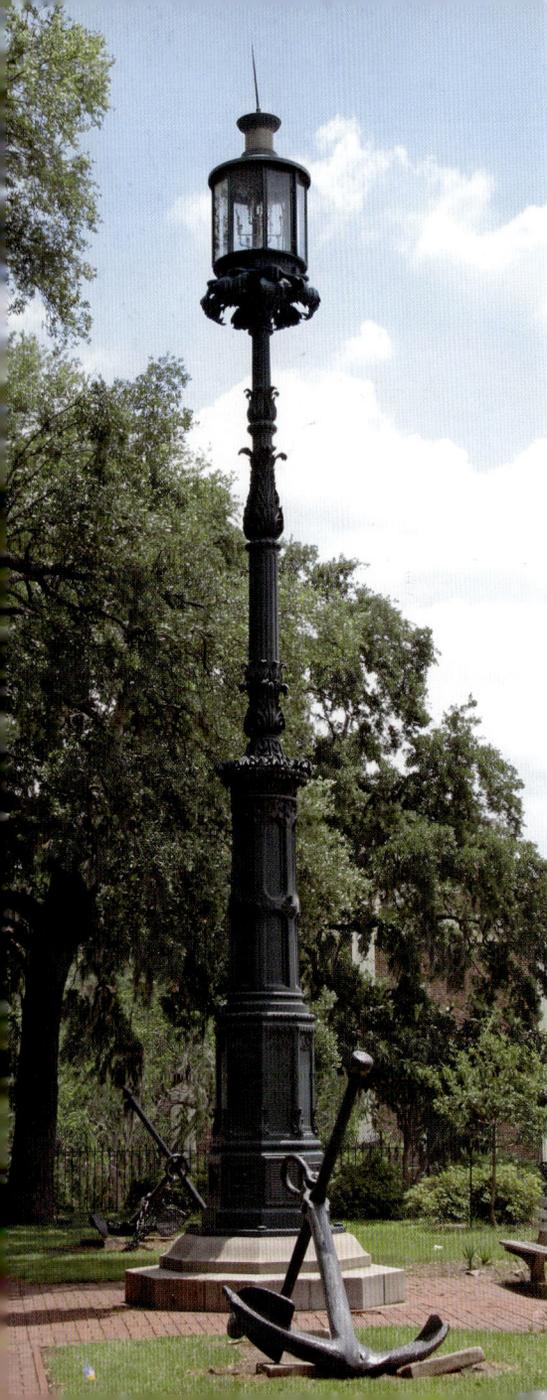

◀ SAVANNAH POST LIGHT, GEORGIA

Congress, in 1856, appropriated $2,000 for a "small light . . . in the city of Savannah, to guide vessels." Savannah Post Light's restoration cost in the 1990s was $200,000.

▶ PUNTA TUNA LIGHTHOUSE, PUERTO RICO

Punta Tuna Lighthouse, built by the Spanish, was ceded to the United States following the Spanish-American War.

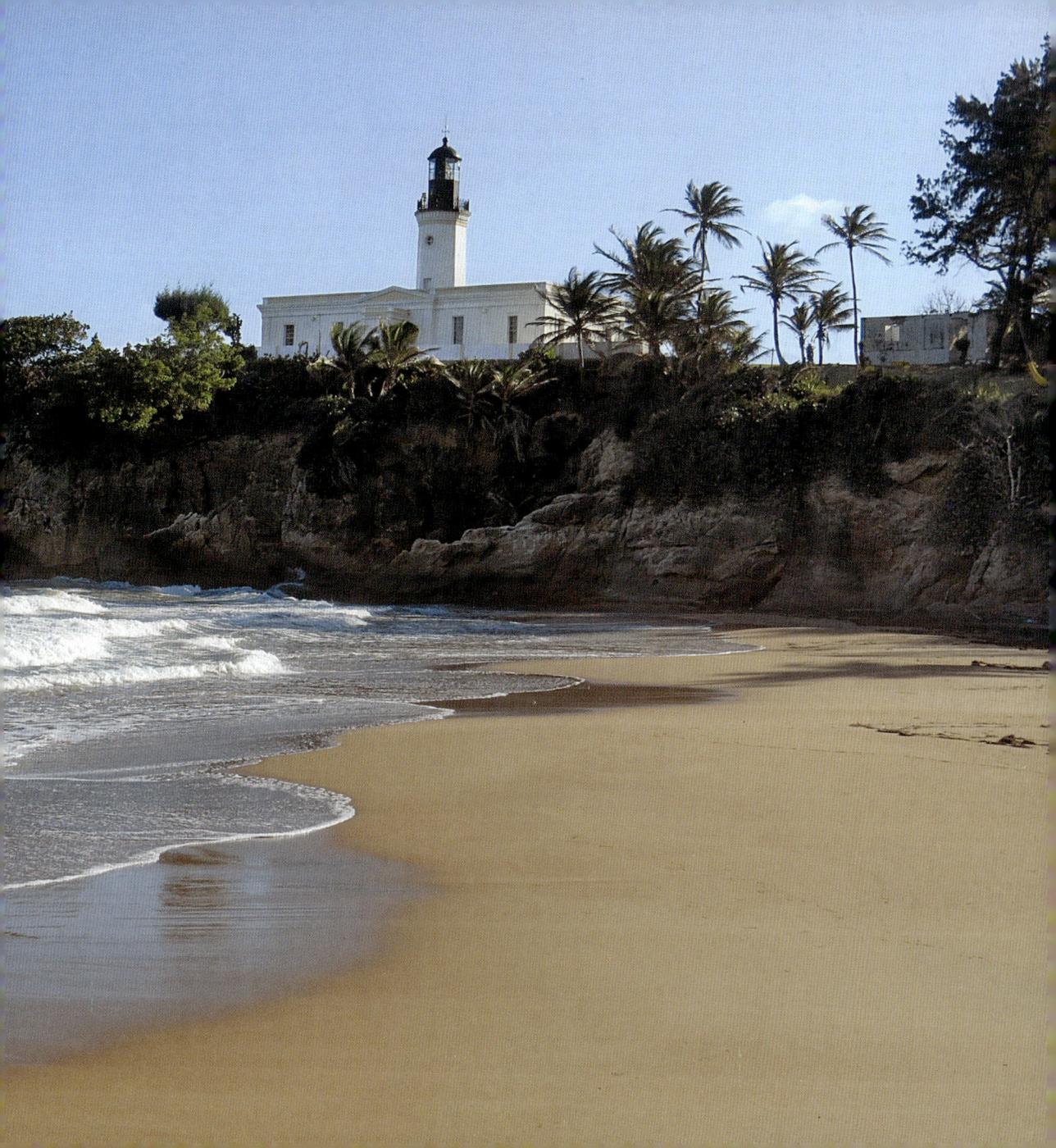

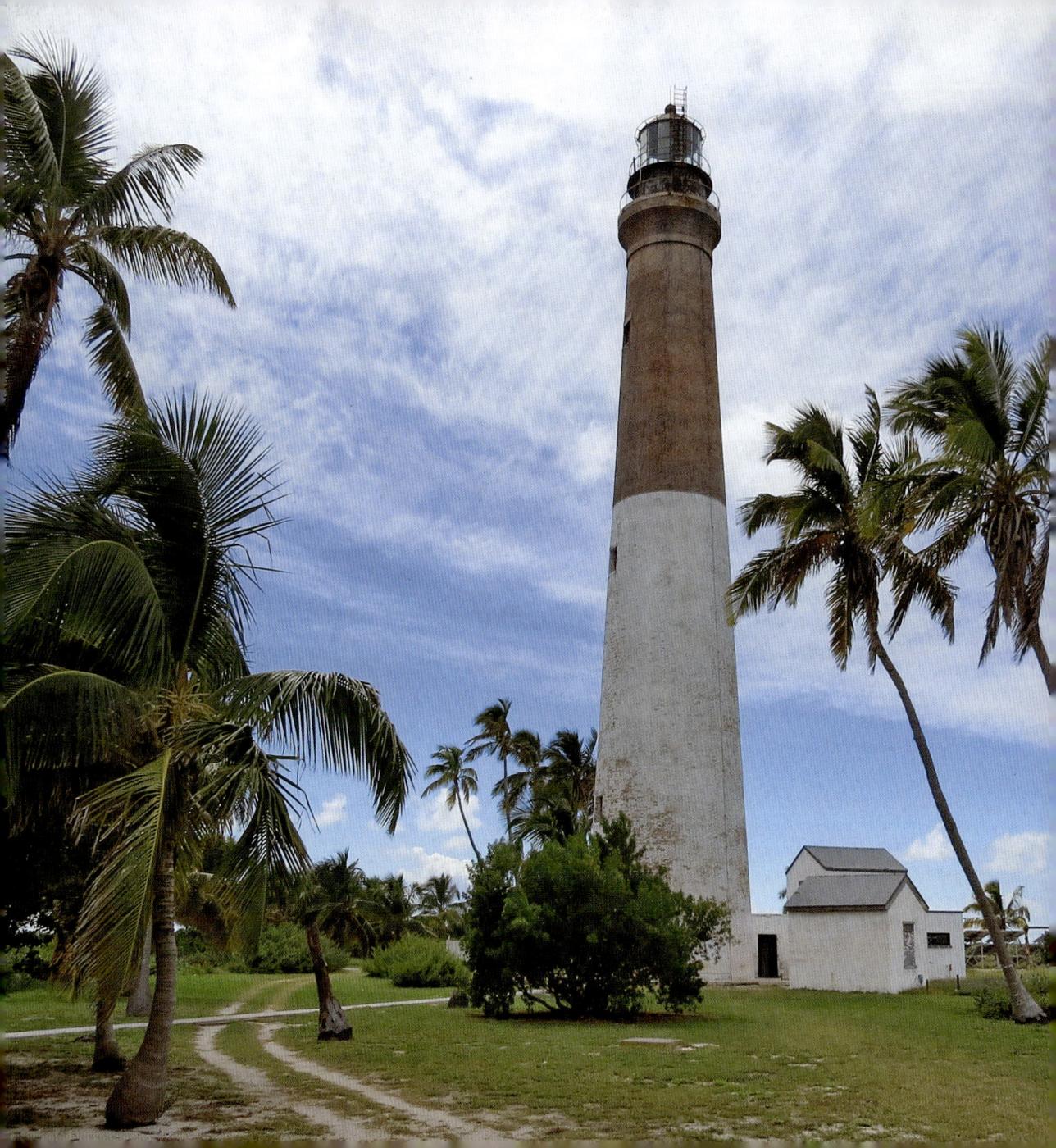

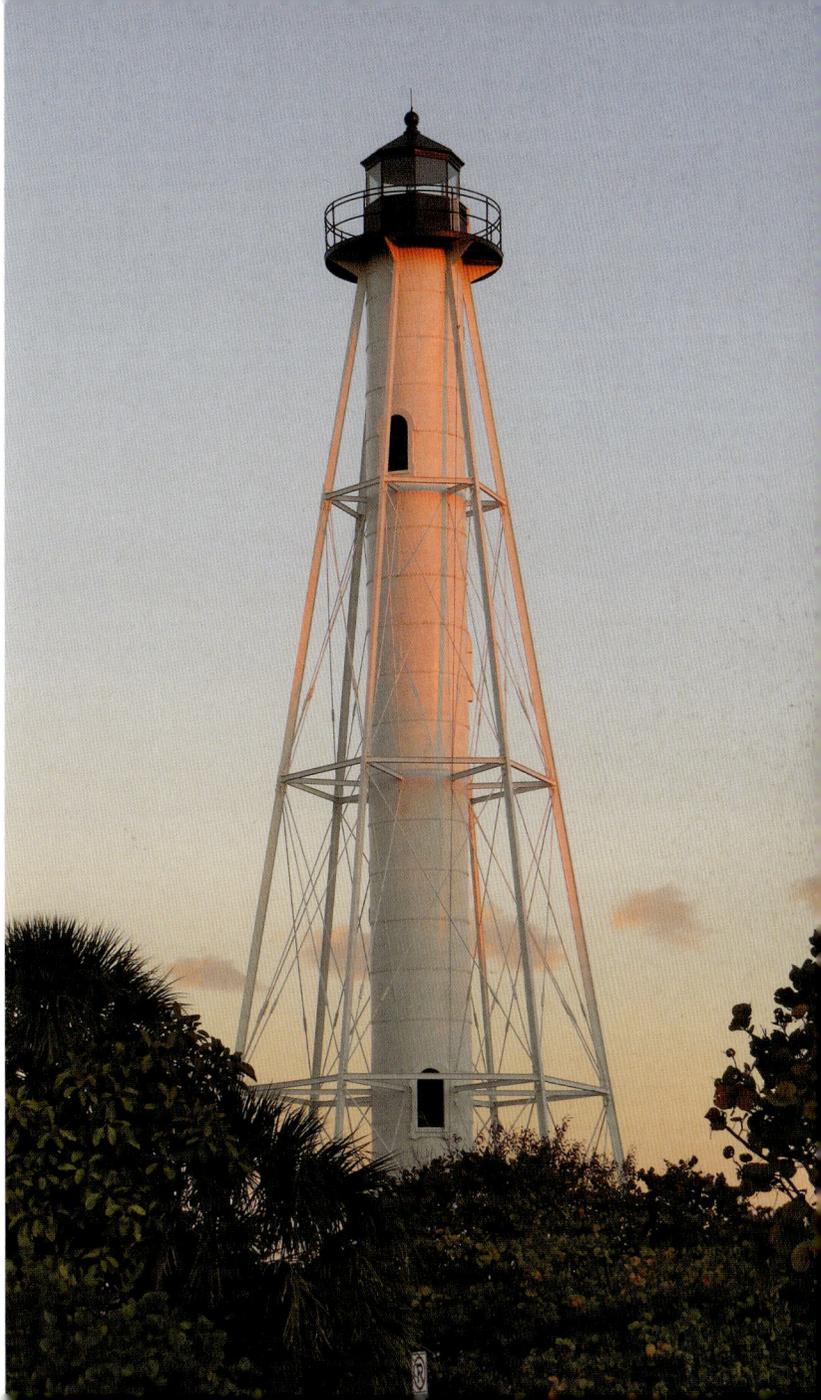

◀ LOGGERHEAD LIGHTHOUSE, FLORIDA

At this lighthouse, the first keeper's wife, one daughter, and two assistants allegedly attempted to kill him. He fled with his second daughter by rowboat.

▶ GASPARILLA LIGHTHOUSE, FLORIDA

Skeletal towers could be disassembled and moved. This one, now in Florida, previously stood as Delaware Breakwater Rear Range Light.

GREAT
LAKES

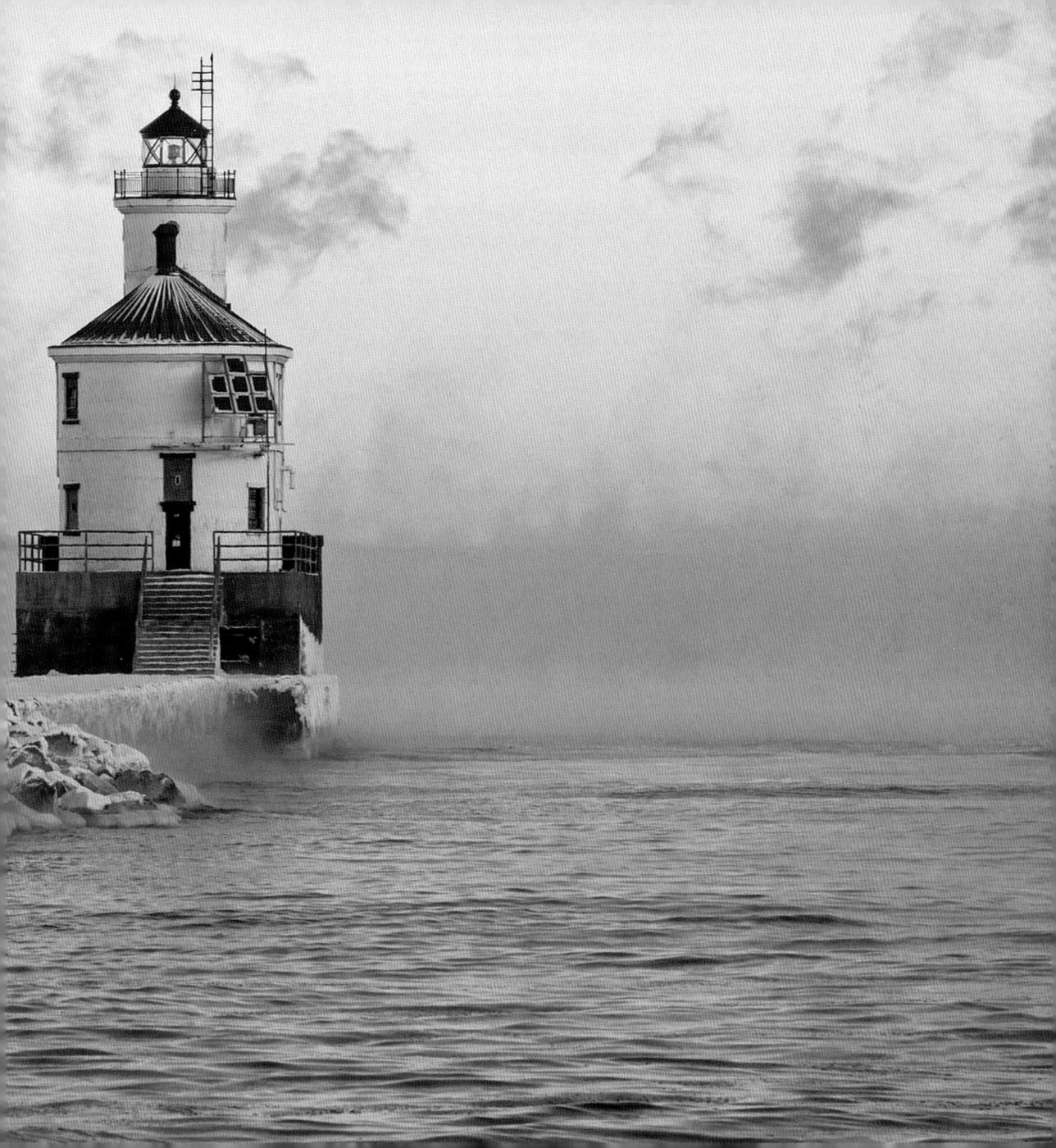

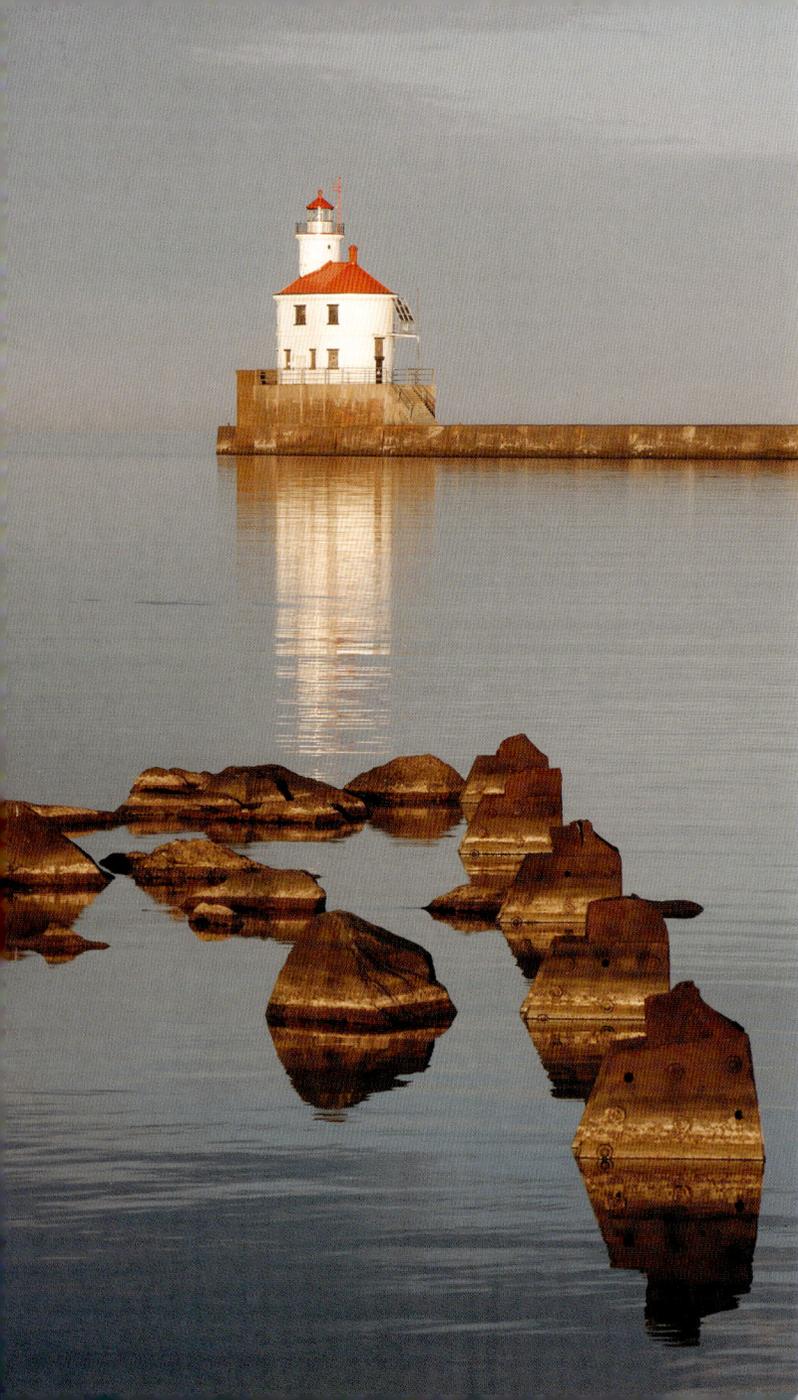

(Pages 96–97 and left)

WISCONSIN POINT LIGHTHOUSE, WISCONSIN

Following several outages without apparent causes, Peter Jones, a frustrated Coast Guard technician, shouted out to "ghosts" at this lighthouse, insisting they "stop messing with the light." The light remained on without fail thereafter.

▶ **MILWAUKEE BREAKWATER LIGHTHOUSE, WISCONSIN**

Development of Milwaukee's waterfront includes restoration of this lighthouse, which is expected to cost up to $2.5 million.

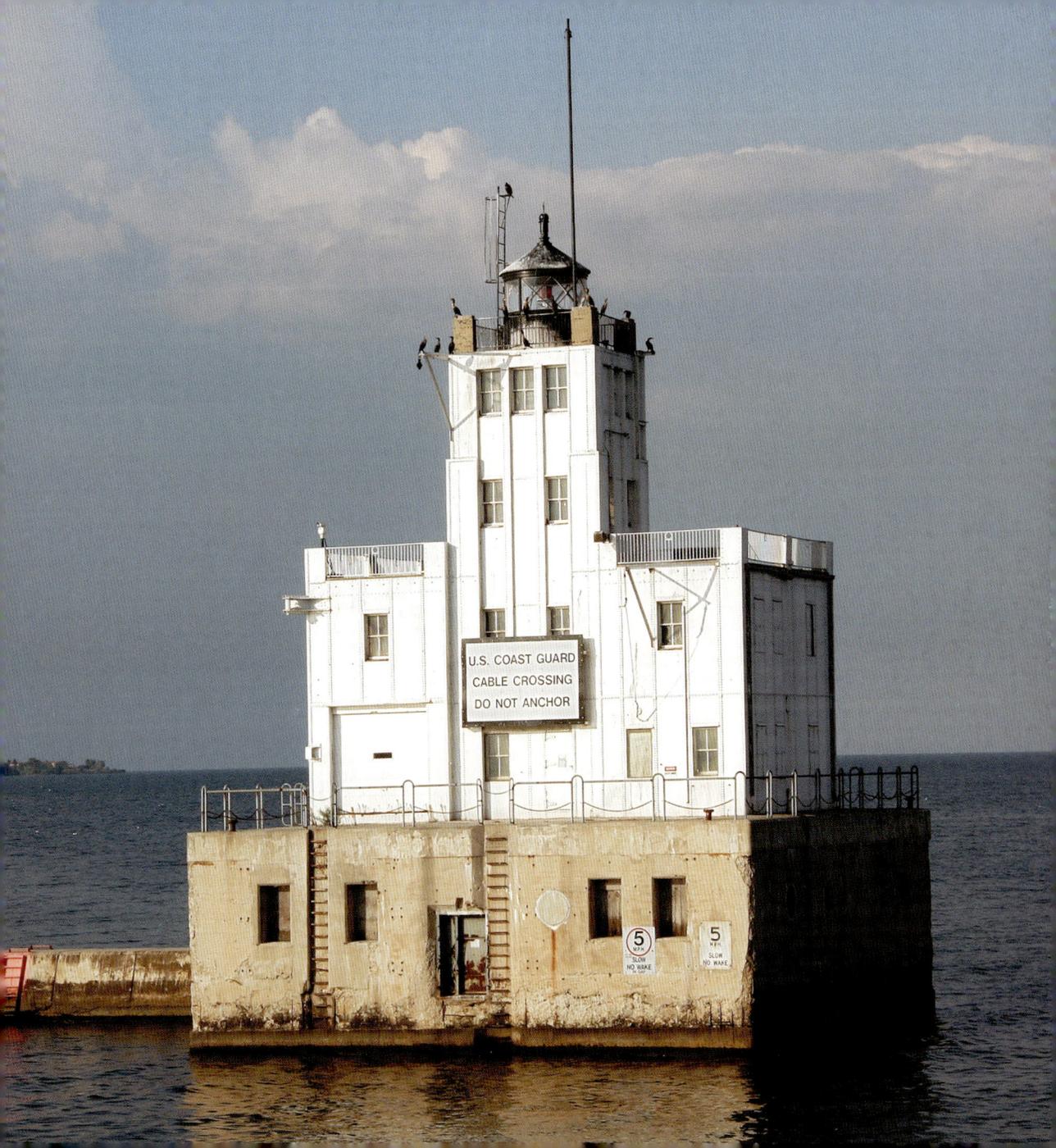

U.S. COAST GUARD
CABLE CROSSING
DO NOT ANCHOR

5
M.P.H.
SLOW
NO WAKE

5
M.P.H.
SLOW
NO WAKE

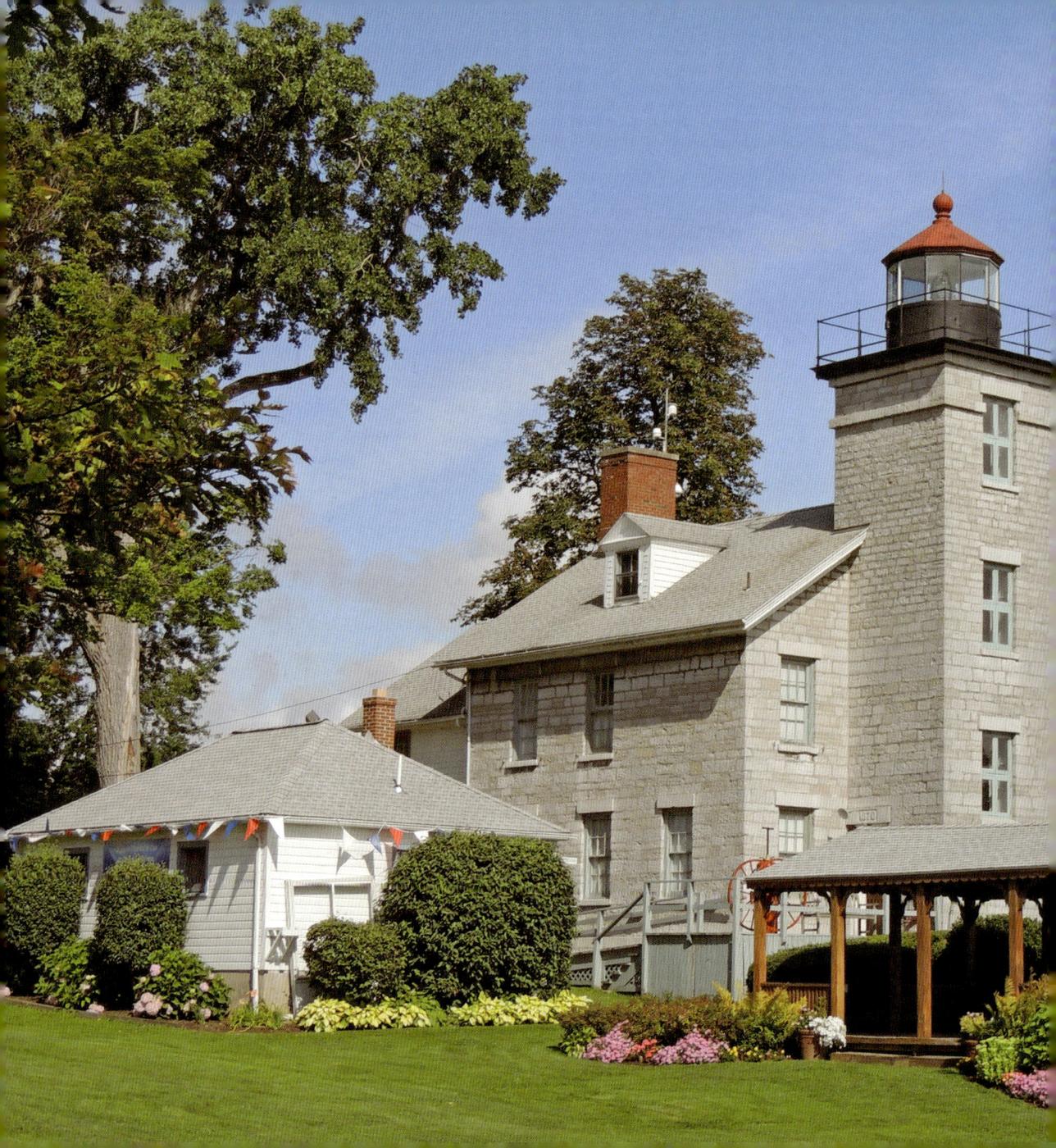

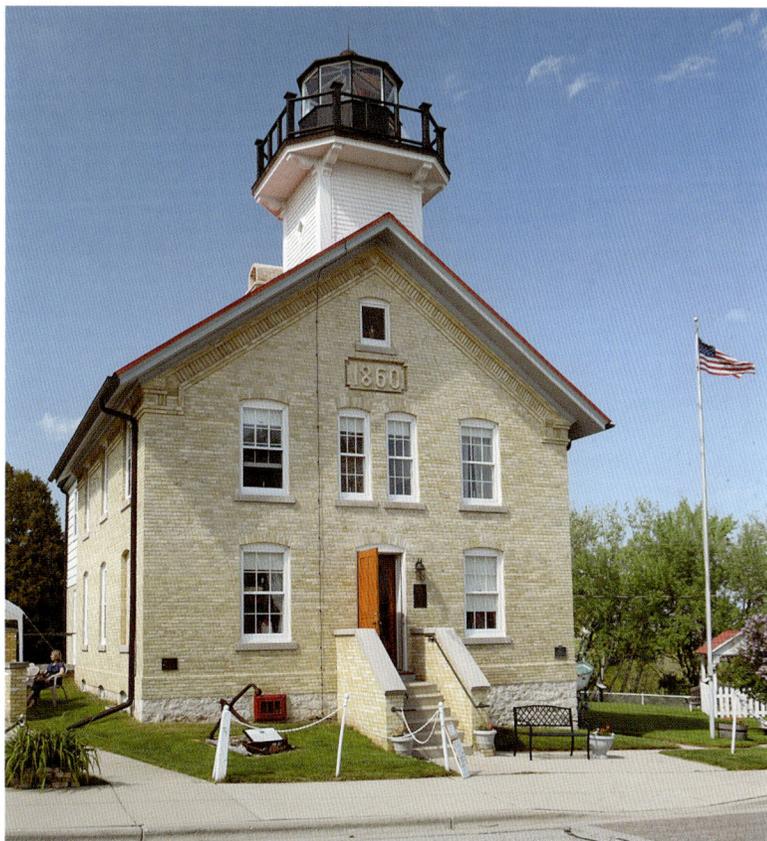

▲ PORT WASHINGTON LIGHTHOUSE, WISCONSIN

A replica of this tower and lantern room was built in Luxembourg and installed in 2002 in appreciation of US servicemen liberating the country during World War II.

◀ SODUS BAY LIGHTHOUSE, NEW YORK

The Sodus Bay Lighthouse Society claims this lighthouse as the "most frequently visited attraction in Wayne County, New York."

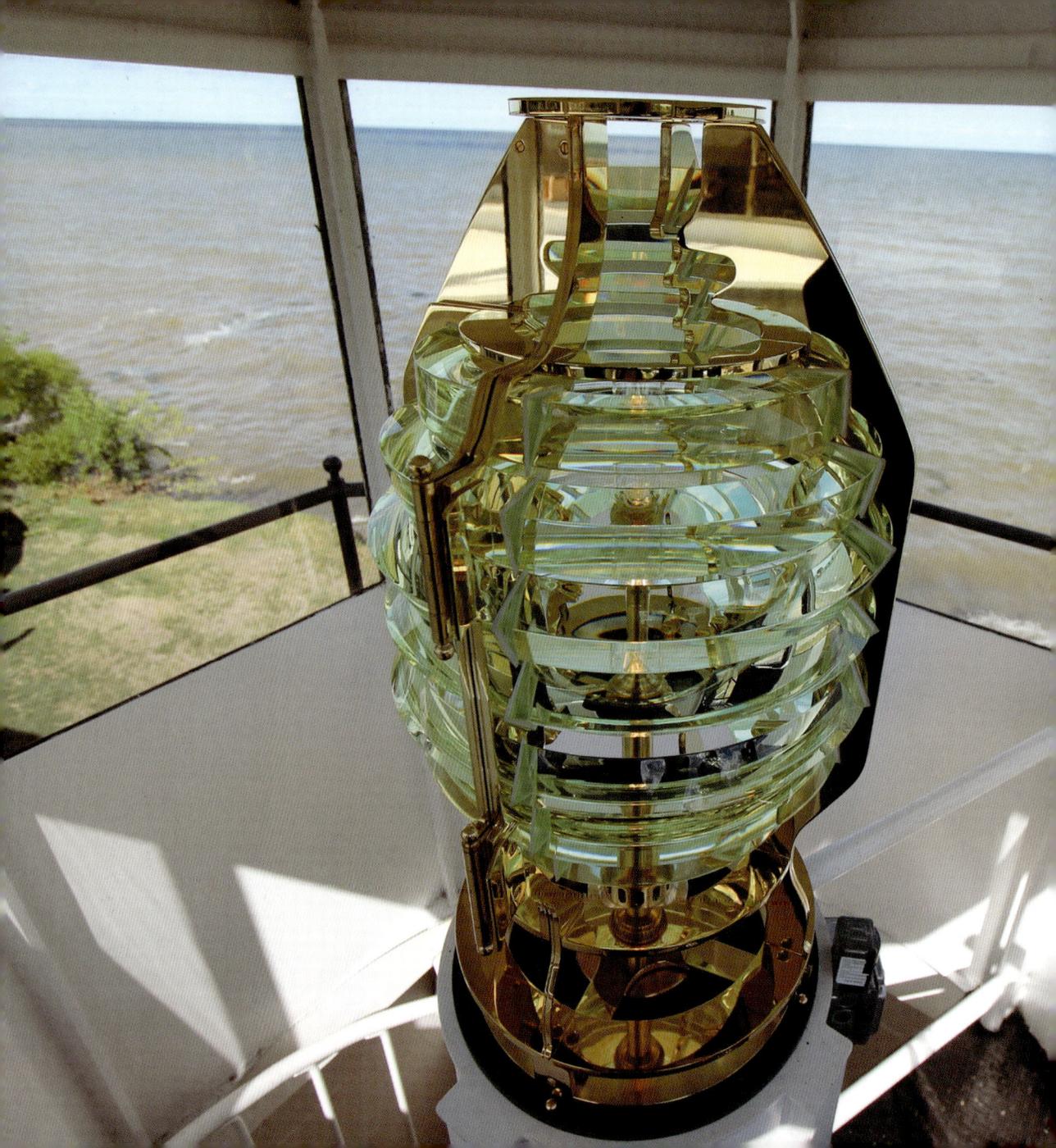

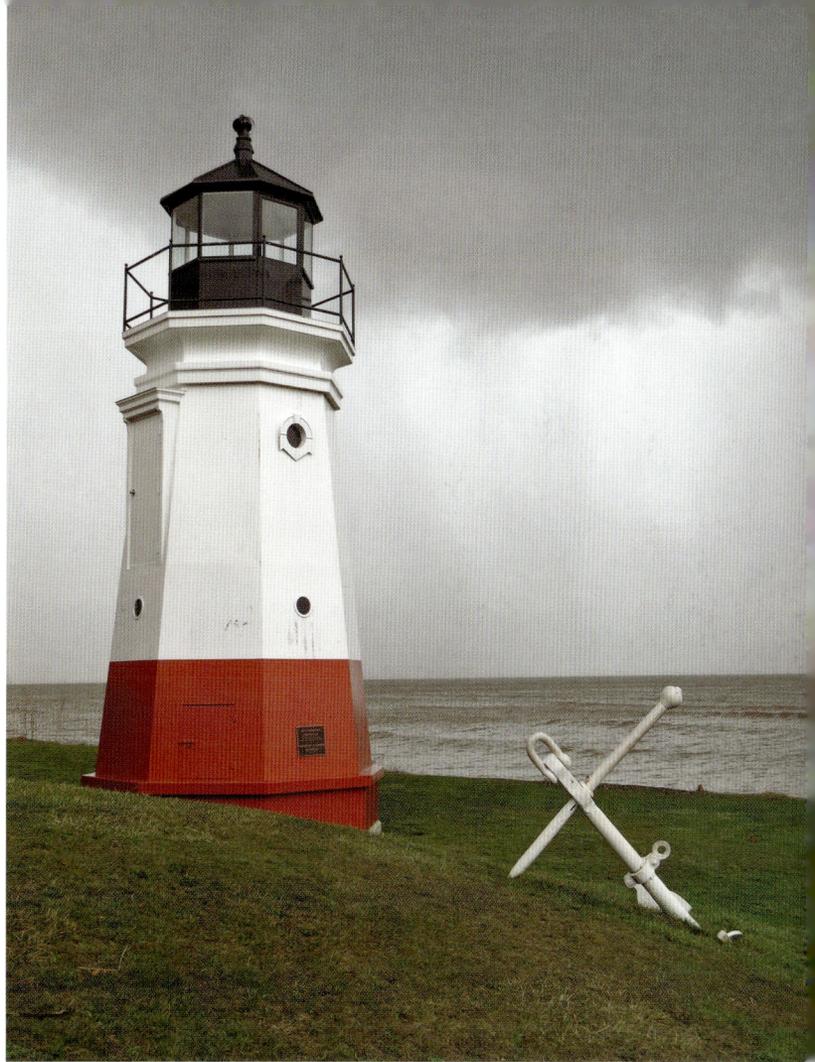

◀ ▲ VERMILION LIGHTHOUSE, OHIO
The nonprofit Main Street Vermilion's Lighthouse Preservation Committee purchased a reproduction fifth-order Fresnel lens for this re-created lighthouse. Iron for this 1877 lighthouse came from melted-down cannons reportedly fired in the Battle of Fort Sumter.

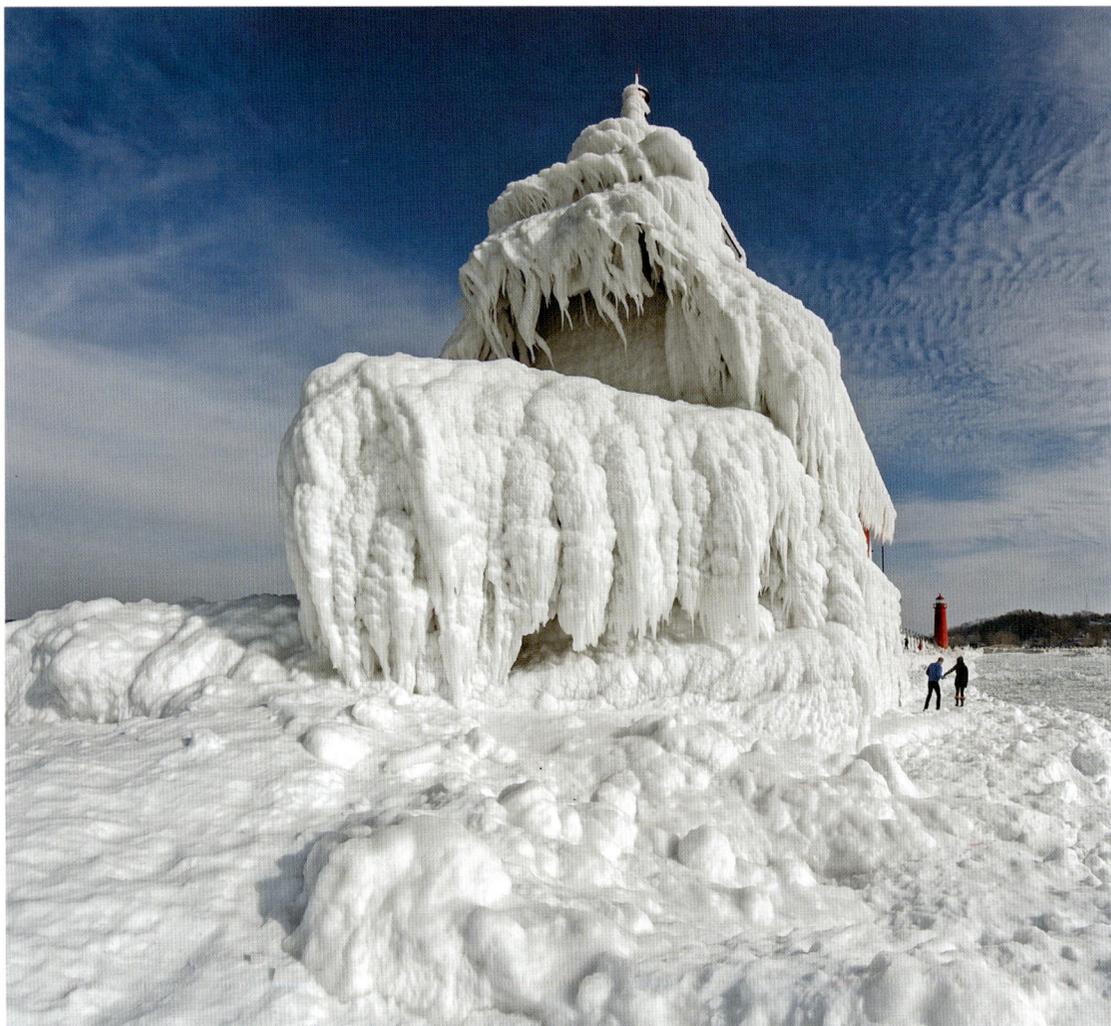

▲▶ GRAND HAVEN PIER LIGHTHOUSE, MICHIGAN
The Coast Guard deeded two lighthouses to the City of Grand Haven in December 2012.
The Grand Haven Lighthouse Conservancy raised more than $400,000 for lighthouse care.

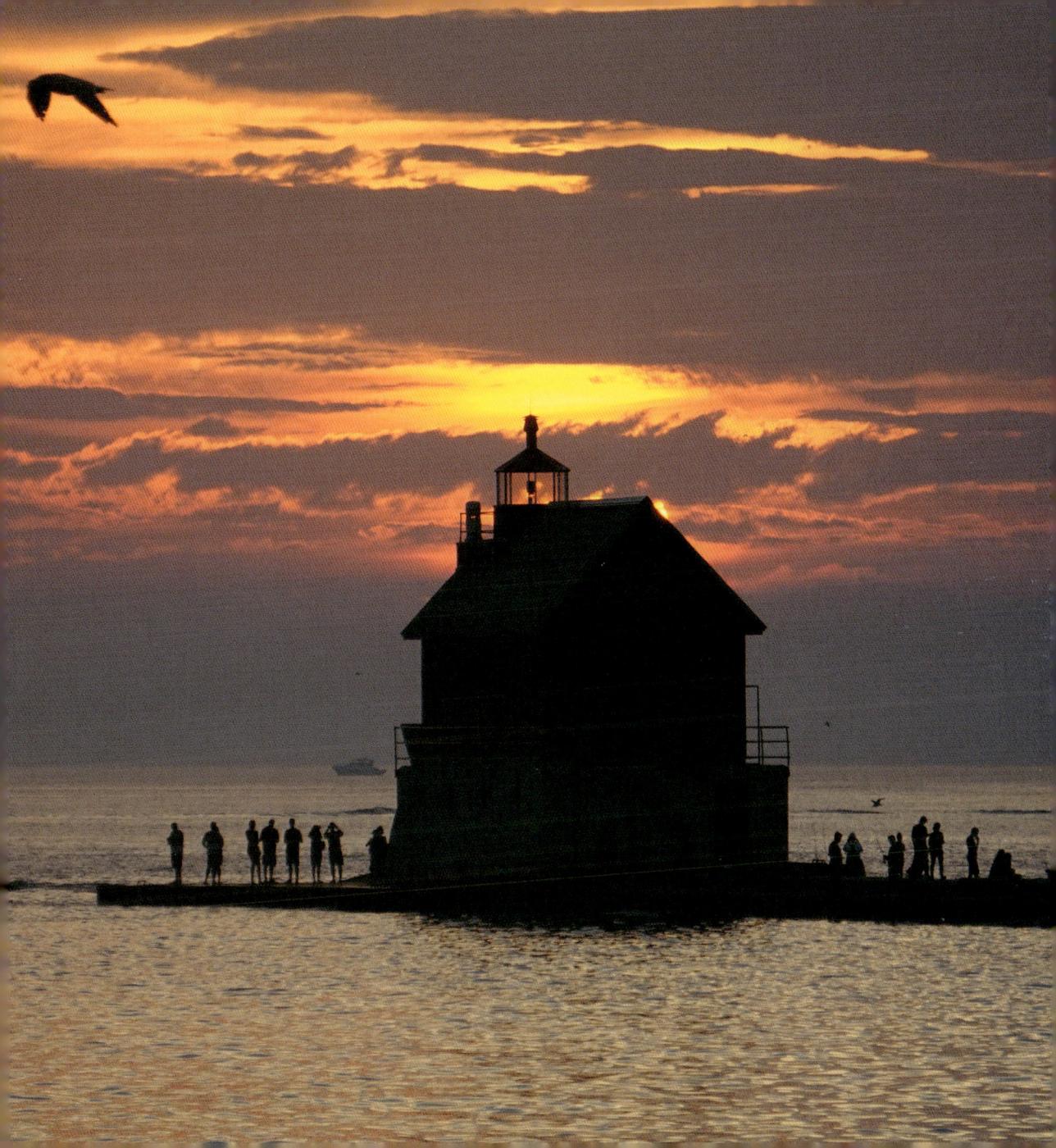

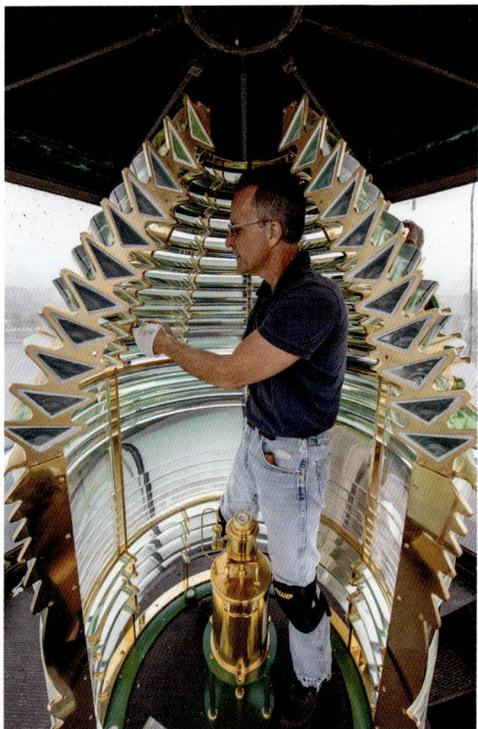

▲ BUFFALO MAIN LIGHTHOUSE, NEW YORK

Dan Spinella of Artworks Florida Classic Fresnel Lenses installs a reproduction third-order Fresnel lens in Buffalo Main Lighthouse.

▶ TOLEDO HARBOR LIGHTHOUSE, OHIO

This lighthouse originally housed a rare, third-and-a-half-order Fresnel lens.

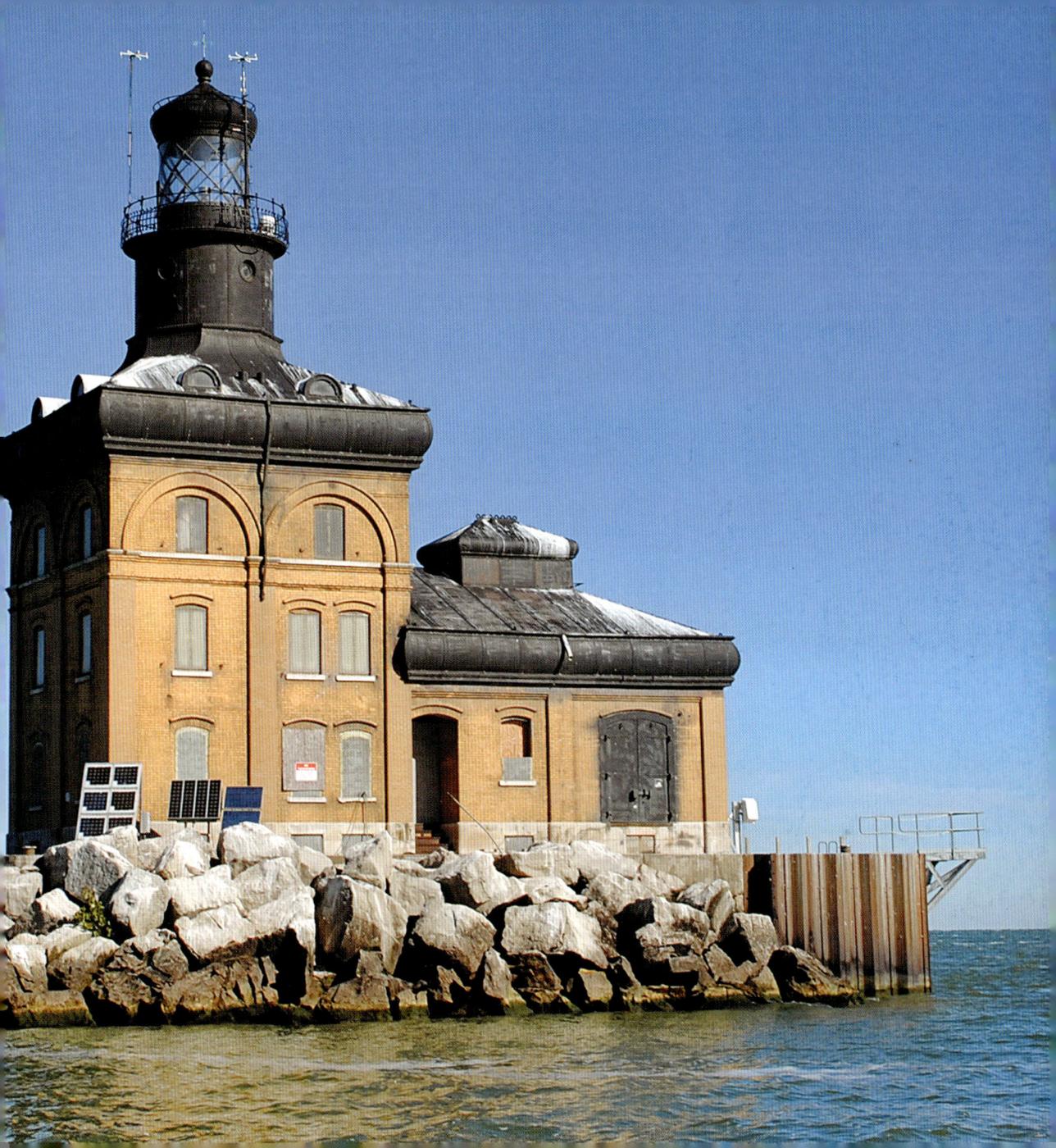

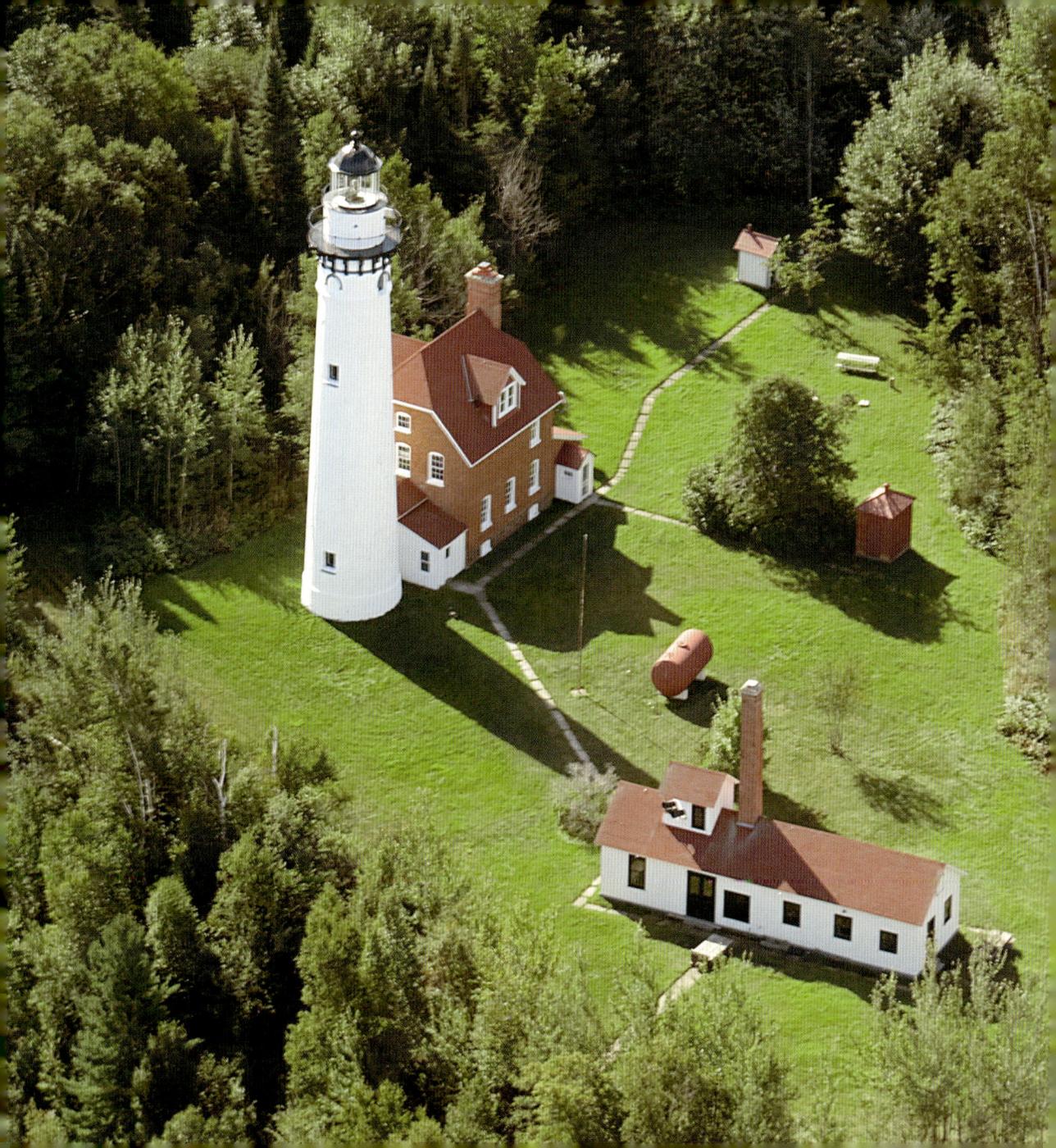

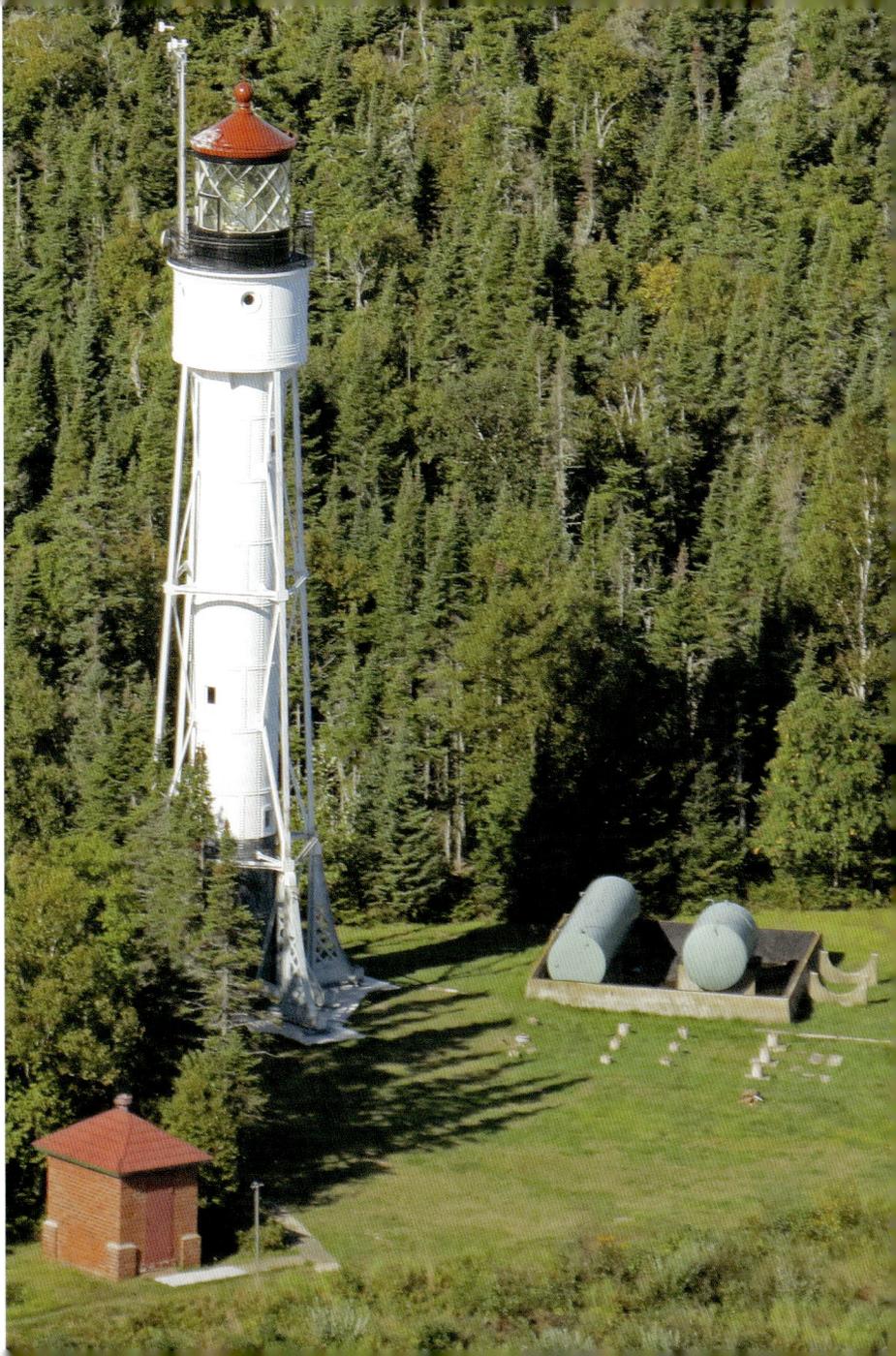

◀ **OUTER ISLAND LIGHTHOUSE, WISCONSIN**

Fall weather stopped work on this lighthouse, and when construction resumed in the spring of 1874, workers discovered the station's new building on the wrong site. They started over, rebuilding at the proper location.

▶ **DEVIL'S ISLAND LIGHTHOUSE, WISCONSIN**

Winds continually shook the 80-foot-tall, half-inch-thick iron of this tower. To steady it, four buttresses anchored new vertical columns and braces.

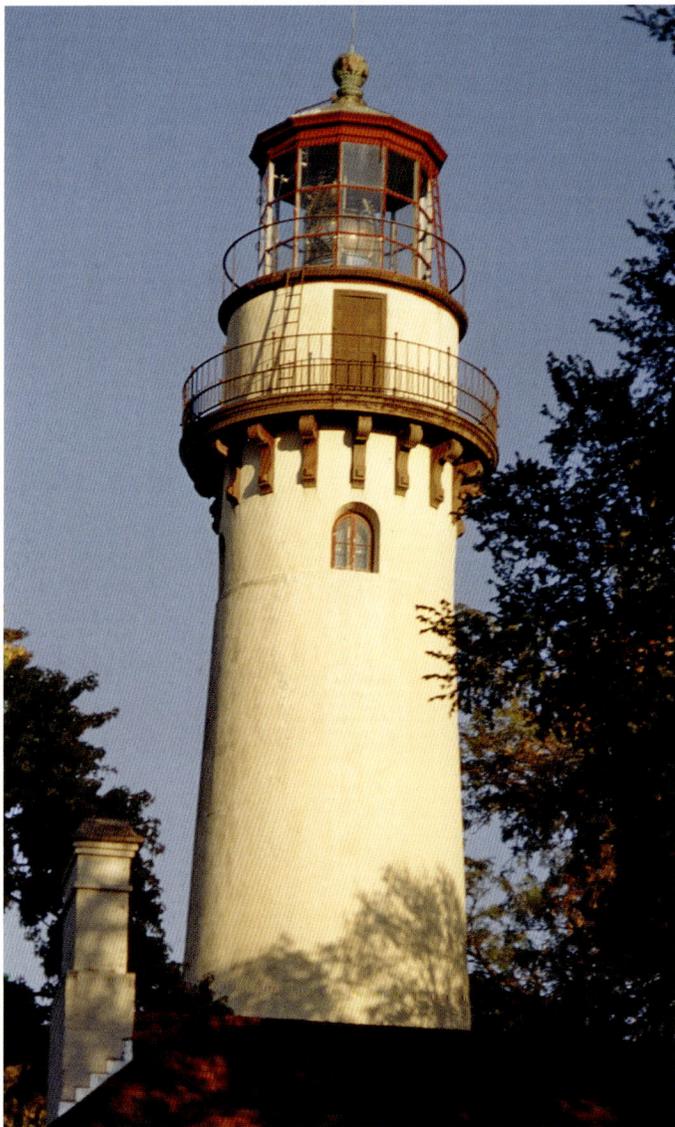

◀ GROSSE POINT LIGHTHOUSE, ILLINOIS

This lighthouse's Fresnel lens was purchased in France for $10,000 in 1860. It was originally shipped to Florida and reportedly buried to keep it from Confederates.

▶ CHICAGO HARBOR LIGHTHOUSE, ILLINOIS

The third-order Fresnel lens of this lighthouse won a gold medal in the 1889 Paris Exhibition, then was exhibited at Chicago's 1893 Colombian Exposition.

(Pages 112–113)
STURGEON BAY SHIP CANAL LIGHT STATION, WISCONSIN

This light station was offered to eligible government and nonprofit entities in 2010. With none bidding, it went to auction in 2014 and was sold to a private bidder.

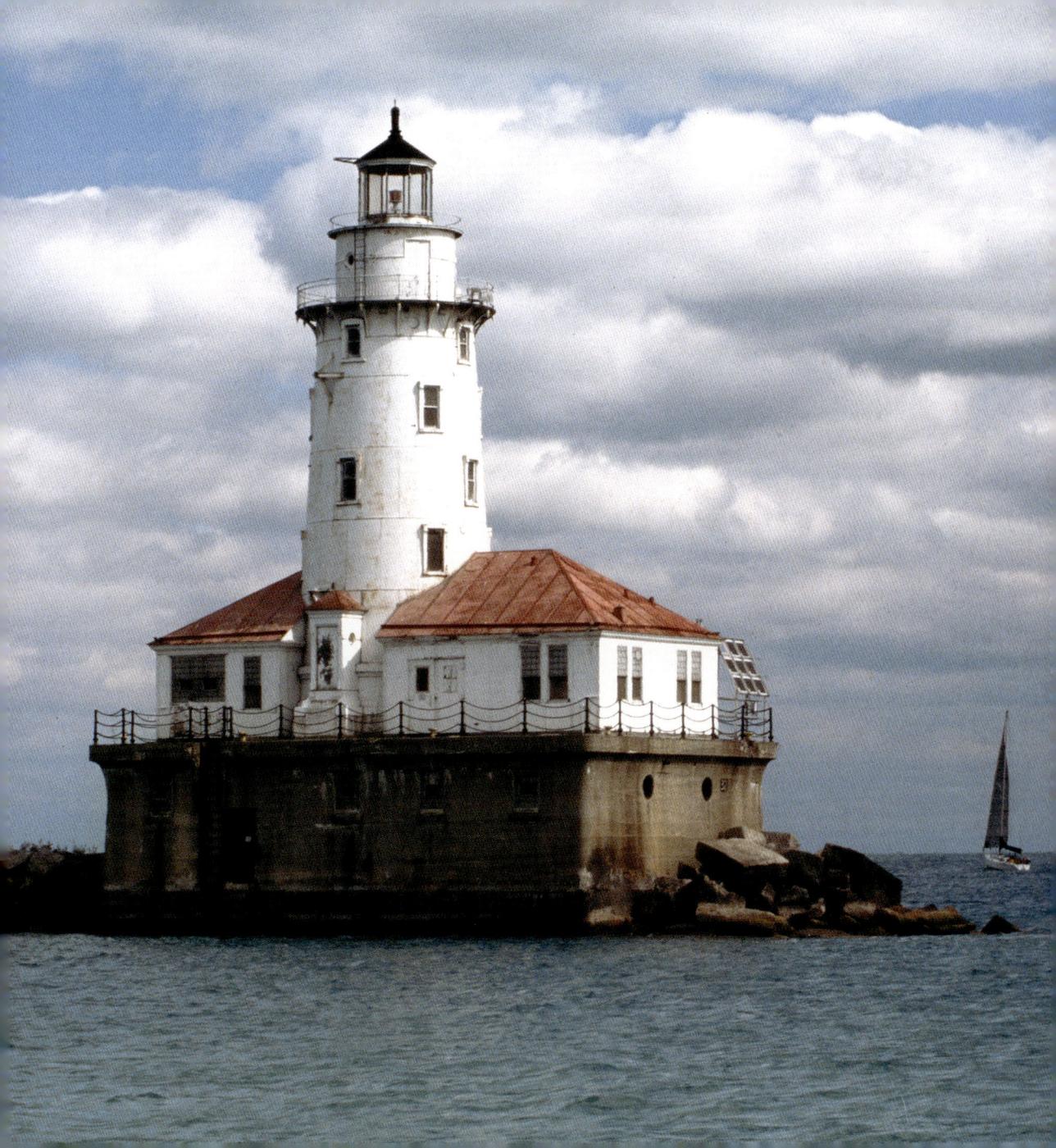

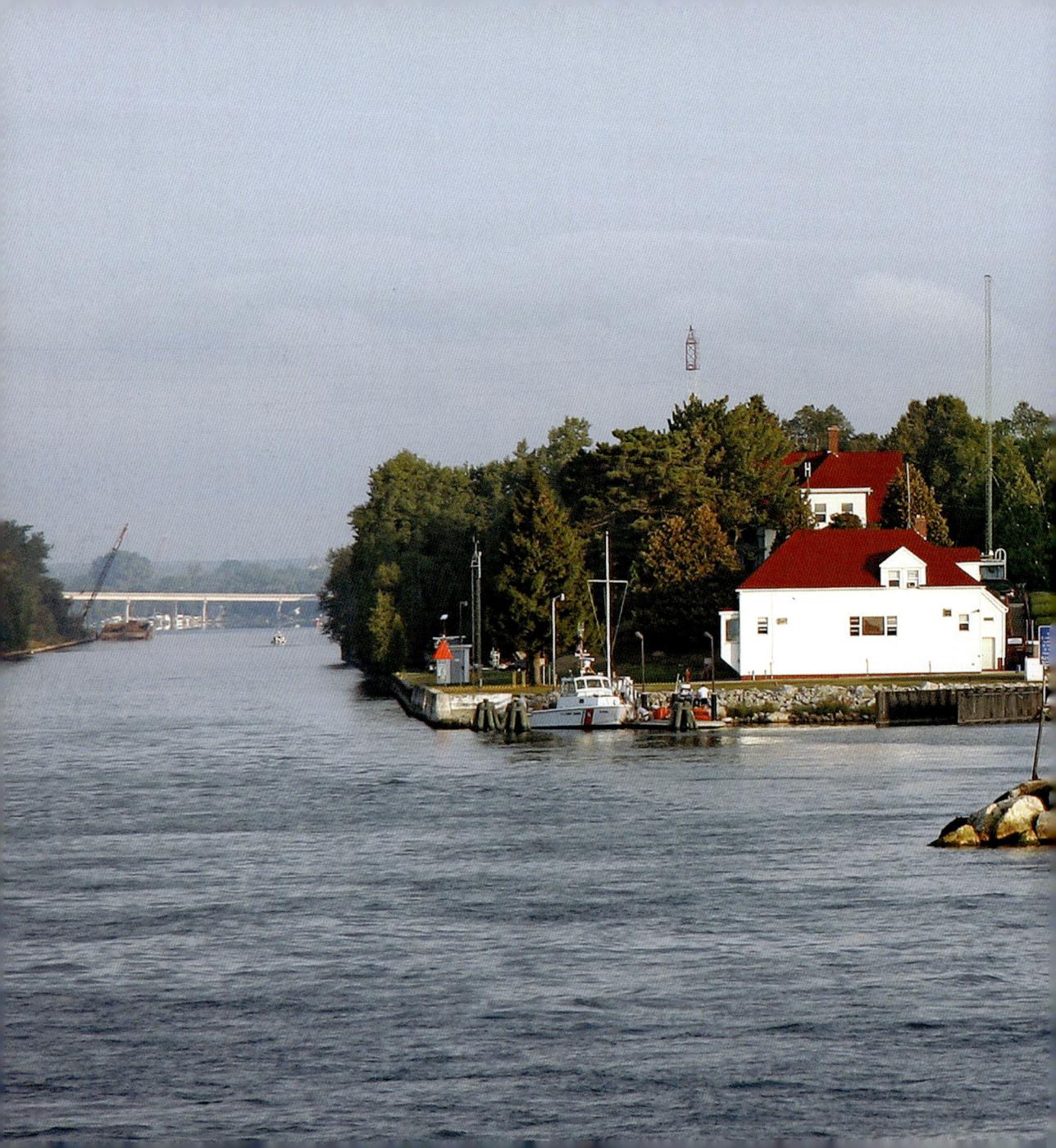

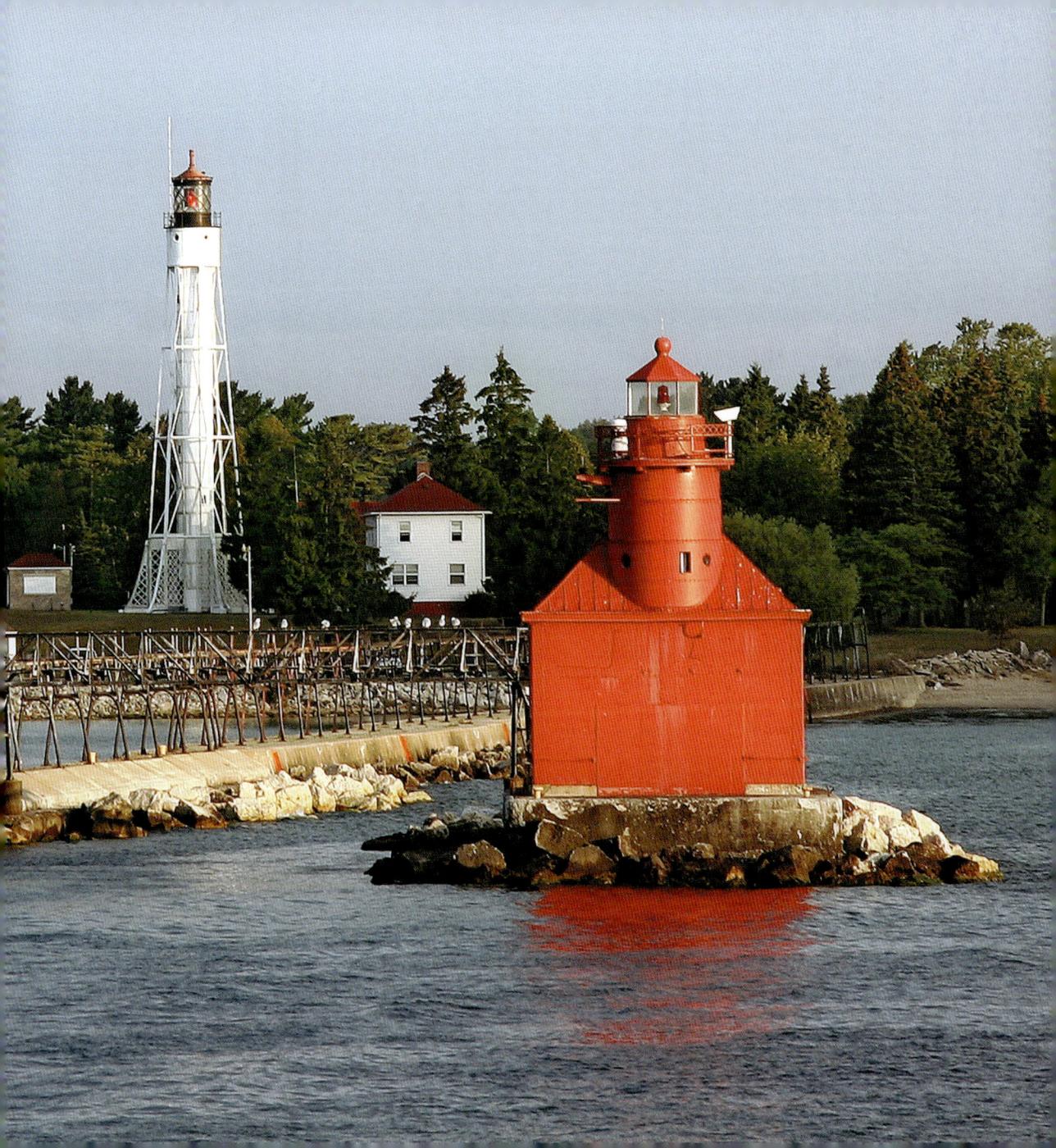

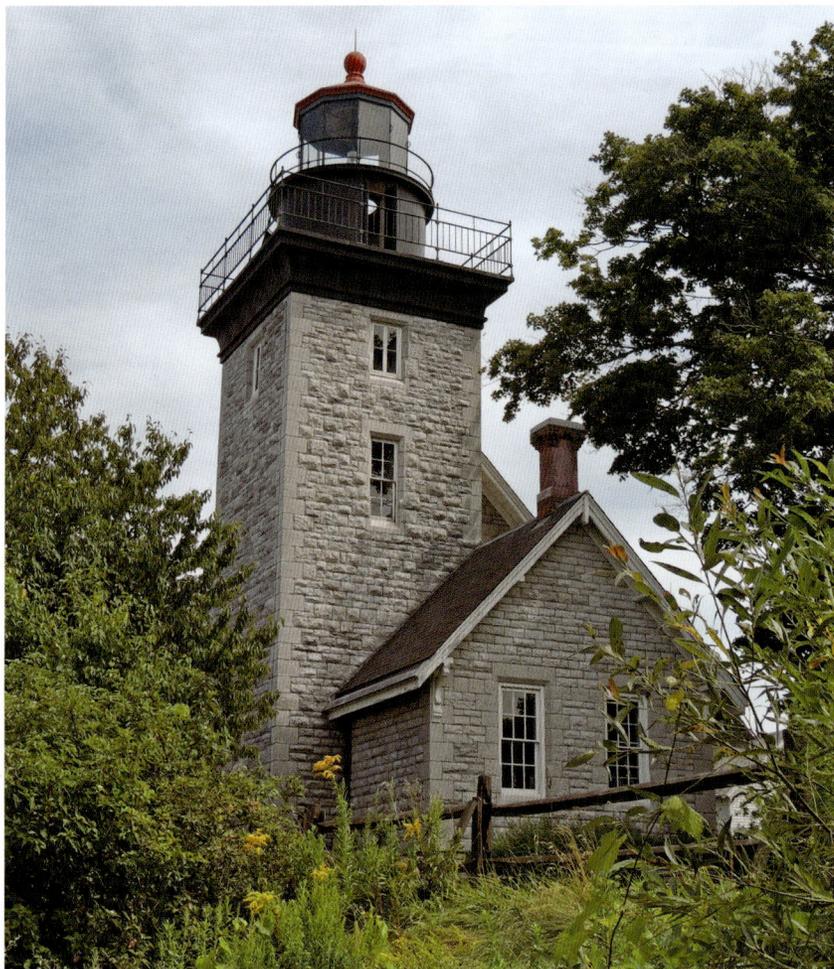

▲ THIRTY MILE POINT LIGHTHOUSE, NEW YORK
Friends of Thirty Mile Point Lighthouse rents rooms for vacationers to experience keepers' isolated life.

▶ SUNKEN ROCK LIGHTHOUSE, NEW YORK
A sixth-order Fresnel lens replaced five lamps set in 14-inch reflectors in this lighthouse in 1855.

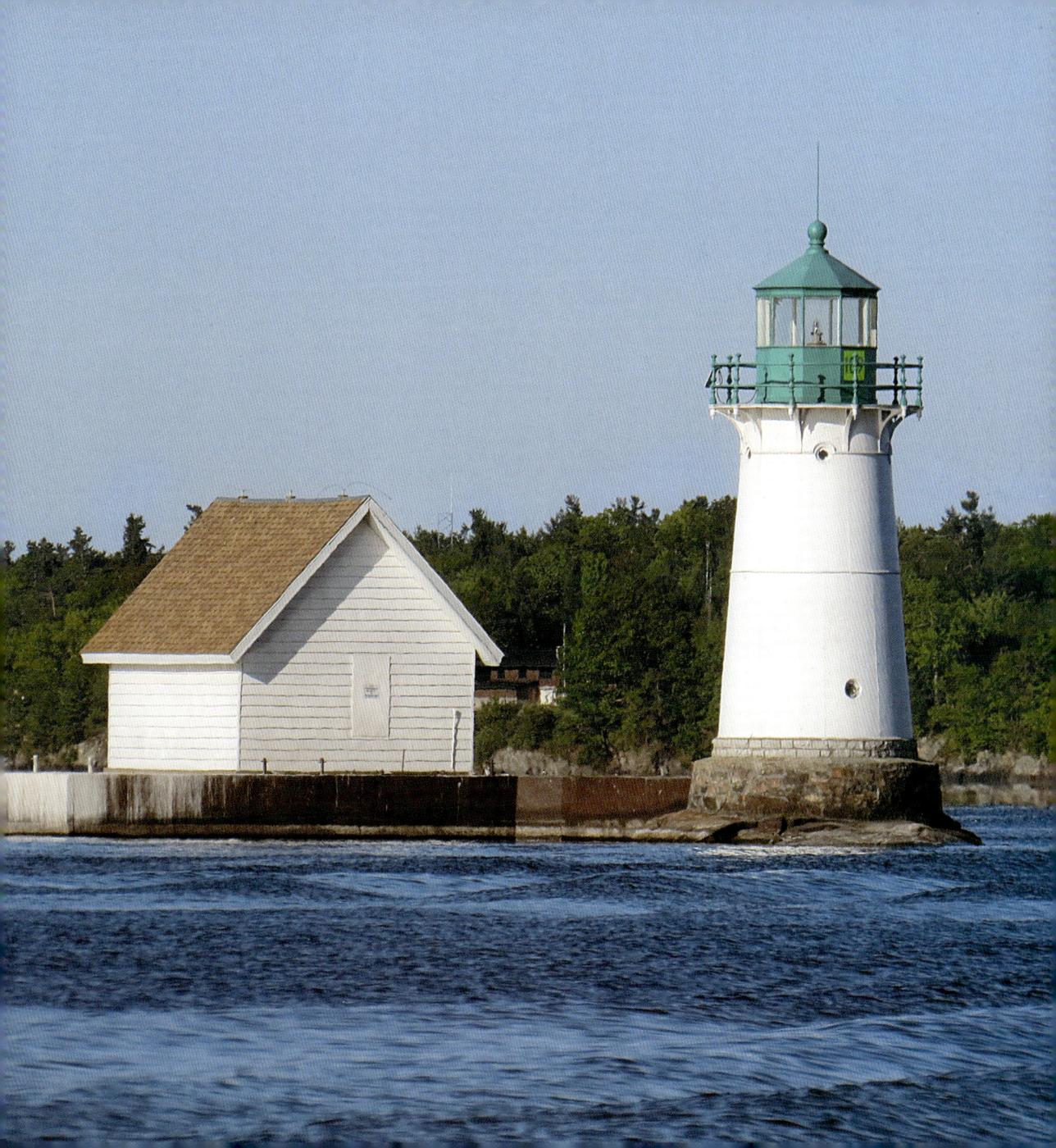

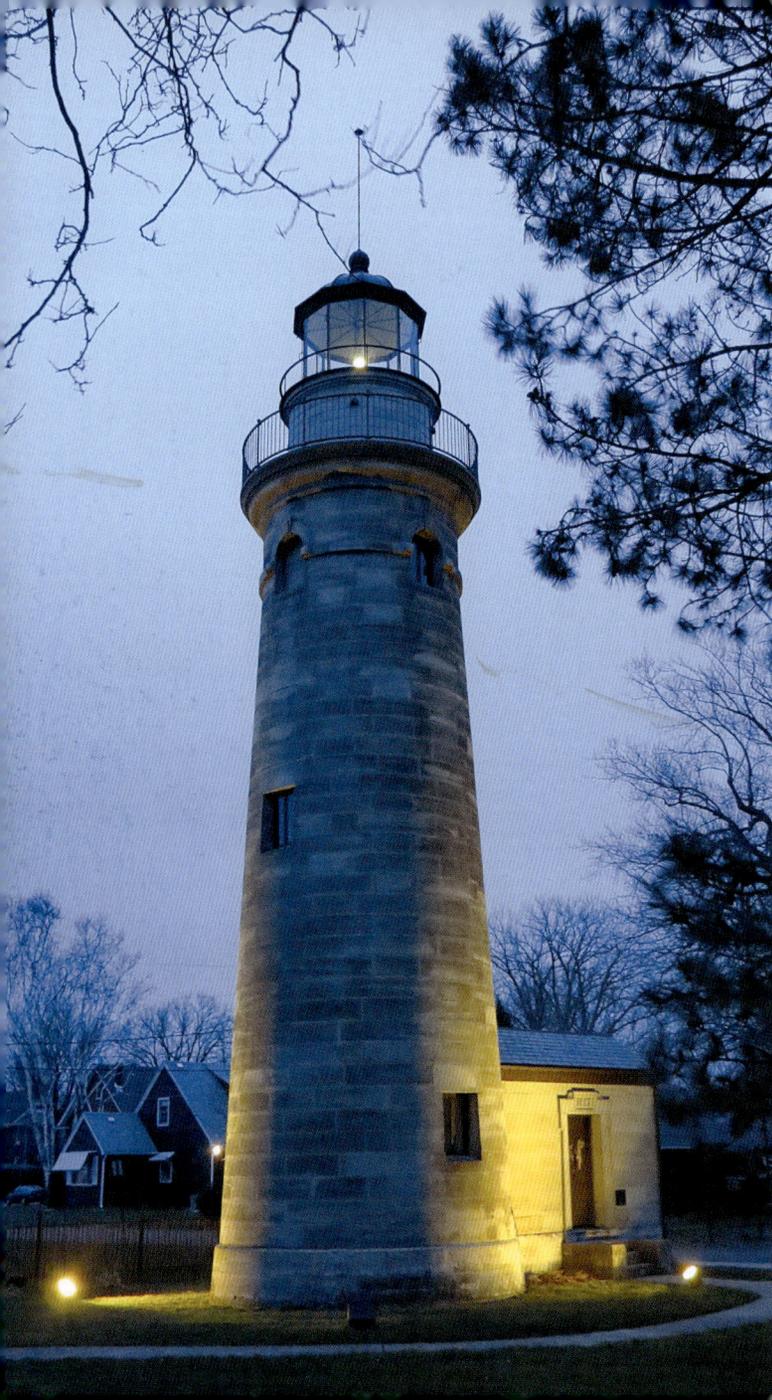

◀ ERIE LAND
LIGHTHOUSE,
PENNSYLVANIA

*Beginning in 2011,
Erie Playhouse actors
in period costumes
reenacted histories
and mysteries about
this lighthouse.*

▶ WIND POINT
LIGHTHOUSE,
WISCONSIN

*In 1923, this lighthouse
was electrified with
a 300-watt light bulb
inside the Fresnel lens.
Electricity was supplied
by the Milwaukee
Electric Railway and
Light Company.*

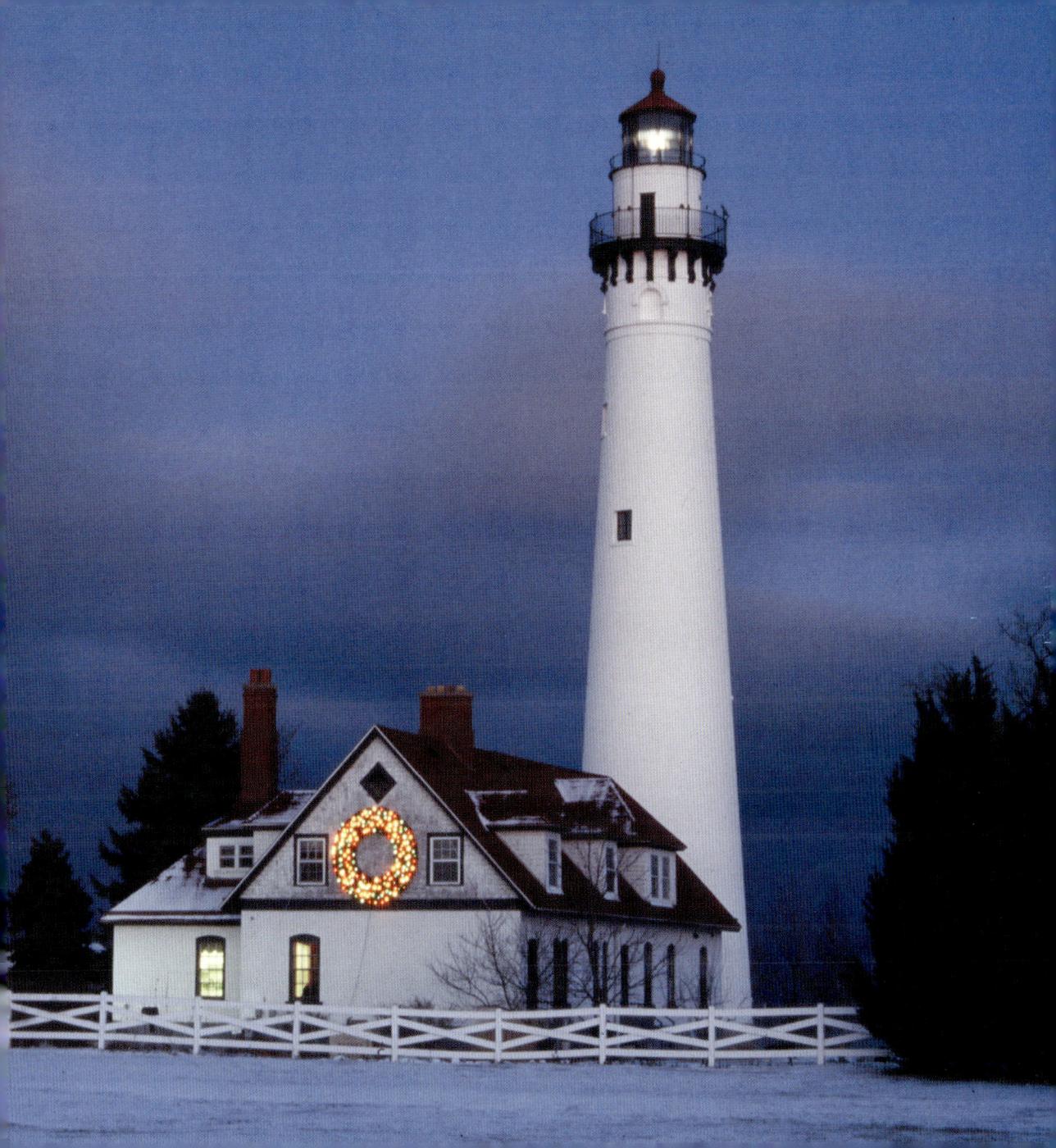

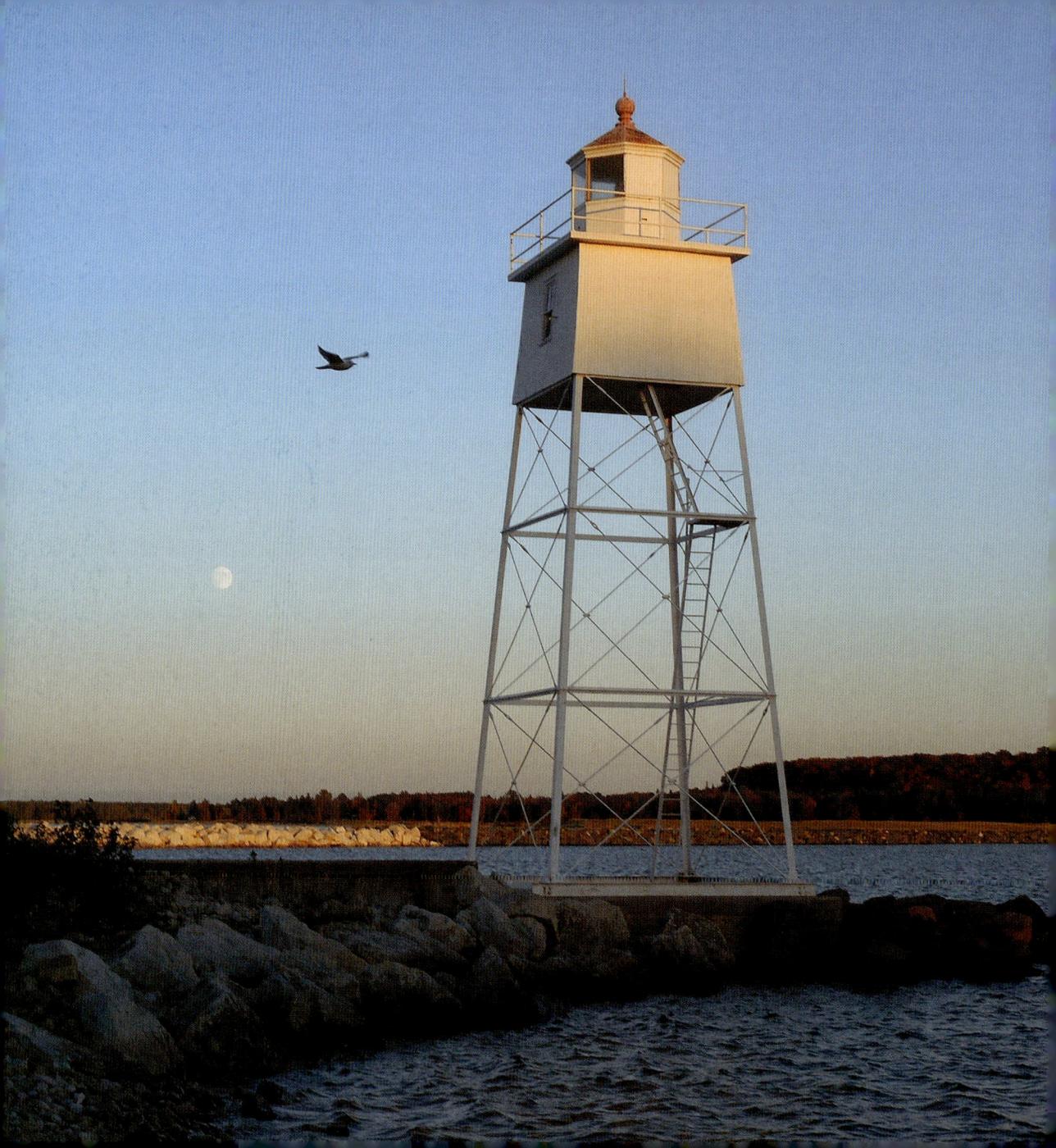

◀ GRAND MARAIS REAR RANGE LIGHTHOUSE, MICHIGAN

The keeper of this lighthouse, Roger W. Campbell, and his wife, Viola, had 12 children. She died, leaving him to care for the six children remaining at the lighthouse.

▶ VERONA BEACH LIGHTHOUSE, NEW YORK

Smokestack constructors Lupfer & Remick of Buffalo, New York, built this lighthouse and two others on Lake Oneida in 1916.

▶▶ BREWERTON REAR RANGE LIGHTHOUSE, NEW YORK

This lighthouse was one of three concrete towers built in 1916 on Lake Oneida for Erie Canal navigation.

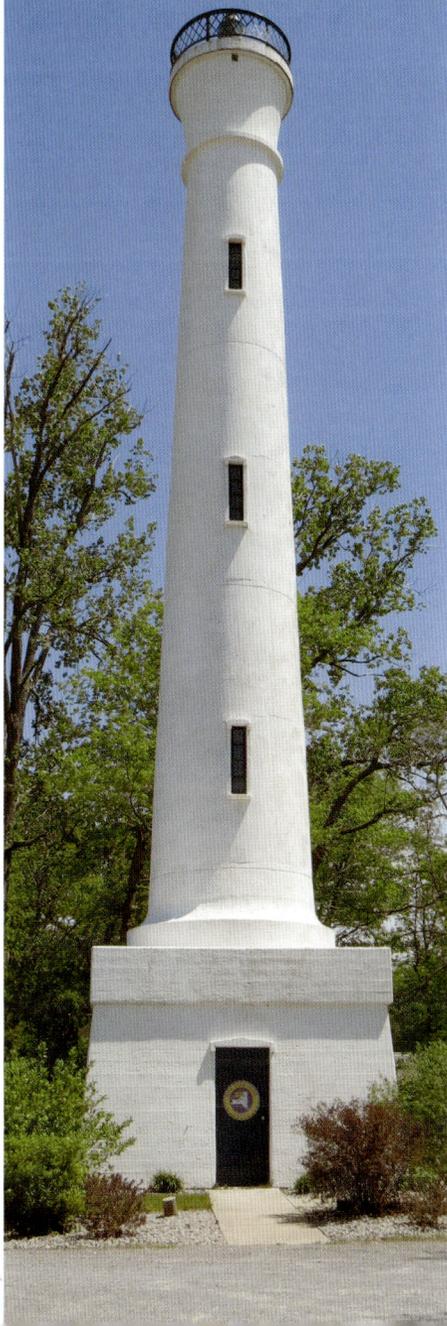

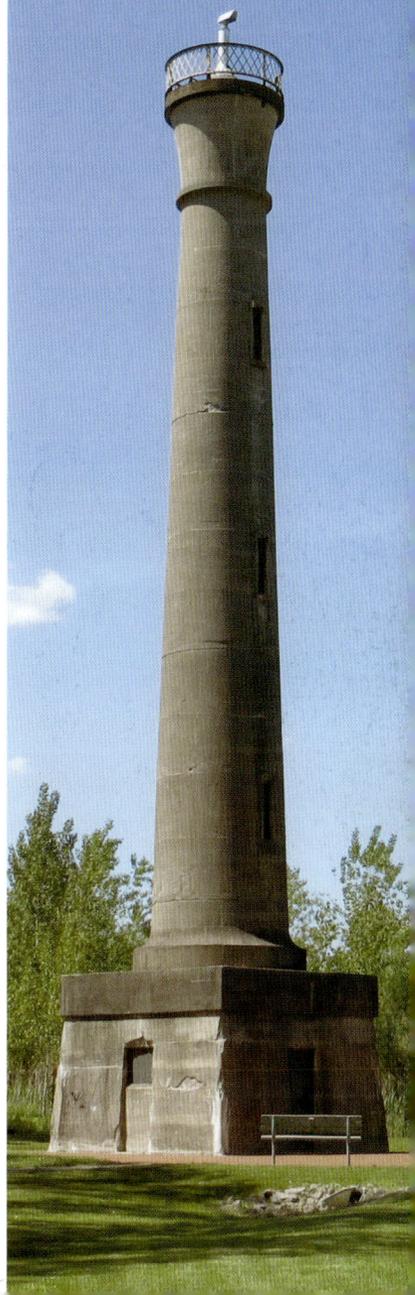

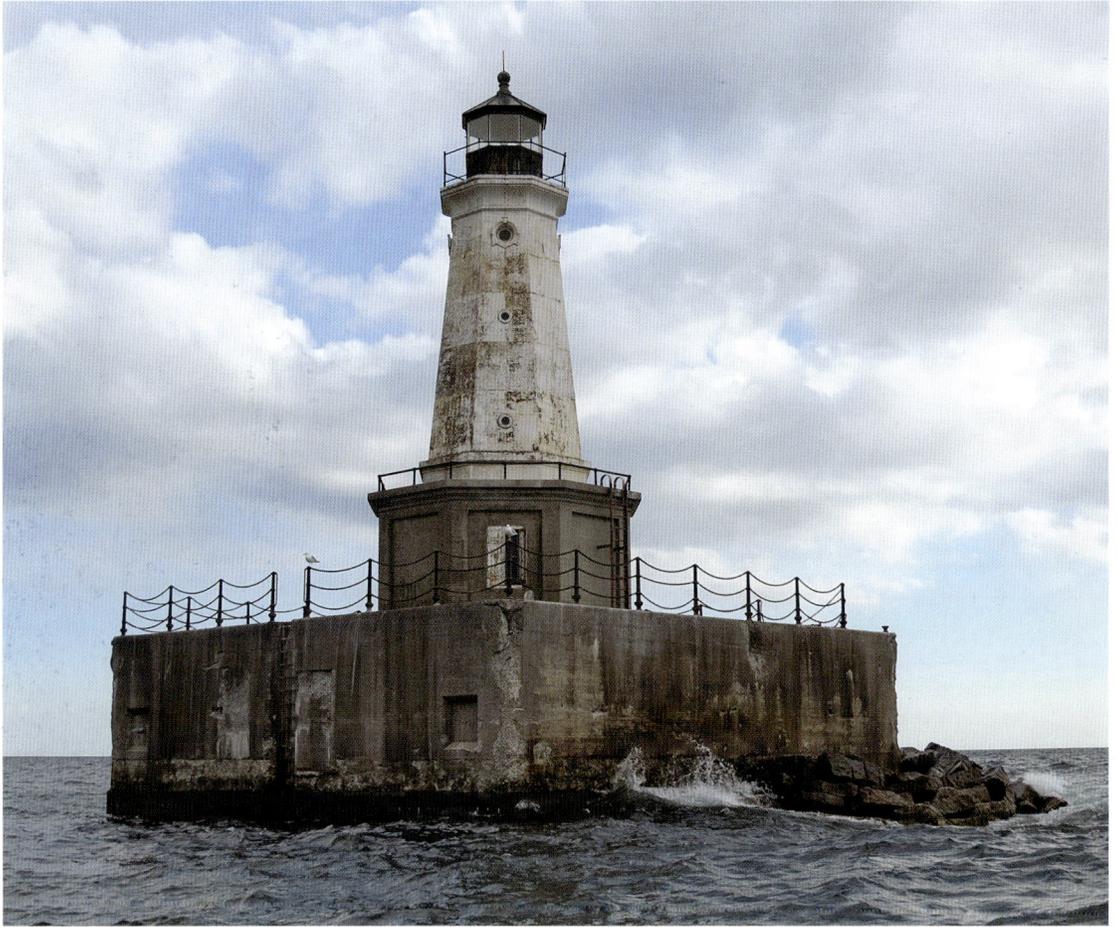

EAST CHARITY SHOAL LIGHTHOUSE, NEW YORK
This octagonal iron tower served at two stations on the Great Lakes.

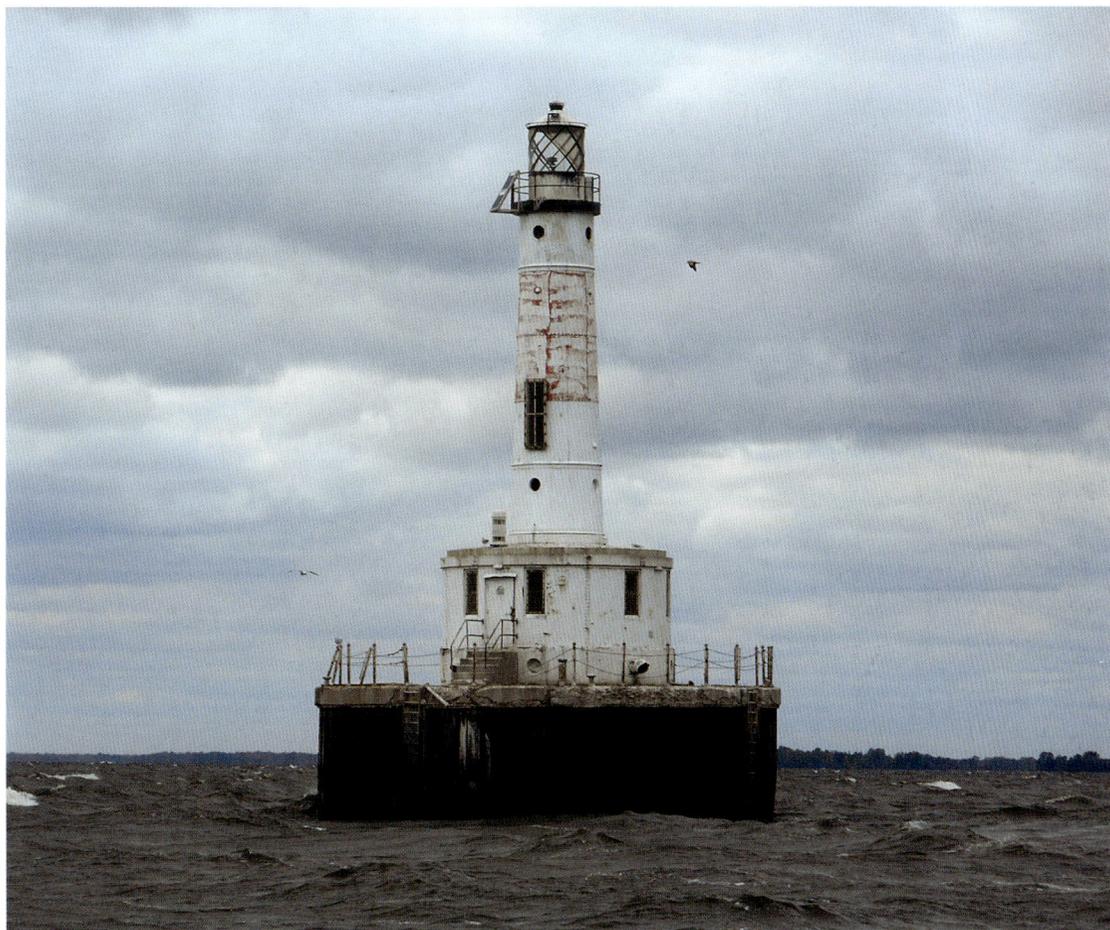

PESHTIGO REEF LIGHTHOUSE, WISCONSIN
In justifying this lighthouse in 1923, the commissioner of lighthouses noted the off-lying Peshtigo Reef as a hazard to shipping into Green Bay.

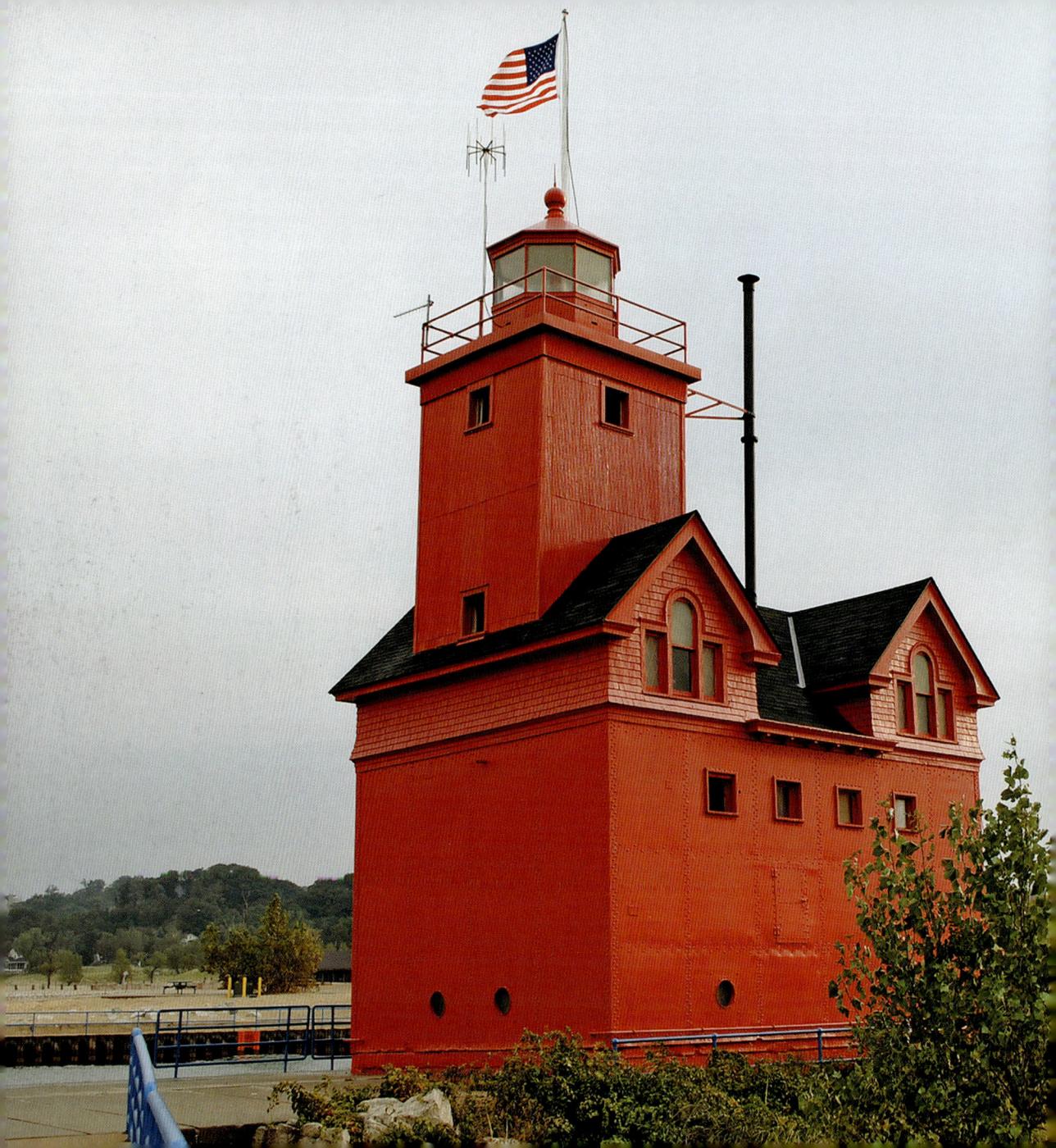

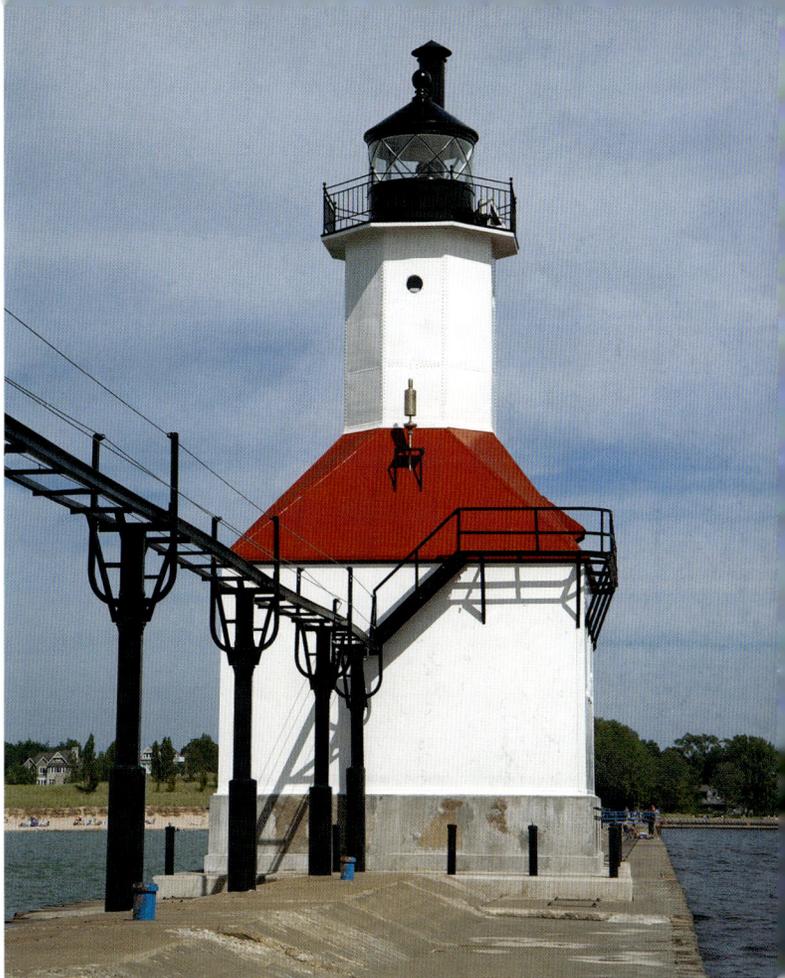

▲ ST. JOSEPH PIERHEAD, MICHIGAN
A Lighthouse Forever Fund Committee was formed to raise $2 million to restore both the entrance and inner lighthouses of St. Joseph Pierhead. The inner lighthouse is pictured here.

◀ HOLLAND HARBOR LIGHTHOUSE, MICHIGAN
This lighthouse's keeper, Van Regenmorter, quit after 37 years rather than learning how to operate the new fog signal.

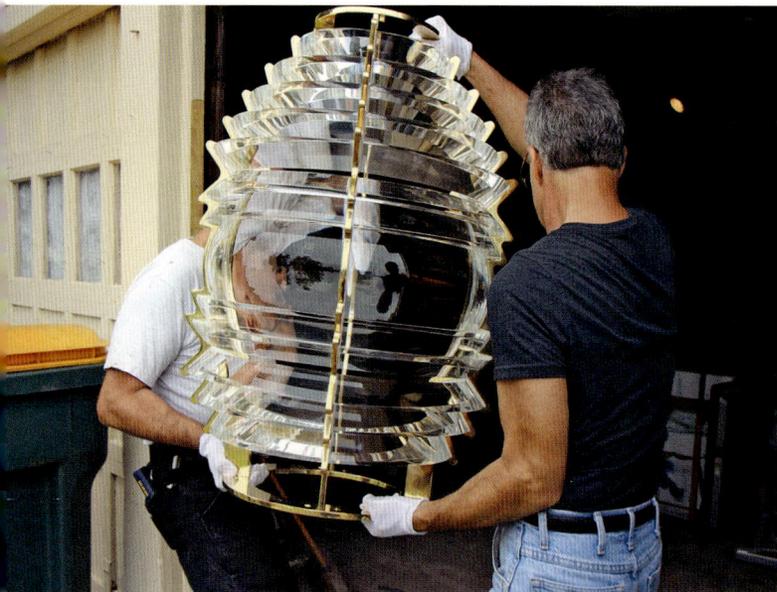

◢ ▶ CHARLOTTE-GENESEE LIGHTHOUSE, NEW YORK

Thomas Jefferson decreed Charlotte-Genesee as an official customs district. Vessels were guided into port with a torch suspended from a tall tree until it was replaced in 1822 with this lighthouse. Dan Spinella and Dean LoPiano (above) carefully toted this lighthouse's reproduction fourth-order Fresnel lens, contributed by an anonymous donor.

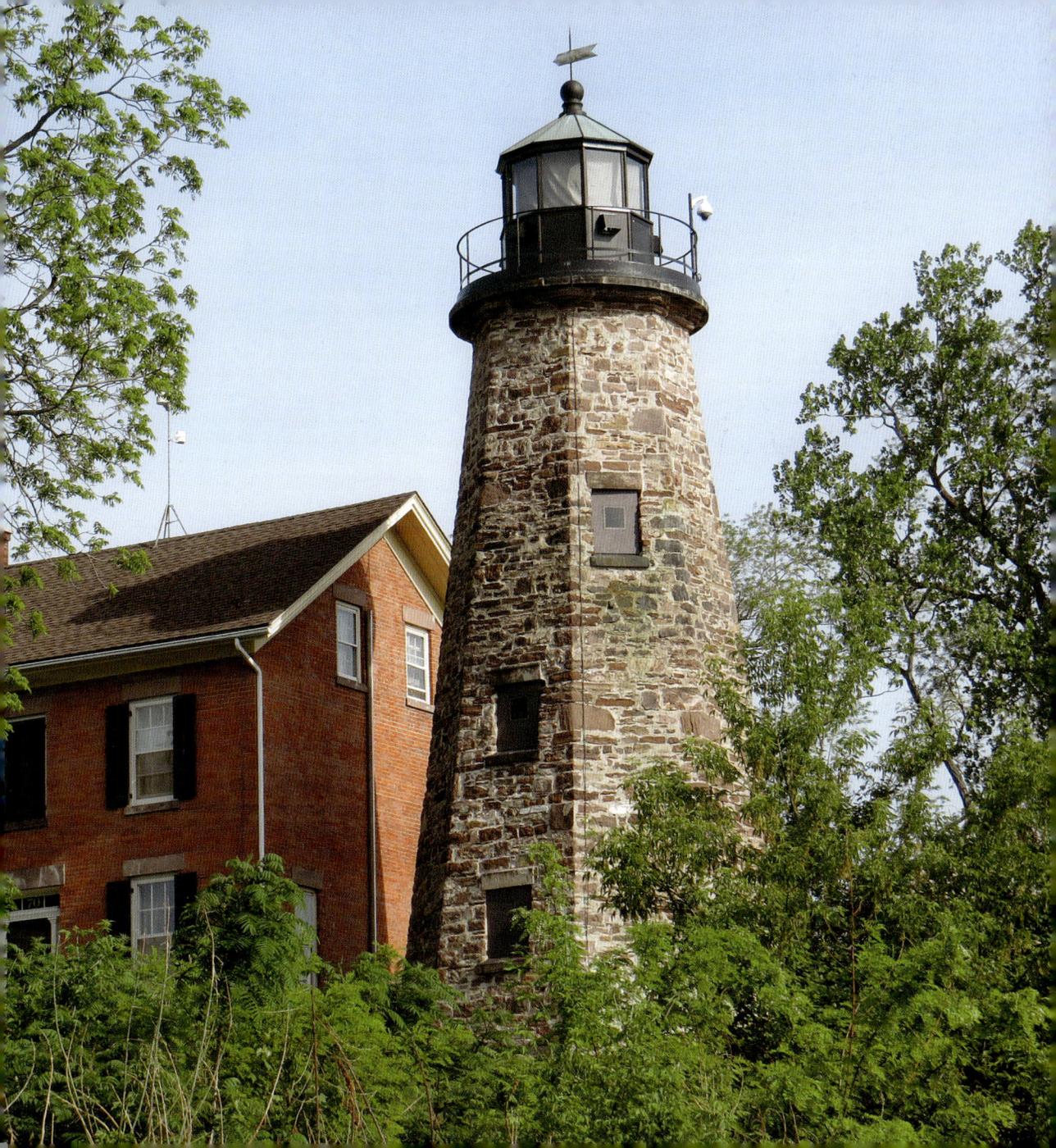

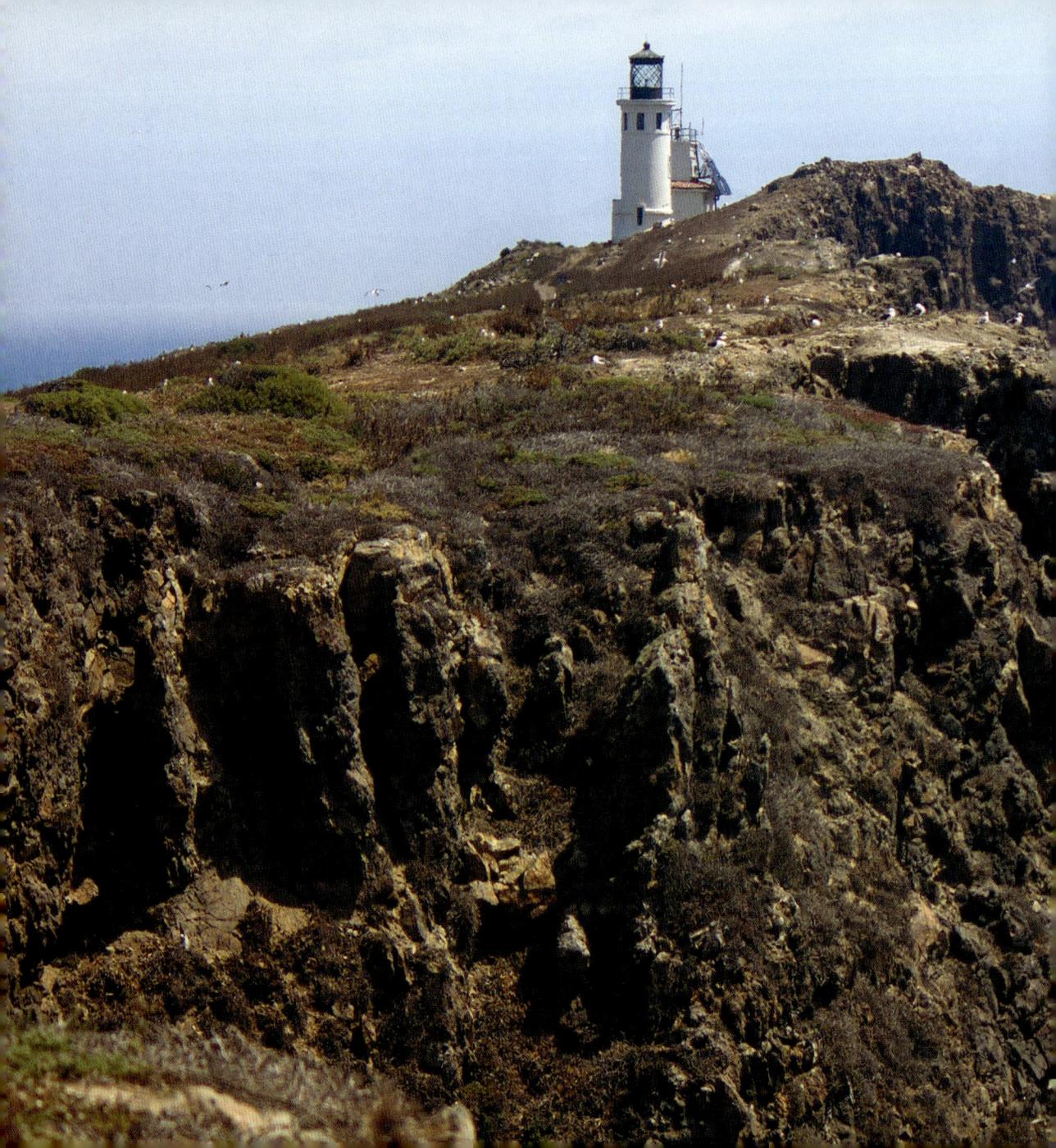

WEST
COAST

(Pages 126–127)

ANACAPA LIGHTHOUSE, CALIFORNIA

Painter James Whistler, in 1854, produced etchings of Anacapa Island to determine a location for this lighthouse.

▶ CAPE ARAGO LIGHT STATION, OREGON

This light station was disbanded in 2006 and its island returned to Confederated Tribes of the Coos, Lower Umpqua, and Siuslaw Indians in 2013.

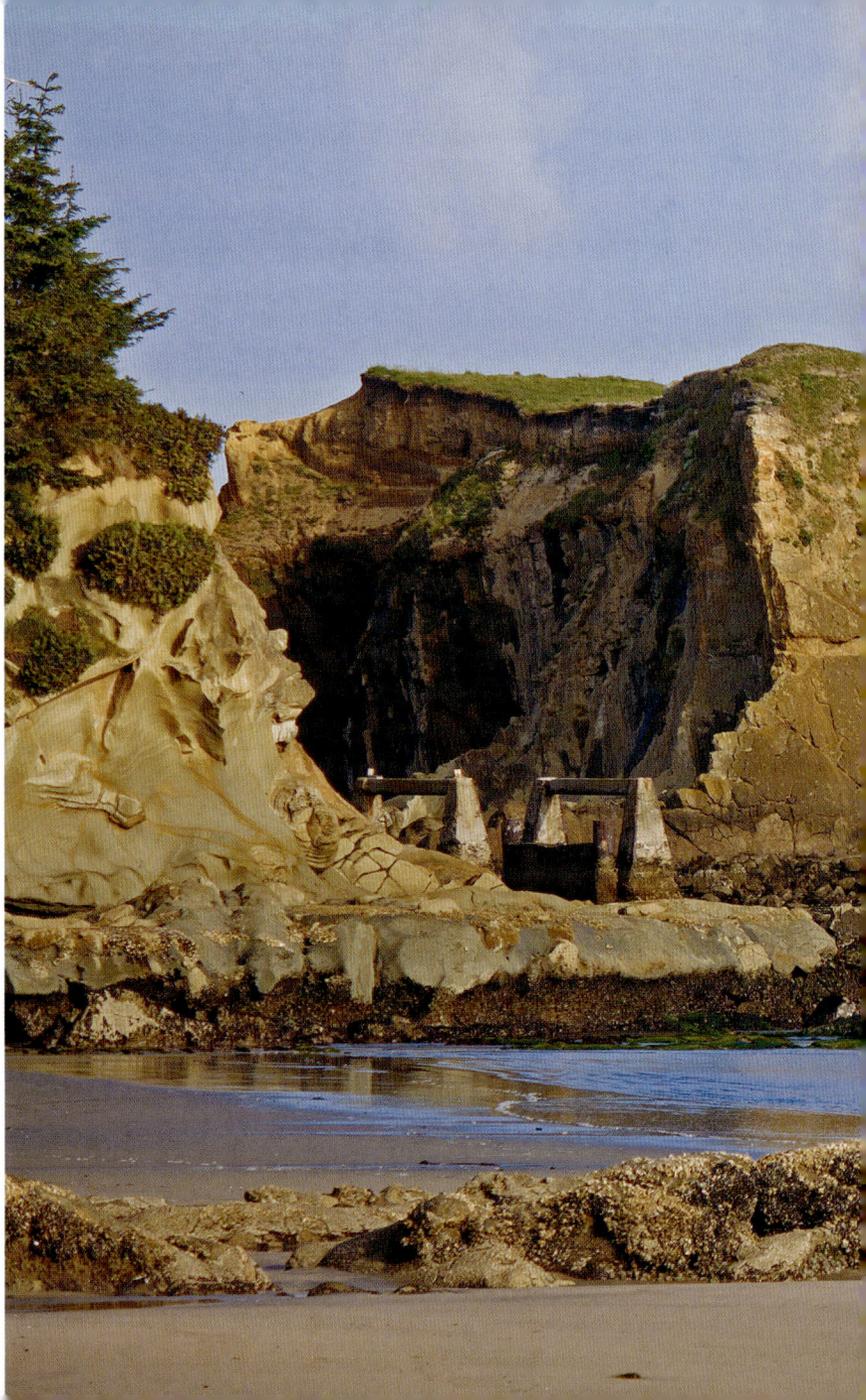

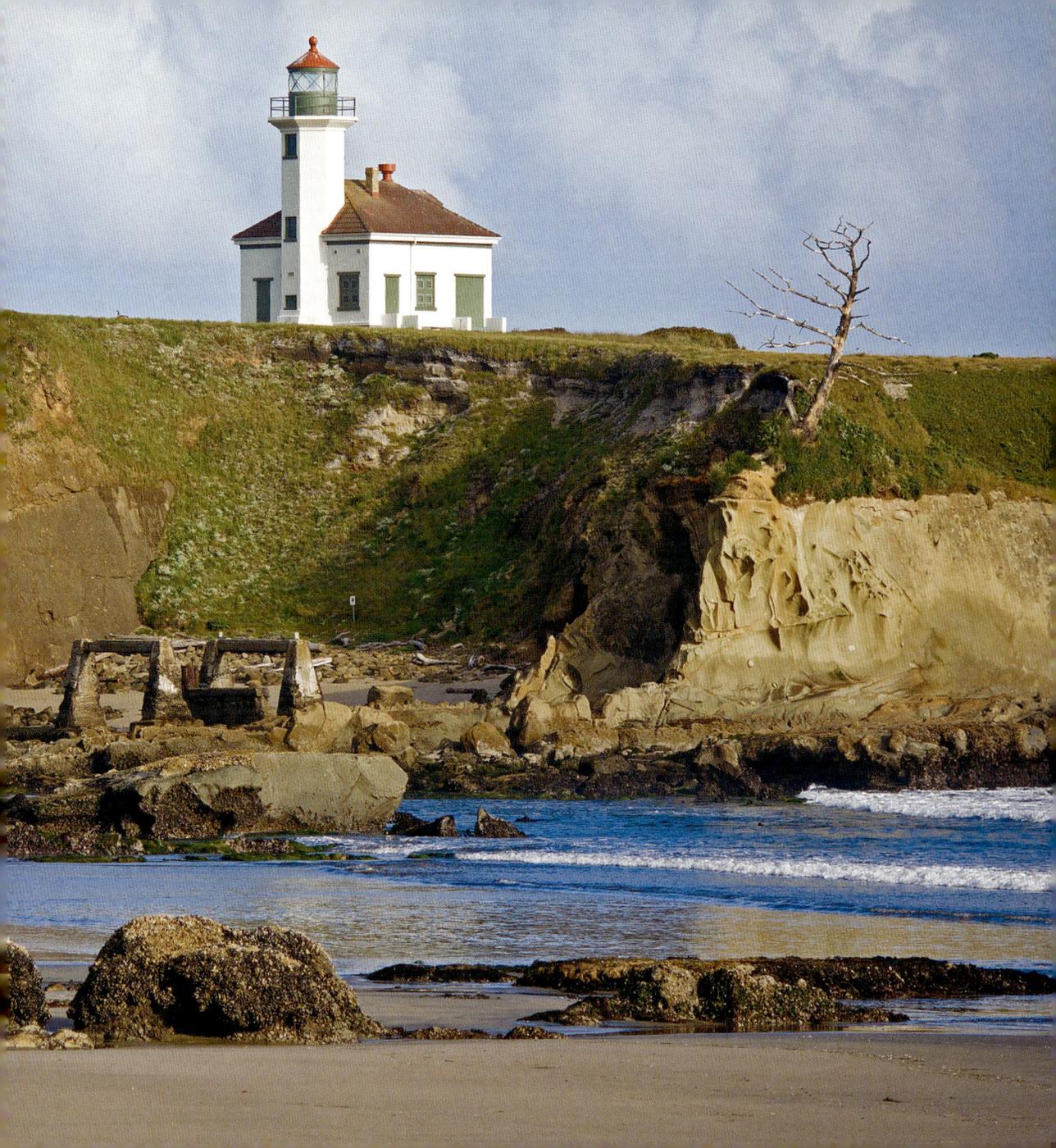

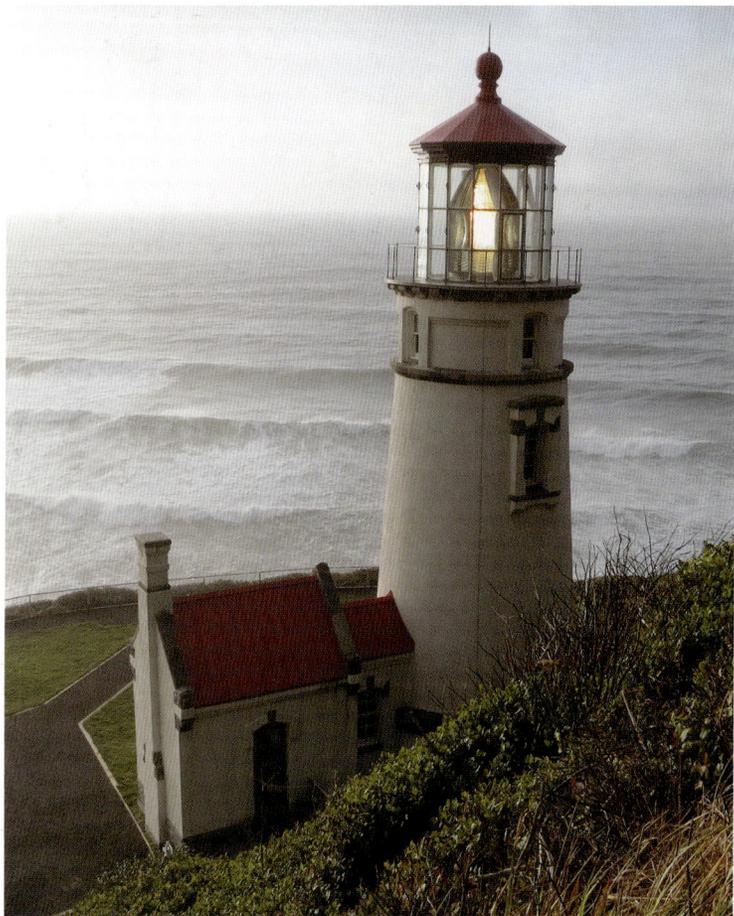

▲ HECETA HEAD LIGHTHOUSE, OREGON

This lighthouse's first-order Fresnel lens revolving mechanism wore out and stopped rotating in 2000 for only the second time in its 106-year history.

▶ COLUMBIA RIVER LIGHTSHIP STATION, OREGON

Lightships were navigation aids anchored at sea. Columbia LV 50 began as Columbia River Lightship Station in 1892. Eighty-six years later, Columbia WLV 606 retired the post.

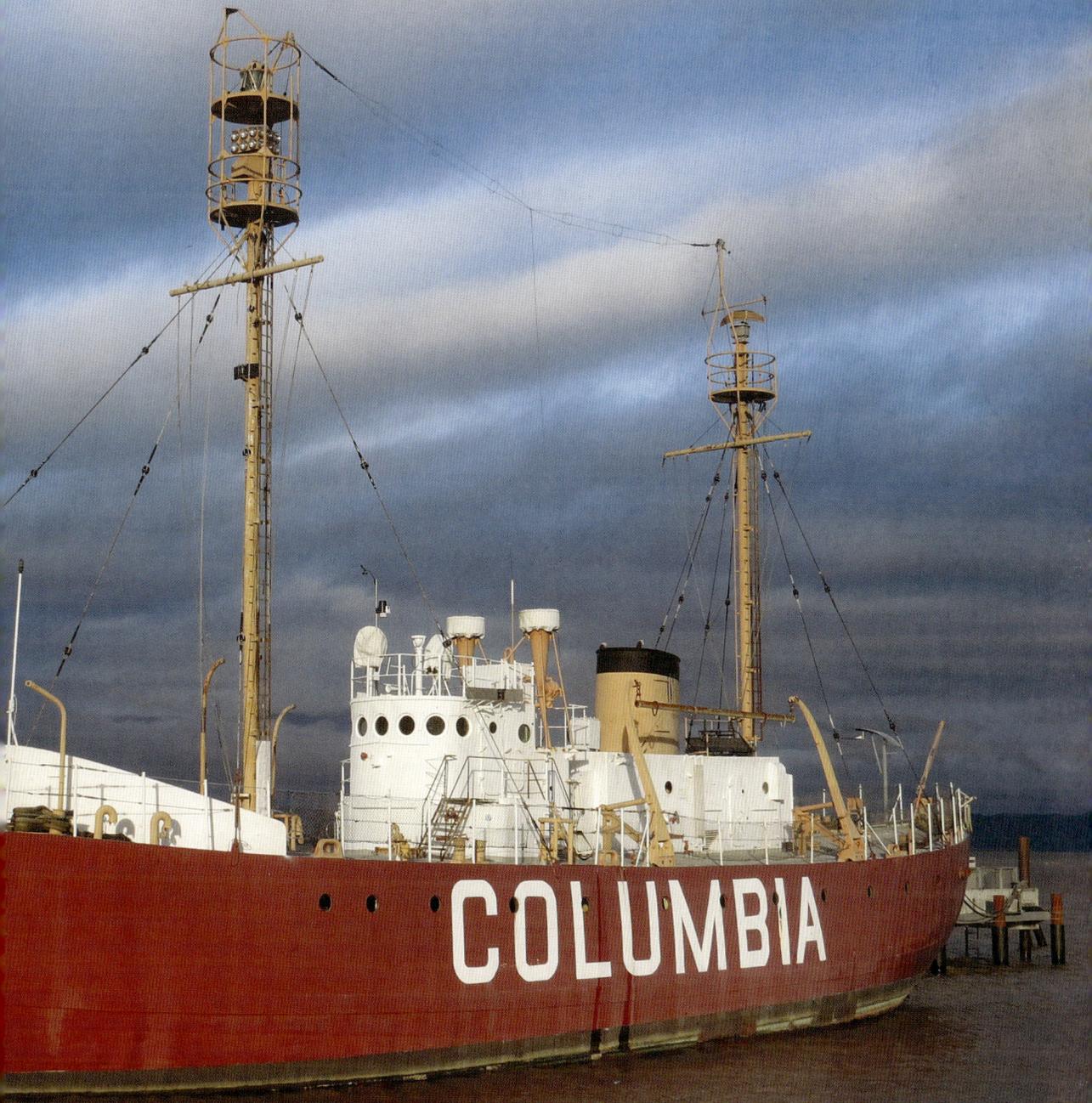

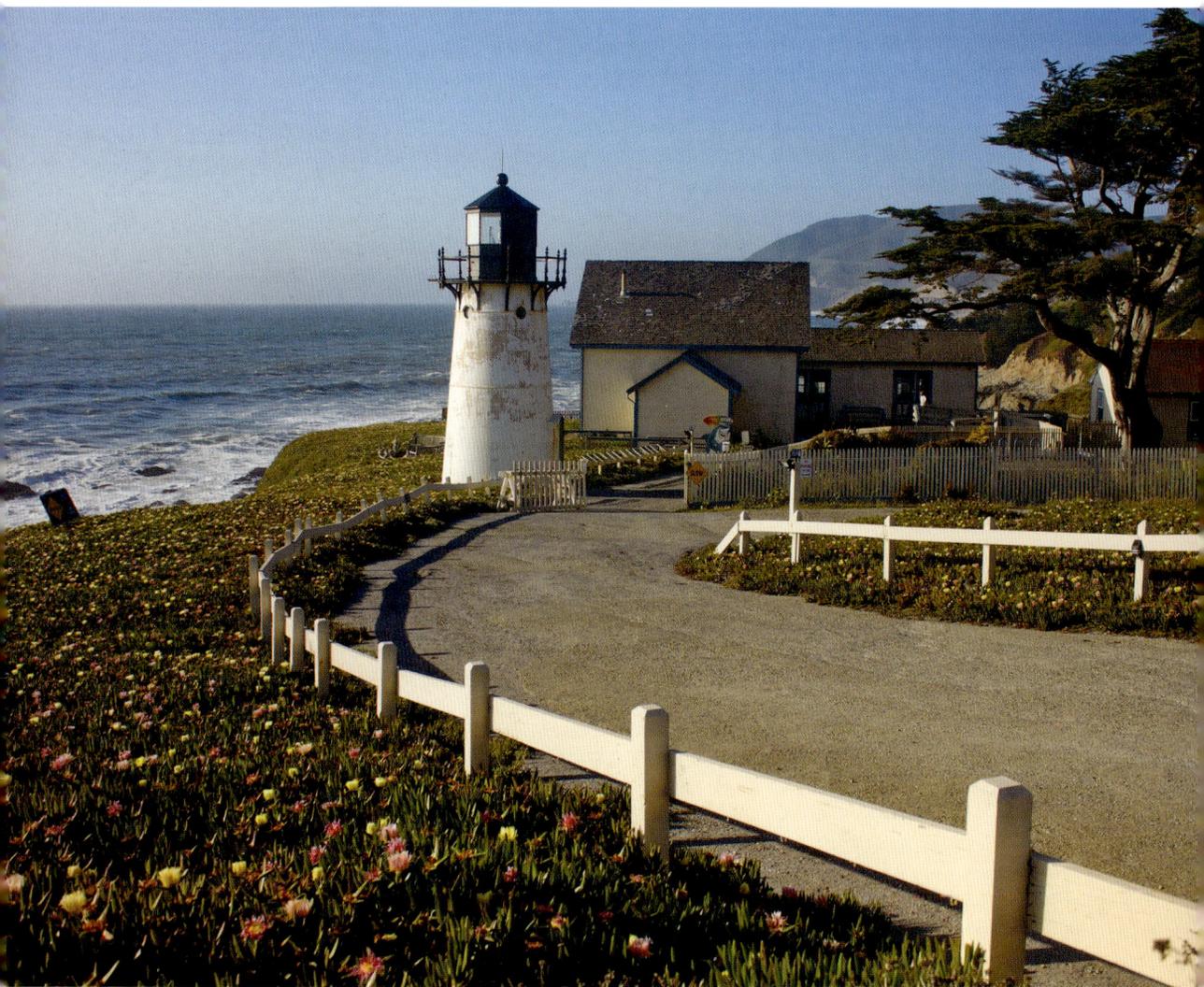

POINT MONTARA LIGHTHOUSE, CALIFORNIA
This 30-foot-tall, cast-iron plate tower first stood at Mayo Beach, Cape Cod, Massachusetts.

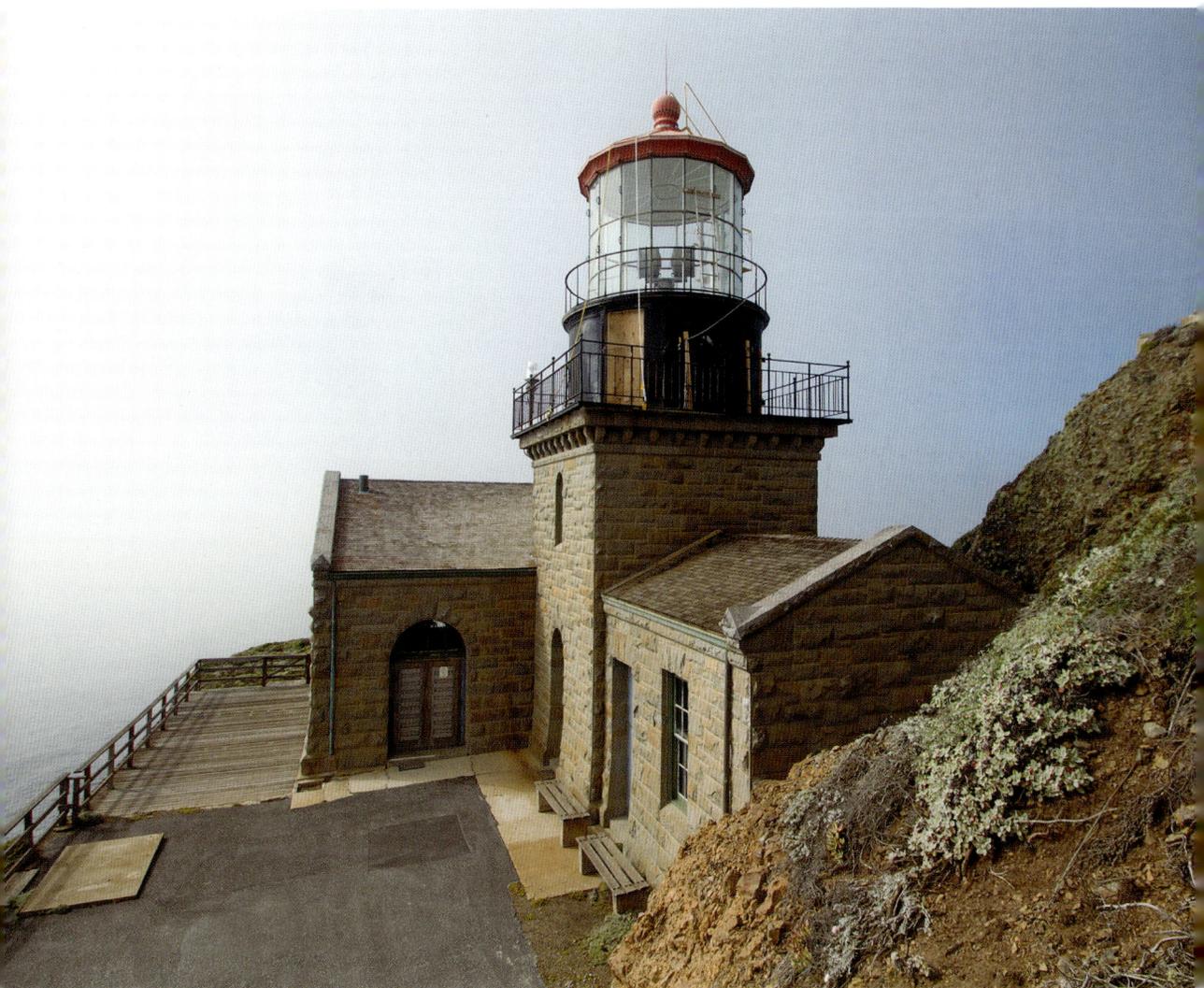

POINT SUR LIGHTHOUSE, CALIFORNIA
A first-order, 4,330-pound Fresnel lens for this lighthouse arrived via a Cape Horn route aboard a square-rigger.

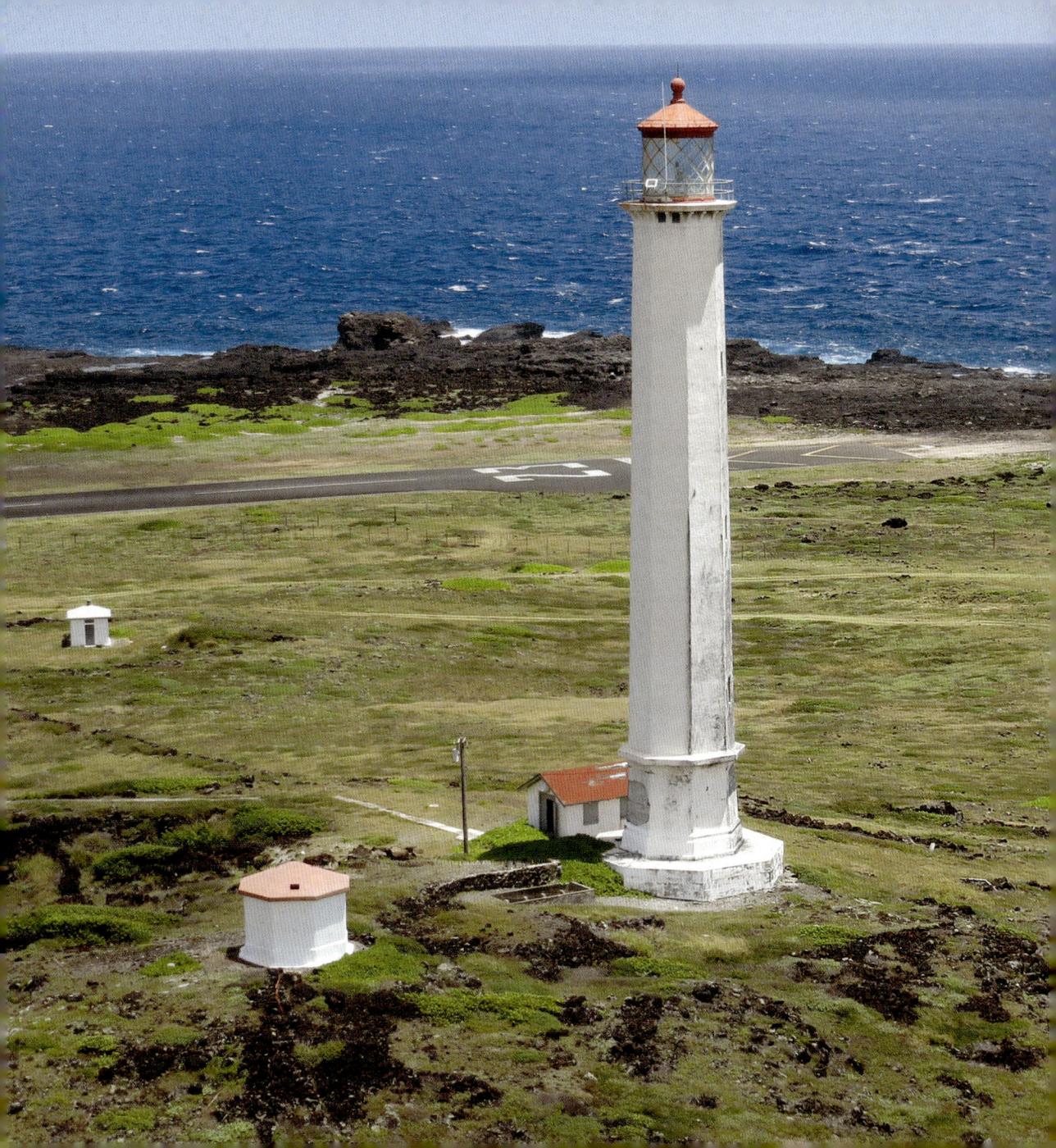

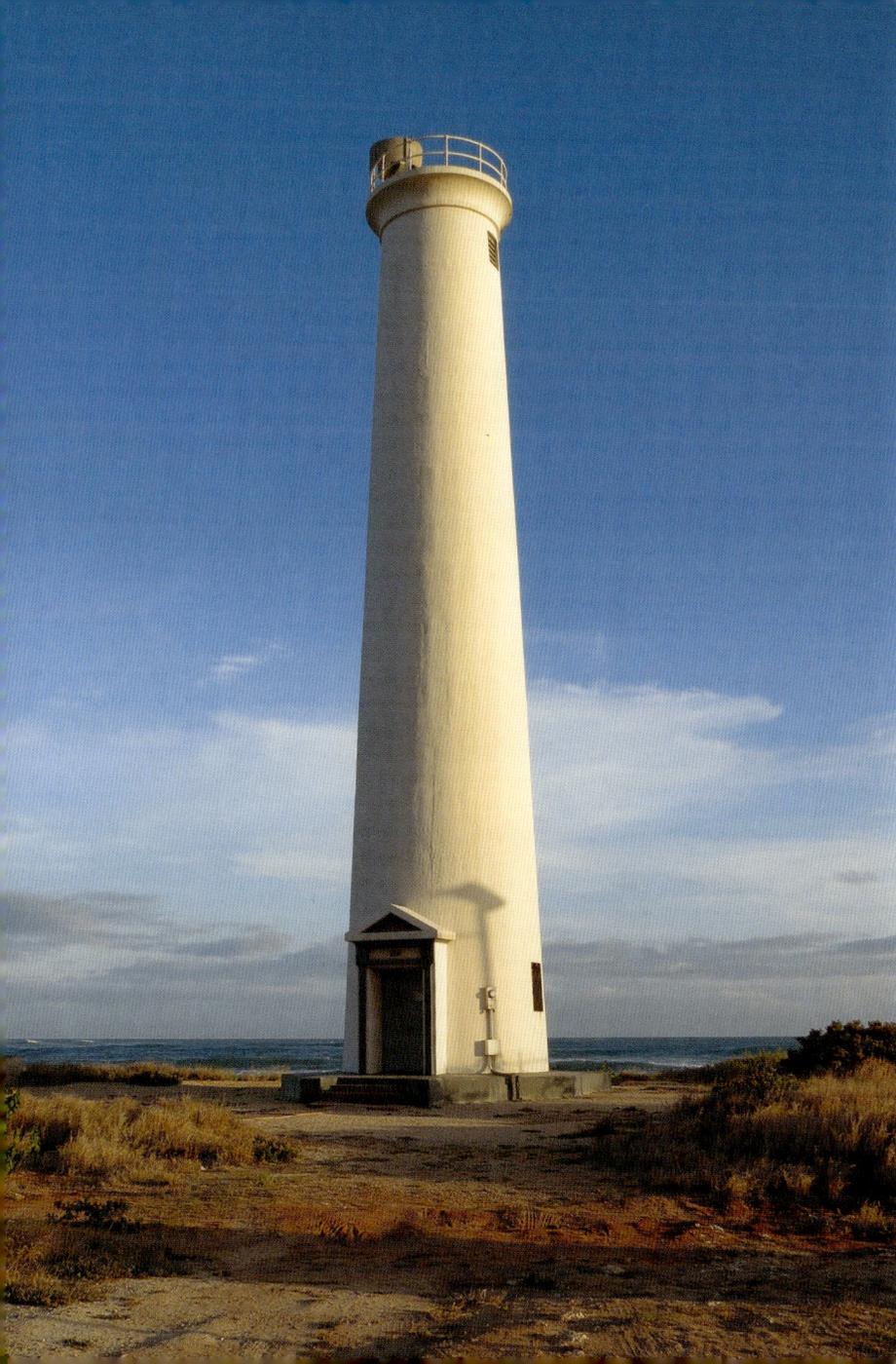

◄◄ **KALAUPAPA LIGHTHOUSE, HAWAII**
Earthquakes splashed mercury from this lighthouse's second-order Fresnel lens bearing. Carboys filled with 200 pounds of mercury were carried up the stairs to refloat the three-ton lens.

◄ **BARBERS POINT LIGHTHOUSE, HAWAII**
This tower was constructed of coral stone. The lantern room was removed later when a modern airway beacon replaced a fourth-order Fresnel lens.

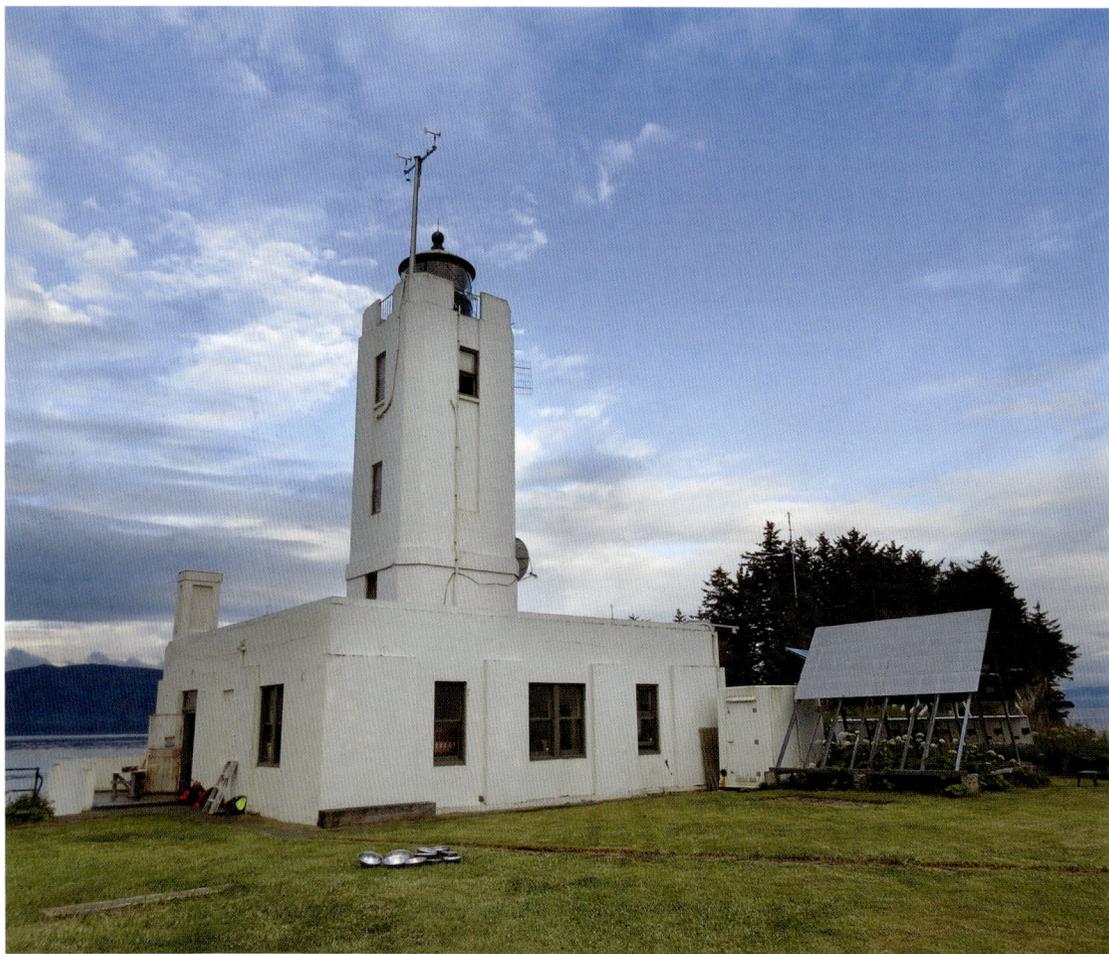

▲ FIVE FINGER ISLANDS LIGHTHOUSE, ALASKA
An assistant keeper rowed away from this lighthouse for food in the winter of 1903 and did not return. A month later, the two remaining, starving keepers successfully signaled a passing steamer.

▶ SENTINEL ISLAND LIGHTHOUSE, ALASKA
This lighthouse displays crests of an eagle, sailing ship, and lighthouse on its Art Deco–style concrete tower.

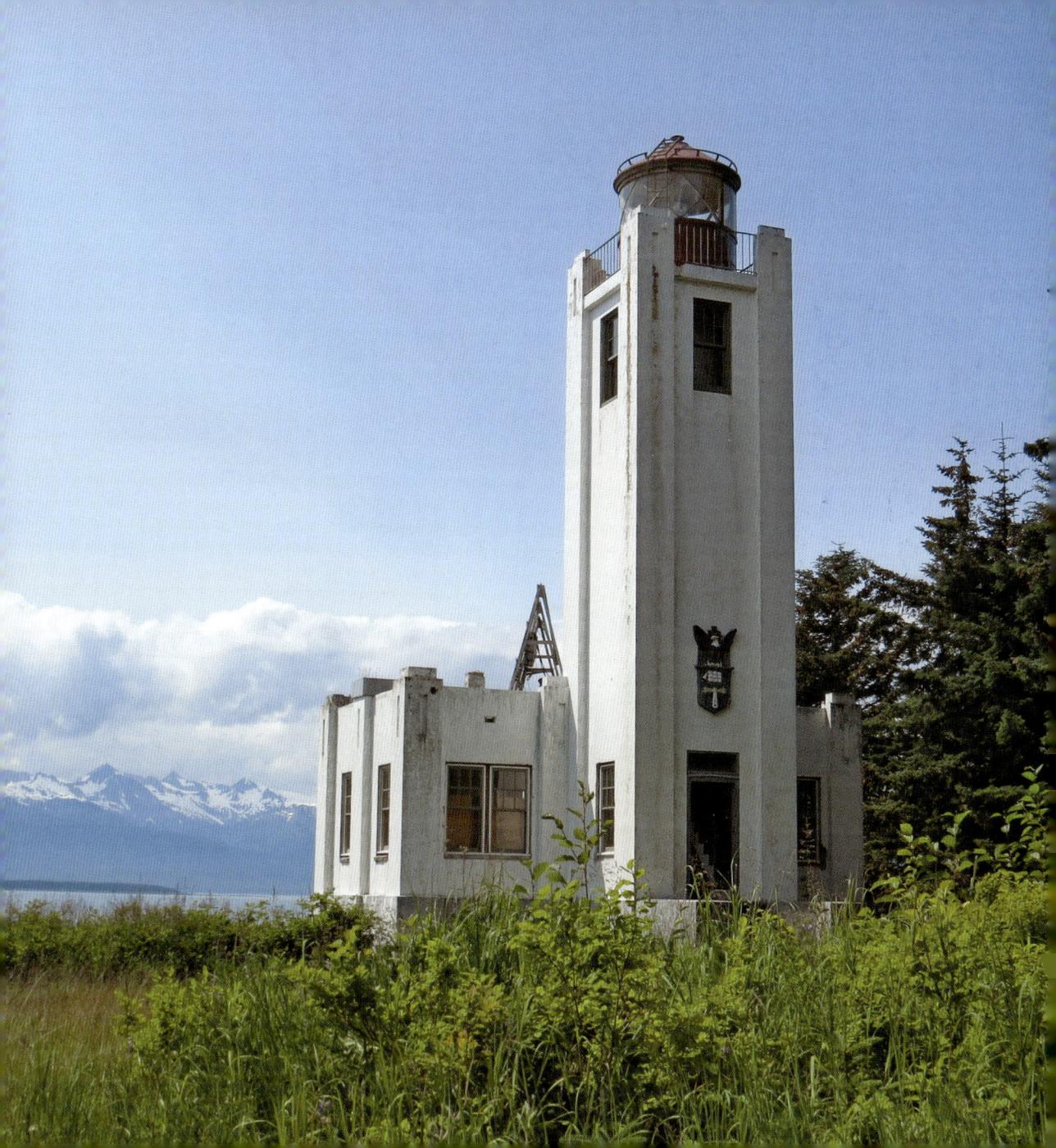

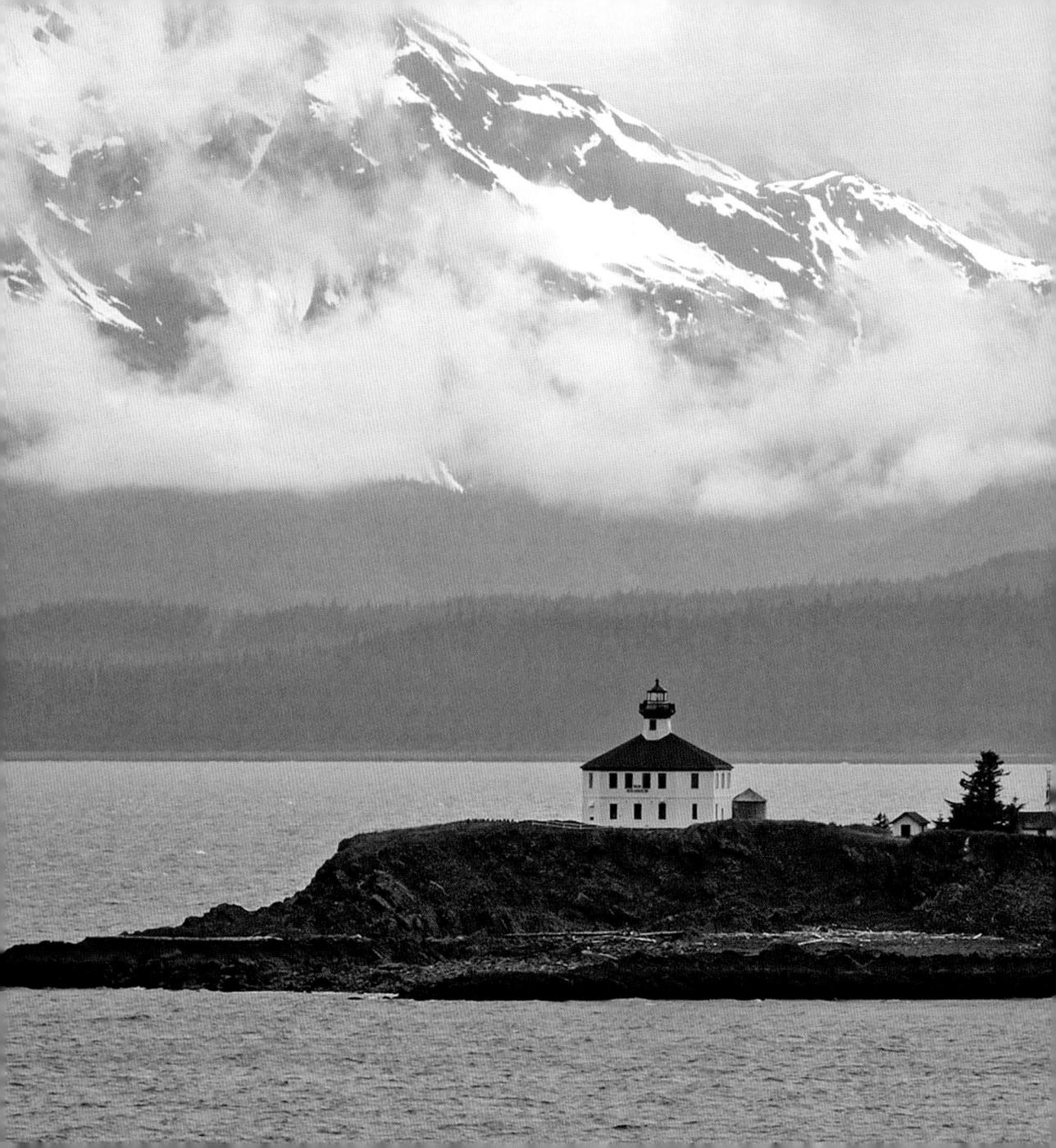

**ELDRED ROCK
LIGHTHOUSE, ALASKA**
*Keepers planted trees near
this lighthouse in 1962; none
had grown previously due to
frequent 90-mile-per-hour winds
and salt spray.*

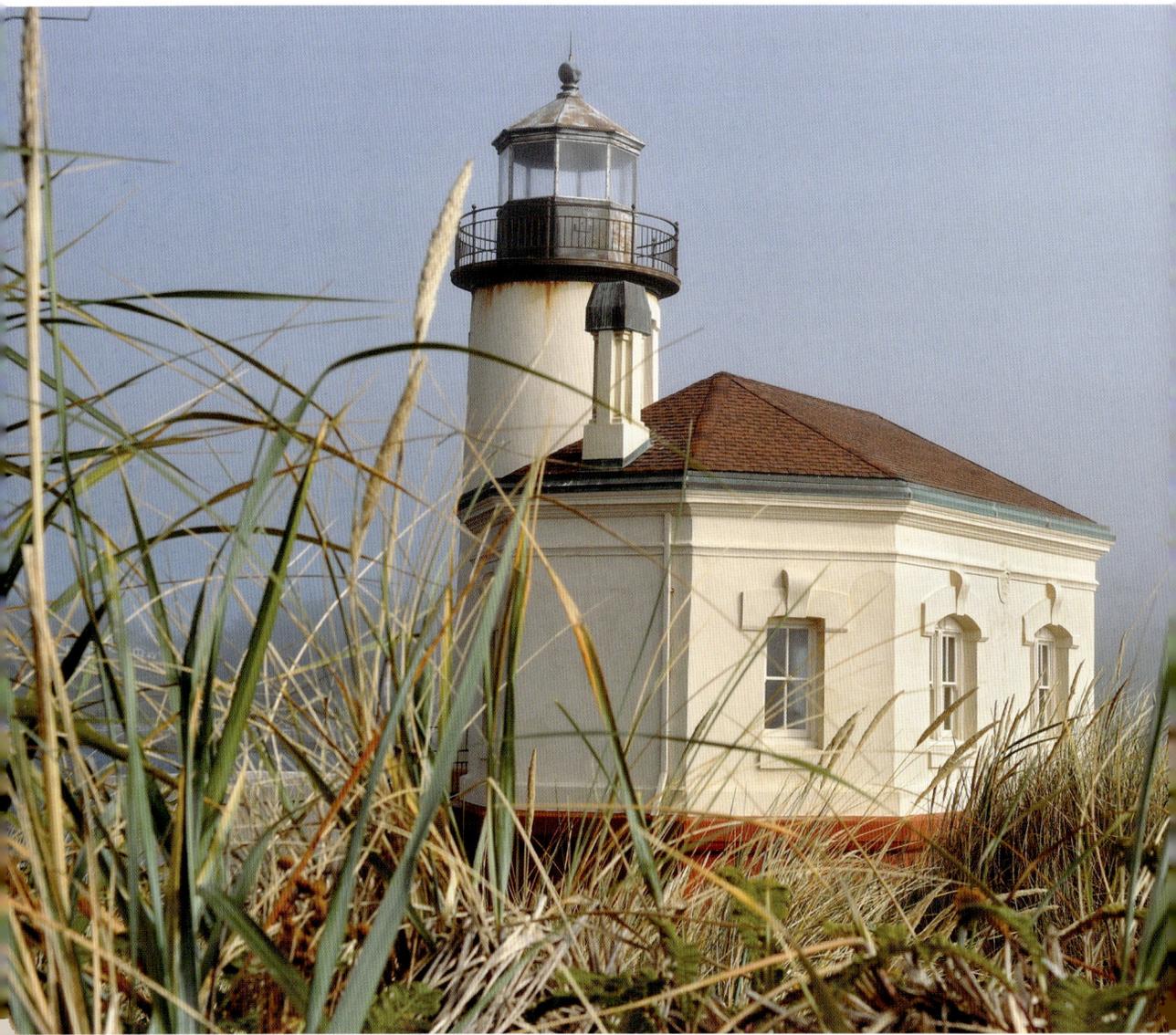

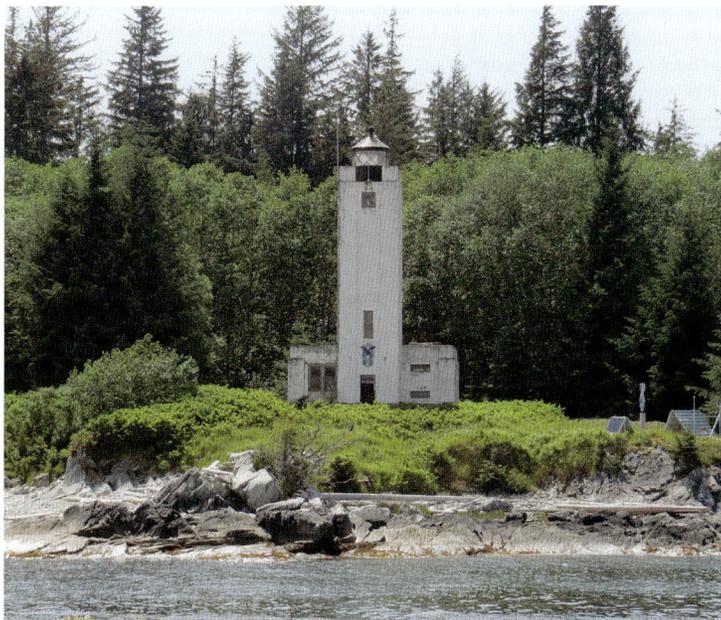

▲ MARY ISLAND LIGHTHOUSE, ALASKA
Mary Island Lighthouse was the fourth Alaskan lighthouse built; it was needed due to the increased ship traffic created by the Klondike gold rush of 1897.

◄ COQUILLE RIVER LIGHTHOUSE, OREGON
A clockwork device raised and lowered a brass cylinder exposing this light, giving it a characteristic flashing signal.

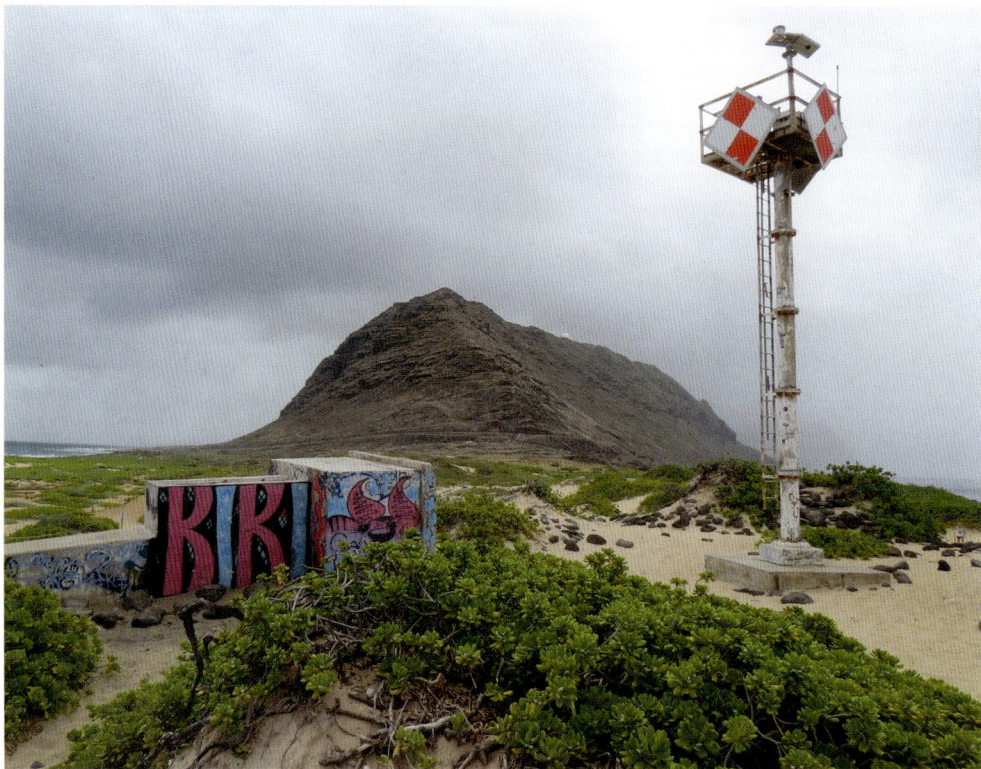

▲ KA'ENA POINT LIGHTHOUSE, HAWAII
The Ka'ena Point Natural Reserve Area was established in 1983 to preserve native species and surrounding dunes following years of vandalism to the property and sacred grounds.

▶ KA'UIKI HEAD LIGHTHOUSE, HAWAII
The original beacon at Ka'uiki Head was a 40-foot mast. The lamplighter hoisted a lit kerosene lantern to the mast top at sunset.

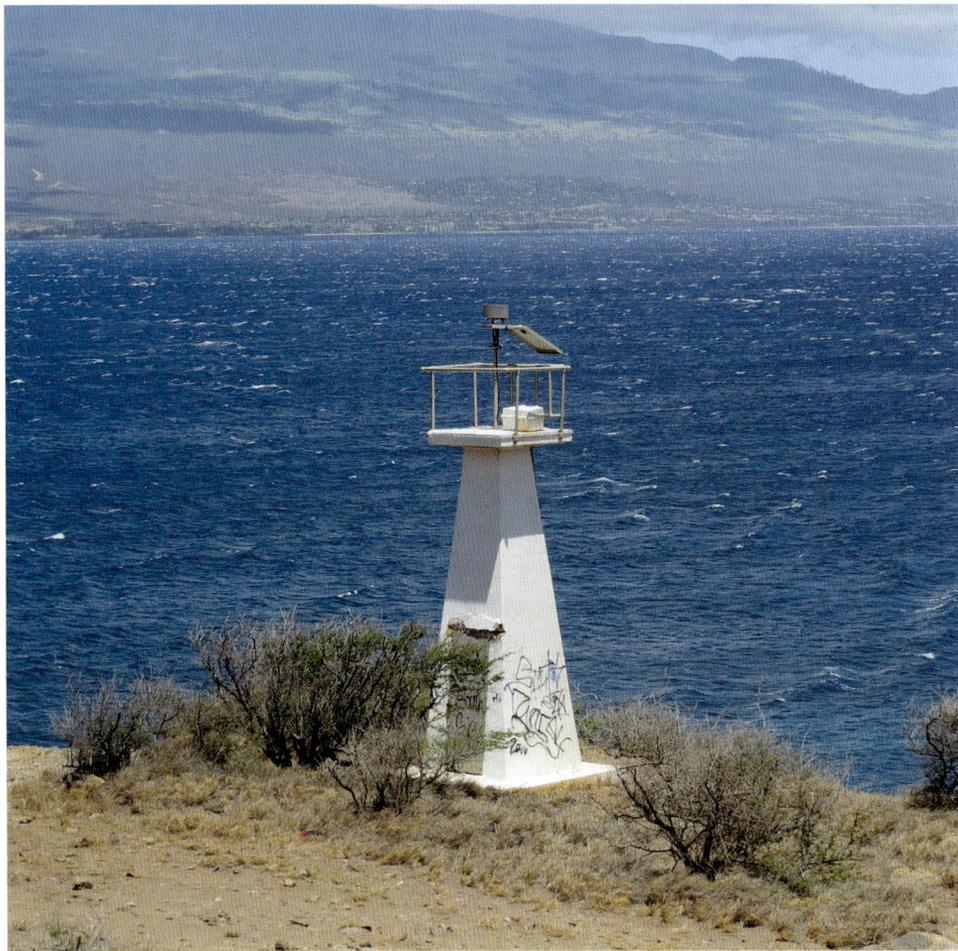

▲ McGREGOR POINT, HAWAII
A red-lens lantern, hung from a short post at this lighthouse in the 1880s, was changed to a lantern suspended from a 12-foot post in 1904.

▶ RUBICON POINT LIGHTHOUSE, CALIFORNIA
Mules once carried fuel to this lighthouse, which stands on a bluff 6,300 feet above sea level overlooking Lake Tahoe, the highest elevation of any American lighthouse.

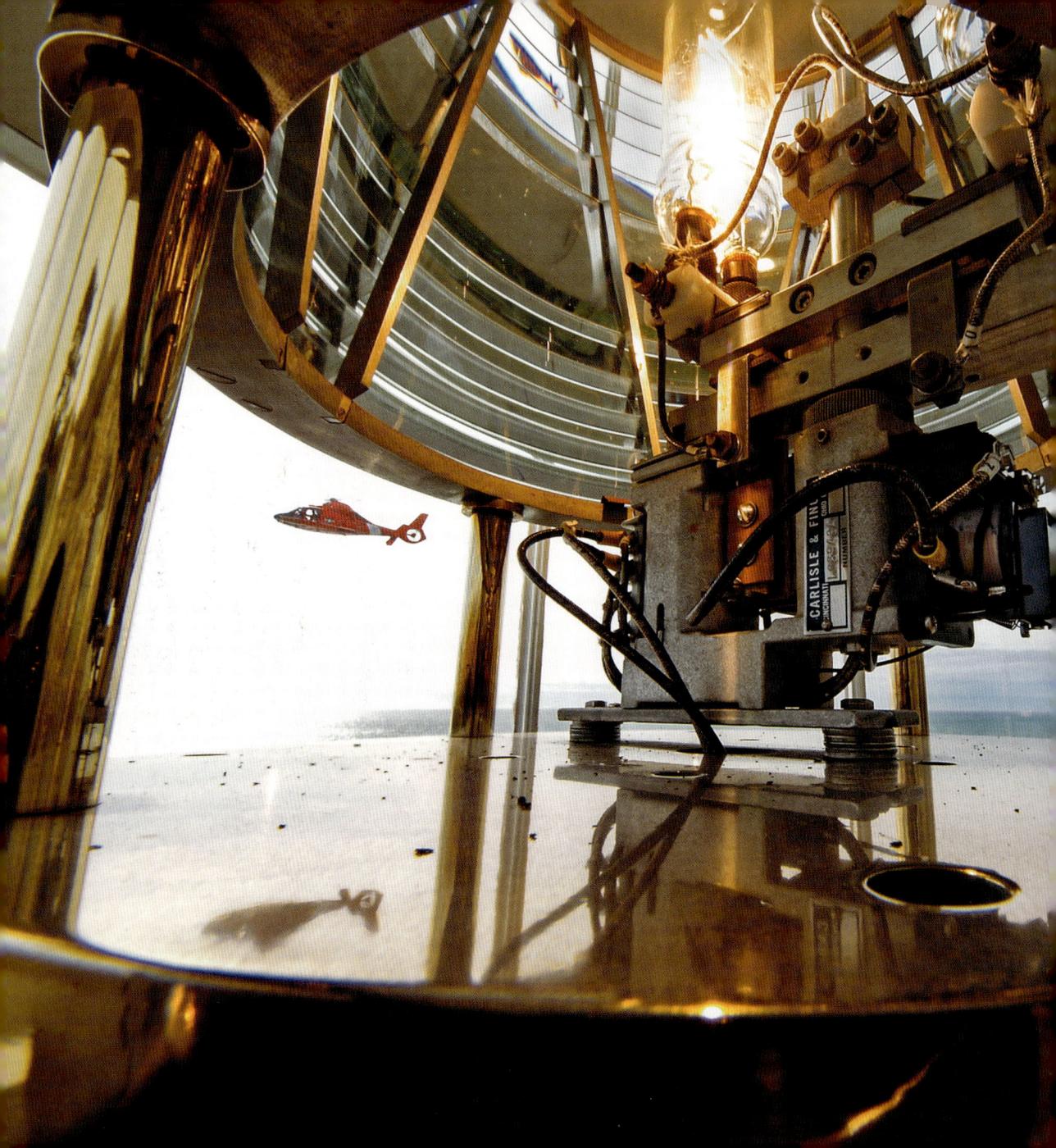

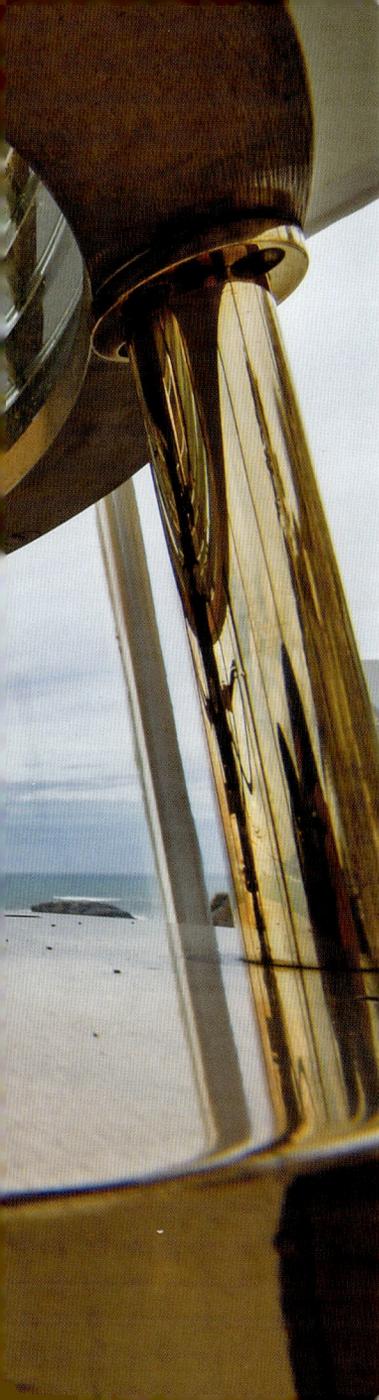

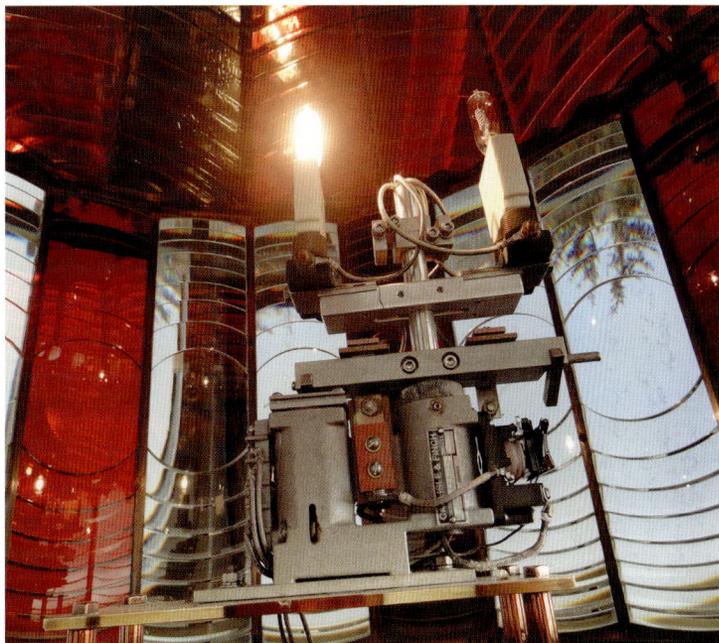

▲ UMPQUA RIVER LIGHTHOUSE, OREGON
This light-bulb-changing mechanism rotates a fresh bulb to the focal plane center of the lens upon the failure of the active bulb.

◀ TRINIDAD HEAD LIGHTHOUSE, WASHINGTON
The working Fresnel lens of this lighthouse reflects two views of a Coast Guard HH-65 helicopter.

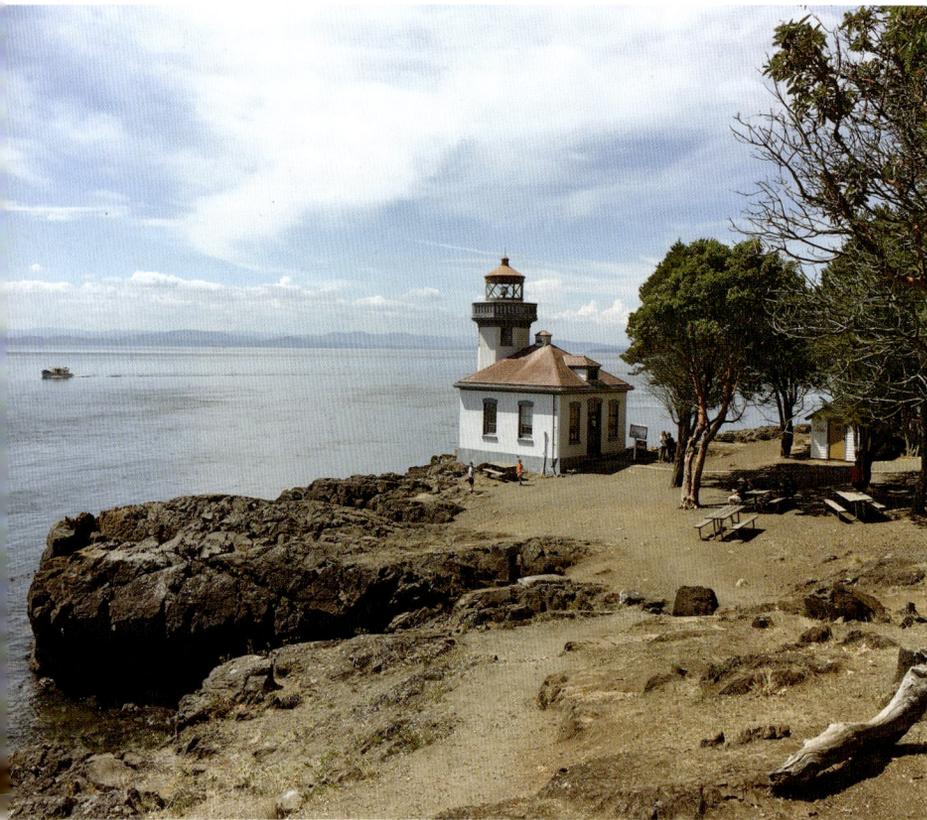

▲ **LIME KILN LIGHTHOUSE, WASHINGTON**

This lighthouse is now home to a research station bordering a whale sanctuary where scientists track the movements and behavior of orca whales.

▶ **NEW DUNGENESS LIGHTHOUSE, WASHINGTON**

This lighthouse sits at the end of a six-mile spit jutting into the Strait of Juan de Fuca. This protected, natural haven is home to more than 250 bird, 41 land-mammal, and eight marine-mammal species.

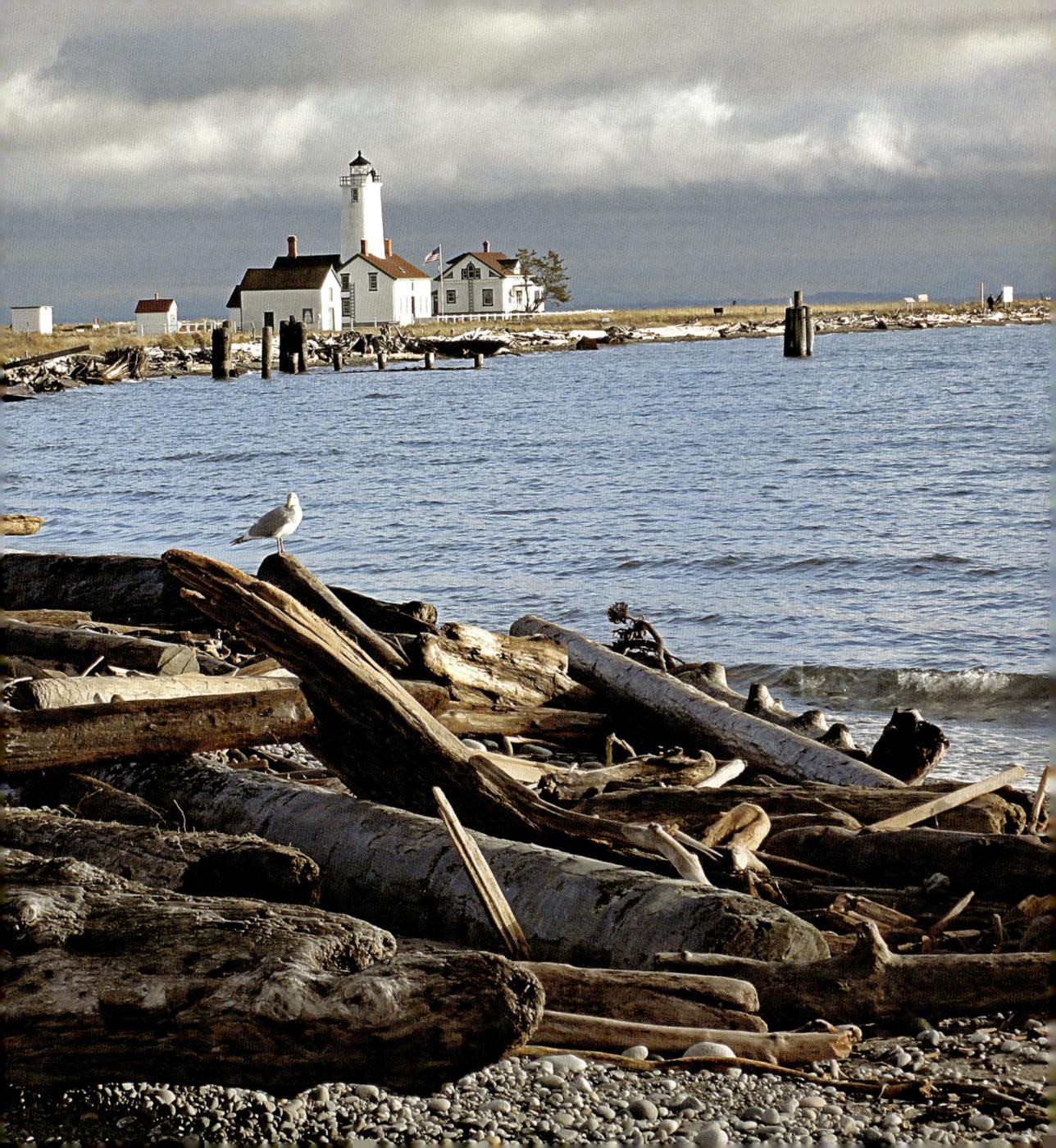

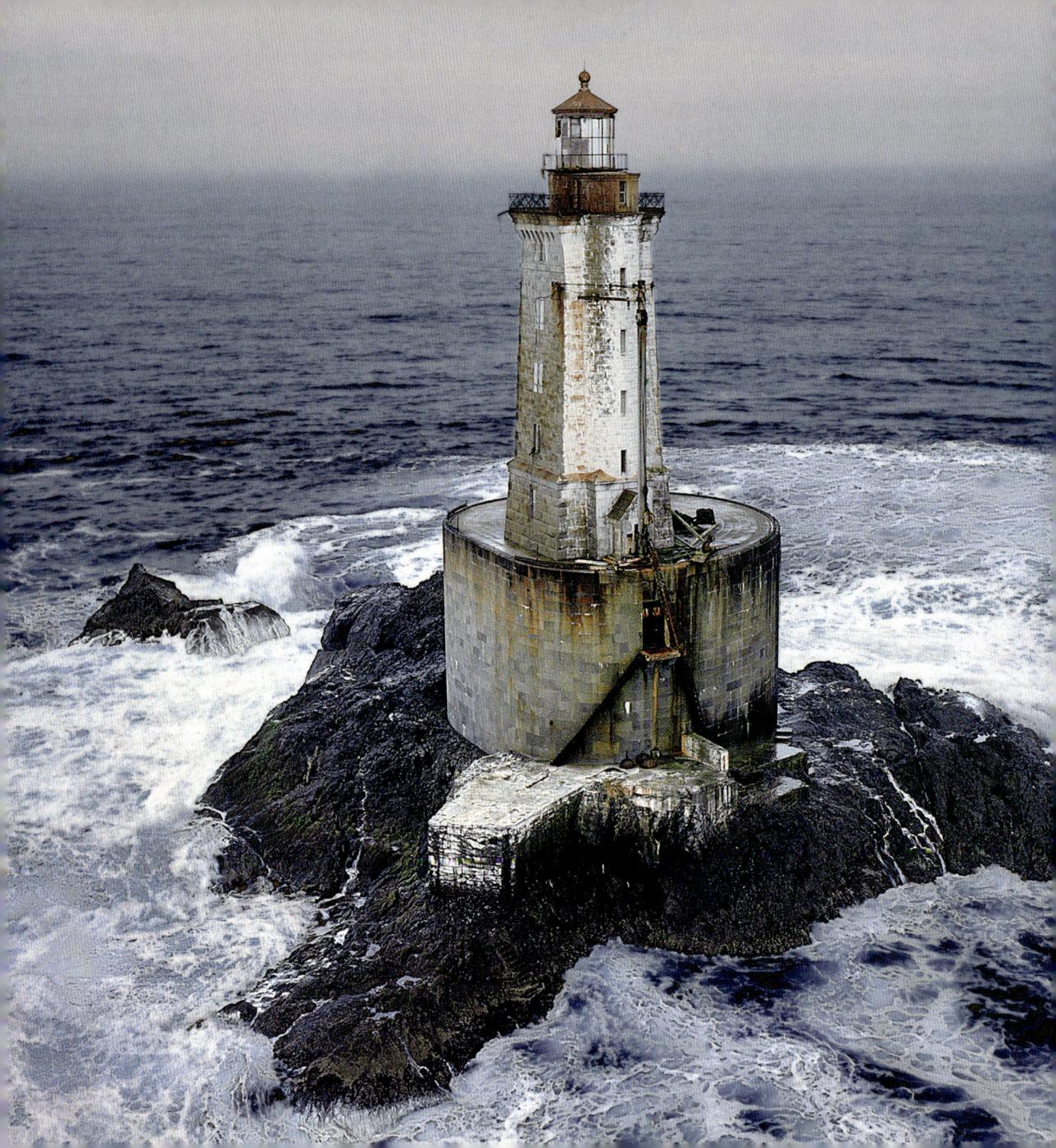

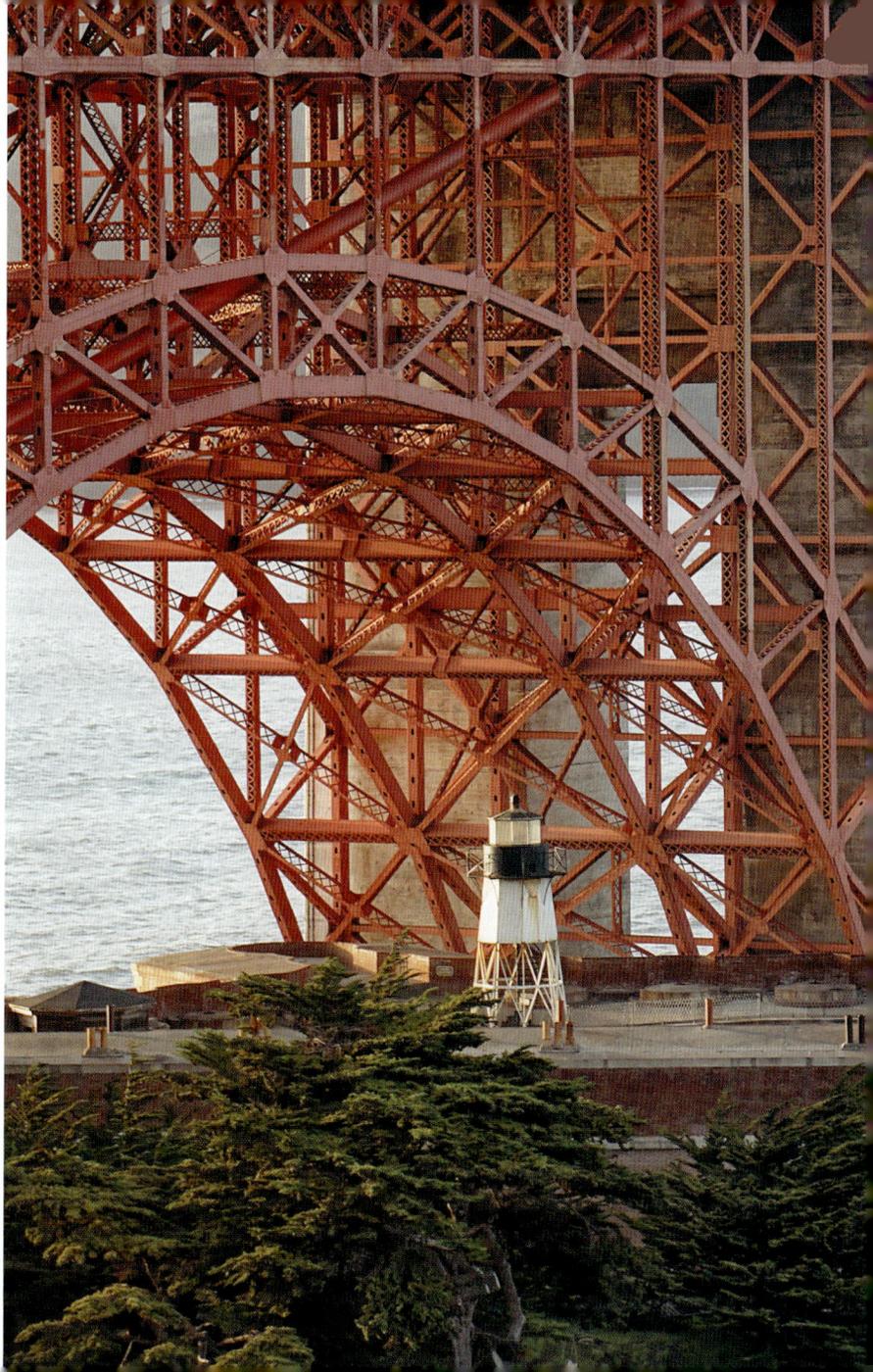

◄ SAINT GEORGE
REEF LIGHTHOUSE,
CALIFORNIA

*A live pig was brought to this
lighthouse for the keepers'
1909 Easter feast. Waves
dashed the foraging pig into
the surf. The keeper leapt
into the ocean, grabbed
the hog, and waited for the
rescue boat. The pig was
confined thereafter until
Easter dinner preparations.*

▶ FORT POINT LIGHT-
HOUSE, CALIFORNIA

*The fog-signal structure at
this lighthouse was badly
damaged in 1867 during a
Fourth of July salute fired
from the army fort upon
which it sat.*

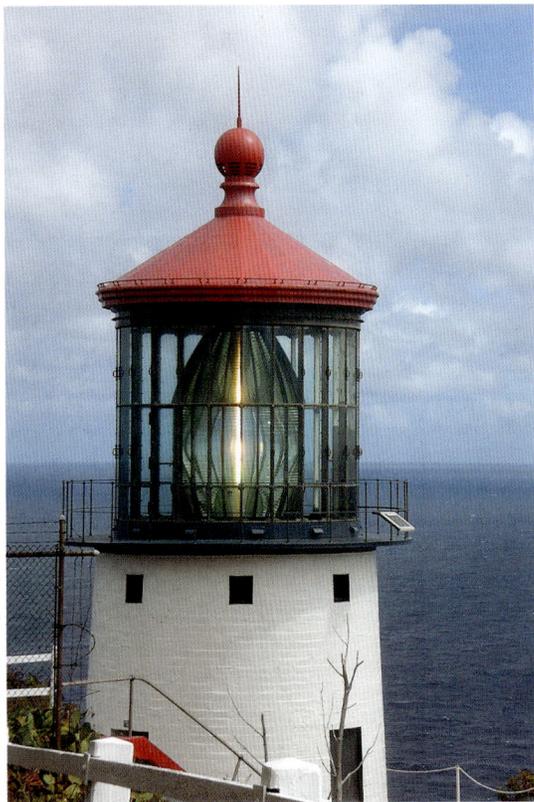

▲ MAKAPU'U POINT LIGHTHOUSE, HAWAII
The only hyper-radial Fresnel lens in American lighthouses was hoisted from the deck of a ship 420 feet below to its location on the side of a cliff.

▶ ALCATRAZ LIGHTHOUSE, CALIFORNIA
One fog bell at this lighthouse was struck with a 30-pound hammer moved by a clockwork mechanism, which required winding by keepers every five hours.

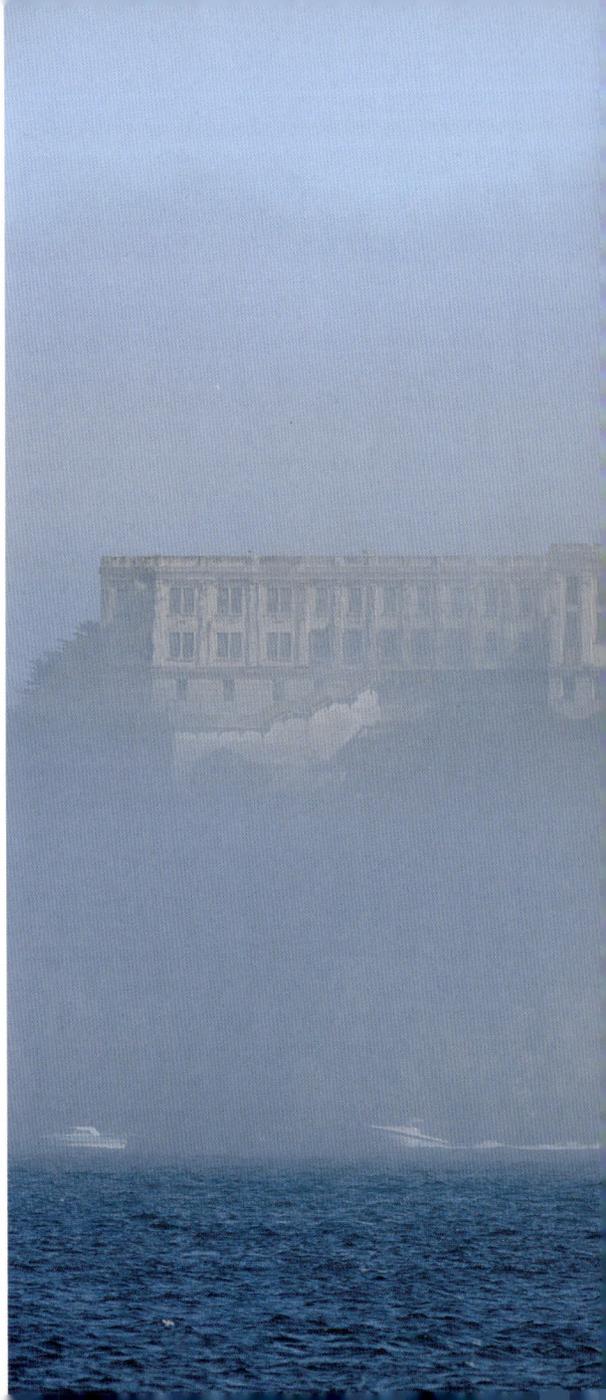

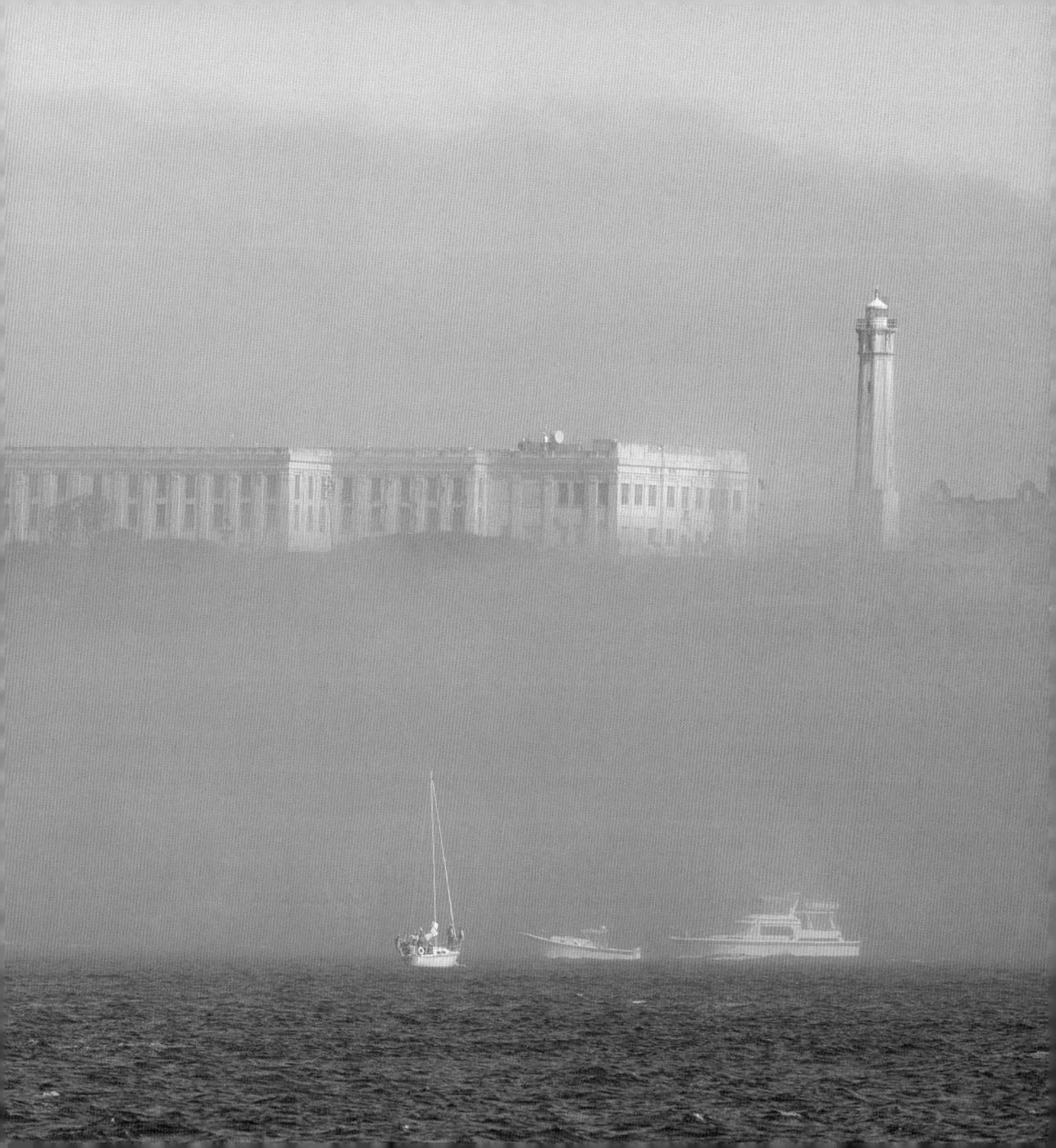

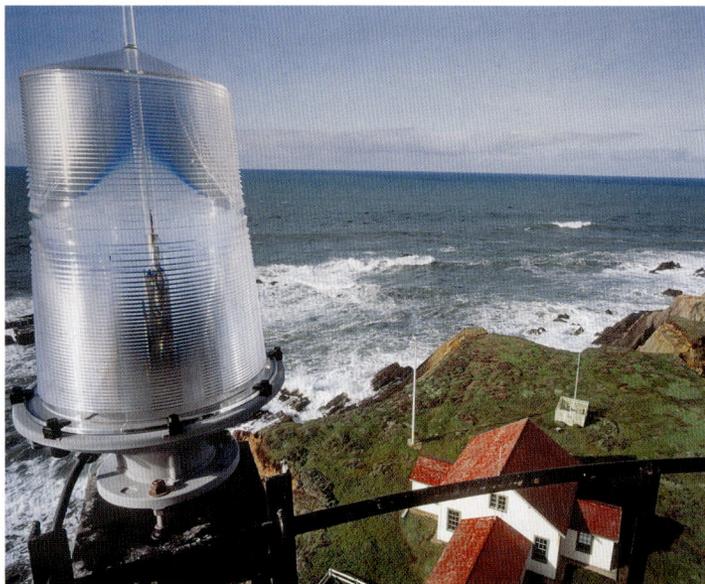

▲ ▶ POINT ARENA LIGHTHOUSE, CALIFORNIA
Modern electric, acrylic light fixtures were installed on lighthouse towers like this one beginning in the 1960s as a program to automate all light stations. The original first-order Fresnel lens floated on five gallons of mercury (about 567 pounds).

(Pages 156–157)
TABLE BLUFF LIGHTHOUSE, CALIFORNIA
The restored remains of the original Table Bluff Lighthouse, once atop the nearby promontory, now sit in a parking lot at Humboldt Bay Harbor.

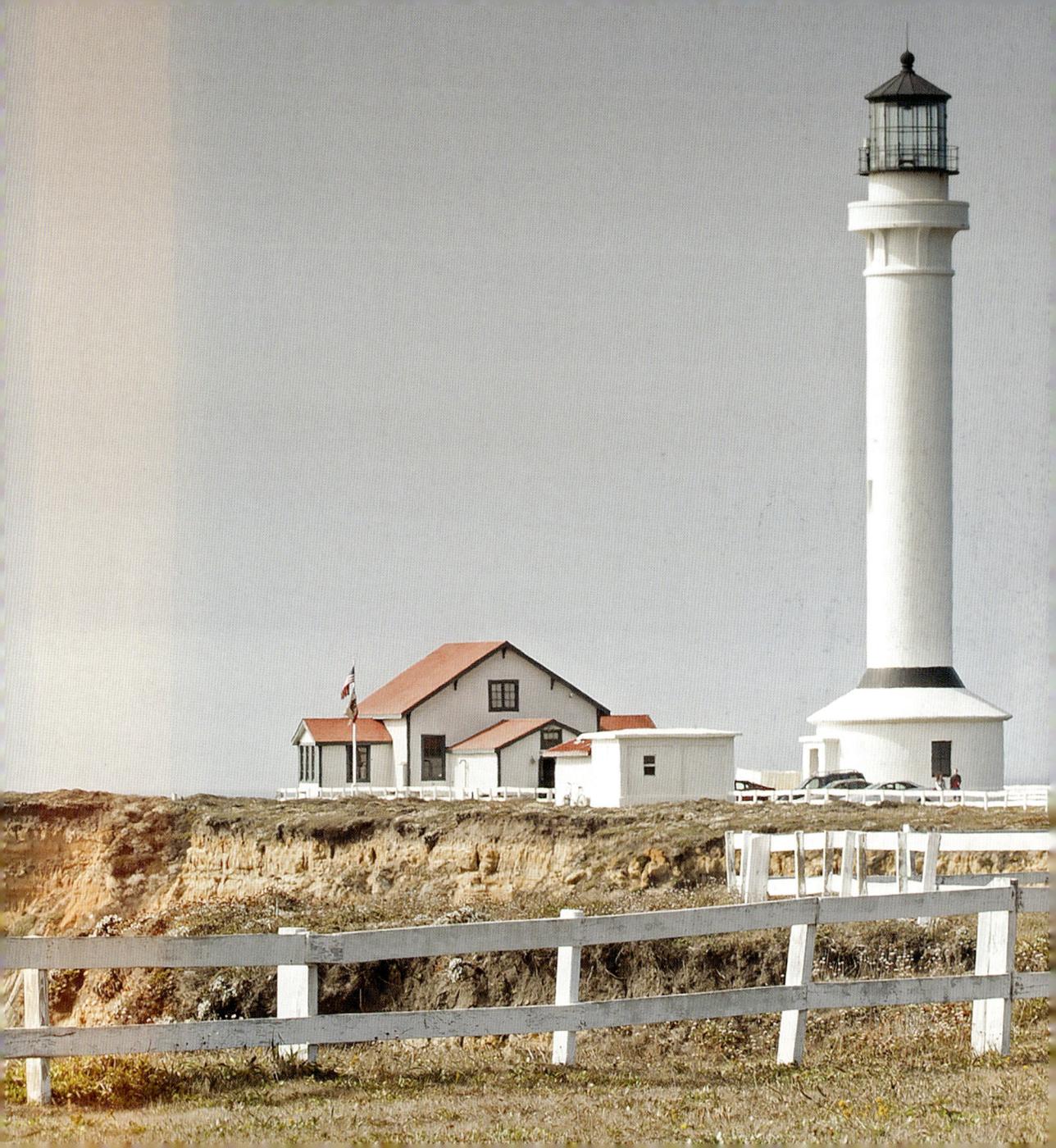

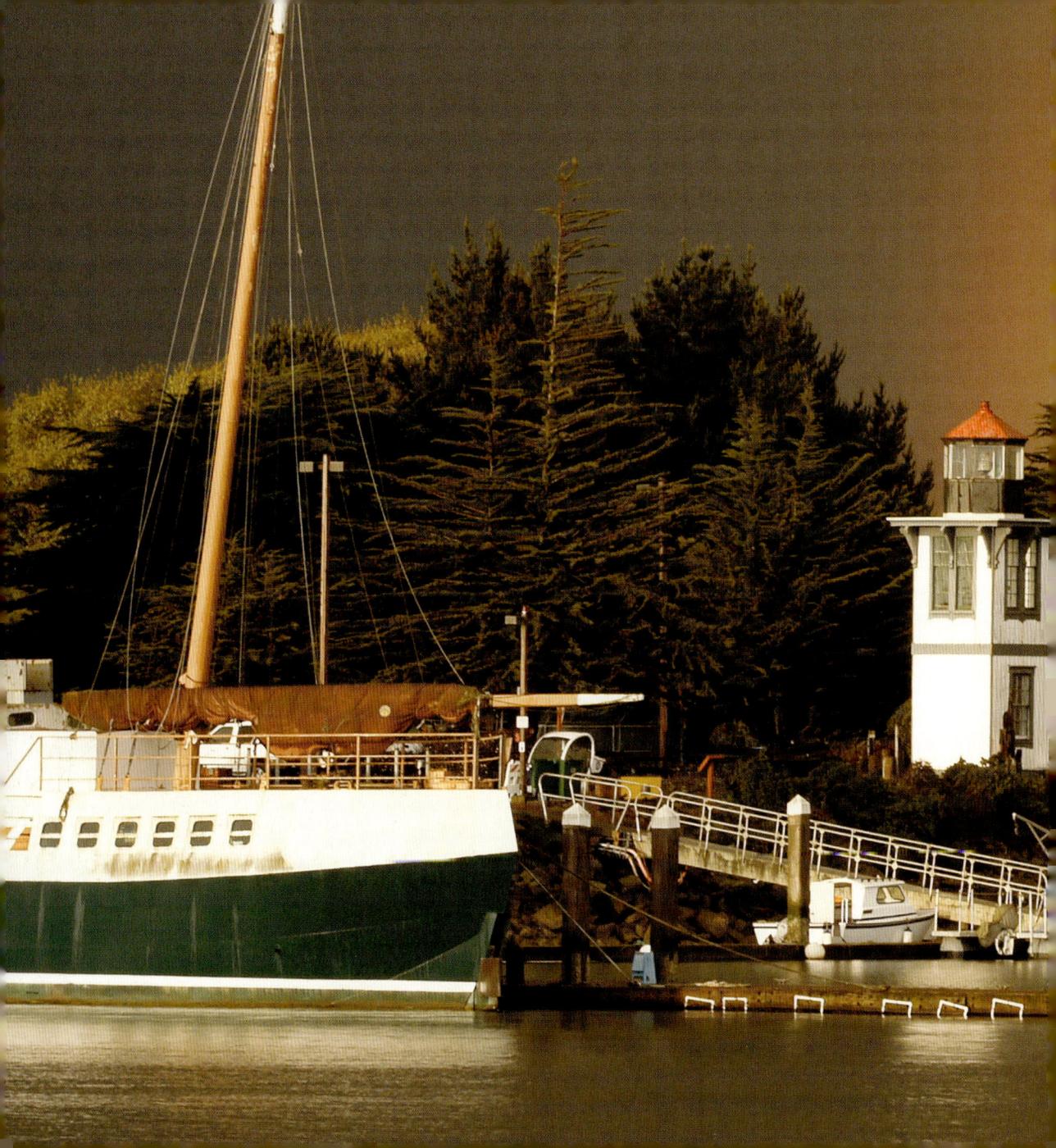

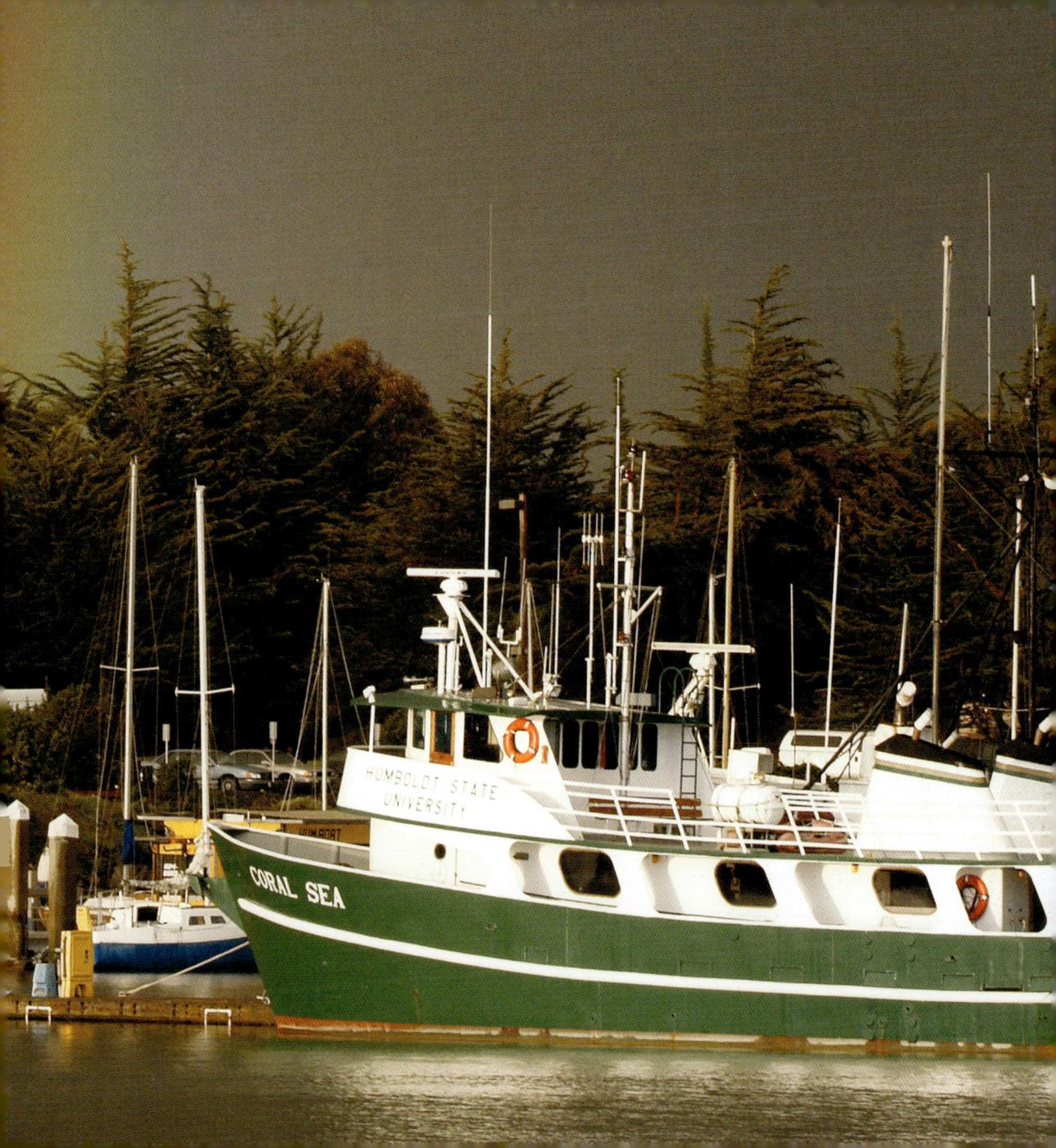

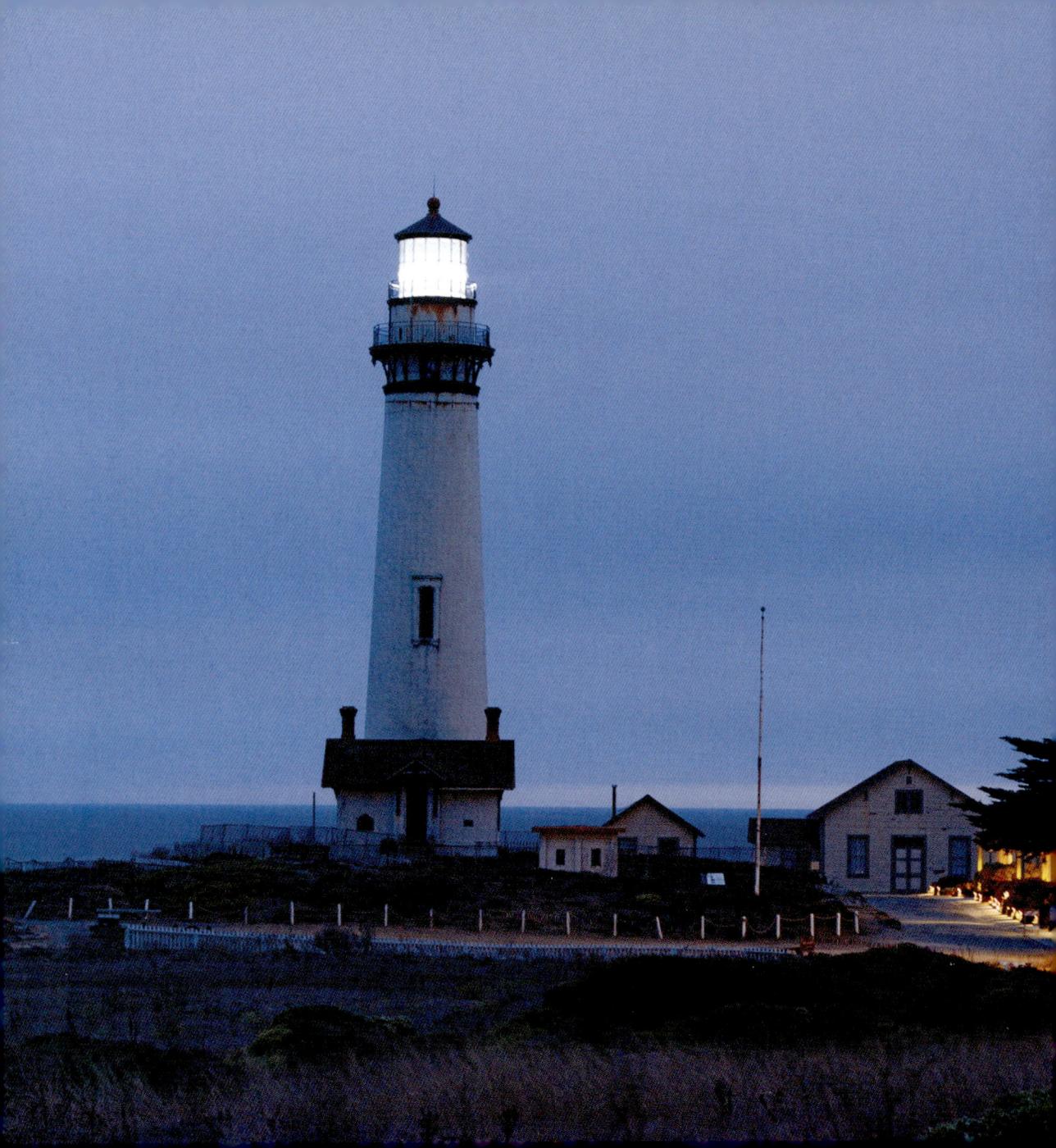

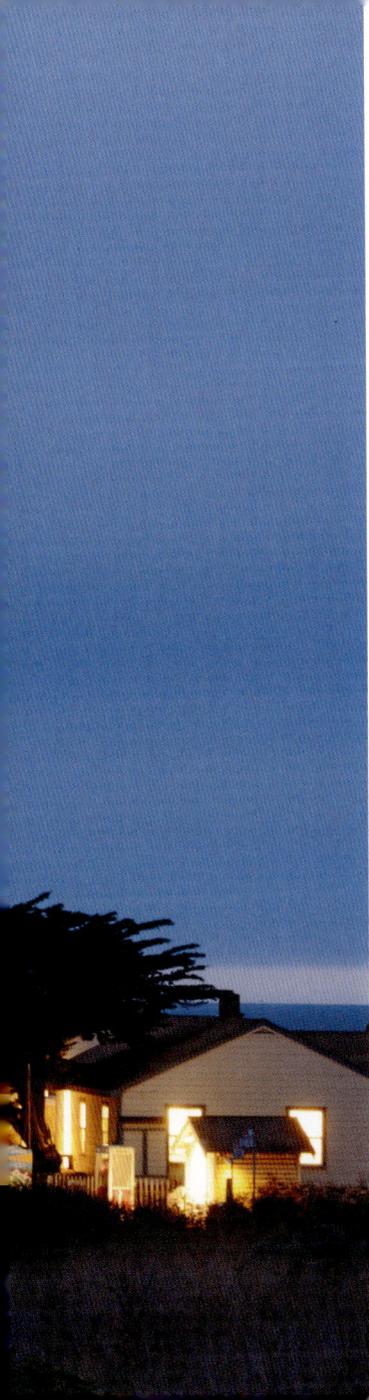

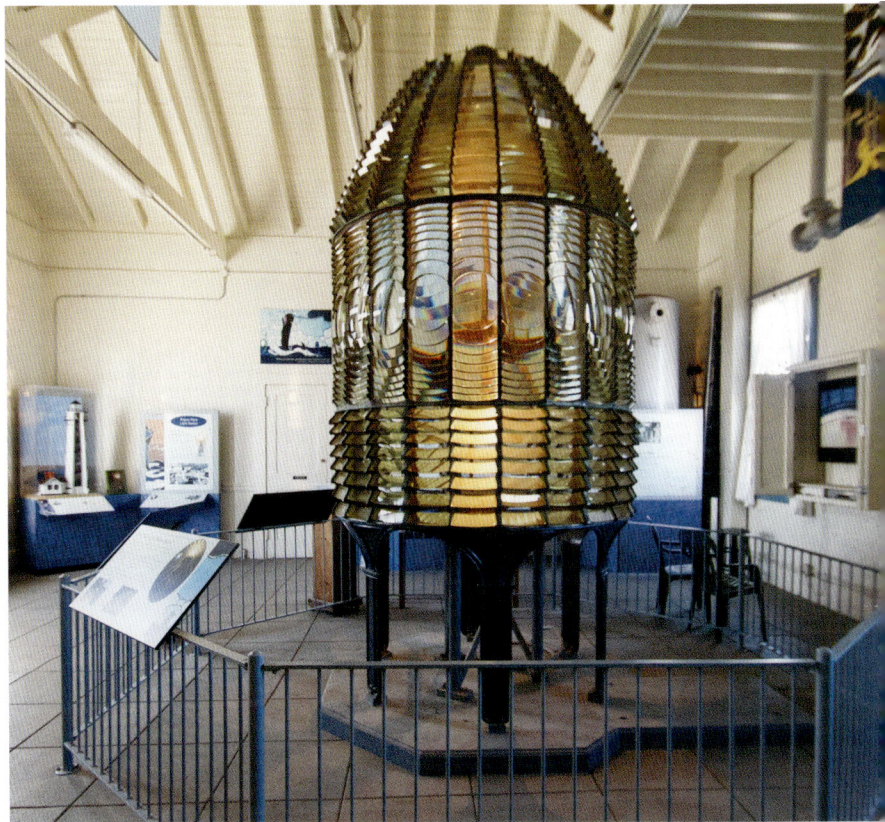

▲ ◀ PIGEON POINT LIGHTHOUSE, CALIFORNIA

The clipper ship Carrier Pigeon *departed Boston in January 1853 on its maiden voyage to San Francisco. The stately vessel smashed into rocks where this lighthouse tower now stands. Pigeon Point Lighthouse's first-order Fresnel lens (above), lit in 1872, originally came from Cape Hatteras Lighthouse, which was extinguished during the Civil War.*

BATTERY POINT LIGHTHOUSE, CALIFORNIA

This lighthouse survived the 1964 Great Alaska Earthquake's tsunami, which destroyed 29 blocks of nearby Crescent City.

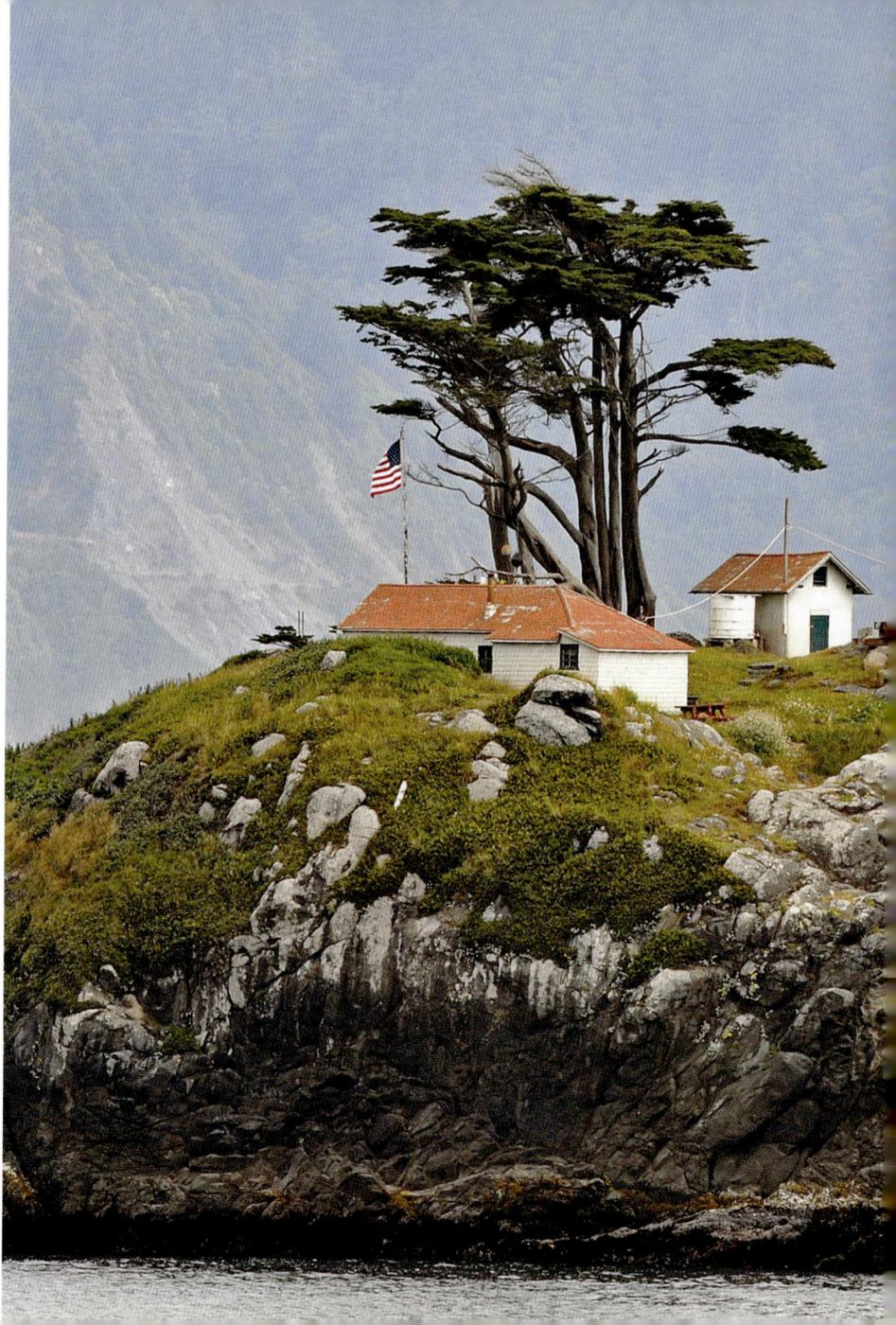

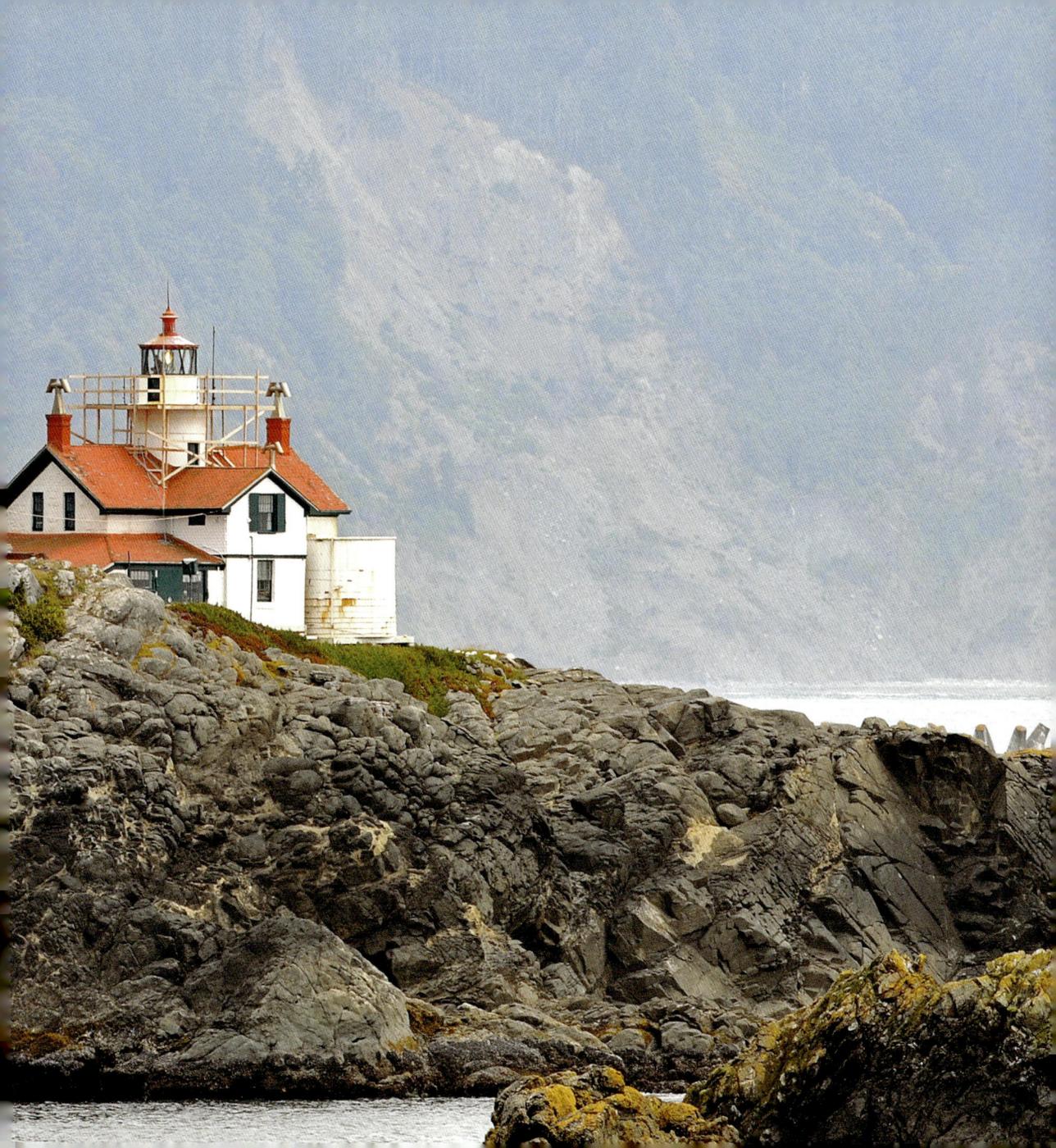

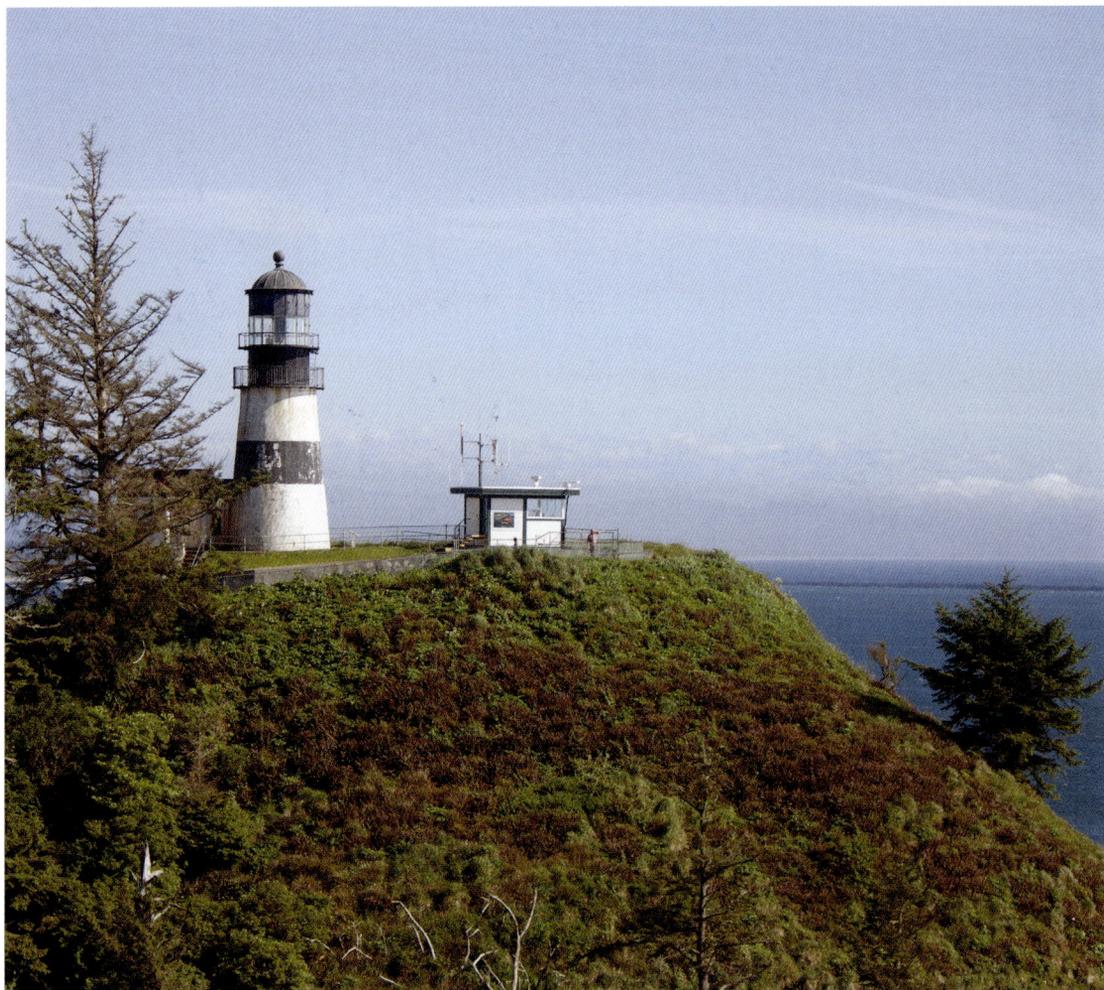

CAPE DISAPPOINTMENT LIGHTHOUSE, WASHINGTON
This point of land was named in 1788 by Captain John Meares, who recorded the location as "Cape Disappointment" when seeking refuge from a storm at the mouth of the then-unknown Columbia River.

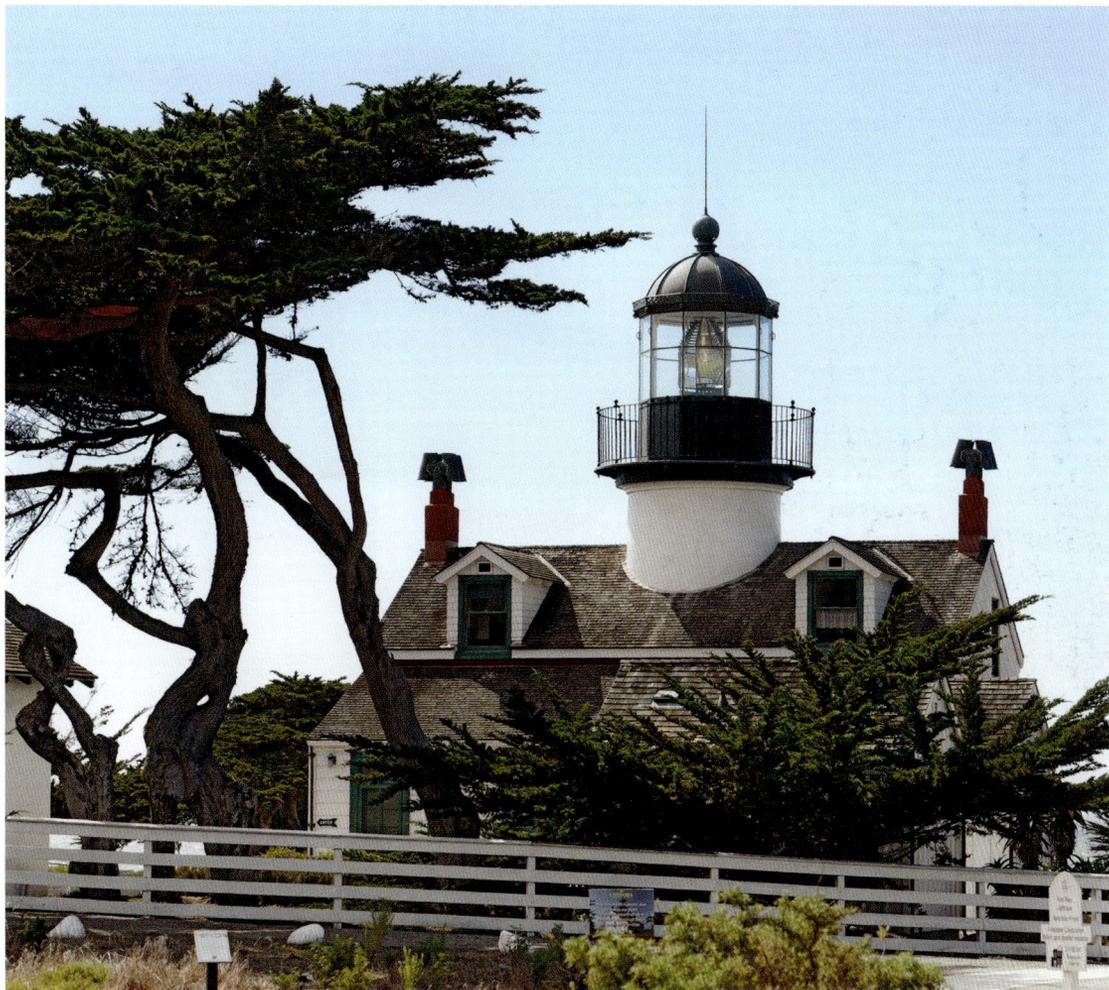

POINT PINOS LIGHTHOUSE, CALIFORNIA
Widowed at 50, Emily Fish was appointed keeper of this lighthouse
in 1893. She served as the popular "socialite keeper" for 20 years.

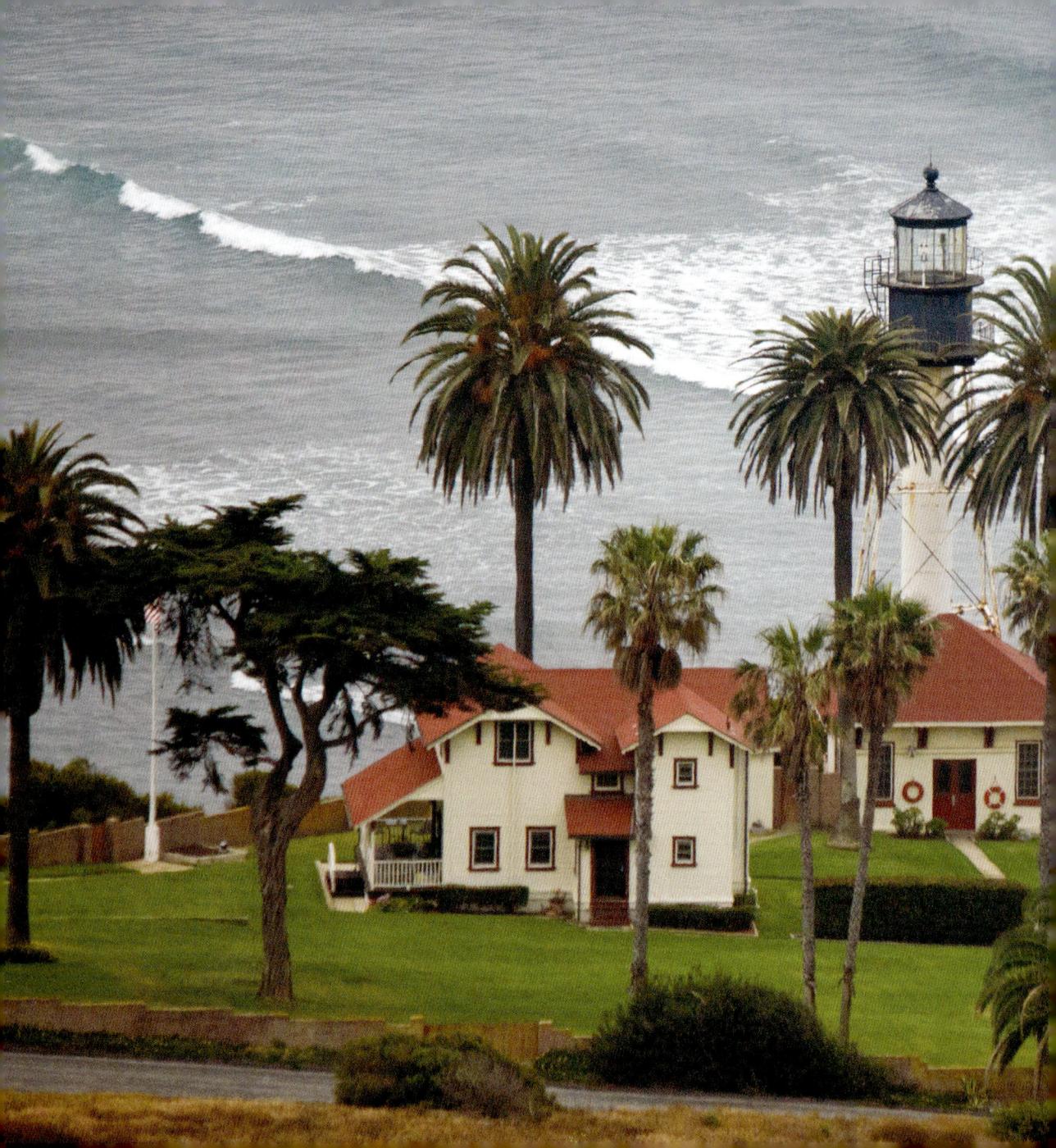

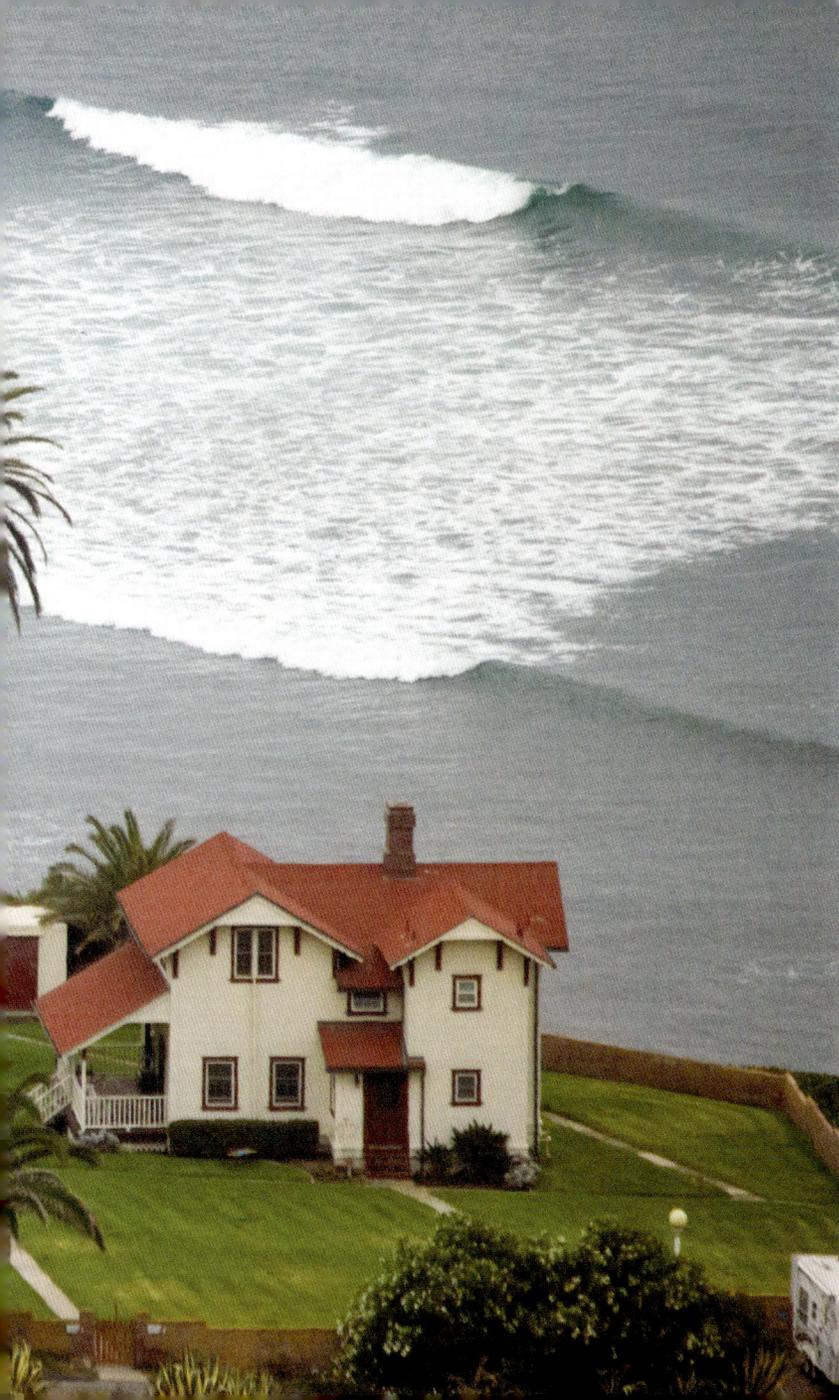

NEW POINT LOMA LIGHTHOUSE, CALIFORNIA

Low clouds frequently obscured the original Point Loma Lighthouse, so New Point Loma Lighthouse was built at a lower elevation in 1890 with three Victorian dwellings and an iron lighthouse tower.

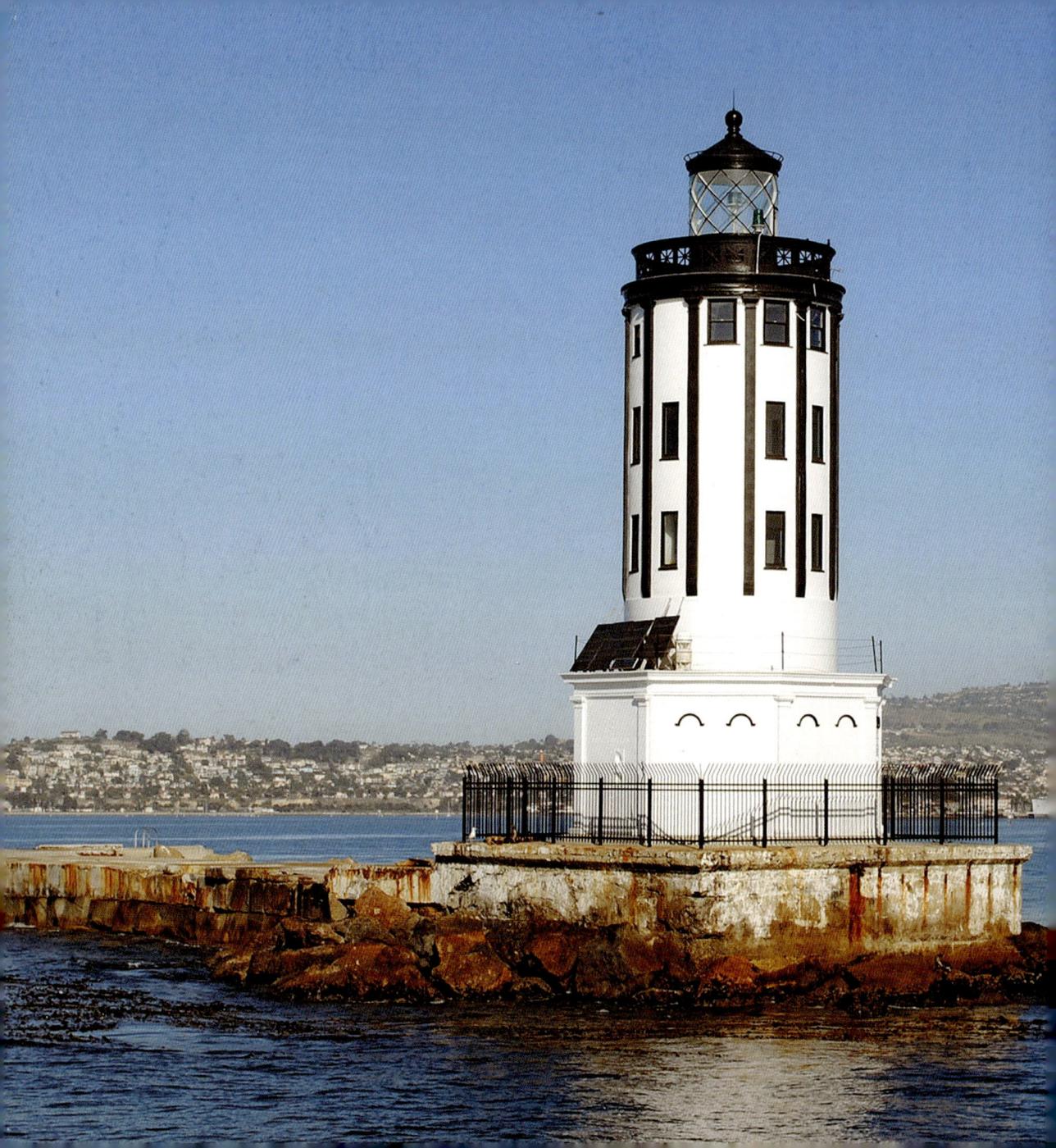

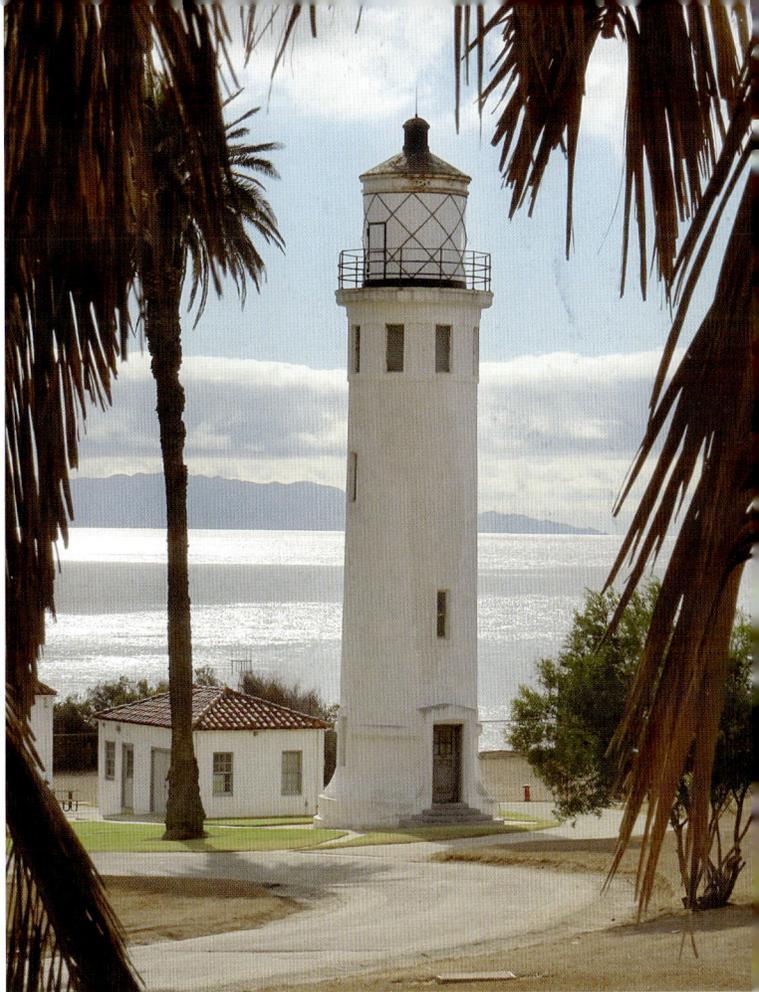

▲ POINT VICENTE LIGHTHOUSE, CALIFORNIA
Viewers of this lighthouse claimed visions of a woman wandering the tower's walkway after its land-side lantern room windows were painted white.

◀ ANGEL'S GATE LIGHTHOUSE, CALIFORNIA
The unique, award-winning Romanesque design for this lighthouse was created by Edward L. Woodruff, employed by the 18th Lighthouse District.

▶ EAST BROTHER LIGHTHOUSE,
CALIFORNIA

*San Francisco's 1906 earthquake broke
"everything glass" in this lighthouse, including
the Fresnel lens prisms.*

(Pages 170–171)
POINT NO POINT LIGHTHOUSE,
WASHINGTON

*The lantern room at this lighthouse still houses
its original fourth-order Fresnel lens.*

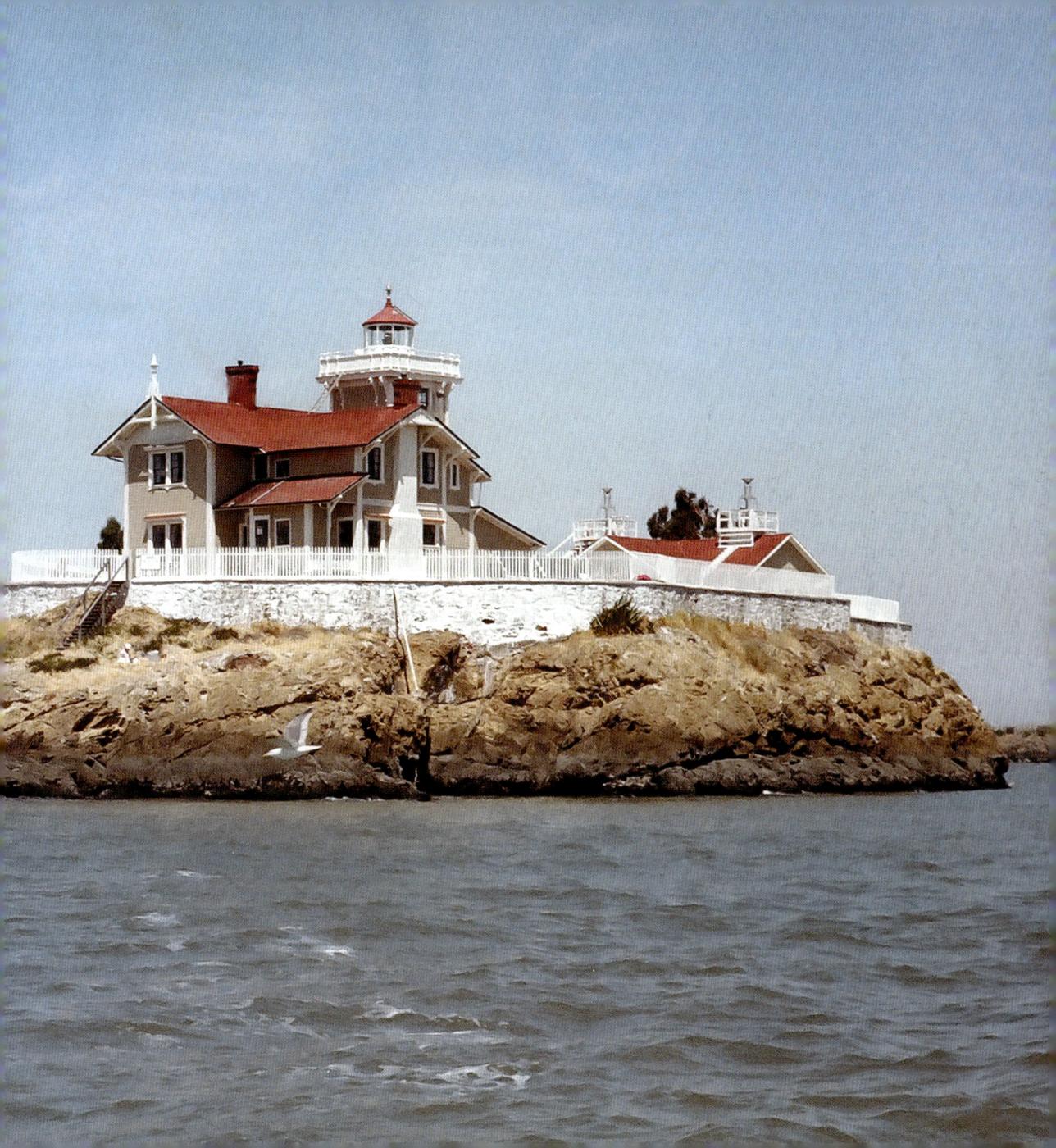

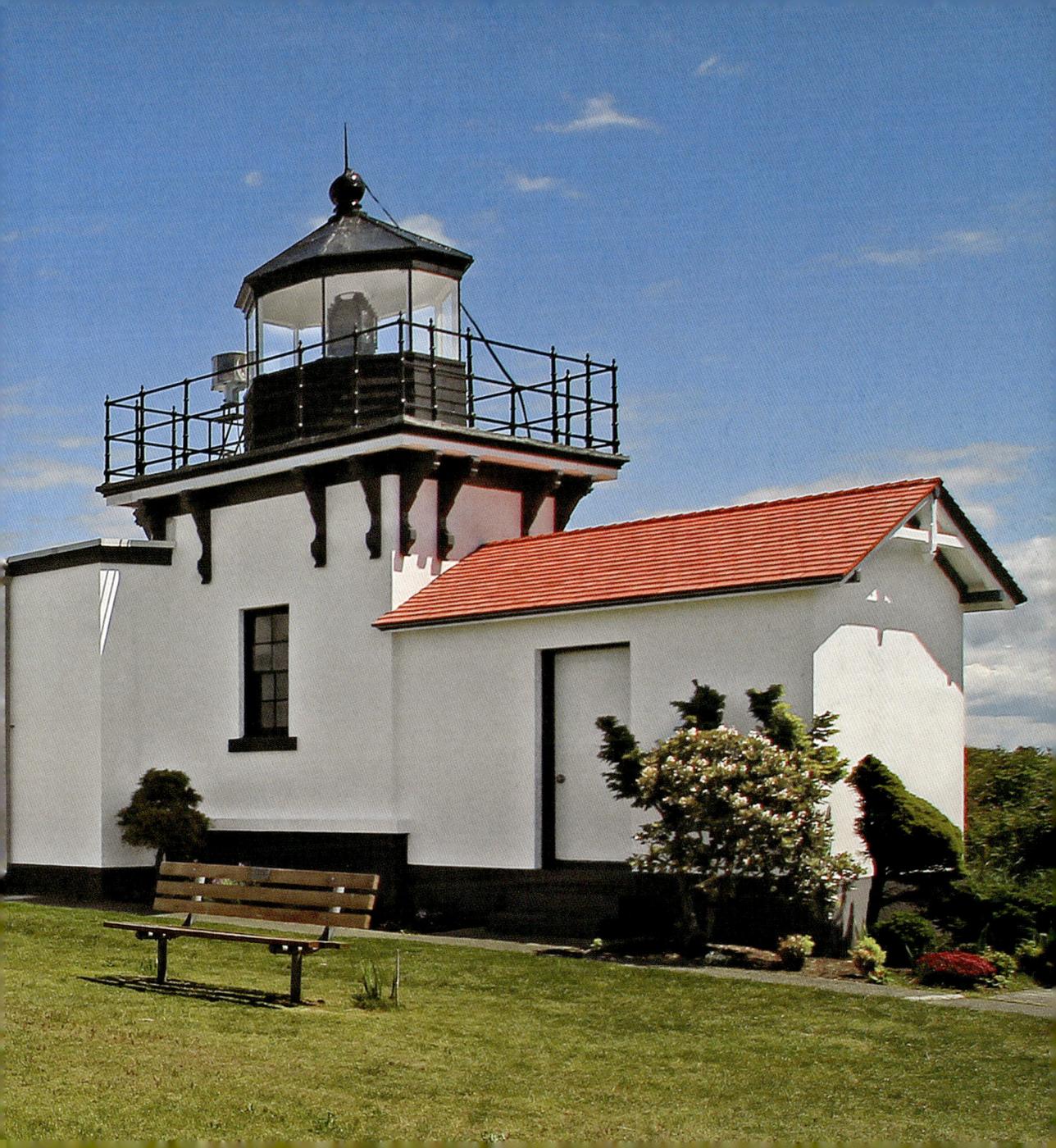

About Fresnel Lenses

French physicist Augustin-Jean Fresnel (1788–1827) advanced wave theory of light. In 1821, he surrounded a common glass lens, already proven to concentrate light into a single dot, with a series of concentric, prismatic glass rings. This multiple-lens apparatus collected light scattered from a single light source, concentrating and focusing it into a beam. During the late 19th century, the need for navigation aids led to the rapid development of the colossal lenses known today as Fresnel lenses. In addition to the famous lighthouse lenses, Fresnel lenses are common in hundreds of applications—from car headlights to flat magnifying glasses.

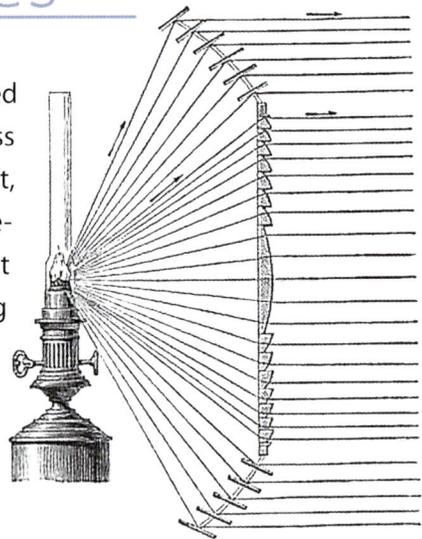

Order	Diameter (Inches)*	Height (Inches)	Weight (Pounds)	Quantity	Value
Hyper-Radial	104.6	148	18,485	1 (1907)	$398,000**
First	72.4	101.97	12,787	57	$364,000
Second	55.2	81.46	3,527	27	$233,000
Third	39.4	62.05	1,984	65	$111,000
Third-and-a-Half	29.4	42.9	1,200	25	$58,200
Fourth	19.6	28.43	441 to 661	350	$36,400
Fifth	14.8	21.3	265 to 441	146	$27,700
Sixth	11.8	17.05	65 to 220	89	$13,100

*Diameter is to the inner lens surface at the focal plane.

**Only one hyper-radial was purchased by the US Lighthouse Service for use in the United States—at Makapu'u Point, Hawaii (see page 152). The 2015 value is based on its original purchase price of $15,280 in 1907 adjusted for the purchasing power of the dollar.

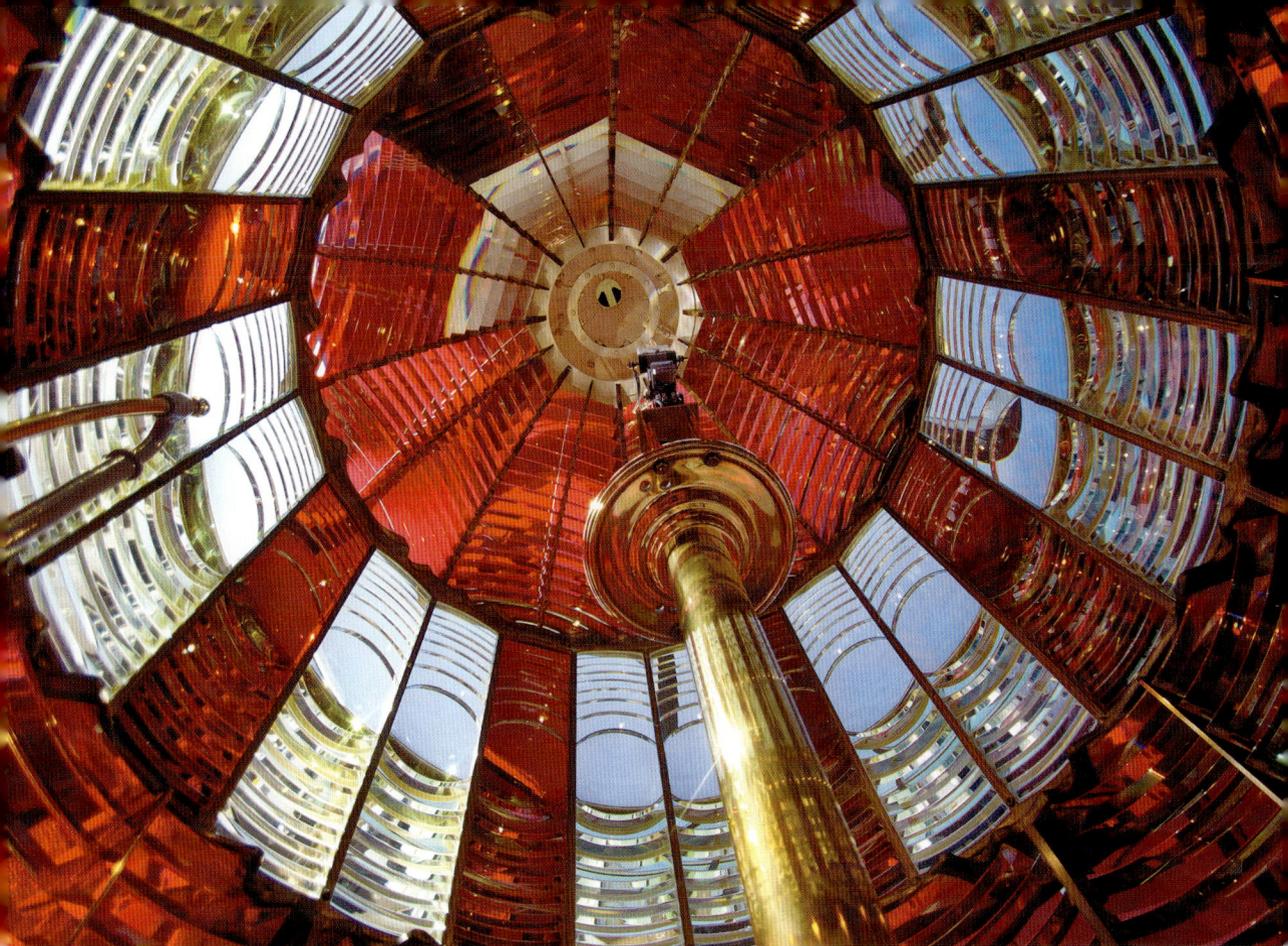

The chart opposite shows common Fresnel lens sizes (called "orders"), quantities, and costs for US lighthouses based on a 1900 inventory. The 2015 US dollar values shown are established on the approximate value in 1900 and adjusted based only on the dollar's purchasing power. These prices do not reflect the true value of Fresnel lenses today. Rarity assigns a far greater value.

UMPQUA RIVER LIGHTHOUSE, OREGON

The ruby-colored glass in this first-order Fresnel lens is created by infusing molten glass with gold.

Photography Credits

© Artworks Florida Classic Fresnel Lenses: pp. 38–39, 102–103, and 124.
© Debra Baldwin: p. 151.
© John David Bruha: p. 86.
© James Conklin: pp. 22, 33 (left), 40, 73, and 84.
© Jeremy D'Entremont: back cover, pp. 8, 13, 16–17, 18–19, 20–21, 24–25 (both), 26, 27, 29, 30–31, 34–35, 36–37
 (both), 39, 41, 42, 43, 45, 46 (top), 47, 48–49, 50–51 (both), 52, 54 (bottom), 54–55, 56–57, 58, 60–61, 62–63,
 126–127, 128–129, 132, 133, 159, 162, 164–165, and 173.
© Ralph Eshelman: pp. 2–3, 46 (bottom), 63 (bottom), 66, 72 (right), 75, 76, 85 (left), 86–87, 92, 98–99, and 112–113.
© Jeff Gales: p. 152.
© Tom Gill: p. 104.
© John Griner IV: pp. 80–81, 98, 101, and 123.
© James Hill: pp. 5, 6–7, 23, 28, 32, 33 (right), 34, 54 (top), 59, 63 (top), 64–65, 66–67, 68, 70–71 (both), 72 (left),
 82–83, 90–91 (all), 92–93, 94–95 (both), 103, 108–109 (both), 114–115, 116, 118–119 (all), 120–121 (both),
 122–123, 124–125, 130–131 (both), 134, 135, 136, 137, 138–139, 141, 142, 143, 144–145 (both), and 167.
© Richard Hoeg: pp. 96–97.
© Chad Kaiser: p. 147.
© Patrick Kearney: pp. 78–79.
© Larry Klink: pp. 88–89 and 154–155.
© Barry Kurek: pp. 44, 110, 111, and 116–117.
© Julie Lake: pp. 74–75.
© Peter Lerro: front cover.
© Carole Meyers: pp. 68–69 and 77.
© Don Mitchell: pp. 14–15.
© Susan Montague: pp. 168–169.
© Dave Olsen: pp. 170–171.
© Jeanette O'Neal: pp. 100–101 and 114.
© Catherine Parker: p. 148.
© Cynthia Privoznik: pp. 148–149.
© Dianne Seymour: p. 49.
© Skip Sherwood: pp. 10–11, 53, 85 (right), 106–107, and 166–167.
© Steven Stafford: pp. 140–141, 152–153, 158–159, 160–161, and 163.
© Thomas Tag: p. 88 (both).
© Gary Todoroff: pp. 146–147, 150–151, 154, and 156–157.
© Joe Uridil: p. 105.
Courtesy US Lighthouse Society Archives: p. 172.
© Barb and Ken Wardius: p. 176.
© Gene Witkowski: p. 106.

Acknowledgments

My grateful appreciation goes to the United States Lighthouse Society (USLHS) and all individuals supporting my efforts in bringing forth these extraordinary views of an American icon in *Lighthouses of America*. This book is a result of the farsightedness and determined efforts of Founder and President of the USLHS Board of Directors Wayne Wheeler and USLHS Executive Director Jeff Gales. The collection of images is possible due to the many individuals who unselfishly shared their favorite photos with USLHS and this book's editors. My regret is we had too little space to show even more excellent photographs from these contributors. Technical support, lighthouse questions answered, and good old-fashioned encouragement were assured from USLHS Executive Editor Ralph Eshelman and Richard Gales. Additional information came from Kraig Anderson's amazing reference resource, Lighthouse Friends (www.lighthousefriends.com), plus the many lighthouse societies' colorful and enlightening websites.

My honor, where visualization and technical consideration counts, was to have at my side talented Graphics Editor Tom Thompson, who used his eyes attuned to art to glean the best of the best for this limited selection from the hundreds of photographs submitted. I borrowed him from his usual pursuits as an excellent painter, wordsmith, TV producer, and organist of world fame.

It is like being with family once again working with Associate Publisher James Muschett, Editor Candice Fehrman, and Designer Lori S. Malkin of Welcome Books.

The photographs on these pages exhibit some unique visions of where the nation, for 300 years, provided visual and sound aid to navigators for their safety, supporting economic enhancement to the people and governments of America. Some photos further illustrate the remoteness where men and women routinely faced exceptionally severe physical extremes and social poverties, forcing heroic actions solely to keep the light lit and gong struck.

—Tom Beard

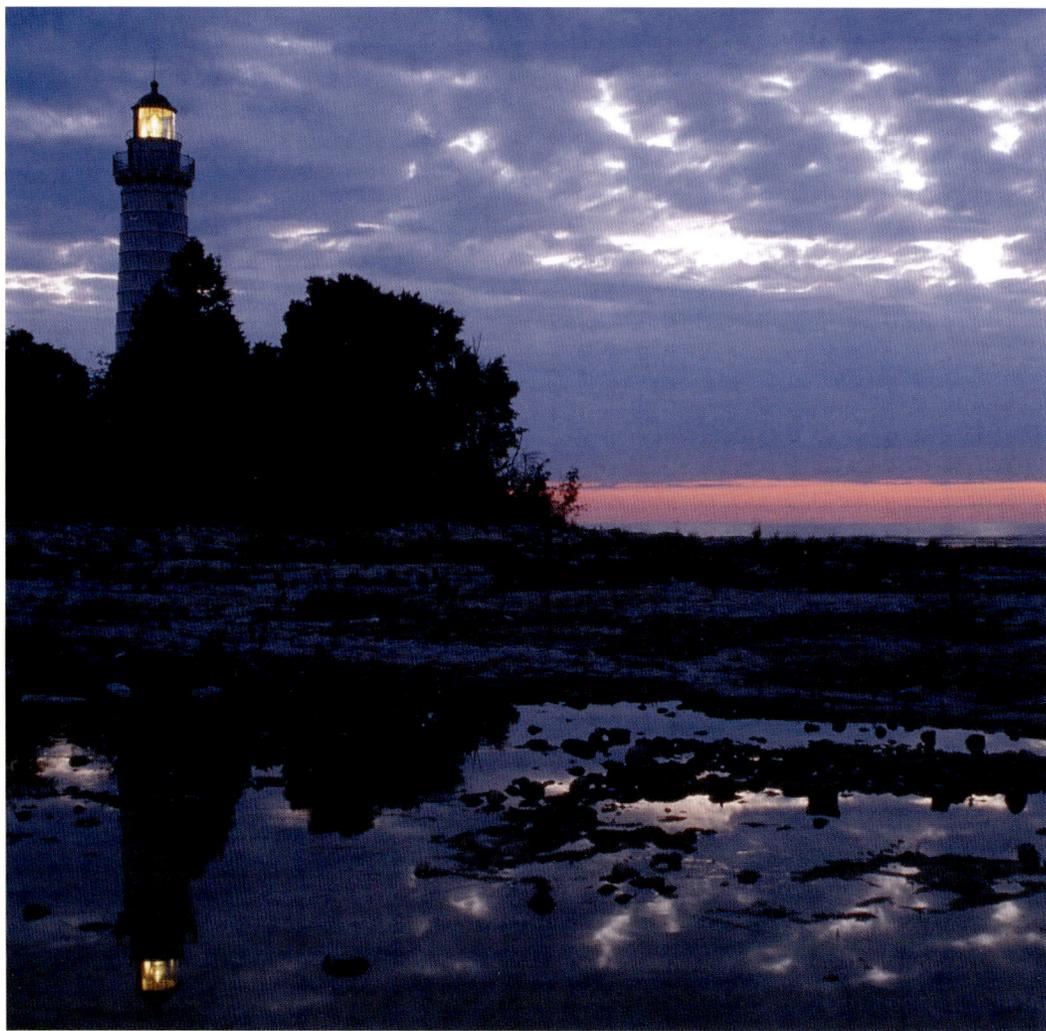

CANA ISLAND LIGHTHOUSE, WISCONSIN